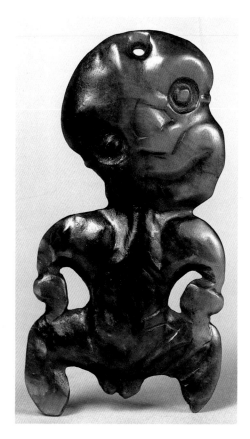

TE MAORI

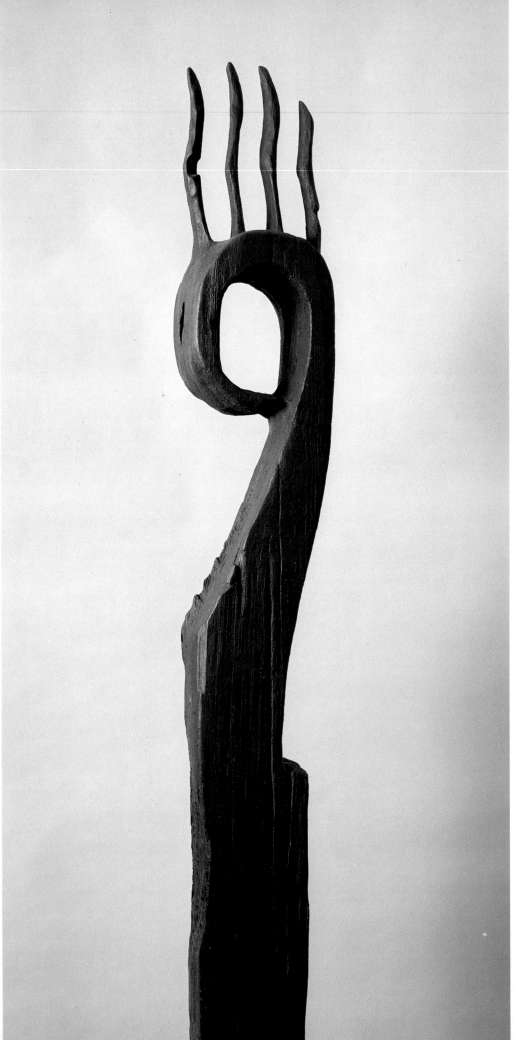

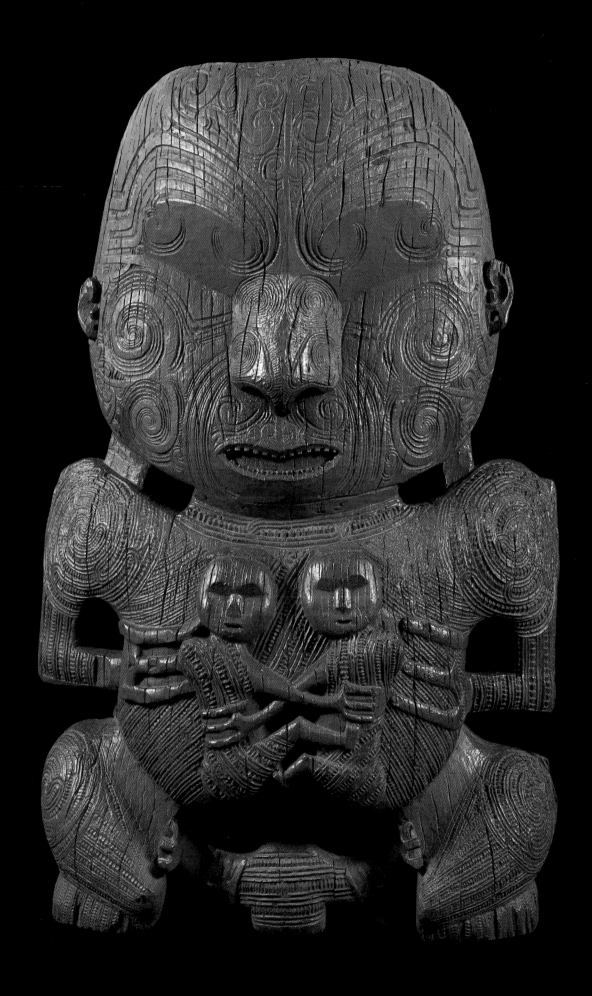

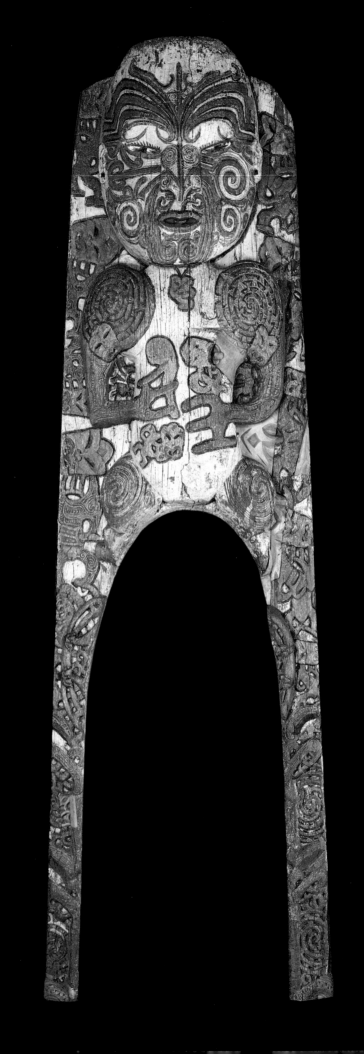

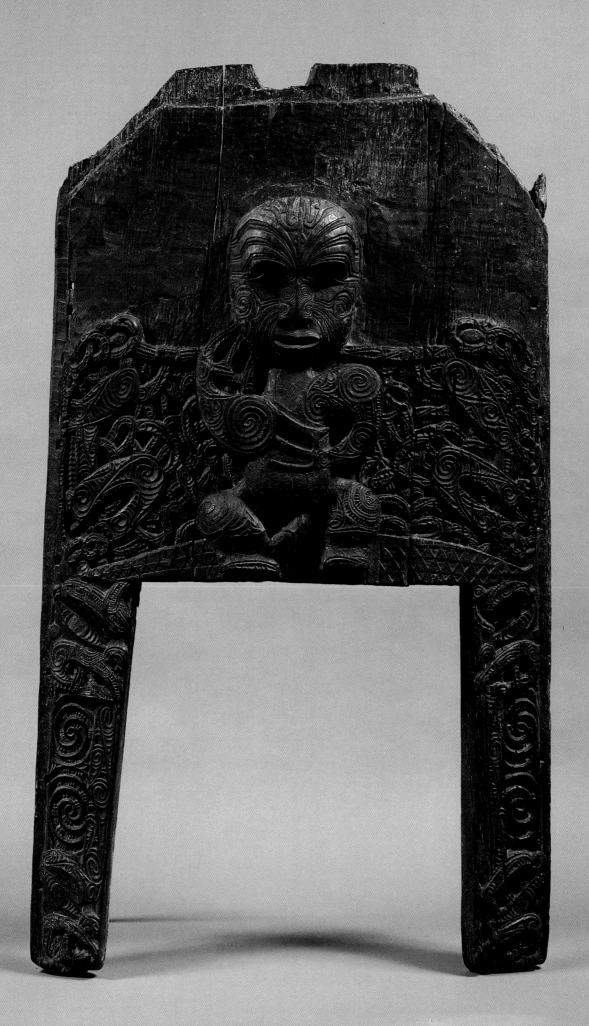

5

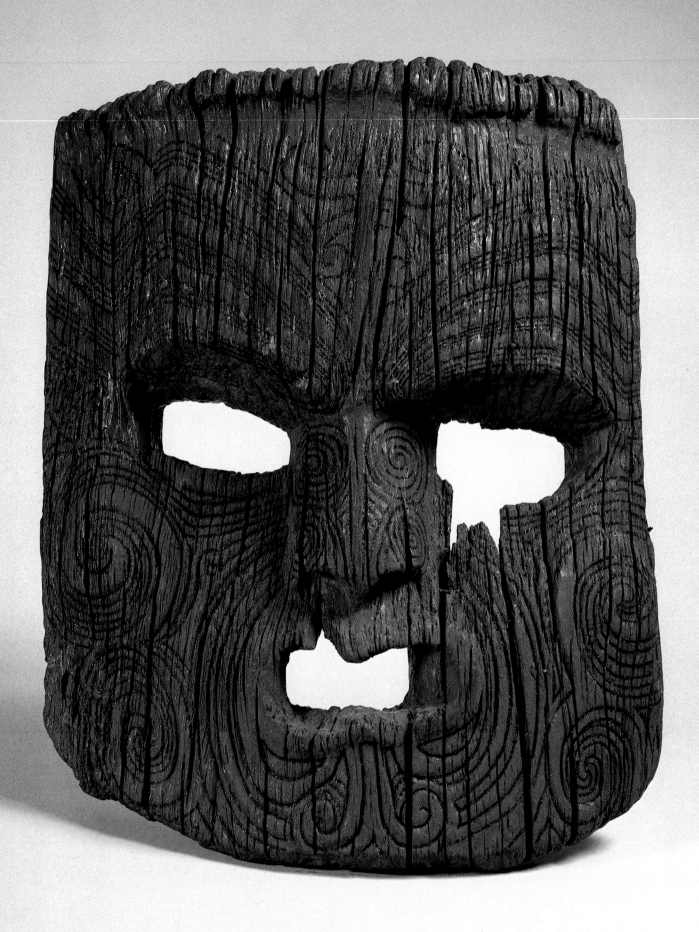

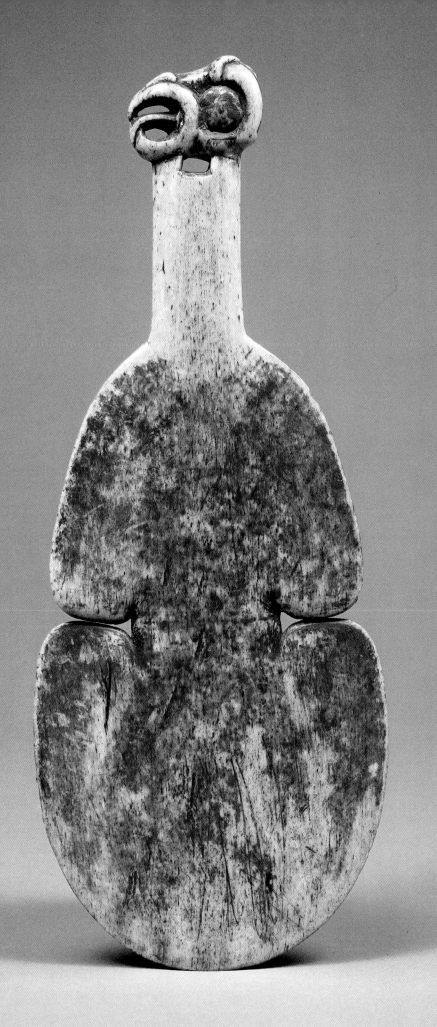

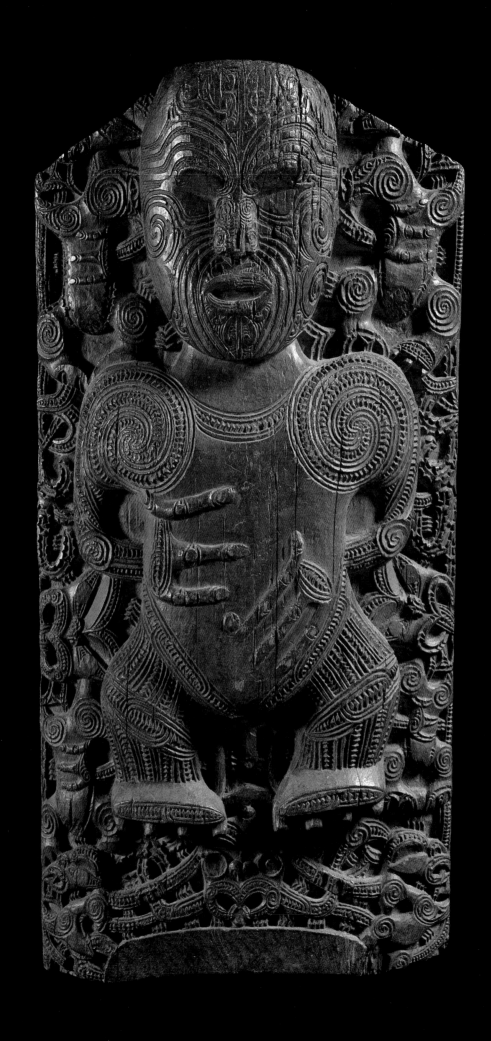

TE MAORI

Maori Art from New Zealand Collections

Edited by SIDNEY MOKO MEAD

Text by Sidney Moko Mead / Agnes Sullivan / David R. Simmons
Anne Salmond / Bernie Kernot / Piri Sciascia

Photographs by Athol McCredie

Harry N. Abrams, Inc. / Publishers / New York
in association with The American Federation of Arts

FRONT COVER:
Gateway of Pukeroa pa, detail (cat. no. 64)

BACK COVER:
Gateway of Pukeroa pa (cat. no. 64)

PAGES 1–8:
Plate 1. Hei-tiki. Pendant (cat. no. 32)
Plate 2. Uenukutuwhatu. War god (cat. no. 28)
Plate 3. Waharoa. Gateway of Pukeroa pa (cat. no. 64)
Plate 4. Gateway figure (cat. no. 66)
Plate 5. Kuwaha pataka. Doorway for a storehouse (cat. no. 87)
Plate 6. Mask from gateway of a pa (cat. no. 90)
Plate 7. Kotiate paraoa. Club (cat. no. 96)
Plate 8. Kuwaha pataka. Doorway of a storehouse (cat. no. 128)

COPYEDITOR: *Irene Gordon*
DESIGNER: *Judith Michael*
CARTOGRAPHER: *Paul Pugliese*

Text copyright © 1984 by Sidney Moko Mead, Agnes Sullivan, David R. Simmons, Anne Salmond, Bernie Kernot, Piri Sciascia.

LIBRARY OF CONGRESS CATALOGING IN PUBLICATION DATA
Main entry under title:

Te Maori : Maori art from New Zealand collections.

1. Art, Maori—Exhibitions. 2. Art, Primitive—New Zealand—Exhibitions. 3. Art—Collectors and collecting—New Zealand—Exhibitions. I. Mead, Sidney M. II. American Federation of Arts.
N7407.M36T4 1984 709'.01'109931074013 83-25725
ISBN 0-8109-1344-5
ISBN 0-917-41875-1 (American Federation of Arts: pbk.)

Printed and bound in Japan

CONTENTS

FOREWORD

During the centuries after their discovery of New Zealand, the Maori people developed art which has become renowned throughout Polynesia for its outstanding quality. A wide variety of intricate Maori carvings, paintings, and woven pieces has given New Zealand a unique and distinctive art heritage. The opportunity to display some of the work of the Maori people in America must be seen as both a rare and exciting prospect.

It is of the utmost importance to the Maori people that their art displayed in *Te Maori* should retain its "wairua Maori"—the soul of their ancestors. It is this living spirit that the Maori would hope the American people can feel with personal intimacy as they view *Te Maori*. To the Maori people their wairua is neither fiction nor myth, but a real and natural spirituality. I expect that most people will appreciate more and certainly better understand this from an experience with *Te Maori*.

The Maori leaders would want me to say, therefore, that *Te Maori* is their people's spiritual offering to the world, a godly gift that may help us all find better ways for mankind to live in peace and harmony. This is a sincere expression of a people who continue to live close to their history, to nature, and especially within the integrity of their ancestors' culture.

In giving my government's support of the exhibition, I commend the many people, both in America and New Zealand, who have created the opportunity for the Maori people to share their treasures. As a Maori New Zealander myself, I am proud to endorse my people's gesture. It is the sharing and the love that is given which is the real taonga, the real treasure. I trust that *Te Maori* will convey this simple human message through its own artistic quality and beauty.

Honorable Mr. Manuera Benjamin Riwai Couch
Minister of Maori Affairs, New Zealand

HE MATAKUPU

Ko nga tāonga ka whakaaria ki te ao i tāraia e nga tohunga o te iwi Māori o ia waka, o ia hapū, i mua noa atu i te taenga mai o tauiwi ki Aotearoa. He kōwhatu, he pounamu, he mataatuhua pea nga whao. Ko te mea whakamīharo kē, ka oti te tārai, te whakairo o ia tāonga, ahakoa he aha taua tāonga, me te mea nei, uru atu ana te wairua o te kaiwhakairo, ki roto ki taua tāonga: i rite ki te oneone i pokepokea ra, kia rite te āhua ki te tangata, a whakahāngia iho ana ki roto ki ōna pongaihu te manawa ora!

Koia nei ra te āhua o ēnei tāonga ki nga Māori whai whakaaro, aroha hoki, ki nga tohunga i karakiatia ai, ki nga ringaringa i tāraia ai, i mirimiria ai. I tēnei rā kua pungarehutia kē rātou.

Ātaahua ana te ngao o nga toki a nga tohunga—he ngao pae, he ngao tū, he ngao matariki.

Tēnei ka tukuna nga mahi a te whao, hei mātakitaki, hei whakamīharo ma te tini, ma te mano. "Toitū nga tāonga, whatu ngarongaro nga tāngata."

E nga Mana, e nga Reo: ko nga mea e tika ana, ko nga mea e kinokore ana, ko nga mea e ātaahua ana, ki te mea he pai, whakaaroa ēnei mea.

Tēnā koutou katoa.

Archdeacon Kingi M. Ihaka
Chairman, Council for Maori and South Pacific Arts

Ehara taku toa i te toa takitahi
Engari takimano, no aku tūpuna;
Te mana, te wehi, te tapu me te ihi,
I heke mai ki ahau, no aku tūpuna...

A MESSAGE TO THE PEOPLE OF THE WORLD

These treasures now presented to the world were fashioned by the experts of the Maori people, from each canoe area and from each sub-tribe, long before the arrival of the strangers [Europeans] at New Zealand. Their chisels were of basalt, greenstone, and obsidian. The amazing thing is that no matter what the construction or form, each was fashioned and completed as though the spirit of the carver himself had entered the work. This was done in the same spirit that earth was shaped in the image of humankind and the breath of life was breathed into her nostrils!

This is the nature of these treasures to the Maori people, who know and who respect the priests who performed the incantations, the hands that adzed the forms and rubbed them lovingly. Today they are gone.

There is artistry in the adzing accomplished by the chisels of the experts —whether it be a preliminary finish, an in-between finish, or the very finest of finished surfaces.

Now the accomplishments of the arts of the chisels are sent abroad for the millions and the thousands to behold and admire. "The treasures live on, but the men who fashioned them are lost."

So you of great power, you the voices that speak, take from [this exhibition] the aspects that are right, those that do no harm, the beautiful, the good.

Greetings to you all.

My greatness comes not from me alone
It derives from a multitude, from my
 ancestors;
The authority, the awe, the divine, and
 the artistry,
I inherited these gifts, from my
 ancestors...

PREFACE

The Maori people of New Zealand rightly prize the mana—the power—of their art and its sacred relationship to their ancestral homes. Thus, the magnificent collections that are the pride of their country's museums have never traveled outside New Zealand and this unique art is virtually unknown by the American public. *Te Maori* represents an important cultural event combining the generosity of the Maori people and the expression of Mobil Oil Corporation's continuing interest in the people of New Zealand.

Mobil has had a role in New Zealand since 1896, when it became the country's first marketer of petroleum products. The company is now a partner in a plant currently under construction at Motonui for the conversion of natural gas to synthetic gasoline. This installation is the first of its kind in the world and is a major commitment by Mobil to New Zealand and its people.

Many people have contributed to *Te Maori*. We especially wish to thank the Department of Maori Affairs and the Queen Elizabeth II Arts Council of New Zealand; the American Federation of Arts, which organized the exhibition; Dr. Sidney Moko Mead, editor of the catalogue, and all the individuals who contributed their expertise to it. Above all, we honor the Maori people who have allowed these splendid works to leave their native land and to travel many thousands of miles for this singular exhibition.

A. Lindsay Fergusson
Managing Director, Mobil Oil New Zealand Limited

ACKNOWLEDGMENTS

I t is a particular pleasure to write the introductory remarks to this publication, which has been produced to accompany the exhibition *Te Maori: Maori Art from New Zealand Collections*. There has never been an international exhibition devoted exclusively to Maori Art, and certainly not one in which all the objects were borrowed from the country in which they were created. The AFA is proud to have taken an important role in organizing this project and, in doing so, giving greater exposure to these splendid and powerful works.

First and foremost, *Te Maori* owes its existence to the wisdom and far-sightedness of the Elders and people of the Maori tribes who have agreed to this journey of their ancestors' *taonga* to a country far away from their homeland and have entrusted them to our temporary care. On behalf of all those who will view these masterpieces, the staff and trustees of the AFA express their profound gratitude to the Maori people.

The project was first proposed to us in the mid-1970s by Douglas Newton, Evelyn A. J. Hall, and John A. Friede, Chairman of the Department of Primitive Art, at The Metropolitan Museum of Art, and Paul Cotton, who was at that time the New Zealand Consul General in New York. It was their enthusiasm and serious commitment that persuaded us to pursue the project.

Since its inception, the curatorial and intellectual responsibility for the exhibition and publication have been in the hands of three people: Sidney Moko Mead, Professor of Maori, Victoria University of Wellington; David R. Simmons, Assistant Director and Ethnologist, Auckland Institute and Museum; and Douglas Newton. In addition to selecting the objects for the exhibition, Mr. Newton worked closely with the Maori people and New Zealand museum colleagues in negotiating the loans and also assumed an advisory role in the preparation of the publication. In addition to acting as a consultant in the selection of objects, Professor Mead served as general editor of this book, enlisting the other authors and contributing two of the essays. Mr. Simmons served as co-selector with Mr. Newton, wrote one of the essays, and prepared the individual notes for each object in the exhibition. To these three, we owe a special debt of gratitude for their scholarly contributions, without which this exhibition would not have been possible.

We are also indebted to the other four distinguished experts who contrib-

uted essays: Bernie Kernot, Anne Salmond, Piri Sciascia, and Agnes Sullivan. Thanks are also extended to Stephen O'Regan, who provided material for the tribal map of the South Island, as well as new information for several South Island objects.

For the publication, we are also obligated to Athol McCredie for his fine photography, to Irene Gordon for her skillful editing, to Robert Morton, Judith Michael, Anne Yarowsky, and Beverly Fazio at Harry N. Abrams, Inc., and to Paul Pugliese for the maps.

The coordination of this unique project has been particularly complex. In the early stages, the liaison work with the AFA was undertaken by the Queen Elizabeth II Arts Council of New Zealand, and we wish to express our thanks for the cooperation of two of its directors, Michael Volkerling and his predecessor, Hamish Keith. As the project progressed, a special Management Committee comprising representatives of government departments (Ministry of Foreign Affairs, Department of Internal Affairs, Department of Maori Affairs) and arts councils (Queen Elizabeth II Arts Council and Council for Maori and South Pacific Arts) were formed in New Zealand. Under the leadership of Ihakara P. Puketapu, then Secretary for Maori Affairs, and with the able assistance of Piri Sciascia, Executive Officer, this committee steered the development of the project with both skill and determination. Without their involvement, the project might well have faltered at several critical stages.

Also of invaluable assistance have been the New Zealand Consul Generals in New York who succeeded Paul Cotton: H. Freeman-Greene, John Ross, Bruce Smith, and Winston Cochrane. Others at the New Zealand Consulate in New York to whom thanks are due are Michael Godfrey, Nicholas Lorimer, and Mattie Wall. Consul General Barton Finney in San Francisco and Richard Woods of the New Zealand Embassy in Washington have also provided important support.

The generous cooperation of the many museum directors who have lent the Maori treasures entrusted to their care has been essential to the success of the exhibition. In citing these directors, we also acknowledge the important contributions made by the many trustees and staff members at their respective institutions: at the Auckland Institute and Museum, G. Stuart Park; at the Canterbury Museum, John Wilson and Michael Trotter; at the Gisborne Museum and Art Gallery, Warner Haldane; at Hawke's Bay Art Gallery and Museum, Robert McGregor; at the National Museum of New Zealand, Dr. John Yaldwyn; at the Nelson Provincial Museum, Steven Bagley; at the Otago Museum, Dr. Ray Forster; at the Rotorua Museum, Ian Rockel; at the Southland Museum and Art Gallery, Russell Beck; at the Taranaki Museum, Ron E. Lambert; at the Te Awamutu Museum, James Mandeno; at the Waikato Art Museum, Ken Gorbey; at the Whakatane and District Museum, Anton van der Wouden; and at the University of Pennsylvania Museum, Philadelphia, William H. Davenport.

For their help and advice, we would also like to thank J.C. Graydon at the Gifford Museum and Stuart Harris, Director of the Maori Institute, Rotorua.

Assembling objects such as these from thirteen lending institutions in New Zealand was a complicated endeavor and could not have been accomplished without the assembly team of Rodney Wilson, Director of the Auckland City

Art Gallery; Jack Frye, National Museum of New Zealand; and Mervyn Hutchinson, New Zealand National Conservator.

No exhibition of this scope and importance is possible without substantial financial support. From the beginning, the New Zealand government has given not only their official sanction, but also their financial help, particularly in the early and critical stages of the project. The United States government has also been generous through the provision of very substantial grants from the National Endowment for the Arts and the National Endowment for the Humanities, as well as by indemnifying the works throughout the tour.

The exhibition was finally made possible by a generous grant from the Mobil Corporation. Thanks are due the management of Mobil South Inc., Faneuil Adams, Jr., President, and Philip W. Matos, Vice President and Regional Executive; to their respective predecessors, Eugene A. Renna and Norman N. Farr; to A. Lindsay Fergusson, Managing Director of Mobil Oil in New Zealand, and his predecessor, Philip W. Marriott. In the New York Mobil office, we want to acknowledge the continuous assistance of Pamela Preston, International Public Affairs Advisor, Sandra Ruch, Manager of Cultural Programs and Promotions, and Barbara Butt, Staff Associate. The funding for the San Francisco presentation was generously provided by the Bechtel Corporation. We also wish to acknowledge the generous assistance of Air New Zealand in providing the international transportation for the works of art.

The AFA also wishes to thank directors and curators at the American museums participating in the national tour. At The Metropolitan Museum of Art in addition to Douglas Newton, we want to acknowledge its director, Philippe de Montebello, for encouraging the project and for graciously granting leave to Mr. Newton to pursue the necessary work in New Zealand. At the Saint Louis Art Museum, thanks are due James D. Burke, Director; Dr. John W. Nunley, Curator of the Arts of Africa, Oceania, and the Americas; and to two members of their Board, John Peters MacCarthy, President, Board of Commissioners, and Richard T. Fisher, Chairman, Board of Trustees, for their strong personal interest in the project. At the Fine Arts Museums of San Francisco, we wish to single out for thanks Ian McKibbin White, Director; Thomas K. Seligman, Deputy Director for Exhibitions and Education; and Kathleen Berrin, Curator of Art from Africa, Oceania, and the Americas.

I want to thank all those AFA staff members who have contributed so much to the realization of this project over the last ten years. In particular, I wish to acknowledge Jane Tai, Associate Director and Exhibition Program Director, for her overall direction of the project; Susanna D'Alton, Exhibition Coordinator, who until recently had direct responsibility for many of its details, which was later assumed by Jeanne Hedstrom; Carol O'Biso, Registrar, who supervised the logistics of packing, transportation, and insurance; Catherine Sease, who served as conservator; and Sandra Gilbert, Public Information Director.

Finally, I wish to express my appreciation to the AFA Trustees and National Patrons for their sustained support during the long evolution of the project.

Wilder Green
Director, The American Federation of Arts

EXHIBITION CREDITS

This book is published in conjunction with a major loan exhibition of objects from the following institutions in New Zealand:

Auckland Institute and Museum
Canterbury Museum, Christchurch
Gisborne Museum and Art Gallery
Hawke's Bay Art Gallery and Museum, Napier
National Museum of New Zealand, Wellington
Nelson Provincial Museum
Otago Museum, Dunedin
Rotorua Museum
Southland Museum and Art Gallery, Invercargill
Taranaki Museum, New Plymouth
Te Awamutu Museum
University of Pennsylvania Museum, Philadelphia
Waikato Art Museum, Hamilton
Whakatane and District Museum

The exhibition was organized by the American Federation of Arts in association with the New Zealand government, the Maori people, and the New Zealand lending museums.

Made possible by a grant from Mobil.

Supported by the National Endowment for the Arts, the National Endowment for the Humanities, an indemnity from the Federal Council on the Arts and Humanities, Air New Zealand, and the National Patrons of the American Federation of Arts.

MANA MAORI
The Art Heritage of the New Zealand Maori

NGA TIMUNGA ME NGA PARINGA O TE MANA MAORI
The Ebb and Flow of Mana Maori and the Changing Context of Maori Art

Sidney Moko Mead

There is a proverb that asserts, *Rārangi maunga tū te ao, tū te pō; rārangi tangata ka ngaro, ka ngaro.* (A range of mountains stands day in and day out, but a line of people is lost, is lost.) The art of the ancestors used to disappear by being consumed by fire, eaten by worms, hidden in burial caves, or simply left to rot. Thanks to the Western practice of collecting "quaint" works of art and to modern conservation techniques, the art treasures of a nation can now be likened to a range of mountains. They remain long after they were fashioned by artists of another era. They can be viewed and contemplated a hundred years or more after their manufacture. But the artists and their world of ideas, beliefs, and cultural practices are, as the proverb says, a line of people who have disappeared forever from this world of light.

A mountain is part of the landscape, it is a reference point, a known landmark to which is attached some cultural meaning. Thus Hikurangi, Tongariro, Ruapehu, Taranaki, Ngongotaha, Putauaki, and Taupiri (pl. 9) have special significance to members of the tribes for whom these names are immediately recognizable as symbols of their people. Together with other named features of the land—rivers, lakes, blocks of land, promontories, holes in the ground, fishing grounds, trees, burial places, and islands—they form a cultural grid over the land which provides meaning, order, and stability to human existence. Without the fixed grid of named features we would be total strangers on the land—lost souls with nowhere to attach ourselves.

The mountain that stands day after day in all kinds of weather is a work of nature that has been given special significance by us. We have added words to it, or in the Maori sense, clothed it, and covered it with words. Some would say that we have hung or pinned words to it not merely by giving it a name which then becomes a summary of all that it stands for, but by creating stories and singing songs about it, and memorializing it in long-lasting compositions such as proverbs. The human imagination is capable of adding thousands of words to a mountain, not all at once but over a period of time and, perhaps, more at one time than another. What is particularly important about the process of adding words to something like a mountain is that some stories can be told over and over again without the audience appearing to become bored.

Art objects are part of a different cultural grid from the mountains and lakes. In the case of art, a substance of nature is modified by the hand of man and shaped to convey an idea in the mind through established ways of expressing things in wood, bone, ivory, or stone. The mountain is accepted in the form

in which it was molded by the forces of nature. We then proceed to clothe it with words, to animate it, to transform it into a cultural object.

An art object such as a wakahuia (treasure box) is an enriched creation (fig. 1). The very name of the object, wakahuia, conjures up in the mind a long succession of vessels of varying shapes and sizes decorated in a variety of ways. If an artist wishes to make a wakahuia, then the name itself, the word,

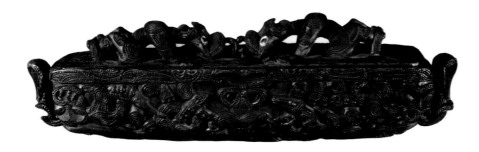

Figure 1. Wakahuia (treasure box). Reputed to have been carved by the famous carver Raharuhi Rukupo of Gisborne. Approximate date 1836. Length 92 cm. (36¼ in.). Auckland Institute and Museum (26230)

demands that he proceed in the full knowledge of what that word means. His choices are limited by what has happened in the past, and by what is occurring in the present. Thus the form and size selected by the artist are already clothed in a thousand words. Then more and more words are added until the object is in the hands of its intended owner(s) and is being used in an acceptable manner. The object touches the lives of several people, and it, in turn, is "touched" by them and later by a succession of persons who may know nothing of its origins. Over time an object becomes invested with interesting talk.

A lump of wood of little or no great significance is thus transformed through the art process, by building words (korero) into it and by contact with people, into a thing Maoris class as a taonga, or in full, he taonga tuku iho. The dictionary describes taonga as "property," or as "anything highly prized" (Williams 1971:381). Thus a taonga tuku iho is a highly prized object that has been handed down from the ancestors. Implied is the notion of *he kupu kei runga* (there are words attached to it). Although there are other terms that have the same general but not equivalent meaning, such as kura (treasure, valued possession, darling) and rawa (goods, property), such terms are rarely used today.

It must be made clear that a taonga tuku iho is not the equivalent of "art object" even though it embraces the latter. If we want to be specific it is necessary to add the qualifier whakairo; hence, taonga whakairo (prized decorated object). The word whakairo on its own could stand for art object, but it presents some conceptual problems in trying to translate it into English. Implicit in the word and in the range of art domains— carving, tattooing, painting, and weaving, according to the dictionary —included in its ambit is the idea that whakairo refers to something more than the shape and form of an object. Its basic meaning is "to ornament with a pattern" (Williams 1971:80), which might lead us to believe that it is a word with a restricted meaning. In point of fact, the Maori view of art is close to Maquet's notion of aesthetic quality (1971:80) which is disclosed in the noninstrumental features of an art object, that is, in the extras added to the basic form by the artist.

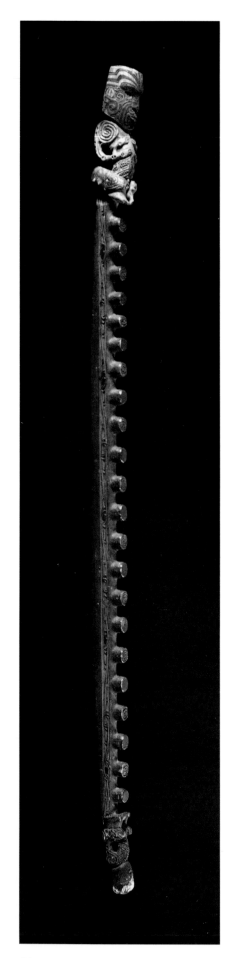

Whakairo is quality, the difference between crudity and elegance, animal and human, nature as opposed to culture. It is uplifting, taking the human spirit close to the rarefied and beautiful world of the gods and rising above the mundane affairs of existence and mere survival. It is closer to Rangi, e tu nei (Rangi [the Sky God], standing above) than to Papa, e takoto nei (Papa [the Earth Mother], lying here). Whakairo represents the triumph of mana Maori (power) over the environment and represents a gift from the ancestors to their descendants born and yet unborn.

In the popular sense a taonga is a highly prized possession to which is attached korero (text or story). An example is a whakapapa (genealogy) staff (fig. 2). Sometimes the korero is described as taumaha (heavy) and what this alludes to is that in the manufacture of the object karakia (incantations) were recited over it, certain ritual ceremonies were performed, and speeches may have been made about it or to it.

Examples associated with the building of the meeting house Hotunui in 1878 as reported by Mereana Mokomoko, for whom the house was built, to Gilbert Mair in 1897 are the following. First, when the ridgepole could not be lifted into place by the Ngati Awa builders a tohunga (priest) called Paroto Manutawhiorangi was summoned to supervise the necessary rituals. He uttered an incantation called Te Huti o Tainui and the ridgepole "was lifted up quickly and easily" (Mokomoko and Mair 1897:42). The second difficulty was when some of the carvers suddenly became ill and died. Mereana Mokomoko and the carvers believed the cause to be a hapa (error). What had happened was that chips from the chisel of Mereana's father, Apanui Hamaiwaho, had been used in the cooking fire. To correct this, a ritual fire of carving chips was lit and two kumara (sweet potatoes) were roasted. When they were cooked Mereana Mokomoko was asked to eat them. She said, "I trembled with fear lest death should come to me also." But she was reassured by the old men who said to her, "Fear not, you are equal in mana to Apanui, your father, and you alone can remove this spell which is destroying Ngati Awa" (Mokomoko and Mair 1897:42). She ate the kumara and eventually the house was finished. This is the carved house that stands at present in the Auckland Museum.

These are the sorts of events which make the korero (text) taumaha (heavy) and which add to the value of the art. If men die in the building of a house, then it cannot be an ordinary house, and if artists die because they committed errors in their work, then their creations are no ordinary works of art. They have invested more than their reputations. Thus the words spoken, the incantations recited, and the careers that have ended become part of the korero. And when the words and deeds are carried out by chiefly people, as in the example of Hotunui, then considerable weight is added to such korero.

The mana of the personalities together with the power of the words and of the form created by the artist conspire to produce a powerful taonga—a taonga with mana, a taonga with immanent power, an object that has within it a hidden force. Every item in the present exhibition is a taonga of this sort because each is also very old, a few are several centuries old. Great antiquity adds yet another dimension of mana to the objects. Just as the old koroua (old male) and kuia (old female) are venerated for their knowledge and wisdom, so

are old taonga respected for the knowledge and wisdom that lie buried in the korero which has to be revealed. But great age brings with it uncertainties about the nature of the korero, for who can possibly know what the tohunga of the early period said, what spells he recited, what curses he may have placed on certain items.

In the Maori view, therefore, we are not dealing with an exhibition of inanimate art objects. The particular collection assembled for display in the United States consists of taonga which contain immanent power and on which are pinned a host of powerful words. The sensitive viewer will feel the presence of power, but will be unsuccessful in actually isolating a source, or in describing its exact nature, and in measuring its intensity.

Yet the observed behavior of some people toward these taonga suggests that there is more present than the art objects themselves. Many Maori individuals are afraid of taonga and will not have them near their food or by their beds. Some tremble in the presence of such taonga, while others stand in awe, or weep. The knowing ones will go to a priest to protect themselves from the power of the words clinging to the objects, while others rejoice in being permitted to touch such valuable and precious treasures. Maori people generally show respect toward taonga and only the ignorant or the arrogant treat them with contempt. Some speak to the taonga as though they are the bridge between the living and the dead and have the power to mediate between the two worlds.

Other writers have referred to this aspect of tribal art. William Fagg (1973: 164), for example, refers to "the belief in immanent energy, in the primacy of energy in all things." From his studies of African art he asserts that "it is energy and not matter, dynamic and not static being, which is the true nature of things." Moreover, "this force or energy is open to influence by man through ritual means." Fagg saw this capability of influencing the force as "the very basis of all tribal belief and observance."

There is no doubt that Maori beliefs and practices tend to confirm William Fagg's observations in regard to African art. The power is charged into art objects not only by the use of words in appropriate ritual and social contexts, but also by applying the processes of art which are themselves builders of words. It is true in the Maori case that an art object is not a static, inert thing. The very terms of judgment that can be applied to art objects stress quite different qualities.

The artist strives to imbue his work with ihi (power), wehi (fear), and wana (authority) and, as an artist, he should try to exhibit these qualities in everything he does. But what are these qualities? Tamati Kruger (1980:138) described them as "elusive" and as being among a range of terms employed by the Maori "in making aesthetic judgments about artistic events or performances, as in *haka*, oratory, *karanga*, *pukana*, *waiata* and so on." A performance that exhibits the linked qualities of ihi, wehi, and wana (power, fear, and authority) gains spontaneous applause and elicits a strong sympathetic reaction from the viewer. From the Maori point of view a performance of a work of art is not beautiful because it has "a pleasing quality associated with harmony of form or colour, excellence of craftsmanship, truthfulness, originality or other often

Figure 2. Rakau Whakapapa (genealogy staff). Te Arawa style. Collected by Gilbert Mair, c. 1863, from the Bay of Plenty. Auckland Institute and Museum (114)

unspecifiable property!" Rather it is beautiful because it has power (ihi), that is, power to move the viewer to react spontaneously and in a physical way to the work of art.

The performance fills one with awe (wehi) so that the spine tingles, one's body hair may straighten up, and the whole body trembles with excitement. It can be said that this is a reaction to something that is beautiful to the Maori. It is an exhilarating artistic experience, which captures the viewer's full attention and holds it. There is authority (wana) in the performance—class, integrity, confidence, and unquestioned competence. The entire experience is uplifting and personally satisfying. It is good for one's soul and equally good for the performer who sees the evidence of artistic success in the reactions of the audience and is thereby moved to new heights of artistry. These reactions apply especially to the performing arts, to storytelling, oratory, posture dances, and singing. The qualities of ihi, wehi, and wana are capable of being expressed in all of these artistic activities but are not restricted to them.

Tamati Kruger (1980:145) put it this way: "The significance of these qualities, *ihi*, *wehi*, and *wana*, lies in their ability to energise Maori identity and to reassert the importance of Maori values." But a statement such as this indicates that the viewing public is already bonded to the art, so that an empathy with it already exists. It also implies knowledge of the sort that enables a viewer to distinguish between good- and poor-quality work. There is no doubt, however, that Maori spectators observing first-class examples of, say, wood carving (fig. 3), or a performance of a dance, feel good about it and for that moment are proud to identify as Maori.

In such a context aesthetic response cannot be a detached and cerebral experience. Rather the response is likely to be active, positive, and often noisy. People want to reach out to others in a spirit of shared ecstasy. Understanding what is required of them, the artists strive to build into their artistic creations the mana (power) that will move people. Some artists will succeed and others will fail, but a single artist can be very successful one time and fail miserably another. In other words, the task of the artist is never a straightforward, easy one. Nor can the artists take the public for granted and serve up anything. Artistic success is what every artist tries to achieve but few actually attain.

A Maori public is as discriminating or as fickle as any other public. It is as demanding as any other, but, it would be true to say, it is a public which reacts spontaneously to what is good. A bad performance is likely to receive either stony silence or some rather loudly expressed opinions of disapproval. Whether good or bad, the artists know where they stand with their public.

In a good performance or when contemplating a very fine piece of carving the response is likely to contain an element of wehi (awe and fear) because the source of ihi is believed to be supernatural. The artist does not have artistic skill as part of his natural endowment, genetic or cultural. Such a belief is consistent with the origin myths which generally support an extra-human source for art. The myth described in the third essay names the sea god, Tangaroa, as being the origin of Maori carving. It is not surprising, therefore, that the talent to carve might also be thought of as coming from the gods. The carver is the

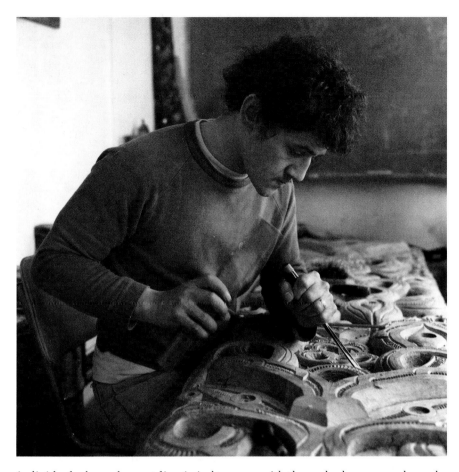

Figure 3. A modern carver at work. Takirirangi Smith, carver of Te Herenga Waka marae at Victoria University of Wellington, carving a poupou (side post) out of a new material called custom wood. His work now exhibits the qualities of ihi, wehi, and wana.

individual whose descent line is in harmony with the gods, hence, as shown by Kernot, the traditional carvers were often men of chiefly rank. The "qualifications" of the artist were probably matters of proper genealogical position (including belonging to a family of carvers) and having knowledge of rituals to appease and please the gods. Thus it follows that an artist is merely a vehicle used by the gods, to express their artistry and their genius. But only the very best of performances and artistic creations are credited to the gods. That is to say, it is only when a work of art is successful that supernatural intervention is said to have occurred and the qualities of ihi and wehi are felt to be present. All other creations, the mediocre and the outright failures, are human endeavors that were not favored by the gods.

It can be said with some justice that the art system provides a cultural grid which mediates between people and their gods as well as between groups of people. As Rudolf Arnheim suggested (1961:205), art "helps man to understand the world and himself and presents to his eyes what he has understood and believes to be true." Some very fundamental truths are reflected in art, truths to do with religion, philosophy, and mythology. Forge (1979:285) indicated that the sorts of truth conveyed in art "are fundamental assumptions about the bases of the society, the real nature of men and women, the nature of power, the place of man in the universe of nature which surrounds him."

This is part of the korero (stories) that are built into art objects. Thus when Maui's quest for immortality is portrayed in art, as in figure 4, the korero includes not only the retelling of the whole story, which concludes with Maui's ultimate failure, but it also leads to speculation about the lot of man. Since

people must live their appointed time and die, what are we to do? The philosophers of old gave us their word through art. We humans can do one of two things: we can either tease the tail of death and challenge it, or we can face the inevitability of death when it comes. These propositions are encapsulated in door lintels and adz handles. In one composition, stylized man is shown biting the tail of a lizard, and in another the mouth of man is locked in mortal combat with the mouth of death (fig. 5). These are powerful statements which we can readily understand. They are images to think with and visions that help to explain in part the philosophy of the old-time Maori.

Figure 4. Pare (door lintel) of the Hauraki type found in a swamp in the Auckland region. The lintel was bought originally by Dr. A. K. Newman and was presented to the Wanganui Museum by another donor. Wanganui Regional Museum (2914)

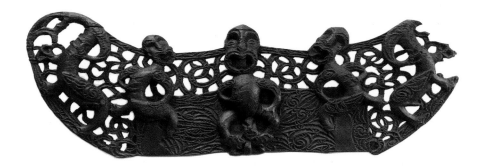

The literature of art history speaks of iconography (Panofsky 1955) and motifs. A study of motifs and their meanings eventually moves the student into the heady realm of iconology—those deeper levels of meanings which have to do with cultural philosophies and ideologies. We are dealing with the same things here, but at a more down-to-earth level. The iconography is nothing more nor less than korero (talk), and iconology is kupu (words); that is, korero

Figure 5. Detail of figure 4. An image of man (the stylized manaia) teasing and biting the tail of death, a lizard whose head is at the bottom corner of the lintel

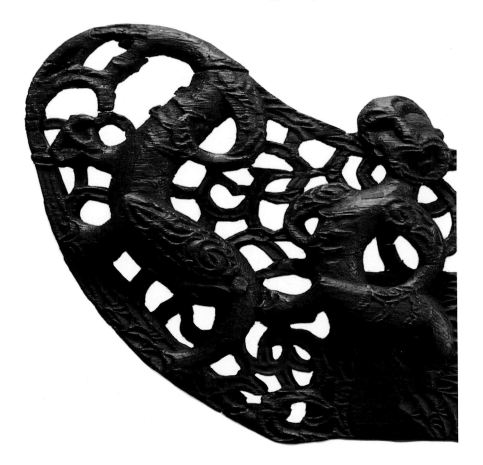

that are reduced to a few fundamental words such as are remembered in proverbs. On the other hand, the artist, while thinking in words, expresses himself through the idiom of art. He hangs his talk on the aria (image, likeness, notion, idea, feeling) of things and on their ahua, that is, on the form and character of events and of people, which must be carved into the wood, bone, or stone.

Clearly it is the task of the student of art to assist the enquiring viewer to understand the kupu. What they want might be no more than the retelling of the story, for much of art has to do with excerpts of stories or summaries of them. The informed student must provide the connected story and give the hundreds or thousands of words that are necessary to explain an image or a series of images in full. This is the korero, which must be revealed by a knowledgeable person.

For example, the image of interlocking mouths probably needs many more words in order to "explain" why death is represented by a lizard. The lizard happens to be a key element in the Maori theory of disease (Best 1941, 1:107). One becomes ill because someone else has despatched a ngarara (reptile, monster, lizard) to devour one's entrails (fig. 6). Illness is passed on deliberately by another person; it is not possible simply to "catch" an illness.

It is interesting to note that the word ngarara also means "the (nga) ribs (rara)," which is all that is left of a person if the ngarara is not stopped from destroying a human life. The doctor's task is to stop the lizard, either by destroying the person who sent it, or by influencing the gods to withdraw the powerful hand of death which reaches for certain individuals when their time is up. The ever-reaching strong hand of death is another image commonly spoken about at Maori gatherings today, but it is not clear whether the stylized hand portrayed on meeting house maihi (bargeboards), or on ko (spades), or on some very old examples of taonga have the same korero attached to them.

It is enough here to demonstrate that the words are there to be spoken once the task of unraveling the korero begins and once the necessary clues are provided by someone, or discovered by the usual procedures of research. Alternatively, they are there to be left unspoken, for what is the use of going into long explanations for people who already know the details! The necessity for words and their number varies from group to group and from individual to individual. Some want a thousand words while others want no words at all; all they want is time to reflect on each taonga and time to appreciate the artistry.

It is important, however, to reflect on the fact that once upon a time a large number of Maori people understood their art and probably did not need to have it explained to them in volumes of words in a foreign language that we require today. Shared understanding encouraged talk at the deeper level of kupu. Much of what we write about today is probably the obvious, common-knowledge korero of yesterday. For example, numerous writers have noted that ancestors are important in Maori carving. Many Maoris know this by experience and do not find it necessary to ask questions about it. For the uninitiated, however, some "explanations" are required. Veneration of the ancestors is a long-standing Maori value that is reflected in the song poetry as recorded in Nga Moteatea (Ngata and Jones 1970), in the oral traditions, such as in Nga Mahi a Nga Tupuna (Grey 1953), and in numerable house carvings. We who are living at

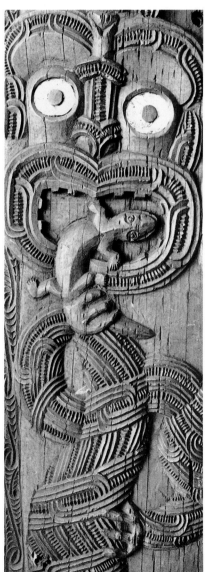

Figure 6. Housepost, from the meeting house Tumoana, 1882, which originally stood at Mamaku marae, near Hicks Bay. It was carved by Hoani Taahu and Haare Tokoata. Portrayed is an ancestor figure attempting to stop the lizard, symbol of death, from entering his mouth. Hocken Collection, Otago Museum, Dunedin (D31.1345). Photo: C. A. Schollum, Photographic Archives, Department of Anthropology, University of Auckland

present are their reflections and their descendants. We are te kanohi ora (the living faces) that are contrasted against te hunga ngaro (the departed ones) whose faces are no longer seen at Maori gatherings and whose voices are no longer heard.

But as individuals we have no identity except by reference to them. We are beings only because they prepared the way for us, gave us a slot in a system of human relations, a place in the whakapapa (genealogy) lines, and membership in a whanau (extended family) and in an iwi (tribe). We owe them the culture and the traditions that we value so highly today. There is no question that an important part of their legacy to us consists of all the examples of Maori art that exist in the museums of the world. In a sense, we owe them everything that we value highly today.

There is an ever-present danger that pursuit of korero leads us to many byways and sometimes takes us on remote tracks that are far removed from the matter at hand. I want to return to a discussion of the art system, or what I call the art grid, which is just one of many such cultural grids in a society. The art grid consists of a complex of various domains of artistic activity, such as wood carving, painting, and tattooing, which brings people into relation with both the performance of the activity and the product of such activity. In the visual arts it is easy to see, feel, and smell the product as a concrete thing. This is obviously not the case in domains such as oratory because the product is momentary.

Thus the products of artistic activity range from the relatively long-lasting, visible, and concrete creations, such as war canoes, memorials to the dead, and greenstone patu (clubs), to very short momentary performances, such as a sung lament which leaves no artifact behind for the audience to touch and feel. In the latter category, however, the language used in the performances as a tool of artistic expression remains in the human mind, which is capable of contemplating words long after they were uttered. But the korero and the kupu, which provide the background information and the "explanations" of the event, tend not to be the same words as those uttered as part of a performance. An oration and the commentary on the oration are two distinct activities.

In the case of the visual arts, and of taonga whakairo in particular, the commentary aspect begins even before the wood is selected. But if it is to be truly a taonga whakairo, the artist must build into the object not only the kupu, but also the qualities of ihi, wehi, and wana. In the end, what the artist achieves is transformation of the materials of nature into art by applying the appropriate processes (technological, ritual, aesthetic, social, and economic) of the art grid and by working within the community to select the korero appropriate to a particular composition.

That the korero can be rediscovered and brought back into the oral traditions of the group is certainly possible, but this is often conditional upon the object being brought home where it can be seen and talked about. Although the object itself can be appreciated as a unique thing, for many people that is not sufficient. They must know the korero and because of this some individuals go to lengths to find the right stories that go with a particular object.

If the korero cannot be found, the owners can resort to several alternatives

that are well known to scholars: they can create a new story; or give it a temporary, speculative story; or they can leave out the unknown part of its history and commence the korero from the moment and circumstances of the rediscovery of the art object. Quite an exciting story can be told in each case. What is important for the owning group is that the taonga is "brought home" so it can be slotted into the art style, the history, and the oral traditions of the people. When the taonga is not brought home into the tribal territory but rests instead in some museum hundreds of miles away, the object and its associated korero remain lost to the owning group.

Such objects are part of the wahi ngaro (the lost portion) of Maori culture. There is much talk nowadays of "seeking the lost portion," of its rediscovery. It is ironical in the case of the present exhibition being held in the United States that a part of the wahi ngaro has been revealed through the negotiations and the final mounting of the exhibition of taonga whakairo in a country on the other side of the Pacific Ocean. The paths of rediscovery can be long and tortuous but they are always revealing and rewarding.

The items represented in the exhibition comprise some of the elements of the cultural grid mentioned earlier. But the grid has been under assault, figuratively speaking, ever since the coming of the white man to New Zealand. Annexation by the British, subsequent conquest of many Maori tribes, and occupation of the land by foreigners from across the sea put the whole of Maori society at risk and dislocated its many interlinking institutions. In addition, the supporting ideologies and practices which helped to provide a coherent, constant, and vibrant art tradition were called into question and became subject to Pakeha (European) evaluation and approval. The cultural grid which incorporated the arts was altered quite drastically until it became very much like a shredded road map.

The result was that Maori art was interrupted and arrested in its development. A great part of it, such as war canoes, storehouses (fig. 7), monuments, and tattooing, disappeared altogether. Inevitably this led to unemployment among the many artists and craftsmen and craftswomen who were the producers of the traditional arts and of the material culture generally. A substantial part of the technology was lost, as well as much of the ritual associated with art. Most importantly, the continuity of the rarangi tohunga whakairo (the line of artists) was all but severed and we lost the names of our great artists, some of whom are mentioned in Bernie Kernot's essay.

The sad truth is that with few exceptions the art, crafts, and technology had gone from the face of the new, respectable, and very Christian Maori villages. Everywhere, the British way was encouraged and the Maori way denigrated, criticized, and seemingly abandoned. Regions such as Northland, where the Christian and Pakeha influence was first established with some rigor, suffered the most. In fact, the far North has not yet extricated itself from the Western web woven in the early 1800s, but there is sufficient evidence to show that Maori nationalism is emerging. Maori art is coming home again to the North after a very long absence. It is returning both in its arrested form, which is very traditional, and in new forms, which are very modern and heavily influenced by Western ideas (pl. 10).

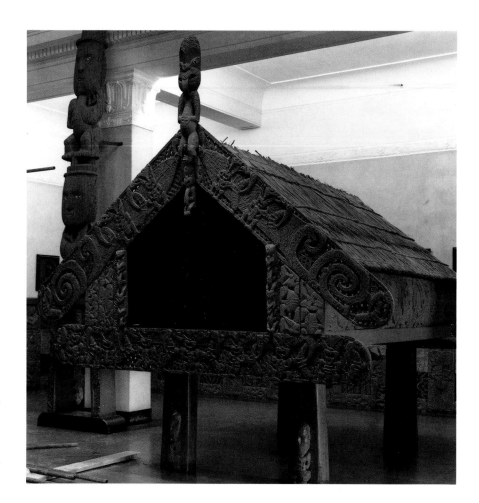

Figure 7. Pataka (storehouse), named Te Puawai o Te Arawa (The Flower of Te Arawa), carved for Te Waata Taranui of Ngati Pikiao by Wero Taroi in 1868. Length of threshold 6.02 m. (19 ft. 8¼ in.). Obtained from the heirs of Te Pokiha Taranui (Major Fox) by the Auckland Institute and Museum (151)

In other regions, such as the Bay of Plenty and the inland tribal area of Tuhoe, Maori art went underground with the Ringatu Church and flourished into the modern period. Some Maoris who were not caught up by the new ideologies simply went on living the best way they could. Fortunately, that was predominantly the Maori way, albeit in attenuated form. But these rural people continued making such things as fishing nets, baskets, and floormats. Oblivious to what other Maoris were doing at the time, they continued to build and decorate meeting houses.

Tourist centers such as Rotorua became regions where the arts continued, but in response to Pakeha wants and to Pakeha demands. Audiences, viewers, and collectors were largely visitors to such areas. Even meeting houses were commissioned by Pakeha entrepreneurs and patrons for non-Maori use. However, under the umbrella of such activity and of the tourist industry generally some essential elements of the traditional technology were retained. Prime examples are the techniques of building and decorating meeting houses and of making piupiu (dance skirts). Thus, although Rotorua has been a tourist center almost from the beginning of European settlement in the region up to the present time, it is still a Maori center as well.

One can be very pessimistic about the smothering influence of Pakeha society upon the indigenous culture of New Zealand. Indeed, as Sorrenson (1979:85) has pointed out, some European observers forecast the eventual destruction of Maori culture, implying that in the end the Maori would be completely assimi-

lated into the dominant society of the Pakeha. But while successive governments have made a fairly determined effort to undermine the bases of Maori culture, the Maori people are still somehow different and distinctive. There are also many of them. In 1981 there were 385,210 persons of Maori descent in New Zealand and they formed 12.1 percent of the total population of 3,180,200.[1] Although economic factors have helped to scatter the Maori people from their homelands, a majority of them see themselves as belonging to a tribe whose turangawaewae (place for the feet to stand) and whose ahi ka (burning fire) are located at specific regions (see maps 2 and 3). The regions are referred to as te wa-kainga, or hau-kainga, the home village, even when most of the land has gone to Pakeha hands. Ancestral features of the land, such as the mountains referred to earlier, lakes, and rivers are still valued as such even when the tribe no longer owns them. In addition, the concept of tangata whenua (people of the land) remains intact despite the alienation of the land.

One reason for this attitude is that the rarangi maunga (line of mountains) and the whenua are still there to be seen every day. Whatever people do, the land remains. Another reason is that ideas such as turangawaewae, ahi-ka, hau-kainga, and tangata-whenua exist in the minds of the people and remain intact there.

Hence a map of the country as presented in maps 2 and 3 is meaningful for Maoris because cultural identity is involved. To most Pakehas, however, and to some urbanized and alienated Maoris, tribes mean nothing. While to others the tribe is everything: it is the focus of loyalty for thousands. It is the beginning of life and the point of departure for all who see themselves as Maori to the marrow in their bones. There is pride in being born into a tribe (iwi) and sub-tribe (hapu), and there is a powerful pull to the ancestral lands of the group. Thus the distribution maps show the locations of the tribes as viewed today and give approximate boundaries to their regions.

It is clear from the maps that a majority of the Maori live in the warmer island, Te Ika a Maui (Fish of Maui), the North Island. The most populous centers are Auckland, South Auckland, Bay of Plenty, and Wellington. In Te Waipounamu, the South Island, the Maori population is sparse and in 1976 numbered about 20,000.[2] But the important point to be made is that the Maori people, all 385,000 of them, are alive and are emerging like the awkward duckling from a newly hatched egg into the big world beyond the shores of Aotearoa (New Zealand). They face the world with what is left of their culture and with a fierce will to survive. Maori art is one base of the culture that has survived. Nonetheless, it has been and continues to be subject to all sorts of ideological, social, political, religious, and economic changes. Maori art has been repudiated, rejected, vandalized, neglected, hidden, and abused by Maori and Pakeha alike. There are some whose only interest in it is to exploit the tourist dollar, or any other dollar that can be made out of it.

Others are genuinely interested in the serious side of the art and want nothing of tourism. On the whole, most Maoris are busily engaged in its rediscovery and revival. They are learning to appreciate its forms and absorb the associated korero. For them the tourist dollar is despicable because the art is sacred and precious as symbols of their identity as Maori. There are other

Maori, young and old, who are in a sort of cultural limbo and await cautiously more overt signs of Pakeha approval before rejoining Maori society.

An equally complex picture emerges when Pakeha attitudes to Maori art are considered. They range from the madly enthusiastic to the downright racist and rejectionist. There are also those who identify strongly with Maori art and view it as a symbol of their identity as a New Zealander. Their love of the art is genuine.

Thus, while the Maori people use their art to identify themselves ethnically and hence nationally as well, the Pakeha population tends to use it as a national marker, and then only the portions that appeal to them. What this means for the art is that it occupies the middle ground between Maori and Pakeha, with the Maori embracing all of it and the Pakeha as yet only picking at it.

The exhibition of the works of the ancestors in the United States might influence more Pakeha New Zealanders to move in a little closer not only to the art objects themselves, but also, more importantly, to the korero and the kupu. They must accept the korero and be glad to listen to it over and over again. To put this another way, the art grid must act as a cultural grid for the Pakeha as well as for the Maori and be accepted as such. As the proverb says, a reed quivering in the wind can be seen by the eyes of people, but what really moves in the heart we cannot see and we cannot know. The heart of the Maori is linked closely to the art. This we know. But as yet only a few Pakeha hearts quiver in quite the same way for the taonga whakairo (art object) or for the taonga tuku iho, the prized object handed down by the ancestors.

One aspect of the dilemma facing the people of New Zealand today is the question, How is Maori culture to be regarded? Do the Maori people want their art to be maintained as their unique contribution to the arts of the world? And do they also want to exercise their right to control it? Such questions are being asked and require of the dominant section of our population a more sensitive and understanding approach to how Maori art is presented overseas. Negotiations for the Maori art exhibition have highlighted the changing status of Maori–Pakeha relations. No longer are Maori leaders content to remain as silent partners in such matters. Rather, they expect to participate directly in the negotiations and they want to speak for themselves and not have Pakeha officials speak on behalf of "our Maoris."

This is new. It is also exciting for the Maori people, because it is evidence of the return and the rise of mana Maori, which is the theme of the present exhibition. But as mana Maori rises again out of the shadows of bad experiences in culture contact during the nineteenth century, the Pakeha section of our population becomes apprehensive. This is their dilemma: the reversal in expectations. Not long ago, joy and excitement at Pakeha settling on new land in Aotearoa meant fear, subjugation, poverty, and death for the Maori people. Hope was the preserve of the white majority and in pursuing that hope there was little thought given to the survival of Maori culture. That Maoritanga did survive and is alive and well today owes more to Maori tenacity of purpose than to Pakeha humanitarianism and good will. The instinct to survive remains strong.

However, despite some awkwardness in Maori—Pakeha relations at the present time, it remains possible to cooperate and work together on events such as this exhibition. As a people we can walk together, argue our differences, and negotiate a new future. There is hope in that fact. The rise of mana Maori is a positive and liberating experience which is part of the international struggle by indigenous populations such as the Maori for self-determination, cultural survival, and escape from domination.

A modern Whanganui proverb says, *Toi te kupu, toi te mana, toi te whenua* (When the word is respected, and the authority of the Maori established, the land will survive). These words are open to many interpretations, for such is the nature of proverbs. It could well be that the man who uttered these words meant that language (kupu), authority and prestige (mana), and land (whenua) were all necessary to the well-being of Maori culture. Toi is an old word meaning, among other things, origin, source, home, aboriginal, art, and knowledge (Williams 1971:431). Thus, one may say that the proverb means: Know the language, know our greatness, and know our land. Thus, kupu and mana have to do with knowing the heritage, the customs, the deeds of the past, and the knowledge. Knowing the art (toi te whakairo) would be included in this.

However, in order to "know" the art, one must find the korero (stories). And revelation of the korero is not as simple as it appears, even though the American anthropologist Franz Boas (1858–1942) years ago pointed to the uniqueness of every group of people and to the need to study a culture in terms of its own "particular historical context" (Harris 1968:274).

It has taken many decades since the heyday of Franz Boas to move away from the notion of a culture being studied by outsiders and of one people being told of its heritage by another. In the present case, the team of writers for this volume are all bicultural and bilingual. Indeed, this is a landmark occasion and an indication that something has been achieved, no matter how tardily. The principal commentators of the past, A. Hamilton (1896), H. D. Skinner (1921), W. M. Phillips (1955), Gilbert Archey (1933), and more recently T. Barrow (1969), did not meet the research requirements laid down by Boas and by a generation of anthropologists in both the United States and Great Britain. None of them became proficient in Maori, and not one thought it worthwhile to meet the language requirement as a necessary preparation for more effective research and as a way of giving proper weight to Maori conceptions about their own art. At long last that has changed.

However, readers might expect far too much if they hope for a revolutionary, inside approach to the description and analyses of Maori art. Nonetheless, at no time before has a group of writers met for long hours to learn from one another and to feel by discussion for an approach that took notice of Maori attitudes toward their arts and recognized the realities of their life. The Canadian scholars Jackson, McCaskill, and Hall (1982:3) writing about the purpose of education for native people advised that what was needed was "a radical departure which recognises that learning must begin from the reality of the learner and from the concrete, daily struggles in which the learner engages." The Brazilian adult educator Paulo Freire, they wrote, advocated the produc-

tion of curriculums by collective means but warned that the "power relations between the learner and facilitator must be ones of equality." These were the sorts of issues which underlay our discussion and which required some resolution.

The result of the talk, the questioning, and the arguing was a sort of negotiated agreement to present, as far as we were able, the understandings of the Maori people about their art. What we wanted might be described as "bicultural scholarship" which aimed at bringing forward, from the body of knowledge we have referred to as matauranga Maori (Maori education), facts that help give a bicultural view to the art. It was realized that in following this approach the culture represented by the English language was powerful and octopuslike in its ability to embrace and assimilate. Nonetheless, the writers tried to reveal unencumbered and fairly the views of the Maori minority about their culture and about the reality of their "daily struggles."

This volume thus represents an effort by a group of writers to set out the korero (talk) and the kupu (words) that provide a context for this exhibition. Agnes Sullivan takes us back to the Polynesian roots of Maori culture and traces connections with other cultures in the Pacific. A new generation of Pacific prehistorians, she says, favors the hypothesis of purposeful migration, which is more in accord with the view stated by Maori writers since they began writing in the 1820s.[3] She also stresses the fact that there is no archaeological evidence to support a theory of other people being in New Zealand when the ancestors of the Maori arrived here. The Maori people were the first inhabitants of this land, and their claim of tangata whenua (people of the land) status is supported by archaeology. The question of whether there was one or more than one set of settlers from Polynesia remains unresolved. Also, we are not able to pinpoint the year of the first landing on the shores of Aotearoa, but the earliest dates obtained so far from occupied sites are no earlier than the eleventh century A.D. Archaeologists have not found the first occupied sites in New Zealand; what they have discovered are sites dating from a time when the people were already well established in the country. These and many other issues are discussed by Agnes Sullivan in her essay and provide a background for matters raised by the authors following her. But hers is an important paper which steers us through a swamp of speculations about the origins of the Polynesians.

I follow with a chapter that describes two approaches to the question of how Maori art developed into what it is now. The first of these provides a mythical explanation, which details the exploits of Ruatepupuke, who ventured into the watery kingdom of Tangaroa, the sea god, and obtained in fully developed form the art of wood carving. The second is a developmental explanation borrowed from archaeology in which an attempt is made to describe the sequence of changes which resulted eventually in the sort of art seen by Captain James Cook in 1769.

In an effort to bring discussion of their art closer to the people who produced it, I propose a sequence that is based on the image of growth and which features bilingual labels, thus:

Nga Kakano—The Seeds (900–1200)

Te Tipunga—The Growth (1200–1500)
Te Puawaitanga—The Flowering (1500–1800)
Te Huringa—The Turning (1800–present)

Besides being better understood by the Maori people, these terms avoid the use of labels such as Early European Maori or the East Polynesian phase for the period I call Nga Kakano—The Seeds. It is an effort, to the degree that is possible and helpful, to deal with Maori art in the context of its own rich cultural background and to free it from other people's myths.

David Simmons follows with an essay that describes the tribal styles, beginning with those known in the literature as Classic Maori, which belong to the Puawaitanga period (1500–1800), and extending to the varied styles of more recent times. His description identifies many tribal styles that have not yet been detailed in the literature. As such his chapter is a valuable contribution in "focusing the microscope" and in giving recognition to tribal groups who have found previously that they were "lumped" with others or simply forgotten.

Next, Ann Salmond explores some of the conceptual pathways of the Maori world and reveals some of its understandings about human nature. She also revisits Maori life in 1769 and provides some glimpses of tribal groups who were rich in art and of those who had little or none, having been "looted" by richer, more powerful neighbors. Attitudes to heirlooms and art objects are discussed, and by the end of this essay the reader has acquired some new and yet old understandings about Maori culture.

Bernie Kernot then directs our attention to the artists of old and tells us something about the status of the traditional carvers and what was expected of them. He describes their training in matauranga Maori, that is, in Maori knowledge, which was part of their intellectual education. Then he shifts his focus to a number of notable carvers and carving traditions of the nineteenth century and examines their achievements against the background of their age. Included in this group is the great Raharuhi Rukupo, who carved our greatest national treasure, the house Te Hau-ki-Turanga, now in the National Museum of New Zealand, Wellington (fig. 31).

In the final essay, Piri Sciascia turns to mana Maori and discusses aspects of Maori pride and prestige as revealed by the exhibition. He concludes that the mana of yesterday is still with us. Giants who possessed a degree of mana walked across the stage of life and have now all passed on. Many of them left something of themselves behind, somewhat like the art objects represented in the exhibition. Their works deserve contemplation. Yet with all this, the oral arts of the Maori and, most importantly, the Maori language are threatened with extinction. This is the present plight of Maori culture as it struggles to rise above the heavy hand of Pakeha institutions and establish its own place under the sun.

But even as there is ground for real concern about cultural survival, there are many signs of "a general renaissance of Maoritanga" and of a searching for that which is lost. Piri Sciascia visualizes a New Zealand in which there is room for hope and scope for the involvement of the churches in Maori art

activities and for the successful staging of huge art events such as the New Zealand Polynesian Festival and the present exhibition.

As contributors we are attempting to provide words to illuminate the taonga and to clothe them. Our efforts amount to several thousand words which will be far more than some viewers need and far less than other viewers demand. As I have already warned, it is possible to supply a trainload of korero, all of it relevant but a great deal of it too far removed from the individual objects to maintain the interest of some viewers. I should also warn that the korero and kupu that we have recorded here do not necessarily coincide with the talk that the tribal groups would generate among themselves, although there will be many points of common interest.

Finally, because of the title of this section, queries could be raised regarding the appropriateness of the phrase *Mana Maori*. Is there mana in art? Mereana Mokomoko (1897:42) as reported by Gilbert Mair, in speaking about her house, Hotunui, said, "As the morning star (Kopu) rose, we, the three women, crossed over the threshold which Te Raihi of Ngati Haua had *tapa'd* [called] Hape Koroki, and then the *mana o te whakairo* [the sacredness of the carving] was subjugated, overcome, and women generally were free to enter and eat within the house." Thus, there is little doubt in Mereana Mokomoko's mind that there was mana in wood carving. The ceremony of lifting the tapu (taboo) of the house does not remove the mana and the tapu from the art. What the ceremony does is "subjugate" and "overcome" their danger; that is, it reduces their potency to a level that is safe for the use of society at large as symbolized by the women.

Therefore, there is mana and tapu in art associated with houses and, by extension, to any art objects that are ritually and socially important, such as canoes, tombs, weapons, clothing, and ornaments. So when we imply that the mana of the Maori is associated with the exhibition, there is some traditional basis to the claim. The mana of the people is not only invested in the examples illustrated in this catalogue, but it is also reflected by them.

NOTES

1. "1981 Provisional Census," in *New Zealand's Multicultural Society: A Statistical Perspective* (State Services Commission, 1982).
2. The exact number is 19,358 according to Table 18 in *A Statistical Survey* (State Services Commission, 1982).
3. One of the first letters written in Maori at the Bay of Islands is dated to 1825.

NGA PAIAKA O TE MAORITANGA
The Roots of Maori Culture

Agnes Sullivan

In 1860 Hoani Nahe of the Ngati Maru people of Hauraki (map 3) wrote the following:

Ka noho te iwi ra i Hawaiki. Ka mea ki te tārai waka mo rātou, hei rapu whenua hou mo rātou. Ka tāraia te waka ra, ka oti . . . ka mānu ki te wai, ka utaina. . . . Kātahi ka rere mai te waka ra, ka whiti mai ki tēnei motu.

(Nahe 1860:3).

That people dwelt in Hawaiki. They planned to shape a canoe for themselves, in order to search for a new land of their own. That canoe was shaped. When it was finished . . . it was launched and loaded up. . . . Then that canoe travelled forth, and made a crossing to this land.

This account, based on the oral traditions of Ngati Maru, in fact outlines what is thought by a new generation of Pacific prehistorians to be the way in which New Zealand was first discovered and settled by the ancestors of the Maori (Finney 1979). Behind such a purposeful landfall lies a longer history of earlier settlements in other parts of the Pacific, earlier searchings, and a development of navigational and canoe-building ability. The actual range of this background has only recently become understood and parts still remain to be clarified. However the broad outlines appear well established.

The Hawaiki of Nahe's text is a generic term for the last departure point of the ancestors. In this case it refers to one or more home islands among the widely scattered island groups of the eastern Pacific in the area called East Polynesia (fig. 8). The Polynesian inhabitants of East Polynesia share a common linguistic and cultural heritage, which can be briefly illustrated by the term for a shared aspect of their traditional technology, the dugout canoe. This artifact, which touches on basic concerns of origins and livelihood, is termed *waka* in Maori, *vaka* in the Cook Islands and the Marquesas Islands, *va'a* in the Society Islands, and *baka* in Easter Island.

The first discoverers of New Zealand, according to current views, were also the first settlers. At least one group of discoverer-settlers may have come from the Tahiti (Society Islands) area or from adjacent islands. Others may have come independently around the same time from the Cook Islands and perhaps the Marquesas Islands. Exact departure points and numbers of founding groups

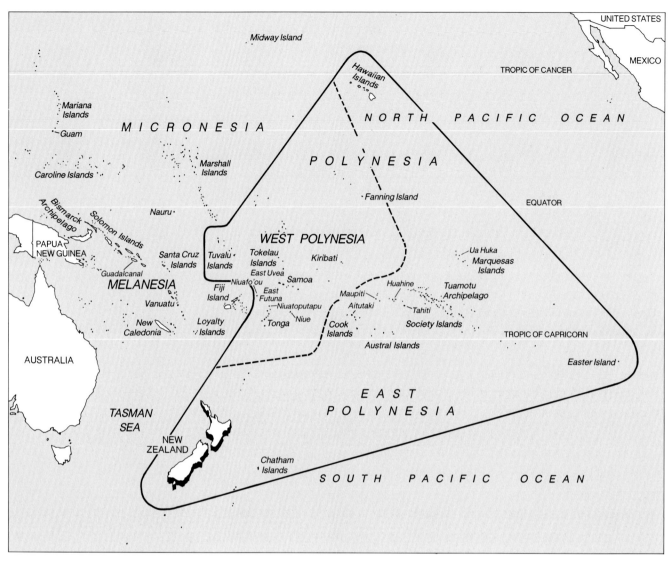

Figure 8. Map of the Central-Eastern Pacific indicating the Polynesian Triangle. Adapted from map courtesy Geography Department, Victoria University of Wellington

have not been ascertained. Current radiocarbon dates for the earliest-known human occupation in New Zealand are no earlier than the eleventh century A.D., though initial settlement probably occurred somewhat before this. The East Polynesian discoverers and settlers of New Zealand are the immediate genetic ancestors of the New Zealand Maori (Houghton 1980:10; Pietrusewsky 1970:9–10). Once in New Zealand, they became the initial Maori population. The earliest-known form of New Zealand Maori culture, described by Sidney Mead as the phase of Nga Kakano (The Seeds), strongly shows its East Polynesian origin through the identical character of stone adzes, fishing gear, and ornament types in early East Polynesian and early Maori occupation sites, as well as by burial customs followed by both groups. From ancestral East Polynesian roots grew the indigenous developments in social and conceptual organization, economy, technology, and art, which Maori society of the Nga Kakano, or seeding, phase underwent in its progression toward the artistic achievements of the eighteenth and nineteenth centuries which form the central theme of this exhibition.

The East Polynesians were island dwellers, canoe builders, navigators, fishers, and gardeners. From comparative reconstruction, or the process of using a set

of related forms to work back to a probable original form which gave rise to them, it can be suggested that the social organization of the Early East Polynesians was based on descent, seniority, and the extended family. Similarly, their view of the world included a belief in the interrelatedness of people and nature, and in the ability of people to exert some control over the natural world by the power of the spoken word.

A technological capacity to pack up and carry with them vital elements of their livelihood enabled the Early East Polynesians to settle and survive on the small volcanic islands and coral atolls that form most of the land in East Polynesia. With adzes fashioned from shell and volcanic rock they built large double-hulled canoes as much as 18 meters (59 feet) long. Remains of such canoes are now radiocarbon dated to the ninth century A.D. in the Tahiti region (Sinoto 1979a:12). They could be used for deep-sea fishing as well as ocean travel and would be able to carry everything the builders needed to search the ocean for a new home and to settle it when found. The freight load of a long-distance canoe would include domestic animals, fishing gear, woodworking tools, garden crop plants, shoots and seeds of cultivated trees, and food and water for an extended family group on a journey that might last for a month or more.

Why should island dwellers wish to move on? Maori tradition, as instanced by an account from Eruera Te Uremutu, of Te Arawa people of the Bay of Plenty (map 3), who speaks of high population and warfare in Hawaiki at a time when part of the population voluntarily decided to leave (Te Uremutu n.d.:5). At such times emigrants were possibly assisted to depart by an otherwise hostile community.

It also appears that the habit of moving on and expanding into as yet unpopulated oceanic areas in the last major region of the tropic-temperate world to be settled by human beings was a legacy from the Polynesian background and from an ancestral culture termed the Lapita culture.

In the 1950s and 1960s the historian Andrew Sharp (1957; 1964) questioned the navigational abilities of the Polynesians. Doubts were cast on the capacity of early Polynesians to steer a fixed course over several thousand kilometers of open ocean without navigational aids, such as sextants, and with canoes that could not sail into the wind. Sharp concluded that New Zealand was discovered and settled accidentally by drifting canoe parties blown astray in storms. Controversy over this view stimulated several decades of technical study and experiment, during which indigenous Pacific navigation systems were extensively examined, computer simulations were made of oceanic conditions affecting voyaging, and replica canoes were built and sailed over oceanic courses using Polynesian navigational methods.

Such work has firmly re-established the traditional view that New Zealand was settled by deliberate voyages. Computer simulations suggest that it is virtually impossible to drift accidentally directly to New Zealand from East Polynesia (Levison, Ward, Webb 1972:234). Practical experiments show that Polynesian sailing canoes (pl. 11) could tack at less than 90° into the direction of the wind. Navigators could keep to a selected course by a careful empirical system of star tracking, mentally visualizing position from a starting point, and attending to

winds, currents, and other oceanic phenomena (Finney 1979:323–351). The only satisfactory present way to account for the first settlement of New Zealand is to assume that around a thousand years ago East Polynesian explorers chose and kept to a southwesterly course hoping to strike land in that direction and eventually, after persisting for several thousand kilometers, were successful.

Where did the people of East Polynesia themselves initially come from? The short answer is, from somewhere in the Samoa region of West Polynesia (an area covering both Samoa and Tonga).

A longer, more detailed answer must also be followed up for the view it affords of historical influences that have shaped Polynesian culture and, through it, New Zealand Maori culture. Present-day West Polynesians are descended from earlier Polynesian populations of the Samoa–Tonga region. In turn, these earlier Polynesians appear as descendants of people with a distinctive material culture called the Lapita culture, who first settled Samoa, Tonga, and Fiji around 3,500 years ago.

The Lapita culture is distinguished by the presence in occupation sites of a coarse sandy type of handmade pottery sometimes decorated with bands of stamped geometric designs. It is named from the village of Lapita in New Caledonia, one of the places where it was first recognized. Well over fifty sites of the Lapita culture are now known. They are spread across a total distance of about four thousand kilometers in the western Pacific, through the smaller islands of Melanesia, as well as in the Fiji–Tonga–Samoa region. Radiocarbon dates for Lapita sites throughout this area range from about 1600 B.C. to about 500 B.C. As presently known, they do not appear to be earlier in any one part of the area than in another. Occupation sites of the Lapita culture are found on coastal areas and on small islands adjoining larger ones. Locations and distribution alike indicate that the Lapita people were skilled long-distance navigators, placing their living sites close to launching points for oceangoing craft.

Lapita material culture has features, such as the earth oven, which reappear as important elements of later Polynesian cultures. Stone adzes imply skilled woodworking, including canoe-making and, possibly, decorative wood carving. Small tattooing chisels in Lapita sites suggest that Lapita people also had the Polynesian custom of face and body tattooing and hint at a similar set of social values identifying the importance of genealogical descent by tattooing. Lapita ornaments include shell beads and shark teeth pierced as pendants (Green 1979:30–40), which are also Polynesian types.

Lapita economy appears to have involved fishing, gardening, and domestic animals. Of the three Polynesian domestic animals, the pig and chicken were present in Lapita sites, and the dog was probably present. Fishing techniques included shellfish gathering, netting, some line fishing with one-piece shell hooks, and probably spearing and trapping. Evidence for gardening is indirect but strong. Most Lapita sites occur in locations where inhabitants would have had difficulty in gaining a living without the aid of cultivated plants. Shell vegetable peelers and probable food storage pits in Lapita sites also imply a horticultural system using root and tree crops similar to the Polynesian taro and breadfruit (Green 1979:32–40).

Plate 9. Putauaki (Mount Edgecumbe), at Kawerau, Bay of Plenty. Putauaki, the ancestral mountain of Ngati Awa, symbolizes the predicament of many tribes who have lost their land and their ancestral burial grounds to progress and to European interests, in this case, a huge pulp- and paper-making company.

40

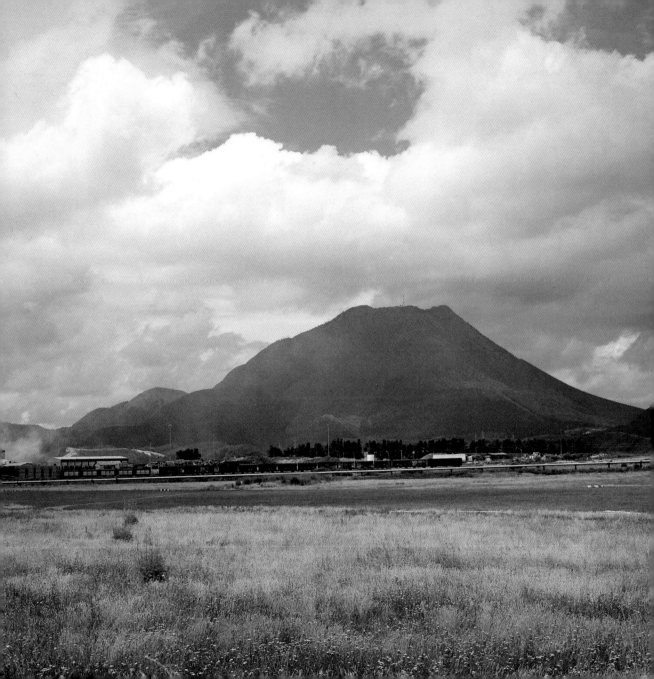

*Plate 10. Whiti-te-ra (The Sun Shines).
Carved in custom wood and painted by Cliff
Whiting, 1969. Palmerston North Teachers
College, Wellington*

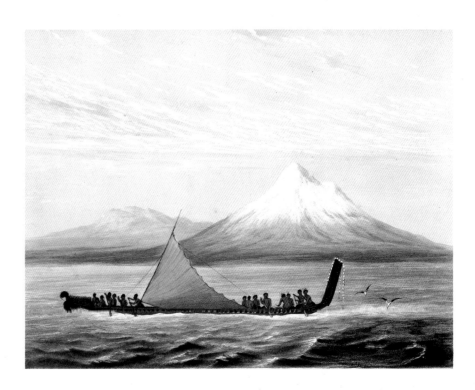

*Plate 11. Large canoe sailing past Mount
Taranaki (Mount Egmont), as drawn by
G. F. Angas in the 1840s. The waka tapu
(canoe reserved for special uses), or the waka
taua (war canoe), is a single-hulled dugout
with built-up sides and carved end pieces.
This type of canoe predominated in New
Zealand in the eighteenth and nineteenth
centuries and represents an adaptation to
coastal voyaging and plentiful timber. Canoes
of the ocean-voyaging era of discovery were
probably of similar length, but with two
hulls, decks, two masts, and deeper keels.*

*Plate 12. A headland pa at Makara, on the
west coast of Wellington. The hilltop in sunlight
is a terraced defensive pa, with edges of
artificial terraces on the inland side, which
appear here as narrow horizontal bands of
shadow. The top and outer slopes are also
terraced, with a small platform on the top,
probably for the leader of the occupying
group. On the outer sides below the terraces
the headland plunges steeply to the sea,
forming lines of natural defenses. On the
landward side, approximately along the upper
edge of the main zone of shadow in this view,
are remains of large deep holes which once
held a defensive line of palisade posts. As
well as being a good defensive site, the
summit is also a good place from which to
spot schools of fish approaching, and it may
have been used for this purpose before the pa
was built, since artifact finds suggest that the
area was in use at an early stage.*

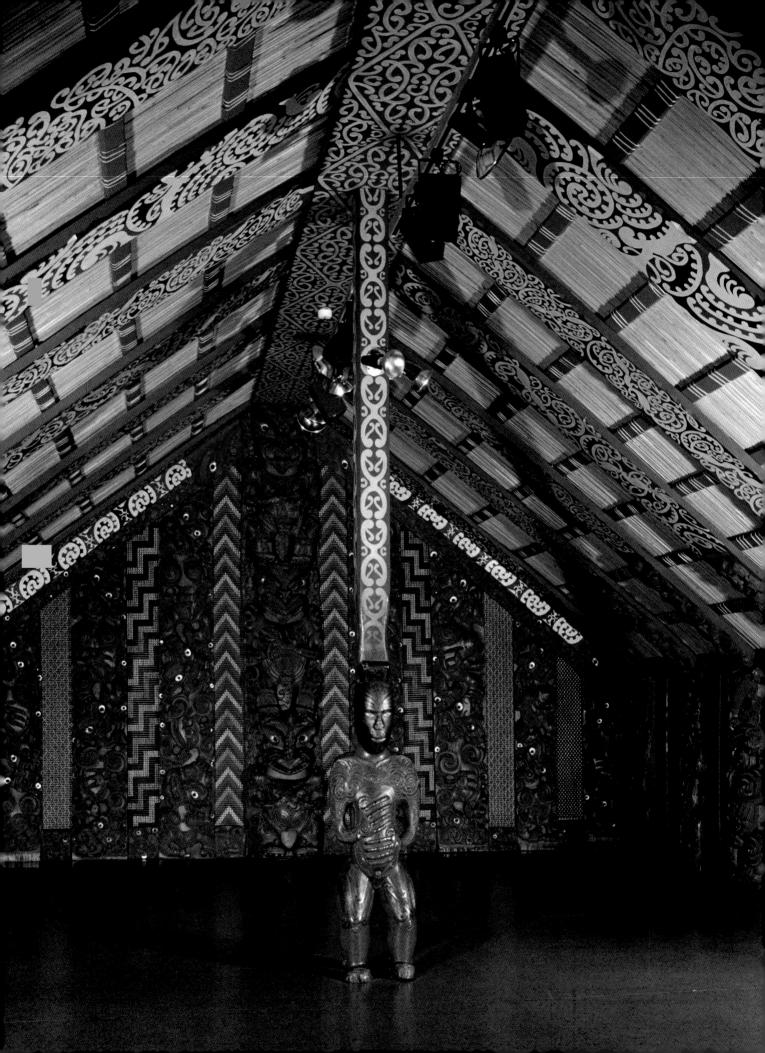

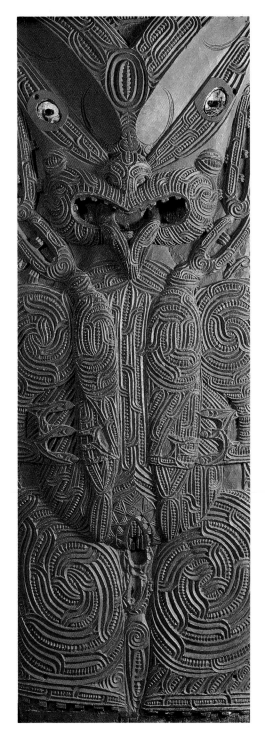

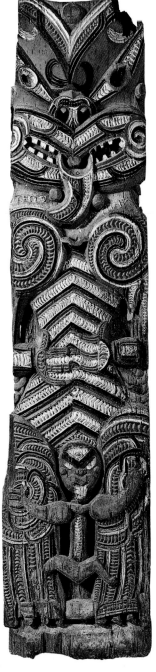

Plate 13. Interior of meeting house Te Hau-Ki-Turanga, carved by Raharuhi Rukupo of Rongowhakaata 1840–42. National Museum of New Zealand, Wellington

Plate 14. Poupou (side post), from Rangitihi, a house carved for Te Waata Taranui of Arawa by Wero of Ngati Tarawhai in 1860. Height 52.3 cm. (20¾ in.) Auckland Institute and Museum (5152)

Plate 15. Poupou (side post), from the meeting house Hotunui, carved by Apanui Hamaiwaho of Ngati Awa as a wedding present for Ngati Maru of Thames. Height 2.13 m. (6 ft. 11⅞ in.). Deposit Ngati Maru tribe, Auckland Institute and Museum (49393)

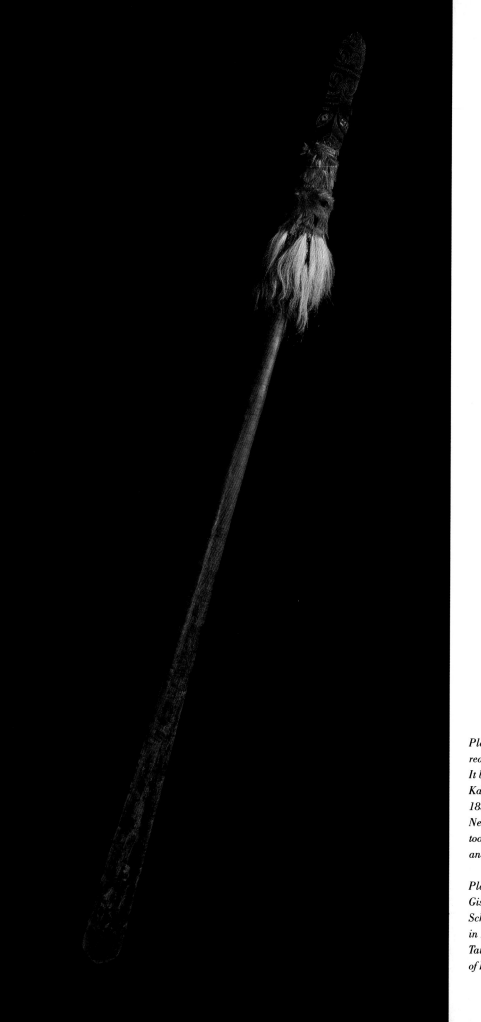

Plate 16. Taiaha (long staff), decorated with red parrot feathers and named Ngaheretoto. It belonged to the chief Tairea of Ngati Kahungunu, who died in England in 1830. The taiaha was brought back to New Zealand by the owners of the ship that took Tairea to England. Auckland Institute and Museum (288)

Plate 17. Meeting house Te Poho-o-Rawiri, Gisborne. Carved by the carvers of the Rotorua School of Maori Arts and Crafts and opened in 1925. The principal carvers were John Taiapa, Pine Taiapa of Tikitiki, and Wihau of Rotorua.

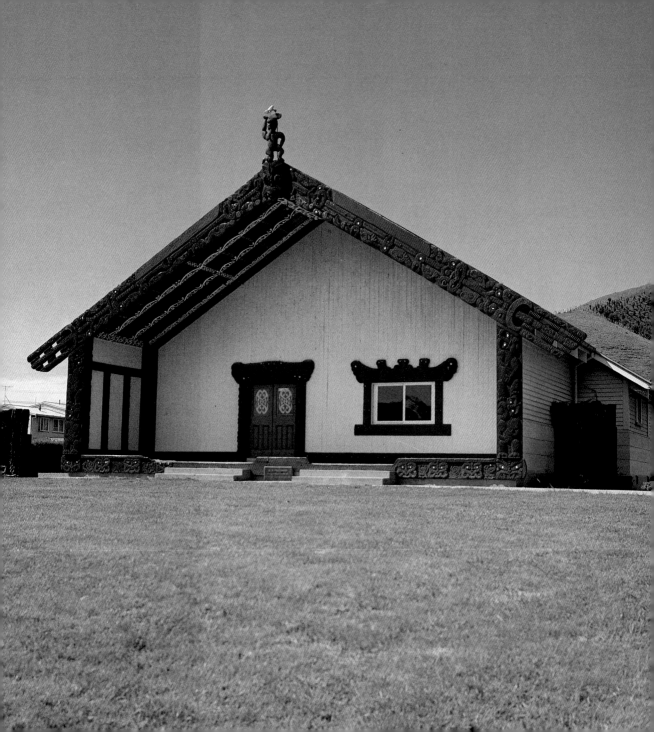

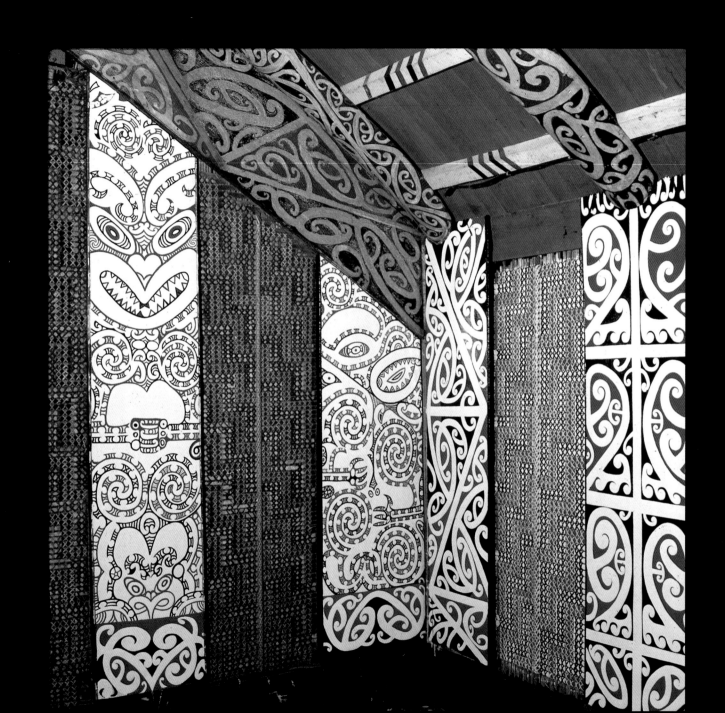

So far there is no conclusive evidence for the origin of the Lapita culture, though an ultimate derivation from somewhere in southeast Asia is indicated. Suggestions for its immediate or not-too-distant source include the high volcanic islands of the Bismark archipelago off the coast of New Guinea (Green 1979:45) and pottery-making cultures in the islands of eastern Indonesia or the Philippines (Bellwood 1978c:255). What seems clear is that in the second millennium B.C., Lapita communities had developed maritime skills and methods of gaining a living in oceanic areas which enabled them to spread rapidly through a vast tract of oceanic islands (Irwin 1980:325) and to survive in otherwise inhospitable localities.

The Lapita culture falls within the distribution area of the outrigger canoe (Green 1977:5), a single dugout hull stabilized by an external float. It is surmised that use of the outrigger canoe allied to superior navigational skills enabled the Lapita people to spread swiftly inside Melanesia by crossing comparatively short distances of open ocean between islands. During this expansion Lapita settlements were at first edged on to small unoccupied islands and restricted coastal zones on already populated larger islands. A section of the Lapita people then managed to increase their navigational range and cross about 900 kilometers (560 miles) of open ocean between the Vanuatu region and Fiji. By doing so they reached totally uninhabited tracts containing relatively large islands in Fiji, Tonga, and Samoa soon after the first appearance of the Lapita culture.

Lapita sites in the Fiji region date from about 1600 B.C. In Tonga and Samoa earliest available dates for Lapita settlement are slightly later, though each area was probably settled soon after 1600 B.C. In all three areas material culture developed along generally similar lines for a long time after initial settlement, though some local divergence was apparent at an early stage. In Samoa and Tonga later changes in material culture within a continuing context of Lapita-based technology took the form of innovations which can be recognized as Polynesian. These Early Polynesian features are seen particularly in Samoa, East Uvea, East Futuna, and in Niuatoputapu, the northern part of what is now Tonga (Green 1981:143–144). Foremost among them are changes in adz types. In Samoa, after 500 B.C., adzes with triangular cross sections, which are particularly characteristic of later Polynesian material culture (fig. 9), appear in sites that continue to show Lapita-type adzes and, for a time, pottery (Smith 1976:83). In Samoa and Tonga during this time pottery lacked decoration, and pottery vessels with thick walls were made. By perhaps A.D. 300 in Samoa and somewhere around the same time in Tonga, pottery was no longer made or used (Davidson 1979:94). Judging from later Polynesian custom, it had probably been replaced by wooden vessels resembling recent Polynesian forms such as kava bowls and wooden food containers. In Fiji, adzes with triangular cross sections were rare but pottery making continued down to recent times. Thus by about A.D. 300 technological divergence between Fiji on the one hand and what can be called the Early Polynesian area of Samoa–Tonga on the other was noticeable. In view of indications of long-term continuity of occupation in Samoa–Tonga from the Lapita phase down to recent times, it appears that Early Polynesian material culture developed in these regions through innovation within a basic Lapita technology.

Plate 18. As part of a conservation exercise, a tauira (pattern) of the past is uncovered in the house of Rukupo at Manutuke, Gisborne. Photo: Cliff Whiting

49

Polynesian languages belong to the Austronesian language family which contains about 500 languages spoken mainly in the Pacific and Island Southeast Asia. Inside the Austronesian language family the closest relatives of present-day Polynesian languages are those of the Fijian area. Both appear to be descended from a language or set of related dialects spoken by the first Lapita settlers of Fiji, Tonga, and Samoa. The development of a distinctive early Polynesian language from which present-day Polynesian languages —including New Zealand Maori—are descended may have been in progress soon after 1600 B.C. (Green 1981:137–152). With close links indicated between the origin of Polynesian material culture and of Polynesian languages, it is feasible to suggest that Polynesians themselves are descended from Lapita ancestors. The classification of modern Polynesians as closest in physical type to modern Fijians from studies of head form (Pietrusewsky 1970:9–10) is in keeping with this view.

By the time that Early Polynesian cultural characteristics were beginning to appear, maritime skills had probably improved still further with the development of the double canoe (Green 1977:13). In this type of vessel the outrigger float was replaced by a second dugout hull lashed to the first by crosspieces. The resulting increase in stability, loading capacity, and voyaging range would have greatly aided the continuation of the seagoing emigration that is indicated in the Early Polynesian period. During this time in Samoa, settlement and horticulture expanded into inland areas (Davidson 1979:94). This suggests an overall rise in population, which may have set off a renewal of emigration. Further ocean searches for new land were directed to the eastern Pacific and resulted in settlement of East Polynesian islands by the early part of the first millennium A.D. As had been the case with Fiji, Tonga, and Samoa, these islands were previously uninhabited.

Initial settlers of East Polynesia were apparently drawn from somewhere in the region of Samoa–Niuafo'ou–Niuatoputapu–East Futuna–East Uvea rather than from main islands of the Tonga group, as East Polynesian languages are more closely related to the Samoic than to the Tongic subgroup of Polynesian languages (Pawley 1966:39–40). Archaeological indications that East Polynesia was settled from the Early Polynesian area include the presence in early East Polynesian sites of the earth oven, Early Polynesian adz types, tattooing chisels, and shellfish hooks. Even a few pieces of residual Early Polynesian pottery were transported several thousand kilometers eastward to the Marquesas Islands, though pottery did not persist in East Polynesia. Early levels of the Hane dune site on Uahuka Island in the Marquesas Islands contain shell graters and shell vegetable peelers, suggesting cultivated plants. Domestic animals (dogs) were also present (Sinoto 1979b:113–131). At a somewhat later stage, Early East Polynesian technology shows a proliferation of adzes on which a lashing grip or tang has been shaped.

East Polynesian areas that were probably settled before A.D. 400 include the Marquesas, Hawaii, and Easter Island. In the Society Islands (Tahiti), the Cook Islands, and New Zealand, earliest available dates for occupation are somewhat later. It has been argued that the Marquesas Islands represent a center of primary settlement in East Polynesia and that other areas were set-

tled by secondary or tertiary movements from this center (Sinoto 1979b:113–131). However, whether or not the Marquesas actually were the initial focus of settlement in East Polynesia, it is clear that New Zealand was first settled from some already occupied part of East Polynesia.

Early Maori sites in New Zealand reproduce most of the range of technological items from early sites in East Polynesia, including the characteristic adzes with lashing grips (fig. 9). Rectangular houses were present in the Marquesas before A.D. 1300 and in the lower North Island of New Zealand before A.D. 1200 (Sinoto 1979b:112; Prickett 1979:39). Two-piece trolling lure hooks (minnow lures) with pearl shell shanks in East Polynesia were the pattern for numerous stone and bone replicas from early Maori sites. A pearl shell lure shank from an early Maori site at Coromandel may be an actual import from East Polynesia, since pearl shell does not occur on the New Zealand coast (Green 1967). Barbed bone hooks with a basal hole for line attachment and a range of ornament types including reel pendants (necklace units) and necklaces of sea mammal teeth are common to both areas. Necklace units were also copied in stone or bone in early New Zealand sites (cat. no. 15).

Early Tahitian sites on the island of Huahine contain canoe parts of the ninth century A.D. Canoe end boards, paddles, steering paddles, a bailer, and a strainer for tightening canoe lashings give concrete evidence of oceangoing capacity during the Early East Polynesian period. Huahine also provides evidence for the bottle gourd (hue), a cultivated plant brought to New Zealand with the first arrivals, as well as hand clubs of wood and whalebone which are prototypes of later New Zealand patu (Sinoto 1979a:18–35). The island of Maupiti in the Tahiti area contains Early East Polynesian burials with grave goods, such as adzes, fishing gear, and ornaments (Emory and Sinoto 1964). These closely parallel burial customs at archaic New Zealand coastal sites such as Wairau Bar (Duff 1956:32–66).

A further indication of the specifically East Polynesian origin of the Maori is provided by the kumara (sweet potato). This cultivated root crop originated in South America and was brought to East Polynesia during the early period of Polynesian occupation by unknown means, possibly by returning Polynesian voyagers who had reached the South American coast. The arrival occurred in time for the kumara to be distributed by Early East Polynesian voyagers to the marginal East Polynesian areas of Hawaii, Easter Island, and New Zealand. In West Polynesia (Samoa–Tonga) there is no clear evidence that kumara was present before the period of European contact (Yen 1974:1–32, 291–296).

A precise origin area for the New Zealand Maori in East Polynesia has yet to be established. Maori traditions term the departure zone Hawaiki, but the detailed location of Hawaiki cannot be determined from traditional accounts alone. A current archaeological hypothesis suggests that during the settlement period New Zealand could have been discovered and settled independently by people from more than one of the island groups of East Polynesia. This is termed the hypothesis of multiple East Polynesian origins for the New Zealand Maori (Green 1966:27–33; 1977:15). Possible origin areas include the Tahiti–Tuamotu–Austral zone, the Marquesas, and the Cook Islands.

Several lines of argument are advanced to support the idea of a multiple

Figure 9. New Zealand Maori artifacts of strongly Early East Polynesian affinities: A. Triangular cross-sectioned adz with lashing grip, found at Petone, Wellington; B. Minnow lure shank of composite fishhook, locality uncertain; C. Reel necklace unit of bone, locality uncertain; D. One-piece bone fishhook, locality uncertain; E. Sea mammal tooth pendant, found at Seatoun, Wellington. National Museum of New Zealand, Wellington (ME.12752; ME.2049; Black Collection 394; Black Collection 426; ME.11821)

East Polynesian origin. Navigationally it is assumed that the initial discovery and settlement of New Zealand was made by East Polynesian exiles who elected to search for possible new islands in a southwesterly direction, not knowing but hoping that such islands existed there. The same direction of search could well have been selected independently by searchers from more than one East Polynesian island group. The fair probability of a successful navigated canoe voyage to New Zealand from these regions is also possibly in favor of several original arrivals, though a 62 percent chance of successful arrival from a departure point in the Southern Cook Islands may point to an immediate Cook Islands departure.

In terms of material culture, each of the suggested areas shows similarities with early New Zealand. The early material culture of the Cook Islands is less well known than that of the Tahiti or Marquesas areas, but the island of Aitutaki in the southern Cook group has yielded adzes and fishhooks of characteristic Early East Polynesian type of about the tenth century A.D. (Bellwood 1978c:139). At present not all East Polynesian parallels in Maori material culture can be traced to a single East Polynesian island group. Thus the prototype Maori patu (hand club) is known so far only from the Tahiti region. Regional differences in stone toolmaking also existed in early New Zealand, and it is possible that such technological variations originated with separate groups of initial settlers.

Linguistic evidence also allows the possibility of an origin in more than one island group. Descent group dialects of New Zealand Maori could spring from initially divergent linguistic tendencies in the founding population. New Zealand Maori has been grouped in a Tahiti subgroup of East Polynesian that includes Tahitian, Tuamotuan, and Cook Islands Maori (Rarotongan) (Green 1966:34), though its closest lexical connections in this group appear to lie with the Cook Islands Maori language (Biggs 1978, reported in Dyen 1981:84). Marquesan elements have been noted in the southern or Kai Tahu dialect of the South Island of New Zealand, and a specifically Cook Islands morphological feature is seen in East Coast North Island Maori (Harlow 1979:133–136).

Recent cultural differences among major descent groups of the New Zealand Maori may also derive from initially existing divergences. Different names for nights of the moon are one such feature. Another is a varying commencement point for the lunar year, which begins around June for the majority of descent groups, but begins around March among the Taranaki people (information from R. H. Broughton, Wellington, 1981).

Each of the three suggested origin areas in East Polynesia has uniquely shared points in its favor. It seems certain New Zealand was settled from one of these areas, though the view that it was settled from more than one remains tentative.

Accounts of the actual crossing to New Zealand from Hawaiki tend to be brief, though Te Arawa tradition describes a whirlpool, Te Waha o Te Parata, encountered by Te Arawa canoe (Te Uremutu n.d.:10). An account of the canoe Tainui from Wirihana Te Aoterangi of Ngati Tahinga of Whaingaroa refers to what are probably sea mammals as companions and protectors of voyaging canoes:

Ko aua taniwha, e kī ana o mātou mātua, he kāhui ki te moana . . . no namata. . . .

Ka tūpato te tohunga kia tomo i raro o te waka, arā i te ihu. . . . Ka karanga atu—
 Kaua e tomotomo, turaki ki waho.

<div align="center">(Te Aoterangi, n.d.:10–11)</div>

Our fathers say that those monsters were a troop of fish in the sea . . . in ancient
times. . . . The navigating expert took precautions to stop them getting under the prow
of the canoe. . . . He cried aloud—
 Do not keep coming in close, keep the sea calm outside.

Te Aoterangi mentions a karakia (ritual chant) by which the tohunga (navigating
expert) called up the aid of these sea monsters for the voyaging canoe. It may
be more than incidental that necklaces of sea mammal teeth figure in early
East Polynesian and early Maori burials. While such necklaces (cat. no. 15)
indicate material wealth and probably high status, they may also have had a
more specific function in marking out people who were skilled oceanic mari-
ners or their immediate descendants.

Further karakia for the control of a voyaging canoe, having to do with winds,
clouds, sea birds, paddling, and bailing, are also listed by Te Aoterangi,
(n.d.:10–12). The existence of similar karakia devoted to these and other
ritual tasks in other East Polynesian areas suggests that karakia as a ritual
device reached New Zealand with the initial discoverers. Waiata (song) as a
literary form in Maori society probably had a similar origin. It is also likely
that specific elements of earlier traditions were among initially imported concepts.
The narrative of Rata the canoe builder, which is widely recorded in Polynesia,
may go back at least to the Early Polynesian period. Likewise, the tradition of
Maui who fished up islands out of the ocean has a distribution in East and
West Polynesia, suggesting possible descent from the Lapita period.

A number of Maori origin traditions which give precise landfalls for the
arrival of voyaging canoes from Hawaiki put them in the East Cape–Bay of
Plenty area of the North Island. Whangaparaoa near East Cape is usually
named as the first landfall. The East Cape region, which juts out considerably
to the northeast, is in fact a likely arrival zone for navigated voyaging on a
southwesterly course from East Polynesia, though any point on the eastern
coastline of the North or the South Island is theoretically possible. The earliest
occupation sites so far known in New Zealand are radiocarbon dated to the
eleventh and twelfth centuries. These sites show local adaptations suggesting
several preceding generations of residence in New Zealand and are thus not
the sites of actual initial arrivals. They suggest, however, that New Zealand
had probably been discovered and settled by some time around 900–1000.

The initial environment encountered by the founding ancestors in New Zea-
land differed in some important respects from Polynesia, a subtropical zone of
small islands and relatively limited natural resources. The new land was at
least five to six degrees colder. It was much larger, with mountain ranges, large
rivers and lakes, and extensive forests. Rock resources were more varied. There
were more coastal fishing grounds, more shellfish in harbors and estuaries,
and coastal sea mammals. There were plentiful bird populations, including
large flightless birds (moa). There were regional variations in climate and
resources, with colder temperatures in the inland and southern regions.

The ways of getting a living with which the first settlers were accustomed

Figure 10. The ti palm. An important technological resource, the leaves of this plant provided extra-strong fibers and young shoots that could be eaten. The pith of the stems was an important large-scale food resource in the Kai Tahu (South Island) region. Stems lopped above the base regenerated in a relatively short time and could be periodically reharvested.

were adapted to the warmer conditions and smaller islands of East Polynesia. The colder, more diverse New Zealand environment began to exert an immediate selective effect on patterns of economic production, particularly on gardening and tree cropping. Initial arrivals would have come supplied with tubers, seeds, and cuttings of the important East Polynesian food plants, and one of their earliest actions in New Zealand would have been to clear small patches of ground for gardens. But as it turned out, the major food trees, such as breadfruit, coconut, and banana, failed to survive and produce. Root crops could be grown only in the warmer parts of New Zealand, and the main East Polynesian root crop, taro, proved relatively unproductive. Of the Polynesian domestic animals, only the dog was successfully introduced into New Zealand. The combined effect of such influences in the regionally diverse New Zealand environment was the very early development of distinctive regional economies.

The East Polynesian discoverers of New Zealand possessed large canoes. Equally important were the means to repair and replace them. Heavy timber was plentiful and rock sources to make woodworking tools occurred in easily found shoreline locations, such as the Tahanga basalt cone at Coromandel. It is probable that initial arrivals very soon set themselves to circumnavigate and survey the coasts of the main islands of New Zealand, assessing the resources of each area as they went and also carrying out preliminary exploration of inland regions. A likely next step would have been the sharing out of the whole country into large initial territories, since such subdivision was a characteristic Polynesian proceeding in new territory. The recorded distribution of early occupation right throughout New Zealand appears to have been the result of early appreciation of the potentialities as well as of the limitations of the different regions.

Southern regions and most inland areas were unsuited to Polynesian garden crops. However, the South Island contained plentiful large-scale sources of protein food, including moa, sea mammals, sea birds, fish, and shellfish, as well as forest plant foods such as berries, edible shoots, and piths. In the south the earliest Maori groups appear to have willingly accepted the loss of gardening, becoming fishers, plant gatherers (fig. 10), and large-scale hunters. Southern Maori sites showing early features in technology and economy are relatively numerous but cover a time span of what appears to be at least four centuries. Although a few of these sites are large, total population at any one time up to about 1400 or so may not have been particularly high. The sites are characteristically located on the coasts at the mouths of streams and rivers, but in southern regions the early Maori groups also systematically utilized resources of inland areas, probably mainly on temporary journeys from coastal bases. Inland sites of these earlier groups include hunting camps, stone tool quarries, and rock art sites.

Most known rock art sites are in inland areas of the eastern South Island. Here hunting and quarrying parties used limestone overhangs as temporary shelters. Marine shellfish in food remains show that users came from coastal areas. Rock artists used charcoal from shelter fires, and sometimes red ocher, to inscribe shelter walls with stylized outlines of people, dogs, birds, and fish (fig. 11). Some human figures consist of trunk and limbs only, a feature re-

Figure 11. Early Maori rock art, at Pyramid Valley in the eastern South Island. Charcoal outlines on the walls of a limestone rock shelter depict the naturalistic forms characteristic of Early Maori rock art, here mainly fish and birdlike forms.

peated in an early Maori pebble engraving (cat. no. 13). Spiral motifs characteristic of later Maori art are present at a few southern rock art sites but may be relatively late features (Trotter and McCulloch 1981:21–39, 64–67).

In northern parts of the North Island and in coastal fringes of central districts, Polynesian crop plants that had survived the transition to New Zealand could be grown and archaic populations could get a living from gardening, fishing, shellfish gathering, and a variable amount of hunting. The mainstay of New Zealand Maori gardening was the kumara, which was successfully adapted as a major food plant in a cooler climate. An important aspect of this adaptation was the development of insulated winter storage for kumara tubers. Rua tahuhu

Figure 12. A clustered line of kumara rua tahuhu (sweet potato store pits) at Mangere, Auckland. Only the excavated pits remain. Formerly roofs and doors enclosed the pits, giving winter insulation to kumara tubers. Important pits were given individual names.

(roofed semi-subterranean kumara stores) are known first in an occupation site of Opito, Coromandel, where they are radiocarbon dated to the twelfth century A.D. (Davidson 1975:36–40). Such rua tahuhu became characteristic features of later horticultural landscapes of the North Island (fig. 12) and continued in use in some areas until very recently.

Earlier Maori gardening is best known from small coastal communities of the twelfth to about fourteenth centuries at eastern Palliser Bay in the Cook Strait area. Here rock-walled kumara gardens were laid out on strips of sandy ground between the sea and the coastal hills. The gardening communities occupied small settlements at the mouths of open streams nearby, also obtaining food from coastal fishing, shellfishing, some sea mammals, and plant gathering. They coexisted with a community of specialist adz makers who lived on the south side of Cook Strait at Wairau Bar and produced adzes of Early East Polynesian types. Through some form of exchange eastern Palliser Bay people obtained from the Wairau Bar group argillite adzes for making canoes and houses (Leach and Leach 1979).

Rectangular houses are a persistent feature of Maori culture. The generalized house plan was probably imported from East Polynesia at initial settlement, and the earliest local example is from the Moikau Valley at Palliser Bay in the territory of the present-day Ngati Kahungunu ki Wairarapa. The Moikau house is radiocarbon dated to the twelfth century A.D. It had side posts of totara timber, a roofed front porch (mahau) across the width of the house, and a sliding door leading from the porch into the interior (Prickett 1979). Sliding doors remained in use till the nineteenth century, and the essential identity of the earlier Moikau house with recent and modern Maori meeting houses is clear.

In the north as in the south, coastal occupation sites containing early forms of adzes and of other gear are widely distributed. A lesser number of sites in inland areas show that the interior of the North Island was used for exploitation of rock sources and some hunting at an early stage. There appear to have been relatively few areas in the north where moa were plentiful, and northern hunting tended to be diversified.

Fishing and shellfishing were general, and many earlier northern coastal sites were probably seasonal camps. It seems likely that all earlier northern coastal archaic communities (as distinct from sites) were gardening communities partly dependent on gardens for their annual food supply. However, one of the more serious information gaps on early Maori occupation in the northern North Island concerns the extent and nature of gardening. Evidence for northern gardening in technologically early contexts is sporadic, and no extended garden layouts like those of Palliser Bay have yet been identified in such contexts.

In the distribution of earlier types of stone tools, a network of interconnections can be traced throughout mainland New Zealand. Obsidian from Tuhua (Mayor Island) in the Bay of Plenty and from other North Island sources reached early sites throughout both islands. Regional networks which cover southern, central, and northern areas suggest a possible mechanism of overall distribution by area-to-area transfer. In a southern distribution area blade knives of silcrete (orthoquartzite) from southern quarry sites were utilized throughout the southern South Island. Silcrete blade knives moved northward toward Banks

Peninsula and reached the North Island. In a central network, adzes of argillite from quarry sources in the Nelson mineral belt were moved in quantity across Cook Strait and to the north. They also went south into the orthoquartzite zone. The Palliser Bay and Wairau Bar communities were part of this central distribution linkage. A northern network moving adzes of basalt from the Tahanga quarry at Coromandel extended into the far north, the Bay of Plenty, and possibly into the southern North Island (Moore 1976:80–86; 1975:32–33).

The Chatham Islands, which are 800 kilometers (500 miles) east of the South Island, appear to have been settled by Maori from New Zealand at some point during the earlier stage of Maori occupation (Sutton 1980). The development of settlement in the Chathams resembles in a number of ways that seen in earlier mainland communities of the southern South Island. The Chathams were too severe for the cultivation of any Polynesian garden crops, and indigenous vegetation was too restricted to provide timber for long-distance canoes. Once in the Chathams, early Maori arrivals were effectively marooned, and there is little evidence for later contact with New Zealand. Chatham Islanders, who probably began to term themselves Moriori in the early nineteenth century, developed an economy dependent on marine foods including seals, sea birds, fish, and shellfish, and on the digging of the fern root. Recent Moriori art forms in wood carving, and rock engravings of possibly earlier date, recall the naturalistic outlines of early South Island rock art. When HMS *Chatham* rediscovered the islands in 1791, members of a landing party were received with the hongi, the characteristic Maori and Polynesian pressing of noses in greeting (Bell 1791, 1:60). The existence of the hongi in this isolated area suggests that along with related ceremonials of the hui (assembly for reception of visitors), it was already practiced by the Maori in early New Zealand and was probably an initial import from East Polynesia.

The early phase of Maori technology and material culture, marked by the continued manufacture of artifacts of basically Early East Polynesian type, had by the later eighteenth century been replaced by the types of adzes, fishing gear, ornaments, and other items of material culture seen and recorded by external observers at that time. These types encompass the later part of the Puawaitanga (Flowering) art style period, as outlined in the essay by Sidney Mead. The replacements include a predominance of adzes with quadrangular to rectangular cross sections, often relatively thin, and without lashing grips. In ornament types, single pendants are now preferred to necklaces. Fishing gear has become more specialized, and stone patu (hand clubs) are both standardized and universal. However, as in the earlier technology, a degree of regional diversity is present.

The process, timing, and spread of this changeover from early- to late-eighteenth-century technology and material culture is a matter of continuing debate which recent archaeological work has not yet clarified in detail. Present indications are that it was complex and not necessarily uniform or contemporaneous for all elements and for all areas. In some cases, transitional forms between earlier and later technological types are present (i.e., for adzes, chunky quadrangular to rectangular sectioned types without lashing grip in some northern regions of the North Island are technologically and chronologically intermediate between early adzes and late-eighteenth-century types). However, such

regularity of change cannot be documented for all areas or for all technological items on present information. Even within a region it appears that the course of technological change may not necessarily have been uniform. In addition, technological changes occurred in a context of environmental, economic, and demographic changes that were likewise not necessarily uniform in all respects.

In spite of indications that change occurred at different rates in different areas, the general source of technological change is not in doubt. Changes were indigenous in origin. Maori technology as seen in the later eighteenth century shows no sign of external influences, but can be fully explained as resulting from development, continuation, or loss of prototypes introduced into New Zealand with the first Maori settlers and from local innovation.

Technological loss, as in earlier adz and ornament types, may have been due both to economic factors, such as new work requirements or unavailability of some raw materials, and to social factors, such as disruption of specialist groups of craftspeople. Technological continuity can be seen in such basic features as the general floor plan of the rectangular house, the earth oven, and probably the kete, a much used all-purpose container made of plaited plant fibers, which occurs in the same form in East Polynesia.

Technological development took diverse forms. In the case of the adz in use in the eighteenth century, a change in form and rock types has been associated with a change in function to a basically chopping tool (Simon Best 1977). An increase in frequency of use of a material is seen in the widespread later use of pounamu (jade) for valued objects. An increase in popularity also apparently occurred in the case of the spiral motif in classic design (cat. no. 136), which as an element of decorative woodwork is radiocarbon dated to around the fifteenth century (Cassels 1979:86–103; Lawlor 1979).

The development of an early prototype into several specialized types of later artifact is indicated in the case of the minnow lure, which probably gave rise to both the later kahawai (lure hook) and the barracouta lure. Intensification of the Early East Polynesian wooden or bone patu is seen in the appearance of stone patu in later Maori sites. These stone patu imply that the initial Maori population came equipped with perishable wood or bone patu, which are not yet well documented archaeologically. The classic hei-tiki, a pendant comprising a carved human figure made predominantly of pounamu, may also be an intensification in stone of a perishable prototype. In canoe design, local development by adaptation to abundant timber and coastal voyaging is seen in later single-hulled canoes of extended length (pl. 11) and rounded hull form.

In rare cases a dated sequence of the changes leading up to the predominance of an eighteenth-century form is available (cat. nos. 73–78). Wooden combs from the Kauri Point swamp site near Tauranga, Bay of Plenty, had simple squarish tops around the sixteenth century. Around the seventeenth century the predominant type of comb had a rounded top, reduced at one side and carved to represent a human head, in a style that persisted into the eighteenth century (Shawcross 1964;1976:269). The change was a gradual one with square-topped combs slowly declining in popularity.

Demographic change in earlier and later Maori populations can be discussed only within broad limits. The founding Maori population of initial discoverers and settlers would have been no more than a few hundred at most, while the

eighteenth-century population was estimated as at least 100,000 (Forster 1778:225). Rates and mechanisms of population growth are uncertain, but the recorded ratio of technologically early sites to other occupation sites is low, of the order of 0.01. Site frequency is a very crude measure of population size, and allowance has to be made for multiple use of sites at all stages, and for noncontemporaneity. Nevertheless, the overall ratio of technologically early sites to sites lacking early types of material culture does suggest that the absolute increase in numbers among people who used early types of artifacts was limited, and that most of the indicated population increase was associated with post-initial technological developments.

Regional environment and economy appear to have directly affected possibilities of population growth. By the fifteenth century large-scale sources of protein such as moa and sea mammals were scarcer, and by the sixteenth century moa had probably disappeared (Hamel 1978:53; Leahy 1974:72–74). In southern regions this caused a redirection of economic effort toward alternative protein sources, with more emphasis on fishing and shellfishing, and in the far south probably also on the taking of smaller sea birds such as the titi (muttonbird). Such sources were probably effective protein replacements, but the inability to grow crops or to gather greatly increased amounts of plant food would have continued to limit expansion of southern populations. The population of the southern South Island could in fact have remained more or less stable from the initial spread of occupation in the region up to the end of the eighteenth century.

In the North Island the population that made and used early types of artifacts may also have been relatively low overall. However, by the nineteenth century probably over 90 percent of the total Maori population resided in the North Island, and more especially in northern districts. The economic basis for the indicated northern expansion was multiple. Fish and shellfish resources, and major inland freshwater foods such as eels, allowed additional exploitation. However, the major economic factor in the northern population expansion was probably increased availability of plant foods from both gardening and food gathering. Northern gardening expanded greatly, and plant food gathering also increased considerably by the large-scale digging of the root of the bracken fern (aruhe or roi).

Expansion of gardening and fern root gathering were probably concurrent in many areas. Along with most of the South Island, most of the North Island was forested at initial settlement. Bracken fern was then probably only a minor element of most vegetational landscapes. Clearing of forests for gardening, along with accidental burning off, enabled the bracken plant to spread widely in the North Island and in some northern coastal areas of the South Island. Once the capacity of bracken to provide a large-scale source of plant food was appreciated, growth was probably promoted by periodic firing of suitable land. The parallel expansion of gardening and fern root gathering in northern areas is also suggested by the linking of Haumia tiketike (fern root) and Ronga ma tane (kumara) as the children of Papatuanuku (the earth) in Te Arawa and other northern cosmologies.

The available record of region-by-region development in gardening, from earlier to later stages, is uneven. In the southern North Island at Palliser Bay

coastal gardening after an initial period of success was overtaken by local climatic and environmental deterioration (Leach and Leach 1979:262). In areas farther north early small-scale gardening appears as the predecessor of a considerable later expansion of gardening. In the Auckland city area there are suggestions of possible small-scale thirteenth-century gardening by a population using early types of artifacts. However, by the fourteenth to fifteenth centuries in this district early types of artifacts had apparently disappeared, and large-scale gardening, not associated with early artifacts, had begun. This expanded gardening eventually took in thousands of hectares of light kumara soils.

By the fifteenth century northern peoples were expanding as permanent settlers into inland regions such as the interior Waikato (Bellwood 1978a:70), which had extensive fresh water food resources. In the case of Waikato, traditions indicate that inland settlement along the Waikato River and its branches comprised a secondary expansion of population from an adjacent coastal region of large-scale gardening around the Kawhia Harbour (Tamaki n.d.; Kelly 1949:71, 85–88).

Expansion of population is associated with a rise in the incidence of warfare, with the appearance of defensive structures, and later with the intensification of weapons seen in the stone patu. The earliest available sites provide some indications of conflict, but the scope appears to have been limited and fortifications are not known. Defensive settlements (pa), fortified by palisades, scarp, ditches, embankments, or natural cliffs (pl. 12), characterize areas where later economic expansion was feasible. They are thus largely confined to the North Island with peripheral extensions into the northern South Island. In Auckland the first occupation of defensive pa appears to be linked to the onset of large-scale gardening. The majority of all pa are in horticultural zones or areas where large-scale fern root gathering was possible. The prominence of warfare in later Maori society may largely reflect pressure on resources in territories that were increasingly subdivided through population growth even though some of the subdivision may have been informal.

Warfare significantly affected economic activities in horticultural areas. Communities that depended extensively on gardening required a state of peace to permit full-scale garden cultivation. Crops were vulnerable to attackers, and severe attacks could suspend gardening completely by forcing a hapu (resident descent group) to flee from its territory. People would remain away until they could safely return, and meanwhile they turned extensively to fern root as a source of food. Fern root was available through the year on a wide range of soil types and provided a ready substitute for garden crops in troubled situations. The extent to which later northern communities in regions suitable for kumara growing depended on garden crops was probably primarily determined by the state of political relationships, with gardening predominating in times of peace.

Maori communities of the late eighteenth to early nineteenth centuries occupied well-defined territories within which they moved regularly to seasonal sites to obtain a range of localized food sources. This mode of occupation can be illustrated from Tamaki (Auckland), where it probably goes back to the fourteenth century A.D. Each territorial group of Tamaki had a main settlement

where the main houses, including carved houses, were located. Here also were the main food stores and gardens. The local population occupied the main settlement over autumn, winter, and spring. In summer the main site was left virtually deserted, while people moved by canoe around a succession of fishing camps adjoining coastal fishing grounds. In the autumn they returned to the main site to harvest crops and to spend the winter, repeating the pattern the following year.

Significant European contact with the Maori population of New Zealand dates from 1769. Large-scale European settlement began in the 1840s. Initial effects on Maori culture were primarily economic. Iron tools were eagerly sought and stone tools gradually discarded. Adoption of the white potato as an additional garden crop in the late eighteenth century finally enabled Maori gardening to spread into colder southern and inland regions. Prior to about 1820 European contact caused little disturbance to patterns of social, economic, ritual, or political activity, though some effect on artistic effort is indicated. Expanded production of greenstone (pounamu) artifacts for disposal to traders occurred at southern sites (Skinner 1959). The output of decorative wood carving may similarly have increased in the early nineteenth century, aided by the use of iron carving tools (Groube 1967:454). In the past century, Maori culture has undergone extensive changes and linguistically is under threat. However, central institutions such as the hui (assembly) and the tangi (funeral ceremonial) have continued in strength and offer a focus for a continuation of linguistic identity.

The roots of New Zealand Maori culture are traceable first within New Zealand, where the seeding, growth, and flowering of the culture in its distinctive features occurred. Beyond New Zealand, the root stock from which indigenous New Zealand Maori culture grew was embedded in the oceanic island world of East Polynesia. Successively earlier root stocks are seen in the Early Polynesian culture of Samoa–Tonga, and in the ancestral Lapita culture. Outside this sequential linkage of ancestor to successive descendant cultures, there is no evidence for any pre-Maori element in New Zealand. The supposed pre-Maori and non-Maori Moriori of mainland New Zealand as depicted by earlier writers are simply the early Maori.

A final aspect of the more immediate East Polynesian connection remains to be considered. Was there, after the initial discovery and settlement of New Zealand from East Polynesia, a later set of East Polynesian voyagers who reached New Zealand around the fourteenth century? The view that there was a Great Fleet of canoes from an East Polynesian Hawaiki, which jointly traveled to New Zealand in 1350, is in its systematized form the work of successive European scholars (Simmons 1976:103–108). This leaves unaffected the status of authentic traditions that describe individual arrivals of various canoes in New Zealand at times which, from associated genealogies, cover several centuries up to about the fourteenth century. The question therefore becomes one of whether occasional voyages from East Polynesia to New Zealand continued until about the fourteenth century.

Archaeologists have tended to argue that the material culture of the New Zealand Maori was based on a single period of initial input from an initial set

of East Polynesian arrivals, since it was well established by 1100 and shows no detectable external influence before the late nineteenth century. An associated view is that the Hawaiki of the canoe arrival traditions is a location inside New Zealand and that the voyages represent coastal migrations inside New Zealand rather than ocean crossings (Groube 1970:157–163; Simmons 1976:315–321). The archaeological argument is not an absolute position, but a "best fit" interpretation of available information. It relies to some extent on the demolition of the concept of the Great Fleet in support of the idea that there were no later arrivals, and it may also have been partly influenced by the controversy on Polynesian voyaging and by a view that Hawaiki traditions are not useful sources of historical information (Piddington 1956).

It is not necessary to enter here into the reasons why archaeological interpretation should not disregard the testimony of Hawaiki traditions. In traditional evidence, however, distinctions have to be drawn between basic and reorganized forms of narratives, and between essential and peripheral elements. Polynesians took great care in the correct transmission of traditions, but absolutely invariant oral transmission through ever-extending centuries and branching chains of transmission was an ideal rather than an actuality. Polynesian traditions were throughout subject to some influences from the times through which they passed down from guardian to guardian (Charlot 1977). Doubts about the historical basis or interpretation of Polynesian oral tradition have tended to focus on aspects which have not been recognized as subject to such change.

In the current state of information, the possibility of voyages from East Polynesia to New Zealand continuing up to around the fourteenth century A.D. must be allowed for both archaeologically and on traditional grounds. While indications of continuation of up-to-about-fourteenth-century voyages from East Polynesia are weak archaeologically, there is no good current evidence against them. As far as is known at present, a generalized Early East Polynesian material culture could have continued up to about this level, not only in its early New Zealand form, but in East Polynesian areas from which voyages to New Zealand could be envisaged. In such a context it is difficult to say conclusively that there were no post-initial East Polynesian arrivals in New Zealand up to about the fourteenth century. As previously mentioned, there is no evidence for any post-initial external influence on Maori technology in New Zealand. This need not mean that later arrivals could not have had a social impact as founders of descent lines.

In traditional terms there appear to be no good grounds at present for suggesting that the central themes of most Hawaiki canoe traditions are to be interpreted other than straightforwardly. In some cases it could be that Hawaiki denotes a locality inside New Zealand. In others it may be possible that, on the contrary, an account of an earlier ocean crossing has been moved forward to a later time in a reorganized context. Neither of these possibilities can be regarded as established, since both need to be argued in structural and comparative terms in a more detailed way than has yet been undertaken. Meanwhile, instances of radiocarbon dated correlations for fourteenth- or fifteenth-century traditional events inside New Zealand (Moore and McFadgen 1978) indicate the need for caution in reinterpreting the central themes of Hawaiki traditions.

KA TUPU TE TOI WHAKAIRO KI AOTEAROA
Becoming Maori Art

Sidney Moko Mead

Many theories have been proposed to find an advanced civilization as a source for the apparently very sophisticated art of the Maori. Speculators have tended to avoid the more obvious solution of local development in a large country rich in resources and with an abundant supply of huge trees. Further, they have ignored the fact of New Zealand being the largest country in Polynesia, with probably the largest population as well. That this land produced an art tradition that reflects an expansive environment should really occasion no surprise at all. Yet it has continued to do so.

Strenuous efforts have been made in the past to show that our art was derived from China, that is, from a sophisticated civilization which undoubtedly influenced some of the cultures close to it (Fraser 1962). Other writers, such as S. Percy Smith (1921), looked to the Euphrates Valley or to India as a possible source for the beginnings of Maori culture. South America was not neglected as a possibility and, in fact, as Gudgeon (1885:13) indicated, had been in the minds of some scholars for a long time. Coming closer to home in the South Pacific, some have tried to argue for a Melanesian influence because it seemed to them that Maori art was rather similar to some of the art traditions in Melanesia, especially of the Trobriand Islands.

It is perhaps a commonplace to say that Maori art belongs to the larger category of Polynesian art. The latter is an embracing term that is recognized and firmly established in the literature in such books as those of Dodd (1967) and Barrow (1972). The art of the people of New Zealand is a manifestation and an example of Polynesian art. Like the art of other island groups, such as Hawaii, Easter Island, Tahiti, and the Marquesas, the art of Aotearoa (New Zealand) is derived from an ancient and common heritage. After centuries of isolation, the portion of the heritage brought to New Zealand was developed, changed, and made to fit the needs of a people pursuing other aims and responding to particular circumstances in different periods of time. Through time, the art became less and less like an older East Polynesian tradition and more and more like the style that we know now as Maori art.

While this developmental model appears to be very reasonable and logical, the Maori people did not appeal to this sort of explanation to account for the

63

presence and appearance of their art. Certain things were held to be change-less and timeless, and art seems to have been regarded in such a way. Carving was not used to show up differences in age—every ancestor is ageless—nor to mark and commemorate, except in a very general way, important moments in the history of the nation or of the tribal group. Traditionally, mythic events and value statements were more likely to be symbolized than historical events.

Moreover, people did not visualize their art as being anything else but time-less and constant. For them the Maori "look" has always been there and cannot be detached from the art. Categories such as East Polynesian, Developmental, Proto Maori, Classic Maori, and Late European Maori are scholars' attempts at differentiating one phase from another. Though it is clear that these labels describe, encapsulate, and summarize a characteristic trend, they are strange terms to Maori ears. Maori people do not readily admit that the ancestors were anything else but Maori, or that their art was at some stage not very Maori in appearance. The constancy of culture, hence of the art tradition, of mythology, and of language is defended as a necessary foundation of identity. These are the taonga tuku iho, the heritage, handed down from the ancestors. It is the analytical mind of the archaeologist or art historian that perceives great differences. To Maori thinkers, no matter how the early art looks, it is still the art of the ancestors, and hence it is Maori and not Marquesan or Tahitian.

Such an assertion rests on the Maori notion of, and attitudes toward, time. The key words are mua, meaning "front," but which also means "before," "in advance of," "formerly," and "first," and muri, which means "behind," "the rear," "the hind part," "the sequel," "the time to come," and also "the future" (Williams 1971:214). Thus the past is constantly in view of ego and the pres-ent is changing into the past as each event occurs. Logically, the known world is the past, out of which Maori art emerged. The unknown is the future, which cannot be seen. What has happened to us is history and it is this that defines our present position. From the day the ancestors first landed on the coast of Aotearoa we were Maori, and we are Maori now. It is the future that we cannot see and hence it lies behind us, not in front as the Europeans would have it.

With regard to art, the ancestors thought about whether man invented it first or whether superhumans such as the gods were the inventors. In common with other Polynesians, the Maori favored the idea of a non-human origin for the various domains of art and for the inspiration of artistic creation. A text written by Mokena Romio some time about the 1890s and published in J. F. G. Umlauff's catalogue (1902) is particularly instructive, as it provides an example of Maori thinking. This text, which describes a Ngati Porou myth of origin, was part of Umlauff's provenance date for the carved meeting house now standing in the Field Museum in Chicago. Another version of this myth was related by the Ngati Porou carver-architect Hone Taahu to James W. Stack (1875) at Christchurch when the Tokomaru Bay meeting house Hau-te-ana-nui-o-Tangaroa was being erected there. The Taahu version as reported by Stack is not as detailed and differs slightly from Mokena's account.

According to Mokena Romio, Ruatepupuke (Rua, who swells up), an ances-tor whose name is associated with the origin of wood carving, discovered Maori

art in fully developed form. The circumstances of his discovery were rather complicated and had to do with committing a hara (sin). Ruatepukenga (Rua, the highly skilled), Ruatepupuke's grandchild, was always crying for sea food and his crying exasperated his father, Manuruhi (Exhausted Bird), who decided that the best solution to his dilemma was to obtain a special fishhook that was bound to catch lots of fish. So Exhausted Bird asked his father, Ruatepupuke, to give him the right fishhook. Instead, however, his father told him to go to the beach and fetch a certain reddish-colored stone. Manuruhi did so. From it Ruatepupuke fashioned a fishlike form, in the manner of a kahawai lure, and he named it Te Whatukura-o-Tangaroa (The Prized Stone of Tangaroa).

Tangaroa was the highly sacred sea god of the Maori world. He did not like anyone taking liberties with his name, and on learning of Ruatepupuke's presumption he determined to get utu (payment) for the insult he had suffered.

Meanwhile, Ruatepupuke had cautioned his son, Manuruhi, not to go out fishing alone and to remember that the first fish caught had to be given to the gods. But many of Manuruhi's friends encouraged him to try out his new fishing lure and not to wait for his father. Eventually, he went to the sea alone and put his hook to the test. And what a magnificent lure it was. He hauled up fish after fish. With every cast there was a fish.

Tangaroa, who was still angry about the first hara (sin) committed by Ruatepupuke, now had further cause for anger—the ritual of the first fish had not been performed. He soon commanded that Manuruhi be fetched, and straightaway that unfortunate fellow found himself before the terrible sea god down in the world of fish. As punishment, Tangaroa removed from Manuruhi his human form and personality and replaced it with the shape of a bird. He then hung him on his carved house as a tekoteko, a grimacing gable figure, in the manner of the Aitanga-a-Mahaki tekoteko (cat. no. 119) and of the Tokomaru Bay house, Te Kani-a-Takirau (fig. 13). Gods had the power to do that sort of thing!

After some time Ruatepupuke realized that something was wrong: his son was nowhere to be seen. He fretted so much for him that he determined to go and find Manuruhi himself. He noted where Manuruhi's footprints ended and, choosing a spot in the sea, he dived down into the deep. Soon he came upon a village and then he spied a house. He could hear the sound of real human voices coming from the house and when he entered he discovered that the carved poupou (ancestor posts) of one wall were talking to the ancestor posts on the other. Similarly, the posts on the back wall were speaking to the posts on the front wall, that is, to the ones in the porch. Then he looked up to the gable and there he found his son Manuruhi glaring excitedly down at him.

At length one of the outside posts asked Ruatepupuke where he was going.

"I am searching for my son," said Rua.

"Well, there he is, hanging up on the house!" the poupou said.

"But why did Tangaroa do this to my child?" asked Ruatepupuke.

"It was because you named your fish lure Te Whatukura-o-Tangaroa," the poupou told him.

Then did Rua understand why his son had been captured by Tangaroa, changed into a bird form, and rendered speechless. He therefore planned a

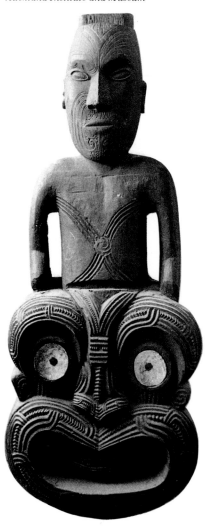

Figure 13. Tekoteko (gable figure), from the house Te Kani-a-Takirau, which was carved by Hone Ngatoto in 1860. This ancestor figure represents Paikea, legendary hero of the Ngati Porou people. Height 130 cm. (51¼ in.). Sir Walter Buller Collection, Auckland Institute and Museum (718). Photo: Auckland Institute and Museum

65

suitable revenge. With the assistance of the poupou he hid in the house and awaited the return of the villagers. (In the Taahu version the character who gives advice to Ruatepupuke is Hine-matiko-tai, and it is also she who is supposed to signal the approaching dawn.) In Mokena's story, Ruatepupuke brooded about the bad thing done to him by Tangaroa and resolved that one bad deed deserved another to pay for Manuruhi's death. He had to have utu. In due course the people returned and proceeded to amuse themselves by playing games with their woman, Hineteiwaiwa. Tiring of this sport, they went to sleep and soon they fell into a very deep sleep. One of the villagers, Tu-tupa-kaurangi, called them three times to wake up, but they continued to sleep.

Then two of the posts, Wheri and Whera, told Tu-tupa-kaurangi about Ruatepupuke's plan and warned him about what was to happen. But Ruatepupuke moved quickly. First he fetched the bird-form carving of his Manuruhi and placed him at a safe distance. Then he set fire to the house. This done, he rushed outside and stood there with his patu (hand club) and began to strike at the people who rushed out of the house, hitting some and missing others. Out came Flyingfish, Stingray, Flounder, Octopus, Leatherjacket, Snapper, and some others.

Many perished in the house. The animated carved posts became silent. Very hurriedly, Ruatepupuke grabbed four of the houseposts from the porch, the silent ones, and ran outside. Then, picking up the tekoteko of his son, he left the world of Tangaroa and journeyed home. When he reached the village, people wept over him for he had been away a long time. The carvings he brought back were eventually placed in a house called Rawheoro in Tolaga Bay, built by the celebrated artist and carver Hingangaroa. He is memorialized in Rangiuia's lament for his child Tuterangiwhaitiri in the following lines:

Me ko Manutangirua,	And it is Manutangirua,
ko Hingangaroa	and Hingangaroa
Ka tū tōna whare,	Whose house,
Te Rāwheoro, e;	Te Rawheoro, was erected;
Ka tipu te whaihanga,	Thus did architecture develop
e hika, ki Uawa.	in Tolaga Bay, o friends!

(Ngata 1930:34)

According to this myth, therefore, carving came from the sea god, Tangaroa, from a being as godly as any god could be. Ruatepupuke was a descendant of Tangaroa, a grandchild. Manuruhi was a great-grandchild in whom the sacred godly quality was somewhat attenuated. The genealogy given by Mokena Romio is: Rangi—Tangaroa—Poutu—Ruatepupuke—Manuruhi—Ruatepukenga.

Beginning from the sky parent, Rangi, the discoverer of carving (Ruatepupuke) was of the fourth generation down. By the time of Hingangaroa (fig. 14), thirty-nine names later, or forty-three from Rangi, the godly element has dissipated, and we are dealing with a real live ancestor participating in very human concerns. Hingangaroa's genealogy is given by Mokena as the following, which accords exactly with that given in Rangiuia's lament: Te Marama—Tatai-arorangi—Te

66

Huapae—Te Rangihopukia—Hine-huhuri-tai—Manutangirua—Hingangaroa.
There are thirty other names between Ruatepukenga and Hingangaroa but these
do not necessarily represent generations.

WHAKAPAPA (GENEALOGY) OF MANURUHI

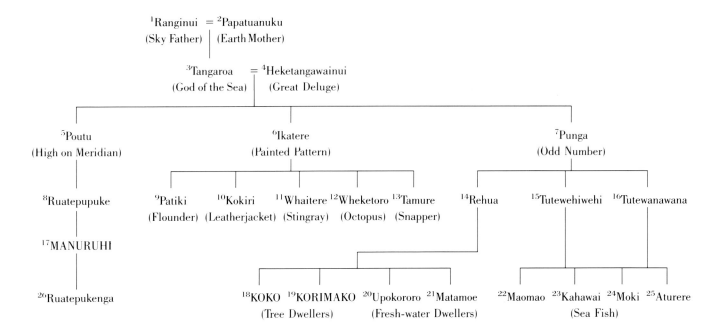

1 Ranginui (Sky Father) and 2 Papatuanuku (Earth Mother) are the primal parents.
They had seventy children, among whom was 3 Tangaroa, God of the Sea, who married 4
Heketangawainui (Great Deluge).
Tangaroa and Heketangawainui begat three children: 5 Poutu, 6 Ikatere, and 7 Punga.
The principal characters in the myth are in Poutu's line (8, 17, 26).
Ikatere's children (9, 10, 11, 12, 13) are sea creatures who rushed out of Tangaroa's burn-
ing house.
Punga's children are divided into two branches. Rehua's (18, 19, 20, 21) are bound to the land
(ki uta), 18 and 19 being tree-dwelling birds, and 20 and 21 being fresh-water fish. Tutewehiwehi
and Tutewanawana, the founding ancestors of sea fish (22, 23, 24, 25), are bound to the ocean.
Mokena did not say which fish are the children of Tutewehiwehi and which are Tutewanawana's,
hence the attribution to both.

Therefore, in the thinking of the Ngati Porou people the notion of develop-
ment is focused upon the progressive desacralizing of the art of carving. It
had been obtained by a relatively godly ancestor, Ruatepupuke, from Tangaroa,
the son of Rangi (Sky Father) and Papa (Earth Mother), and the epitome of
godliness. Then the carvings were kept safe for a period and finally taken up by
a descendant of Ruatepupuke's, many generations later, the exact number not
being important to the story. By the time of Hingangaroa, carving is considered
an activity of mortal man and is no longer the preserve of the gods.

Thus, as represented in Mokena Romio's text, carving was seen as originat-
ing in the world of the gods and not in the world of mortal man. It was devel-

oped by the god Tangaroa and kept by him in his ocean kingdom. If man was to obtain this divine gift an intermediary or culture hero had to go and fetch it. He had to face some dangers and go through a series of hara (sins) providing a take (cause) for utu (payment) which, when carried out, began another hara-utu sequence. While these activities are "happening" the storyteller is trying to "explain" other characteristics of Maori art to us.

For example, it is interesting that in the transformation of Manuruhi into a tekoteko (gable figure) for Tangaroa's house, his human appearance is removed and he is given the form of a koko or tui (parson bird), which is number 18 in the genealogy, and thus the name of Manuruhi (Exhausted Bird).

The logic for giving Manuruhi the form of the koko or parson bird (*Prosthemadera novaeseelandiae*) is provided in Mokena's genealogy but it is not easy to follow. Tangaroa's three children, Poutu, Ikatere, and Punga (numbers 5, 6, 7 in the genealogy), represent different sorts of progeny. The Poutu line is visualized as being mainly human and is thus of superior status to the rest. These are the people who are made to do largely human activities in the myth. Ikatere's children are creatures of the sea and though some of them are dangerous to humans, such as the stingray (11) and the octopus (12), they are all food. In the story, Ruatepupuke does something to each of them and this explains their present form. Punga's children are divided into two groups. On the one hand, Rehua and his descendants are confined to the land and to freshwater lakes and rivers. Two birds are specified as children of Rehua: the koko or tui (parson bird; 18) and the korimako (bellbird; 19). It is not clear why they are included except that they are beautiful, and beauty as represented by wood carving belongs to the realm of Tangaroa. Tutewanawana and Tutewehiwehi and their children, however, are confined to the ocean. As a group they are not important to the present discussion.

Tangaroa's action can probably best be explained as the replacement of high or tuakana (elder sibling) position by low taina (younger sibling) status. Manuruhi's superior and tuakana (elder) position in the genealogy as a largely human form was taken away from him. He was given instead a lowly bird form from the youngest of Tangaroa's children. The punishment is thus explained in the genealogy as a transfer and downgrading of position, which is well understood in a Maori sense as a loss of tuakana status. But as has already been said, the koko is a beautiful bird and it is a child of the sea god, Tangaroa. Thus, in terms of aesthetics the transfer might be seen as a heightening of beauty. In fact the koko together with the korimako (bellbird) are very appropriate metaphors for the art of wood carving. As tree dwellers, these birds provide an important intellectual link between the realm of Tangaroa, the sea god, and the domain of Tane, God of Forests, who provides the timber for wood carving, such as totara (*Podocarpus totara*), kauri (*Agathis australis*), and pukatea (*Laurelia novaezealandiae*).

The text also describes the result of Tangaroa's revenge on Manuruhi. When Ruatepupuke looked up toward his son he saw a created form, a portrait, whose eyes glared excitedly down at him. The portrait could not speak to Ruatepupuke, but it was possible for Ruatepupuke, the observer, to receive a message and interpret it correctly. In this case he recognized that the tekoteko was his son even

Figure 14. Poupou (side post), carved in 1982 by Takirirangi Smith for Te Herenga Waka house at Victoria University of Wellington marae. The ancestor Hingangaroa is depicted above; below him is his wife, Iranui, and across his breast are his sons Taua, Hauiti, and Mahaki.

though the human appearance had been removed. His interpretation was confirmed by the carved houseposts which talked to him.

It is interesting, too, that the ancestors on the walls of the house were made to talk to one another like real people. Tangaroa as divine creator had produced the ultimate in realism—the talking poupou, which was a sort of animated post in which the form carved on it was capable of movement and the mouth was able to speak the language of mortals.

Tangaroa thus provides an ideal for human carvers to emulate—the suggestion of movement in the figures, and the suggestion of speech or of talk. The fact that human carvers could not make their poupou really talk was "explained" in the myth as being the result of Ruatepupuke's fire. Nonetheless, good creators could make their poupou "talk" in a different way, in a silent language that could be understood by those observant people who understood the artistic code of communication. It could be said that the moment in the myth when Ruatepupuke looked up and saw his son Manuruhi trying desperately to speak to him is remembered in all carvings that show an open mouth "struggling to speak."

The myth provides one way of explaining not only how Maori art came to be a part of the cultural heritage of Aotearoa, but also goes some way toward describing some of its characteristics. It is worth dwelling on the fact that the myth reveals insights about the nature of Maori art that we would not get from an archaeological perspective. Furthermore, as an explanation of origin it is satisfactory in its own right. This particular version of the myth comes from the Tokomaru Bay–Tolaga Bay end of Ngati Porou's territory. It is not a composite of many different tribal versions but is really one of several versions from the traditions of Ngati Porou.

A Tuhoe version of this myth was recorded by Best (1977:775-776). In it Ruatepupuke is again the mediator and the person who obtained the art of wood carving, but here he receives it not from Tangaroa, but from the Hakuturi, a tribe of forest fairies (Best 1977:1000). The sea god's house is ornamented as in the Ngati Porou version, but this time all the decorations are painted and not carved. It was not until Tangaroa visited Ruatepupuke's house that he was able to view such excellence in wood carving and be deceived by the poupou and tekoteko. Thus, in this version man displays his skills to the god, Tangaroa, who by comparison is shown to be inept. This is a reversal of the order assumed in the Mokena Romio text.

Tangaroa's people are destroyed as before, but the reason (take) is because he stole Ruatepupuke's pet bird—no doubt the analogue of Manuruhi. Only the flyingfish escapes when the sea god's children are exposed not to fire, but to sunlight, which is often the destroyer of non-human forms such as fairies.

Thus, while the stories appear on the surface to be rather different, they are, in fact, very similar in basic structure. The two versions serve to provide a Maori view of the origin of painted art and wood carving.

These myths do not confirm or negate the developmental model of the archaeologists. Rather, they provide a different explanation of how things came to be the way they are at present. Maori thinkers appear to have asked three main questions. Where did the art come from? How did man acquire the knowledge (matauranga)? Why was mortal man (ira tangata) able to acquire

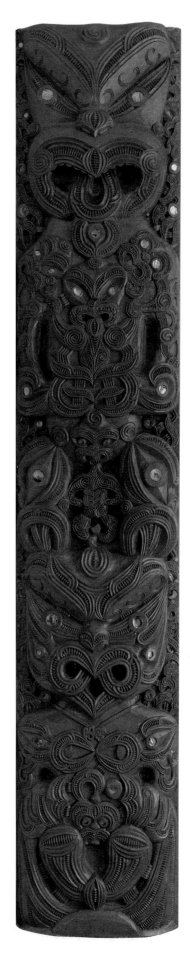

the knowledge (matauranga) from the gods (ira atua)? These questions are answered at the level of mythic knowledge and in terms of the norms of the society.

Archaeologists may ask similar sorts of questions, but in place of the "why" question they are more likely to place great emphasis on "what" Maori art is. As already indicated, a great deal of attention is given to the first question. Where did the art come from? But in answering it we must link this item to the broad questions of where the ancestors of the Maori people came from. This has already been described by Agnes Sullivan in her essay and consequently needs no further elaboration. That the foundations of Maori art are East Polynesian seems not to be in doubt. This base was introduced into the country by the first settlers on this land. A new environment provided new materials which, in turn, necessitated the development of new techniques and skills. There followed eight centuries of tinkering, experimenting, and inventing new forms by generations of artists and by hundreds of creative minds. What they created became what we now see represented in this exhibition.

It is a mistake to imagine, as several learned men have done, that traditional Maori art was exactly the same as the original forms brought to New Zealand by the first settlers. Nor is it correct to assume that because a Maori motif looks somewhat similar to a motif of another culture of another time, that some human agent from the donor country must have made a special trip to introduce it to New Zealand. That sort of mobility of man seems to be more characteristic of the jet age than of earlier times. It is much more reasonable to attribute such similarities to chance and to the nature of human creativity and ingenuity. Man is inventive and responsive to differing social, environmental, and political influences. The Maori artist is no less a creator and innovator than that of any other culture. However, that is not the only explanation. It should also be recognized that art systems the world over share certain limitations in artistic compositions that relate eventually to the nature of human thinking. Artists everywhere often use similar structures (such as compositional devices) to express their feelings and ideas.

The image I present is of Maori art being somewhat like Hingangaroa's house, in which a small part came as a taonga from the early ancestors while everything else was locally produced. The tahuhu, or ridgepole, can represent the East Polynesian base and provides a continuity with our history and distant origins. But the body of the house, the walls, roof, door, and window represent the contribution of generations of artists who helped to give shape to what we know today as Maori art. It is their collective achievement which has given us an art heritage.

The image of the house is used purposely to illustrate some of the forces that influence the work of the artists. The carved meeting house of the Maori is a complex structure which probably did not reach its peak of development until about the 1840s when the famous house Te Hau-ki-Turanga was built. Part of its complexity has to do with the integration of several domains of art—painting (kowhaiwhai), latticework (tukutuku), wood carving (whakairo rakau), and architecture (te whaihanga)—in combination with genealogies, ancestor worship, mythology, and various customs that are associated with the building. A struc-

ture such as this requires a long period of progressive experimentation in order to resolve not only the artistic and technical problems, but also the social, political, and ritual imperatives that must be considered in the manner in which the house is used.

The Cook expeditions made a drawing of a carved poupou and it seems similar to poupou of more recent times. This first report of such a carved slab indicates that the architectural model of the meeting house was already present in the late 1700s. However its clear identification as a communal meeting house rather than a chief's house did not come until after some very drastic and revolutionary changes had altered the settlement pattern, the religion, and the technology of the Maori. Some of these forces of change required more people to live in larger villages. This in turn led to the development of large structures to accommodate the crowds that gathered together to hear the messages of Christianity. Out of the new set of needs came the large decorated meeting house that subsequently became a necessary part of any village.

A similar argument can be put in the case of the spectacular war canoe that Sydney Parkinson illustrated during Captain Cook's First Voyage. The decorated canoe with its prow leaning in toward the wind and its high stern trailing streamers of feathers would have taken a long period of time to develop to the stage seen by Captain Cook in 1769, or even to the earlier versions seen by Abel Tasman in 1642. The decorated storehouse, another spectacular architectural structure, provides another example of a highly valued building that must have taken years to develop.

As we have seen actually happen in New Zealand, some wonderful constructions, such as the war canoe, the storehouse, and the decorated monument to the dead, which took centuries to develop, became redundant within a remarkably short period and were set aside. These great works of art have vanished from active use and must be seen now either in museums, where they have been preserved for posterity, or in special display areas, as in the grounds of the Institute of Maori Art in Rotorua. It is always sad to see important developments in the arts being arrested and later abandoned, but the archaeological record bears witness to this being a common and expected occurrence in human history.

As Agnes Sullivan has indicated, it is possible to reach far back in time, to about 1000 B.C. or beyond, for the beginnings of Maori art. One can look to the canoes, or to the adzes, or even to the tattoo implements as the source of our canoes, our adzes, our tattoos. But this idea of a continuity from say 1600 B.C. in Fiji to 500 B.C. in Tonga and from thence to the present is really difficult to grasp because so much can happen to prevent the transmission of the heritage. One important example is the case of pottery. Why was pottery not brought to New Zealand?

It is possible to argue that the mythic and archaeological explanations are equally difficult to understand, or that both are satisfactory. One can be taken through a sequence of developments from Lapita to Early East Polynesian and then to Maori and find it all fantastic and incredible. For example, in her chapter Agnes Sullivan has drawn our attention to certain taonga in New Zealand, such as fishing lures, "harpoon heads," and necklaces, being very close in-

deed to similar forms in the Marquesas, and other objects being almost identical with those from early Tahiti. From these and other lines of evidence archaeologists postulate hypotheses, that, for example, the source of early Maori art is Tahiti, since Maori is very close to the Tahitian language, or the Marquesas, because of resemblances in the archaeological record in addition to some linguistic resemblances with the South Island.

From this point onward there are real difficulties in explaining how and why our ancestors came from several points in East Polynesia and how one tells whether this is plausible or not. In Mokena's account, Ruatepupuke went to sea, to Tangaroa, and through various means obtained the art of carving and brought it back to the land of Aotearoa. The archaeologist, who cannot use Ruatepupuke as a way of constructing an interesting theory, must try to trace the movement of people over great expanses of water and through great spans of time. The missing links in the sequence often command more attention than substantial matters, such as how the Early East Polynesian art heritage changed through time and became Maori art.

We know a little about the beginning of the sequence in New Zealand and a lot about traditional Maori art of the eighteenth and nineteenth centuries. In between is a period of 800 years during which many changes must have occurred. This could be described as the wahi ngaro (the lost portion). What happened during the wahi ngaro period? What happened to the people, and what did they do to the art? We do not really know what transpired; we can only guess and suggest some plausible theories. There is, however, some suggestive evidence, such as the Kauri Point combs (cat. nos. 73–78) already mentioned by Agnes Sullivan, which shows a development from an earlier rectangular form to a later curved form that was seen by Captain Cook (cat. no. 159). But even here the sequence does not span a period of 800 years and does not reveal a complete line of development.

One may look to "long-range continuities" as described in Mead (1975), such as the circumstantial evidence for tattooing, the use of tapa cloth, shark-tooth necklaces, whale-tooth ornaments, and so on. These objects provide a little light to illumine the wahi ngaro, but they rarely ever light up the areas behind or in front of them so that developmental sequences can be reconstructed.

In the end we must emulate the storytellers of old, for what they did was to provide a way of explaining complex phenomena in a manner which the listeners could understand. My task is similar. I propose, therefore, to use the image of growth as a way of organizing the many clues, isolated facts, speculations, and data relevant to the development of Maori art. That the scheme proposed is based on archaeology is acknowledged without need of apology. What is gained is that the labels used are more intelligible to the Maori people themselves and help to bring the description of their art closer to them. The periods proposed are relatively simple and deal in 300-year lots. A century within a period can be specified as C1, C2, or C3, C1 referring to the first century within the style period, C2 to the second, and so on. Based on analogy with developments in the arts elsewhere one can argue in terms of large units of time being required for really noticeable changes to take hold in art. The unit of 300 years may not be the correct choice, but it is observable that within the present period (Te

Huringa) Maori art has not really changed significantly in the 180 years that have elapsed. Such changes as have occurred appear to be revolutionary and many, but despite them, the base against which judgments are made about artistic performance today is still that of the Classic, or Puawaitanga, period. Contemporary artists continue to reach into the Puawaitanga period for their inspiration, their models and motifs. We have to wait a longer time to see what eventually happens to the art system that was functioning when Captain Cook first visited Aotearoa in 1769. Artists are still working, reworking, and rediscovering the same basic style of art that prevailed earlier. Thus the following chronology is proposed as a relatively simple way of ordering the facts of stylistic change, while the labels used are based on the image of growth.

1. *Nga Kakano—The Seeds*. 900–1200

This metaphor is well understood in the Maori world and refers to the idea of "seeds sown from Rangiatea," which many understand to be a place overseas, perhaps in the Society Islands group. In this case Nga Kakano represents the original artistic traits that were introduced into this land during the first settlement. Included in the "package" were tattooing, canoe-building, various adzes, fishhooks, the technology of tapa making, netting, and basketry, and the patu. The "seeds" were brought to the land and allowed to develop (cat. no. 4). Even though the new environment would have demanded some immediate changes in material, one would expect that the art styles of the Kakano Phase would follow pretty much an East Polynesian pattern. Hence, in shape and in general composition the art of the Kakano style period resembles examples found in the homelands of the sort already described by Agnes Sullivan.

2. *Te Tipunga—The Growth*. 1200–1500

In the Tipunga (Growth) style period the art styles are becoming more localized and, because of isolation from the rest of Polynesia, increasingly different from, for example, the tattooing of the Marquesas, Hawaii, or Tahiti. The same package of artistic traits is carried along, but many new ones are introduced and no doubt new rituals discovered because of the demands of the environment. This style period includes part of the Developmental Phase and part of the Experimental Phase which have been proposed by Green (1963).

The prime object of this period is the Kaitaia lintel (fig. 15), which shows the curvilinear trend to be latent and not developed. But clearly established is the composition, which can be described as ABA. Here B stands for a central frontal figure or tiki, which was sometimes represented only by a head, and A represents a manaia-type figure, which is a full profile figure or may be only the head. This type of composition is an important one in the next style period. An important decorative motif which is relatively common in the Tipunga style period but which continues into the next is the V-shaped notch, which is either cut or filed along the edges of bone, ivory, or stone objects, or is pyramid-shaped, as occurs in early pendants. These details occur in small objects such as chevroned amulets, stone reel necklaces, whale-tooth amulets (Skinner 1974), argillite pendants, and minnow shanks (Duff 1977).

On the evidence of small objects such as fishhooks, lures, and amulets generally, as well as of rock art, it is possible that artists of the Tipunga period

Figure 15. The Kaitaia lintel, found in a swamp at Ahipara. Width 2.26 m. (7 ft. 5 in.). A prime example of art of Te Tipunga period (1200–1500). Auckland Institute and Museum (6341). Photo: Auckland Institute and Museum

made use of motifs derived from nature much more extensively than was done later. Fish and bird forms were the most favored motifs. This observation, however, requires the support of more research on materials reliably dated to the Tipunga style period. Nor can we assume that all objects that feature notches and chevrons must necessarily belong to the Tipunga period.

3. Te Puawaitanga—The Flowering. 1500–1800

This style period corresponds roughly to the Classic Maori. During this time an idea that began to be developed in the Tipunga style period (namely the shift toward a more cursive approach) reached its high point in development. But in the work done during the first century (Puawaitanga C1), features such as notching and chevrons continued for a time, before finally giving way to the full blossoming of the distinctive highly curvilinear aspect of Maori art. Many of the objects selected for the exhibition belong to this period and exemplify the classic or "flowering" stage. By this time little is left of the old Tipunga style, which concentrated on straight lines and geometric arrangements. Tattooing broke free of the geometric sort of patterns that were more typical of basketry, plaiting, and weaving (fig. 16). In wood carving a new freedom was apparent. Constructions became expansive, decorative carving more competent (fig. 17), compositions more daring, war canoes much grander, and the chief in full costume more of an awesome spectacle because of the art's greater concentration on his presentation as a social man than ever before.

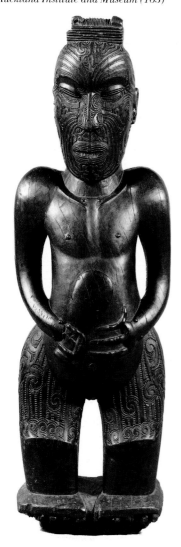

Figure 16. Poutokomanawa (center post figure), from Tikapa, Ngati Porou territory. Te Huringa period C1 (19th century). A superb image of the great Ngati Porou carver Iwirakau, which shows the form of tattoo on the face, thighs, and buttocks that was popular in the Puawaitanga period (1500–1800). Auckland Institute and Museum (163)

In smaller items such as combs, and as exemplified in Shawcross's study (1964), a more rounded comb design, Type A (cat. no. 78), becomes fashionable and dominant during the Puawaitanga period, especially in C3 (the third century). What had been more popular before was a Type B comb (cat. nos. 73, 74) in which the outline was rectangular. It is inferred from the data that Type B was popular during the Tipunga style period. Certainly developments in the combs of Kauri Point provide us with some of the best evidence for the shift away from a more geometric and rectangular mode of art (Tipunga style) to the curvilinear style so well known now and associated with the Puawaitanga or Classic Maori style.

Birds and fish forms continue to feature in the art but are no longer as popular as before. They are replaced by lizards in house, pataka (storehouse), and mortuary carvings, and by dogs in amulets and bowls.

4. Te Huringa—The Turning. 1800–present

This is the present style period, during which some remarkable things happened.

Some regional styles collapsed and seemingly died. The Treaty of Waitangi was signed in 1840 and from that moment the Maori grip on the sovereignty of their land began slipping away. The first one hundred years of this style period (Te Huringa C1) represent for the Maori a time of tremendous upheavals, revolutions, and bitter land wars during which the very survival of the culture was put at risk. While at first the new technology fascinated the Maori people and the idea of having visitors from another world presented all sorts of wonderful and exciting ideas, it all soon turned sour. By the 1860s some fierce battles were being fought over the sovereignty of the land. The Maori people lost those battles, and during the heat of the wars and in the years following a large quantity of art objects was looted, sold, or gifted to colonels, captains, governors, land agents, and sundry officers who worked among the Maori (cat. no. 87). The objects eventually found their way into other hands, of sirs, lords, ladies, counts, and earls, and into the museums of the world. Other very valuable objects were destroyed during the land wars or abandoned following the conversion to Christianity and the subsequent loss of the land (cat. no. 64).

When the smoke cleared away and the pain of contact with a dominant Pakeha group had to be accepted the people turned again to reconstruction and to art. Some impressive meeting houses were built toward the end of the nineteenth century and many of them have survived. Thus the image of Tangaroa's house that Ruatepupuke set out to destroy by fire becomes useful. To update the myth, we have to imagine the Pakeha missionaries and settlers playing the role of Ruatepupuke. As in mythical times, so in the nineteenth century, some of the art survived—enough to maintain the continuity with the past. The art of the Huringa period is the kind of Maori art that is well known to collectors, museums, ethnologists, and students around the world. As indicated by the objects in this exhibition, it is characterized by increased size and complex elaboration of surface decoration that is extended to a wider range of artifacts.

As we near the end of the twentieth century tremendous changes are still occurring, and Maori culture is still engaged in a life-and-death struggle to survive as a distinctive, viable, and living culture. Nonetheless, many abandoned styles have been revived, and there is evidence aplenty of rearguard actions to try and save the indigenous culture of the Maori from being overwhelmed and made redundant in today's economic recession. New forms of art, borrowed from the traditions of the West, have been introduced into the Maori world. Maori artists trained in the art schools of the Pakeha are spearheading a movement to change the face of Maori art more radically than ever before. One does not know whether they innovate with love and understanding, or whether they are about to ignite new fires of destruction.

Meeting houses are still being built, and this time in urban areas where the bulk of the Maori people now live. Therefore Maori art is still being produced. To the remaining poupou left over from the fires of the Europeans are added some new techniques, new mediums, new technology, and a host of new philosophies. What is left of the legacy is ready to be handed on to new generations of artists among whom will be some of the caliber of Hingangaroa. They will build new houses in which Maori art will flourish.

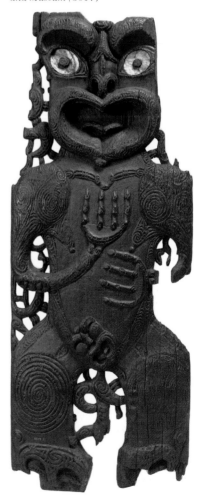

Figure 17. Poupou (side post), found in a stream at Whangara. The carving is believed to have been a part of Hine Matioro's house which stood originally at Porewa Island. Height 112 cm. (44 in.). Auckland Institute and Museum (5017)

NGA TAONGA O NGA WAKA
Tribal Art Styles

David R. Simmons

The art of the Maori has its roots in Polynesia, but the trunk and branches of the tree are in Aotearoa. Aotearoa (New Zealand) is a large land mass some thousand miles long and up to two hundred and fifty miles wide. It consists of two main islands lying within the temperate zone from 34° to 48° south latitude. Some of the small offshore islands are larger than some of the inhabited islands in tropical Polynesia.

Maori art reflects the environment of land, forest, and mountain. The shape of the hills of Papatuanuku, the Earth Mother, are there in the flowing lines; the children of Tane, the trees and ferns, are there as curling fronds in the spirals and patterns. The freedom to work large pieces of wood is given by the trees of Aotearoa.

Maori art is an expression of the unity of all things in the world. In the beginning there was Te Kore (nothingness); out of this came Ranginui (the sky) and Papatuanuku (the earth). Their children, the gods, lived between them until they craved light and separated their parents. Tane became god of forests; Tangaroa, god of the sea; Tawhirimatea, god of winds; Tumatauenga, god of war and men. The gods made man. According to some tribes, Tane made man; in other tribes, Tiki did the deed.

One of the godly heroes, Tawhaki, climbed into the heavens to get the three baskets of knowledge; another, Maui, fished up the North Island of New Zealand, which is Te Ika a Maui (Maui's fish), and left his canoe as Te Waipounamu, the South Island. Then came the ancestors to settle the land and duly give thanks to Rangi and Papa, the gods and their ancestors, never forgetting that these islands are the koha (gift) given to them which they in return must treat with respect.

The first settlers in New Zealand found a land that was much colder than their tropical home, yet was rich in bird life. The sea produced fish and sea mammals, some of which were familiar, such as dolphins and whales, and others that were new, such as seals and their relatives. The initial response was to use the bounty of Papatuanuku, the Earth Mother, and her children, Tane of the forests and Tangaroa of the sea, and to live as sea people forever circumnavigating a rich and bountiful coast. Yet all things must change; popu-

lation increased and the round of natural succession was complicated by an ecology that now for the first time included a large land animal, man. A choice was made to control rather than exploit the environment. The introduced kumara (sweet potato) became one of the main food sources. Agricultural villages based on stored kumara led to competition for land, and then to warfare and migration to take over new territories. Thus were the Maori tribes born.

These tribes were sea people. Fittingly, a tribe or federation of tribes with a common origin often refer to themselves as a waka (canoe), meaning their origin canoe, their land and their people. When tribes visit, the visitors are symbolically pulled onto the marae with the shout

Toia mai! te waka! Haul up! the canoe!
Toia mai! te waka! Haul up! the canoe!

The tribal origin canoe is also the source of mana, land ownership, and the focal point of genealogies, because all members of the tribe are regarded as descendants from the crew. The commanders were said to be direct descendants of the gods and from them are descended the chiefs of the tribes. Some tribes have no origin canoe, yet are still thought of as waka by other tribes even though they only refer to themselves as iwi (bones).

Maori tribal art forms are those that were developed within the waka or iwi. A waka such as Tainui traditionally regarded itself as different from and as competing with another waka, such as Te Arawa or Mataatua. Culture contact with a dominant Pakeha (European) culture has not dimmed the spirit of tribal rivalry even today. It would be unusual to find many gifted sculptors within each such unit as a waka or grouping of iwi, because such men are rare in any society (Kubler 1962). But it is more than likely that it was just such gifted artists who created the distinctive art forms of the various tribes. Less gifted but technically skilled wood-carvers have followed, and so the tribal art styles have developed.

Except by gift or war, such styles tended to remain in the home waka as symbols of tribal mana. This was reinforced by the complementary force of tapu (taboo) whereby the tribal ancestors protected the mauri (life force) of the tribe and punished those who sought to destroy it. One way of circumventing this problem was to capture carvers of other tribes and force them to create new items for their conquerors. An example of this is provided by the pataka (storehouse) of the Bay of Plenty. The earliest known example, made with stone tools at about 1780, is the Te Kaha storehouse of Te Whanau-a-Apanui, now in the Auckland Museum. Surface decoration sequences suggest that the form then spread from the East Cape into the Ngati Porou area of the East Coast as a stone-tool style and westward into the Bay of Plenty where it took on characteristics of the Arawa tribal style of carving, mainly as a metal-tool style. The spread into the Arawa areas was peaceable, probably by trade and gift. In the 1820s, Hongi Hika, a Ngapuhi from Northland, raided the area. He had obtained muskets and was out to avenge ancient defeats. He saw the Bay of Plenty pataka, captured some of the carvers, and took them back to the

Bay of Islands. Eight years later, in 1828, a European, Augustus Earle, drew storehouses standing in Ngapuhi villages in the Bay of Islands that were in the Arawa–Bay of Plenty style (Earle 1832).

This incident also illustrates the importance of prestige objects. In the eighteenth century the main focus of tribal mana (prestige) was the carved war canoe. After the arrival of missionaries and the lessening of the intertribal musket wars, the carved pataka was the prestige object in the Bay of Plenty, East Coast, Bay of Islands, and Hauraki, with a different style of storehouse fulfilling the same role in Taranaki, Wanganui (Whanganui), and Horowhenua (Ngati Kahungunu). Such forms, it appears, did not reach the South Island. By about 1820 the chief's dwelling house became larger and more permanent, as villages were lived in for longer periods. This was the result of the introduction of the white potato. By 1840, however, the chief's house was often smaller than the rush churches built for missionaries. The tribal assembly house probably developed out of the enlarged chief's house, the temporary guest house erected for visitors, and the early churches. The meeting or assembly house replaced the storehouse as the prestige object and as the focus of tribal pride. Today it remains the tribal center.

THE TRIBAL ART STYLES

Distinctive tribal art styles may have developed out of the transitional pieces already present in the sixteenth century—the Waitore bow cover in Taranaki (cat. no. 136), the Kauri Point combs (cat. nos. 73–78), or the Awanui carvings (cat. no. 6). But the dated pieces are too few and too scattered to be used definitively in this way. All we can say with certainty is that by the sixteenth century Maori art was clearly recognizable. Perhaps by the seventeenth century, and certainly by the eighteenth, the tribal art styles were easily distinguishable. The main records for the eighteenth century are those made by the European navigators Captain James Cook, Jean-François de Surville, and Marion du Fresne, supplemented by the artifacts they collected and the wooden pieces worked with stone tools which have been found in swamps. In some cases we can give traditional dates to certain pieces. However, as a consequence of European contact and settlement in the early and mid-nineteenth century, immense changes occurred in Maori life and culture. Thus the distribution and character of post-European tribal art is quite different from the pre-European art styles.

A broad and general division of Maori art styles can be made using fairly simple criteria. These link together pieces carved by individual artists within a shared tribal tradition. They also serve to differentiate articles carved by artists of one tradition whose pieces, for various reasons, are found in another tribal area. That the artists themselves could recognize work in this way is evident from such items as the war canoe prow in the Taranaki Museum, which was carved as a gift by Ngati Tuara, an Arawa sub-tribe, for Te Rauparaha of Ngati Toa. Ngati Tuara have Ngati Raukawa connections, and Te Rauparaha's mother was from Ngati Raukawa. At the time of the gift he had for political reasons taken over the paramount chieftainship of Ngati Raukawa, in name at least.

Ngati Tuara's gift to Te Rauparaha is carved in the Ngati Raukawa style, except for a manaia (profile figure) head on the base which is carved in Arawa style. This latter identifies the tribe of the carvers by the form and surface decoration which is foreign to the Ngati Raukawa.

The criteria used to identify the tribal styles are too numerous to detail. Briefly they are:

the shape of the body, whether serpentine or square in outline
the way the arms and legs are attached
the shape of the hands and feet
the shape of the head
the shape of the eyes
the type of nose used
figures as two-dimensional or three-dimensional in concept
the use of naturalistic mask
the type of manaia figure
the use of marakihau (marine creature) figures
the type of surface decoration employed
the organization of the carving

Following these criteria, two major forms of Maori tribal carving emerge. These are the serpentine body styles based on an S curve, usually a narrow tube, found in Hokianga, Hauraki, East Cape, and Taranaki. The other major division can be described as based on square-on body figures of rectangular shape, found in the Bay of Islands, Thames, East Coast, Rotorua, Waikato, Wanganui, Horowhenua, and the South Island. These are very broad divisions, each covering many tribal art forms. Combinations of the two major styles can occur. The East Coast area, for example, employs a square-on style, though some of the minor figures are serpentine. A further point is that certain features cross the boundaries and are found in both areas. In Northland, examples of what may be called pure Bay of Islands carving and pure Hokianga pieces are matched by pieces that have characteristics from both areas. It is, in fact, much easier to refer to a Northland style than to offer a clear differentiation into local styles or variations.

Sir Apirana Ngata, writing in 1936 but published in 1958, and following Gilbert Archey, refers to these two main style divisions as the northwestern (or serpentine) and the eastern (or square). His explanation of the shared features was that of time, the northwestern style being ancestral to the eastern style. He suggested that the traditional migrations of the descendants of Awanuiorangi from the north to the Bay of Plenty and Taranaki could be responsible for the differences, but that it was likely that a common center had developed between Whakatane (Ngati Awa) and the East Coast with diffusion north and south. The northern style ended with the arrival of Europeans in the early nineteenth century, while the East Coast with its more gifted artists seized the opportunity to expand their art with steel tools (Ngata 1958, no. 22:31).

The division into serpentine and square—Ngata's northwestern and eastern—is a result of observation, but is supported by the minor dialectical differences found in spoken Maori, which also follows this division. Ngata was also

correct in characterizing the serpentine styles as older than most of the square styles. Stone-tooled items are, with very few exceptions, the only examples we have of the serpentine styles; they are rarely made with metal tools. There are very few examples of the square styles made with stone tools but an absolute wealth of metal-tool examples, so there is a time relationship between the two major style divisions.

The Ngapuhi tradition of the Ngati Awa in the north refers to two major movements out of the area, by land to Taranaki and by sea to Tauranga and Hawke Bay. An important Tauranga ancestor, Kauriwhenua, is associated with Mangonui Harbour in Doubtless Bay, as are Tamatea and Kahungunu of Hawke Bay. Nukutaurua, the name of the first village established by Kahungunu on Mahia Peninsula, is also the name of the reef at the entrance of Mangonui Harbour. The proverb associated with both places is

He rangai maomao ka taka ki tua o Nukutaurua e kore a muri e hokia.
When a shoal of maomao fish passes Nukutaurua, it will not return to where it began.

Kauriwhenua is believed to have said it at Mangonui, and Kahungunu at Mahia. The maomao is a fish common at Mangonui and uncommon in Hawke Bay. As Ngata remarks (1958, no. 22:30) "The Kahungunu who established himself in the Gisborne-Mahia area at one time lived near Tauranga." The brother of Kahungunu was Ranginui. Ngati Ranginui live on the north side of Tauranga Harbour. Only one early northern style bone box in the Auckland Museum provides evidence for the early carving style of the area. The Ngati Awa traditions of the tribal movement from the north to Taranaki and the Bay of Plenty follow the same lines as the serpentine styles.

The serpentine style is associated with Ngati Awa in the Hokianga area and some other parts of Northland. It is the style of the Hokianga Ngapuhi, the Ngati Wai on the east coast of Northland, Te Roroa of Waimamaku in Hokianga and their relatives to the south, Ngati Whatua of Kaipara. It is the style of Hauraki. There is a saying among Ngati Whatua and Ngati Maru of Hauraki that Ngati Whatua are tangata whenua (locals) on Ngati Maru marae and that Ngati Maru are tangata whenua on Ngati Whatua marae. The connections may be common Arawa ancestry through Ihenga and Taramainuku who lived in Hauraki and Kaipara. A gap which remains is the connection between the early serpentine carving, which may have been carved by the Awa peoples who settled at Whakatane, and a square style developed by the later Ngati Awa in the nineteenth century. The earlier style may be the one that we are calling Te Whanau-a-Apanui of East Cape, which may have been more widespread than the evidence at present suggests. The collection made by Captain Cook on the First Voyage includes paddles decorated in East Cape style from Gisborne. On the Second and Third Voyages similar paddles were collected at Queen Charlotte Sound, perhaps having arrived there by trade.

The serpentine style is found at East Cape, particularly in the early pataka carvings from Te Whanau-a-Apanui. The relationship is more directly through Hauraki, a link found in genealogies. It was recognized by Te Whanau-a-Apanui, once the custodians of Marutuahu, the mauri (life force) of the Ngati

Plate 19. Pendant. Rei niho (cat. no. 4)

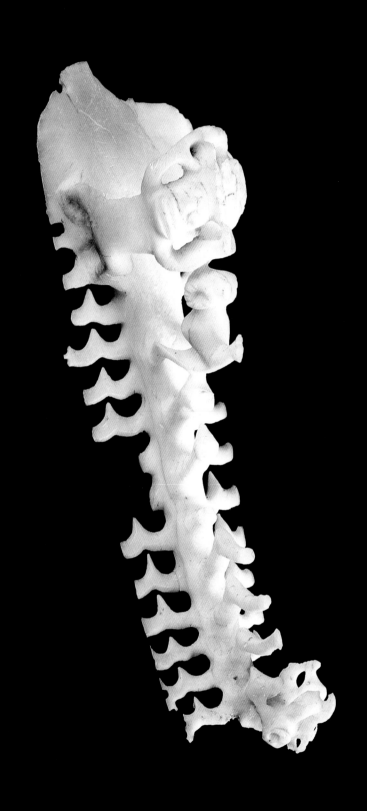

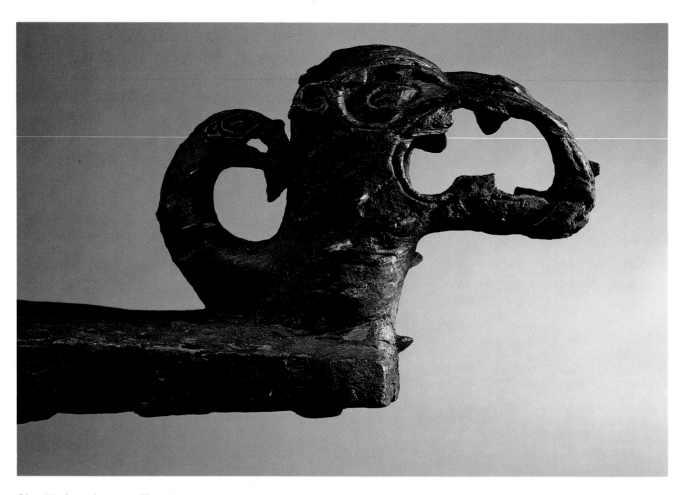

*Plate 20. Canoe bow cover. Haumi
(cat. no. 6)*

*Plate 21. Whale tooth pendant. Rei niho
(cat. no. 16)*

Plate 22. Amulet. Rei niho (cat. no. 19)

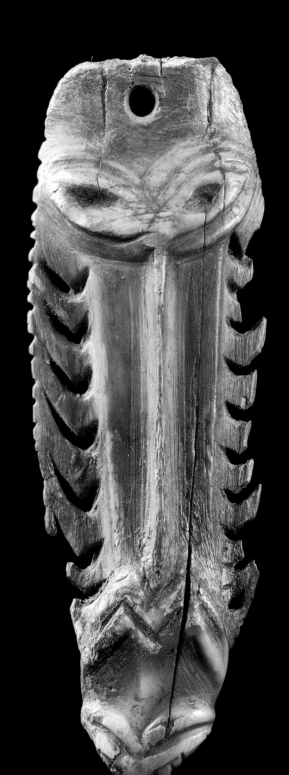

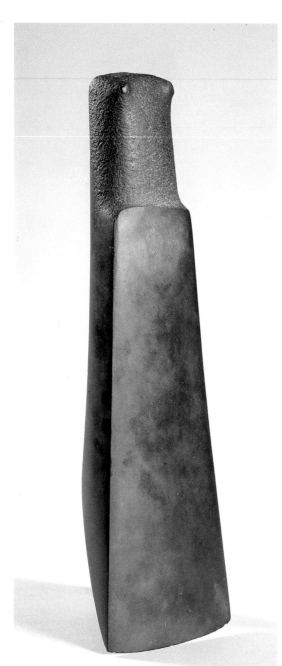

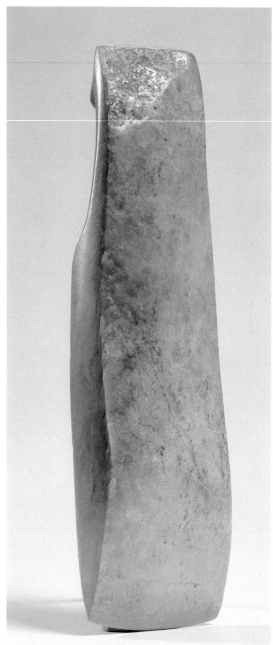

Plate 23. Adz. Toki (cat. no. 18)

Plate 24. Adz. Toki pounamu (cat. no. 25)

Plate 25. Pendant, chevron type. Rei niho
(cat. no. 27)

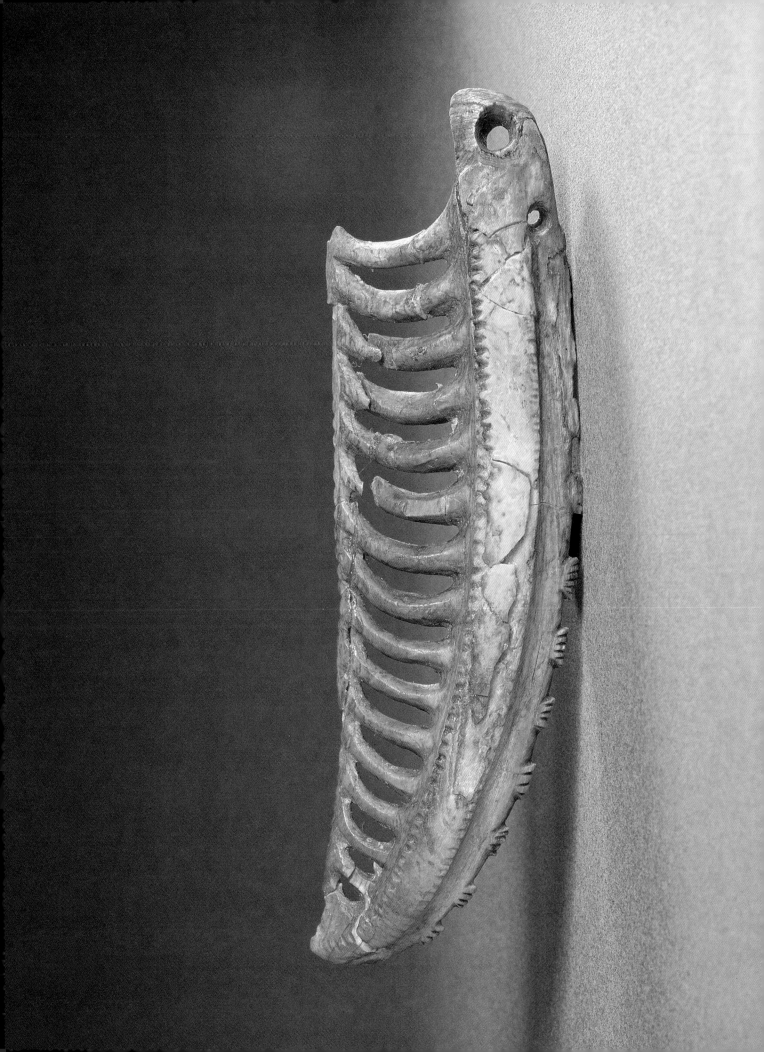

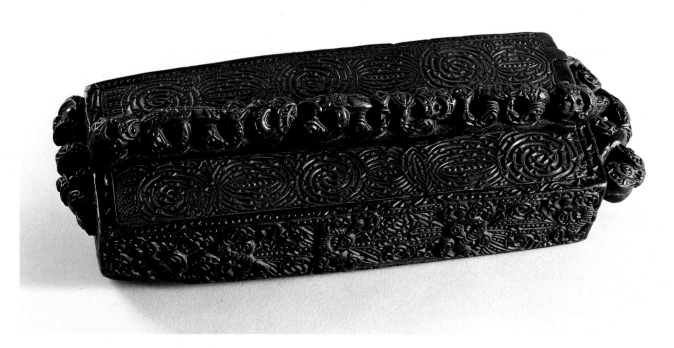

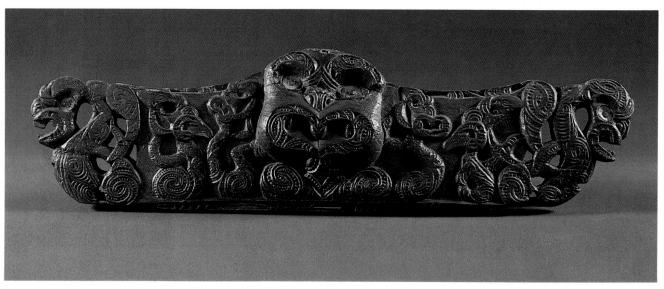

Plate 26. Feather box. Wakahuia
(cat. no. 29)

Plate 27. Threshold for storehouse. Paepae
(cat. no. 30)

Plate 28. Amulet. Hei-tiki (cat. no. 31)

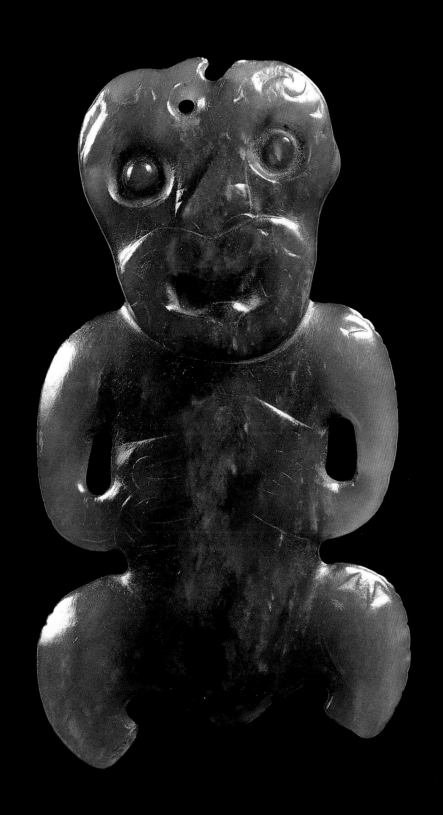

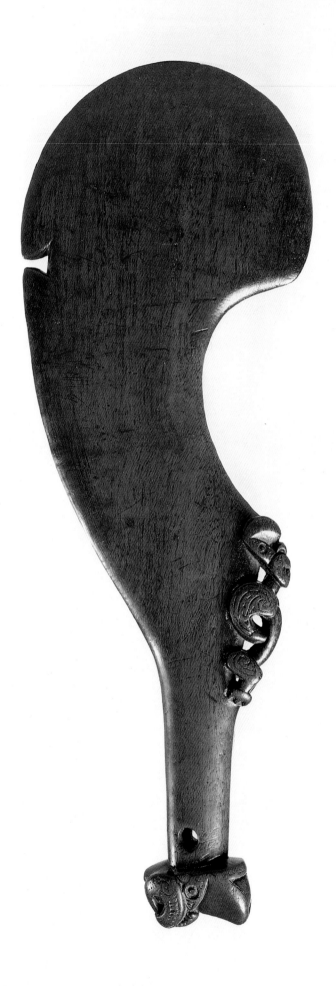

Plate 29. Club. Wahaika
(cat. no. 45)

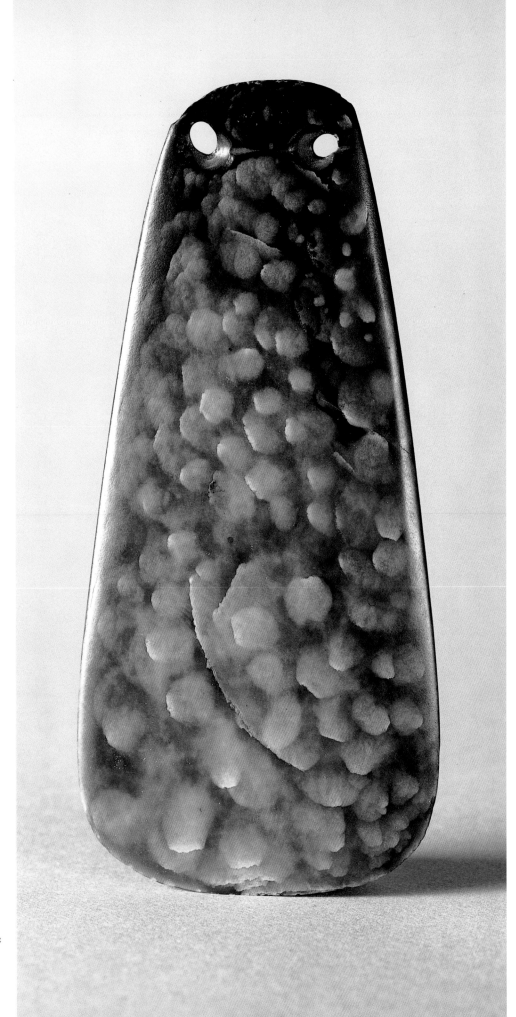

Plate 30. Pendant. Hei-pounamu
(cat. no. 48)

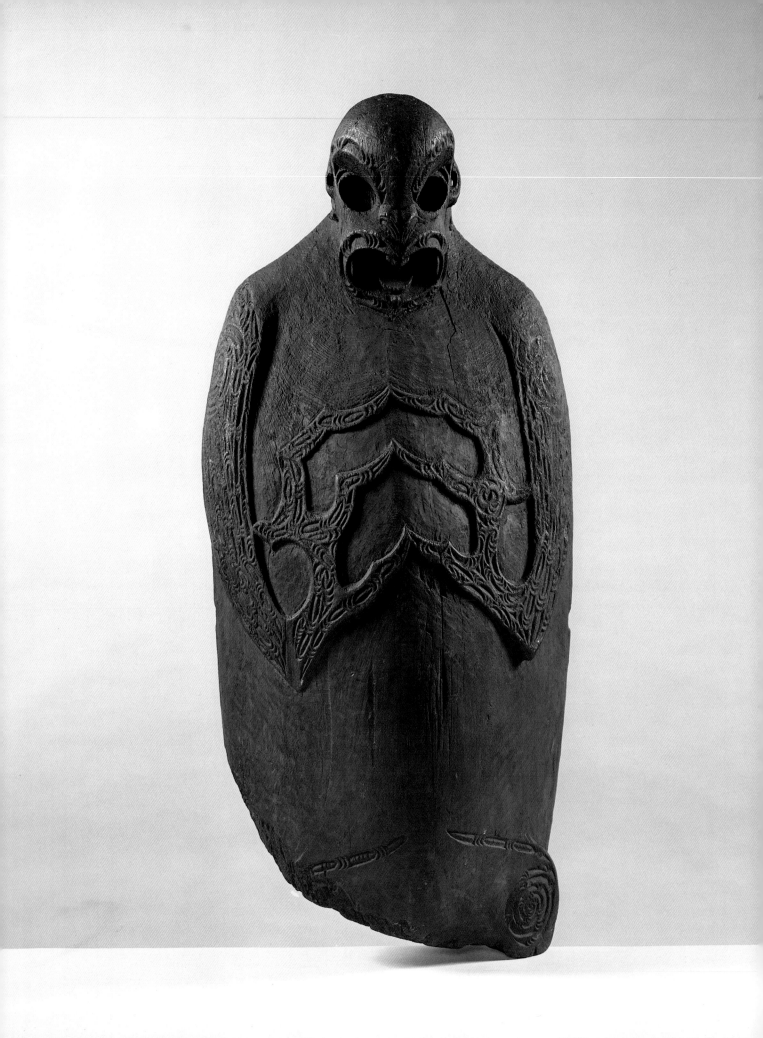

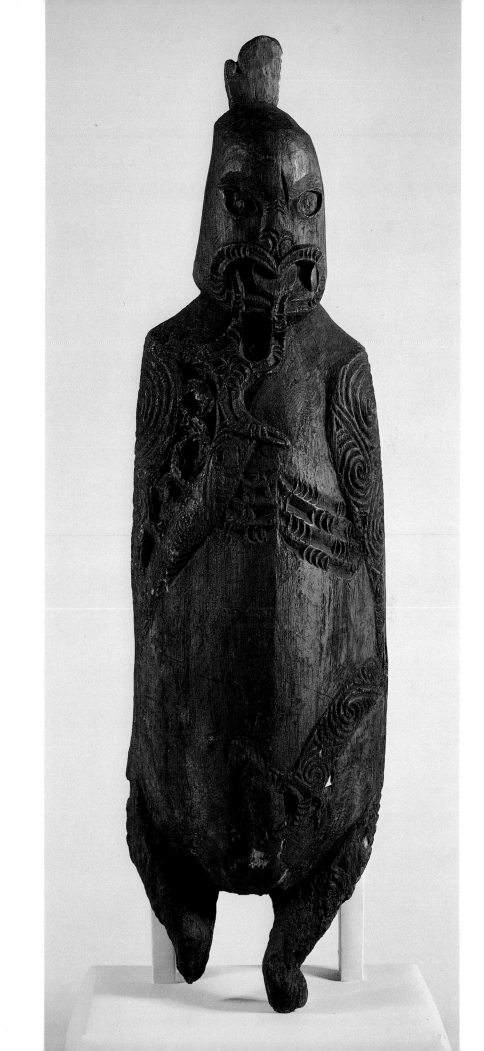

Plate 31. Burial chest. Waka tupapaku
(cat. no. 33)

Plate 32. Burial chest. Waka tupapaku
(cat. no. 61)

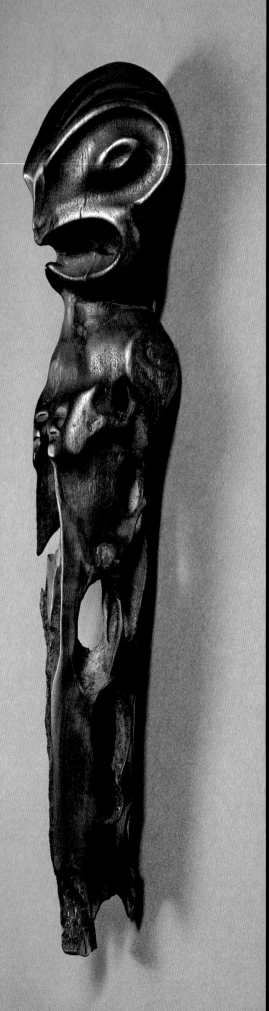

Plate 33. Godstick. Taumata atua (cat. no. 50)

Plate 34. Sinker. Mahe (cat. no. 52)

Plate 35. Ceremonial adz. Toki poutangata (cat. no. 34)

Plate 36. Flute. Nguru (cat. no. 39)

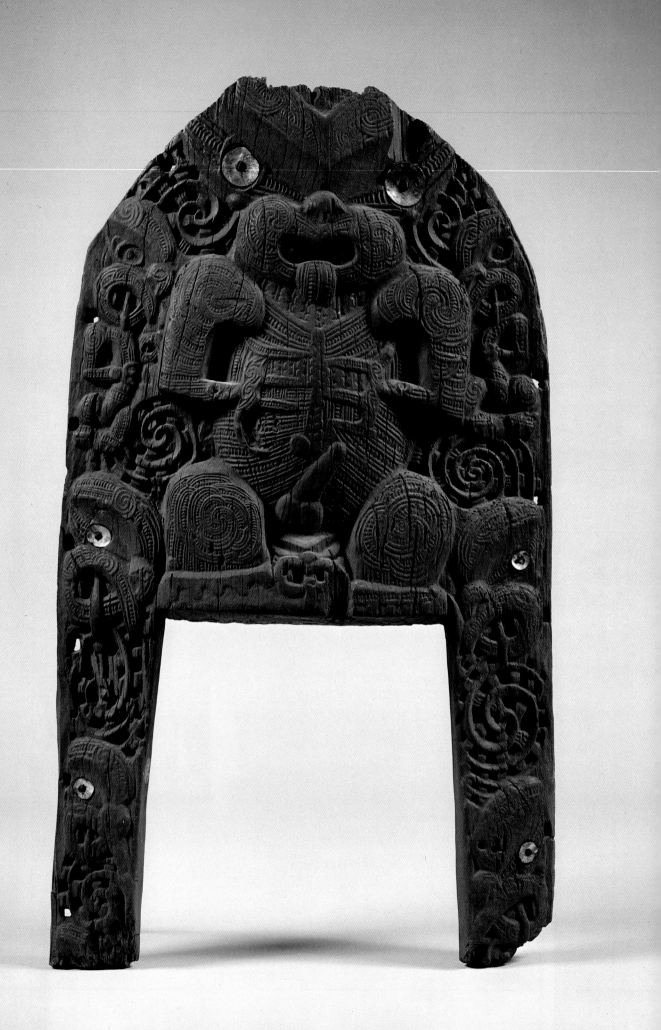

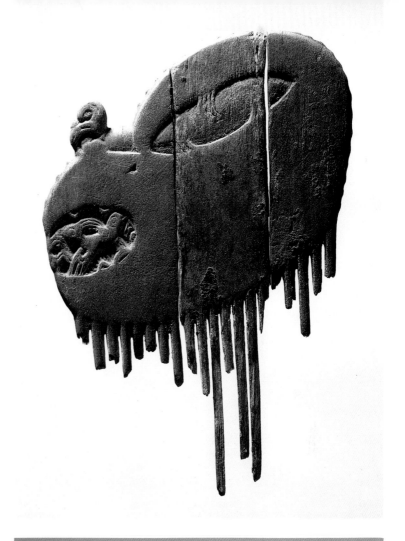

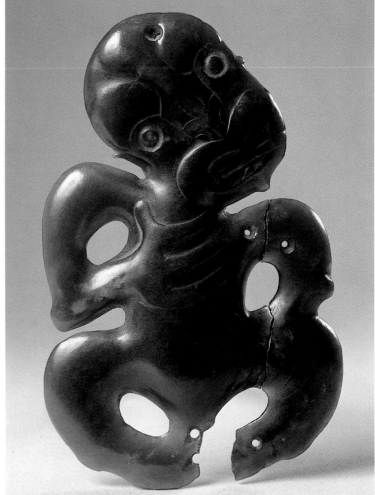

Plate 37. Doorway for a storehouse.
Kuwaha pataka (cat. no. 67)

Plate 38. Comb (cat. no. 78)

Plate 39. Pendant. Hei-tiki Rutateawhenga
(cat. no. 97)

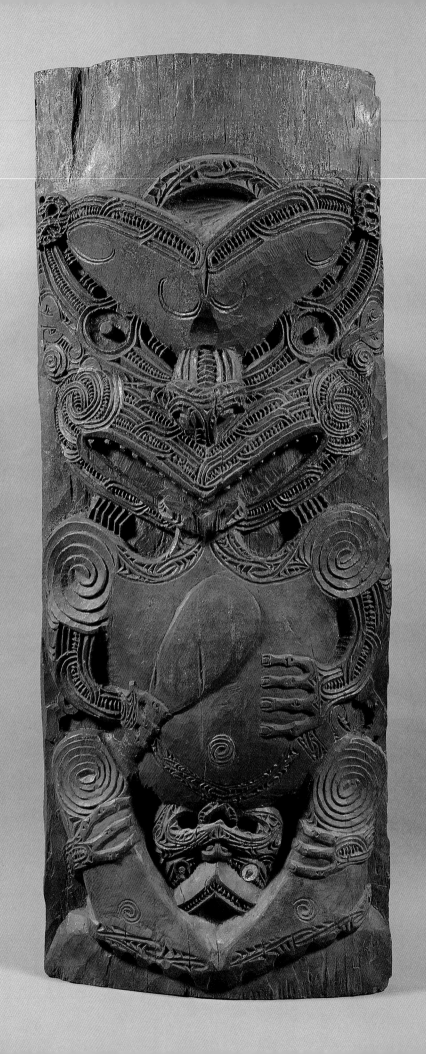

Maru of Hauraki tribes. On the western side of the island there is a remembered link between Hokianga and Taranaki. When Sir Peter Buck visited Hokianga the relationship between his Te Ati Awa kinsmen and Te Roroa was recognized; it has since been reinforced by marriages.

The serpentine style of Te Whanau-a-Apanui is an apparently simple form which uses the raised notched line, the taratara a kae, as the surface decoration, which is formed into spirals or curving lines. The heads are long with high brows and rounded foreheads usually the same width as the mouth, though some figures have brows wider than the mouth. These features are best exemplified by Te Potaka, the storehouse in the Auckland Museum which was carved at Maraenui in 1780. Later pataka made with iron tools in the East Coast area have taratara a kae notching on the body, but the heads, of Ngati Porou design, are decorated with lines (haehae) that have diamond chevrons (pakati) between them. An example is a paepae (front board) of a pataka from the Waiapu Valley in the Auckland Museum. The carvings seen and drawn at Tolaga Bay by Captain Cook's artists in 1769 have a similar head shape with surface decoration of pakati and haehae. Traditionally the Tolaga Bay carvings were the work of a very gifted artist, Paikuerangi, whose tools had so much mana they are said to have been able to work without him (personal communication).

There is cross-fertilization. Stone-tool carving in the East Coast styles is rare to nonexistent except for that recorded or collected by Cook and a poupou from Hine Matioro's house at Whangara now in the Auckland Museum (fig. 17), whereas Te Whanau-a-Apanui carving with stone tools, especially for storehouses, is not uncommon. The Cook collections in Europe include paddles decorated with the Whanau-a-Apanui taratara a kae collected at Gisborne and in the northern South Island. The bailer Porourangi, carved for the canoe Houwairangi at Whakaki near Wairoa, is carved in Te Whanau-a-Apanui style with stone tools (cat. no. 110). At the other end of the Bay of Plenty, the Te Whanau-a-Apanui carving is present but is combined with Arawa features, as, for example, the lintel in the Auckland Museum from Te Puke which has the Arawa cup-shaped head and raised taratara a kae. Later storehouses in the Arawa area of Maketu use a negative form of the raised notched line: a groove is excavated with the "cliff" edges being notched while the center of the groove is left as a raised line. In very late carving the notched edge becomes a single "terrace" edge which curves and loops.

Early examples of Te Whanau-a-Apanui carving style were present in a swamp site at Kohika in the Bay of Plenty dated to the sixteenth century. This would suggest that it could be ancestral to the other carving styles in the area. In the eighteenth century the style is fully developed; it then spreads into the Bay of Plenty and East Coast. There it meets up with the Tolaga Bay–Gisborne style. The carving of Paikuerangi seems to relate closely to the Gisborne style of Rongowhakaata. Both the Tolaga Bay and Gisborne styles probably developed as a result of relationship with the Ngati Kahu area of Northland. The cross-fertilization of the Te Whanau-a-Apanui and Ngati Porou carving is encapsulated in the traditional account of the origin of carving in these areas. Tukaki of Te Whanau-a-Apanui and Iwirakau of Ngati Porou are said to have gone to the Rawheoro school of learning established at Tolaga Bay to learn the

Plate 40. Side post. Poupou (cat. no. 89)

97

art of carving. They took as a gift Ngaio-tu-ki-Rarotonga, a famous cloak, and took back in return the manaia and taowaru, the knowledge of carving (Ngata 1958, no. 23:37). Iwirakau lived some ten generations ago, that is, about the seventeenth to early eighteenth centuries.

The square styles, as Ngata notes (1958, no. 23:31), are a later but not separate development from the serpentine styles. Certain features found on secondary figures in the carving of Rongowhakaata—head shape, claw hands, type of surface decoration—are also found in the carving of the Ngapuhi of the Bay of Islands but more particularly in the pieces that can be identified for the Ngati Kahu of Doubtless Bay. Ngati Kahu attribute their origin to Kahungunu, ancestor of Ngati Kahungunu of Hawke Bay. Aperahama Taonui (1849:7), of the Popoto tribe of Ngapuhi of Omanaia in the Hokianga, mentions in a manuscript written in Maori:

Toi whose great people were the Tini o toi . . .
Toi begot Apa
Apa begot Rauru the ancestor of the learned carvers of Ngati Kahungunu.

(Translation by author)

Awa
Awanui the ancestor of Ngati Awa who lived in Taranaki,
this was his village in olden times. All men know this story.
Rakei
Tama-ki-te-ra
Puhi-moana-ariki. This is the ancestor of Ngapuhi.
This is the end of the tapu people scattered about. Start with real men: these things were uttered slowly on return from a burial of a corpse to remove tapu so the hands could take up food.
Puhi-moana-ariki begot
Rahiri, its chief.

(Simmons 1976:208–210)

Figure 18. Taurapa (sternpost) of the war canoe Te Toki a Tapiri, carved by Raharuhi Rukupo of Rongowhakaata in 1836. Height 183 cm. (6 ft. 11 in.). Auckland Institute and Museum (150)

Other manuscripts from the Bay of Islands written before 1854 refer to the connections between Ngapuhi and the Ngati Porou tribe (Simmons 1976: 217–218). An account by Patiki of Te Aupouri in the far north—"He Whakapapa, Korero na Te Aupouri" (Ancient History of Te Aupouri)—refers to the ancestors landing at Waiapu on the East Coast.

The migration landed at Wai-apu and three children were born there—Po being the third. When Po was nearly grown up the people migrated to Kaitaia and settled down there, until the time when the child Puhi was born, from whom are descended the Ngapuhi tribe. The people spread and after a time Ngati Awa were expelled by Ngapuhi, they migrated to Kaipara and as far as Taranaki. Some of the Ngati Awa migrated from Mangonui and, under their chief Kauri, settled down near Tauranga.

(Simmons 1976:218–220; translation 220–223)

Other Aupouri and Rarawa accounts refer to the same tradition of Po, who is the origin of Ngati Porou and Ngati Kahungunu. These may be from the same sources as the above (Simmons 1976:224). Ngati Whatua of Kaipara share the same tradition (Simmons 1976:228).

According to elders of Ngati Kahungunu, there were Ngati Kahungunu and Ngati Porou living at Whatuwhiwhi in Doubtless Bay until 1845 when the war against Europeans broke out in the north. Some of the people died and were buried at Whatuwhiwhi. They are said to have been there because of the ancestral connection. It is possible that the Ngati Kahu and Ngapuhi Bay of Islands style of square carving is derived from the East Coast. I would suspect that there was communication both ways. The resemblances noted could be explained in this way. A Bay of Islands lintel, collected in 1806 and received by the Museum of the Salem East India Marine Society in Massachusetts in 1807 (Simmons 1982:185, pl. 132), has northern decoration on the bodies and a square head decorated with East Coast haehae and pakati. However, the piece is carved with stone tools in kauri wood (*Agathis australis*), a tree that does not grow on the East Coast, and the facial surface decoration is not what is expected in the area (Simmons 1982:pls. 134, 136, 138, etc.). This could indicate a close connection between the two areas before marked European contact. Traditional information would suggest initial movement from the north with perhaps a later return from the East Coast in the beginning of the nineteenth century if not somewhat earlier. Certainly by 1820–30 some carvers can be named who are said to have traveled between the two areas.

The most important center for the square styles was the Rongowhakaata tribal area of Turanga (Gisborne). It was here that Raharuhi Rukupo flourished. His first notable task was at Turanga where he was in charge of carving three war canoes, which included Te Toki a Tapiri now in the Auckland Museum (fig. 18).

The Arawa tribes of Rotorua have a tradition that the first fully carved house in the area was a gift from Turanga. It is certainly true that the carvers of the Ngati Pikiao tribe, the main early house-carvers of Arawa, used a style very reminiscent of Rukupo's work. In turn, the Arawa tribes became a center for

carving. In the nineteenth century Rongowhakaata of Gisborne, Ngati Porou of the East Coast, and Arawa of Rotorua carved many houses, some of which are still standing. Other centers developed in the Mataatua tribal area of the Bay of Plenty and in the Waikato, but many of the other tribal areas were content to allow their carving styles to be replaced by works from the great schools.

TE AO KOHATU Pre-European Maori Art

Tribes of Tai Tokerau

The northern tip of the North Island is the domain of a number of tribes (see maps 2 and 3 and also maps 4 and 5, which refer specifically to the distribution of art styles).

Ngapuhi is really a federation of independent tribes whose waka (origin canoe) was Ngatokimatawhaorua. They occupy the area between the Bay of Islands and Hokianga.

Aupouri and *Rarawa* are two tribes who ascribe their origin to the Mamari, companion canoe of Ngatokimatawhaorua. They live in the tail of the fish, the far north and the west coast around Kaitaia.

Ngati Kahu are the descendents of Tamatea and Kahungunu who migrated to Hawke Bay. They live around Mangonui Harbour and Doubtless Bay.

Ngati Wai and *Patuaharakeke* are tribes who live north and south of Whangarei.

Ngati Whatua migrated from the tail of the fish to their present position at Kaipara and Auckland. Their origin canoe is Mahuhu.

All these tribes are connected by genealogies even though they warred with each other. In the art sense it is not possible to define strict tribal styles because the motifs cross tribal boundaries. The style can only be defined broadly as Tai Tokerau or Northland.

NGATI KAHU FORM OF TAI TOKERAU. There are very few pieces that can be identified as Ngati Kahu. The most notable is the lintel which was formerly in the James Hooper collection in England (cat. no. 30). The head shape of the human figure is almost rectangular with small round eyes. The manaia motif has either a pointed head or is rounded.

NGAPUHI OF THE BAY OF ISLANDS. Ngapuhi are the people of the Bay of Islands today. I suspect that in the eighteenth century they moved into the area from the west. The distinctive tribal form of the Bay of Islands relates more to Ngati Kahu, and perhaps to formerly numerous tribes like Patu Keha who occupied the offshore islands of the Bay in 1772.

The most important artifact collections for the Bay of Islands are in the Peabody Museum of Salem in Massachusetts. These are two collections made by whalers in 1806 and 1811 and catalogued into that museum in 1807 and 1812. The 1806 collection includes a carved door lintel for a chief's house, a feather box, and a number of weapons in wood, all carved with stone tools. The 1811 collection has items made with metal tools. It also includes one of the two known pieces of decorative weaving for the whole of the Tai Tokerau. The Salem collections show the changeover from stone to metal tools that took place

in that area between 1806 and 1811. By 1820 soft iron tools were in fairly general use (Simmons 1982).

The Bay of Islands figures have head shapes very similar to those of Ngati Kahu with a rectangular head, but they are placed on a short body with shoulders much wider than the head. Surface decoration is of unaunahi (rolling spirals).

Jade or nephrite hei-tiki normally follow and parallel the wood carving styles, with most tribal areas having one or two forms of tiki (human figure pendant). However, in the Tai Tokerau, ten different types of hei-tiki are found, which include the basic forms for the rest of New Zealand. The ancestral form of tiki would seem to be the upright form with head vertical, arms on chest, and pendant legs, as in the Ruapekapeka tiki (cat. no. 31). Later tiki are much more tightly arranged into a rectangular adz shape. The nephrite for making hei-tiki originated on the West Coast of the South Island, yet it would appear that the center for development of the hei-tiki could have been the Tai Tokerau

Similarly, the area of the greatest variety of feather boxes is the Tai Tokerau. These are the boxes in which head adornments—feathers, hei-tiki, and pendants —were kept, hung up out of harm's way because of the strong tapu (taboo) on the head. The possible spread of the tiki forms could be related to a parallel spread of the boxes to contain them, which were often given as koha (gifts) from one chief to another.

NGAPUHI OF HOKIANGA. Ngapuhi and Ngati Whatua meet and mingle in the Hokianga area of the west coast of the Tai Tokerau. The art styles of the area are shared. In general, the carving style is based on a sinuous body with high pointed or domed forehead. These carvings seem to have been used on the doorjambs of kumara storehouses. In this area such storehouses were often above ground and were the most decorated structures in the village. The art form associated with these storehouses cuts across present-day tribal boundaries, and examples are found in the north at Awanui near Kaitaia and down the west coast to the Kaipara near Auckland. In ancient times this was the domain of the Awa people who migrated to Taranaki and the Bay of Plenty.

Closely related to these storehouse carvings are the waka tupapaku (burial chests) of the Bay of Islands and Hokianga (cat. no. 33). In style these follow the western form of carving with the same type of domed heads and surface decorations. Secondary burial of the type practiced in Tai Tokerau is not a feature of tribes living farther south, with the exception of some rare pumice burial boxes from the Waikato region.

Ngati Whatua of the Kaipara

The most notable example of the domed-head/serpentine-body form of carving was found in the Kaipara. Traditionally it came from a house built about 1650; the carvings were still in use in 1825 when they were dismantled and hidden in a swamp. The Ngati Whatua form is an extreme development of the northern serpentine style. The Otakanini carving is the work of a great sculptor. If the traditional date is correct, this carving may have been the model on which the Ngati Whatua serpentine form was based. The typical surface decoration used is grouped crescents across a groove.

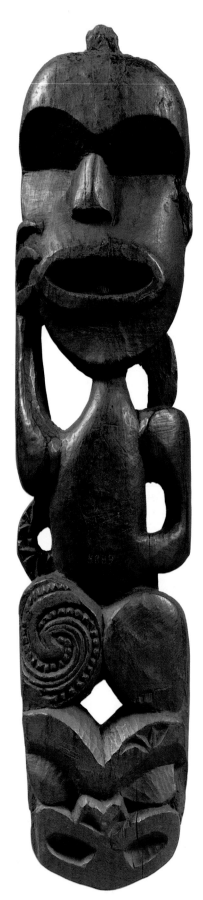

The Waikato and Hauraki Tribes

The Waikato confederation and the other Tainui tribes take their origin from the Tainui canoe, which landed at Kawhia Harbour on the west coast of the North Island sometime in the thirteenth century. The hauling song used to drag Tainui to the sea when it was built in Hawaiki is still used by Waikato when welcoming other chiefs, and it is used by other tribes when welcoming Waikato.

Tōia Tainui,	Pull Tainui,
Kia tapotu ki te moana	To bring it to the edge of the sea.
Kōia i hiri hora te mata	Surely glanced the
Whaititiri takataka tūmai	bolt of thunder
I taku rangi tapu.	falling on my sacred day.
Ka tangi te kiwi	The kiwi cries
Kiwi!	Kiwi!
Ka tangi te moho	The notornis cries
Moho!	Moho!
Ka tangi te tieke	The saddleback cries
Tieke!	Tieke!

Allied to, and descended from, the Tainui are the Hauraki tribes who live on the Hauraki Plains and Coromandel Peninsula. In the eighteenth century, tribes who traced their origin to the Arawa canoe lived on the eastern side of the Peninsula. Bay of Island tradition and the earth forest types of both Tainui and Te Arawa canoe areas would suggest a relationship with the Bay of Islands.

ART OF THE WAIKATO. Waikato wood-carving art is rare. In general it resembles the Bay of Islands forms (fig. 19) rather than the serpentine forms of the western area and Kaipara. Waikato hei-tiki have small, somewhat rounded triangular heads slightly wider than their fairly squat bodies with well-rounded shoulders (cat. no. 58). This is also the common form of Hauraki tiki, though they tend to be more rectangular in outline. The triangular head shape of Waikato is paralleled in wood carving, though the more common head shape is long, with rounded brows and slightly wider mouth (cat. no. 60).

HAURAKI CARVING. This art is even rarer than that of Waikato; there are four lintels, a windowsill, and a few smaller pieces—a bowl and weapons—decorated with small areas of carving. The most notable carvings from Hauraki are the pieces from a house that stood at Patetonga. The lintel and windowsill were carved with stone tools in the same style as an earlier lintel. This latter lintel is small, about the size for a chief's house. The Patetonga lintel itself is large (cat. no. 55). Traditionally it was carved for a meeting house erected about 1850. The Patetonga carvings belong in the nineteenth century, yet, because they are the work of stone-tool carvers, we can presume them rightly to belong to the eighteenth century. It was the last carving made in this style. Related pieces are known from the adjacent area of Thames.

The Hauraki style of the Ngati Tamatera is a serpentine form with sinuous-bodied figures and long rectangular heads with slightly domed foreheads. The brows may be wider than the mouth in the related forms of Thames. Surface decoration is by grooves spanned by grouped crescents and by very open,

almost cusplike spirals. The Hauraki style is closely related to the serpentine Hokianga form, to the Taranaki style of carving, and to the East Cape style.

Ngati Hei of Coromandel

There are no large pieces of carving from the eastern Coromandel. The Ngati Hei are the descendants of the Arawa canoe. What is known of their carvings comes from rare pieces, like the pumice head from Whakahau Island (cat. no. 51).

The Arawa and Mataatua Tribes of the Bay of Plenty

The Arawa canoe landed at Maketu in the Bay of Plenty. Some of the crew migrated back to Coromandel but the rest stayed in the Bay of Plenty until, in the time of Rangitihi about four generations later, the Arawa people were sufficiently numerous to take up the central lakes region around Rotorua.

The main pieces from the Arawa area made in the eighteenth century are canoe pieces. There is only one known stone tool carving, a portion of a store-house from the central lakes area (fig. 20). There are pieces from the coastal region in one of the later Arawa forms but nothing to indicate that these forms were Arawa in the eighteenth century.

The Mataatua canoe landed sixteen generations ago at Whakatane. Tribes descended from people on board are the Ngaiterangi of Tauranga, Ngati Awa of Whakatane, Tuhoe of the Urewera, and Whakatohea of Opotiki. It is the canoe ancestry that unites these otherwise rather disparate tribes.

The Kauri Point combs, which give the only dated sequence for the development of Maori art, came from within the Ngaiterangi area. The early style in the area derives from the Whanau-a-Apanui style of East Cape, though there is some indication that the Arawa style may also have been present (cat. no. 84).

Whanau-a-Apanui of East Cape

Te Whanau-a-Apanui have the same origins as the East Coast tribes of Ngati Porou, Aitanga-a-Mahaki, and Rongowhakaata. They have no single origin canoe.

The art styles of the East Cape and Bay of Plenty in the eighteenth century were closely linked. In general the best examples of Whanau-a-Apanui work, such as Te Potaka storehouse (cat. no. 91), have human figures with tubular bodies which are often shown sideways. The Whanau-a-Apanui style has a fairly close resemblance in overall forms to Hauraki, though this does not apply to the taratara a kae (raised notched decoration) so characteristic of the style. The Arawa or Bay of Plenty form uses a more "flowerpot"-shaped head with notched lines excavated rather than raised, with a central line in the resulting groove. At the other side of the Whanau-a-Apanui territory the style spills over into the East Coast where it takes on the triangular head shape with line and chevron decoration (pakati and haehae) on the face.

The resemblance of Whanau-a-Apanui to Hauraki carving is not accidental, as there are traditional links between the two areas, links which suggest a much closer, or even shared, origin in the past.

Figure 19. Tekoteko (gable figure), from Orakau in the Waikato. Made in the 18th century for a chief's small dwelling house. Height 58.5 cm. (23 in.). Auckland Institute and Museum (5589)

Figure 20. Carving from a storehouse that stood on Mokoia Island. Carved with stone tools in the 18th century. Height 69 cm. (27¼ in.). Auckland Institute and Museum (52)

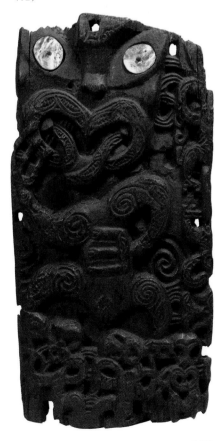

Ngati Porou of the East Coast

The Ngati Porou are the descendants of Porourangi and have no true origin canoe. They state that Maui fished up the land and they have been here ever since. Cohesiveness as a tribal group is partly the result of their geographical isolation, protected as they are by mountains to the west and the sea to the east. A Ngati Porou carving was recorded by Captain Cook's artists in 1769 at Tolaga Bay, and there is only one other known piece, which was carved with stone tools, namely Hine Matioro's poupou (fig. 17).

Ngati Porou head shapes are illustrated by these two carvings. Surface decoration is by grooves and crescent notches. The heads and bodies of the figures are usually of similar width. This style was named Iwirakau by Ngata (1958), after the ancestor illustrated in figure 16.

Rongowhakaata and Aitanga-a-Mahaki of Gisborne

In 1769 the tribes of Gisborne met Captain Cook, who collected some of their art forms, which included items decorated with the taratara a kae notching of the East Cape. The Gisborne style is clearly distinct from the rest of the area. The human figures have triangular heads which are narrower than the very dumpy bodies. The shoulders and thighs are usually rounded. Surface decoration is by haehae and pakati. Naturalistic human figures are used as pole or gable apex figures (cat. nos. 120, 126).

Ngati Kahungunu of Hawke Bay

The Ngati Kahungunu tribe are descended from Kahungunu of the Takitimu canoe. Their carving form is a version of the Gisborne style and very few pieces made with stone tools exist (cat. no. 124). There was close relationship among Ngati Kahungunu, Ngati Porou, and Ngati Kahu of Doubtless Bay.

Te Ati Awa of Taranaki

Te Ati Awa give their origin canoe as Tokomaru but place more importance on their descent from Awanuiarangi, who was a younger brother of Rauru and a godly visitor who appeared in a pool, hence the name, which means "the great waters of the sky."

The north Taranaki wood-carving style of Te Ati Awa is closely related to the serpentine styles of the Hokianga and Hauraki. The head shapes are very triangular, usually with the sacred mountain Taranaki (Mount Egmont) shown between the brows.

In ancient times Taranaki was one of the volcanoes in the central plateau, but he was forced to leave because he tried to steal Pihanga, the wife of another volcano, Tongariro. Part of an ancient song refers to this.

Tū kē Tongariro,	Tongariro stands apart,
Motu kē Taranakai	Taranaki is separated
He riri ki a Pihanga	By strife over Pihanga
Waiho i muri nei	Leaving in later times
Te uri ko au-e.	Its descendant, me.

The bodies of north Taranaki figures are tubular with a ridge down the center. Open cusp spirals, fishnet design, and a spiderweb design are typical of the style. One notable characteristic is the way the figures are thought of as two-dimensional and not solid so that arms, legs, or fingers can twist through eye, jawbone, or mouth. Similarly, on weaving sticks two serpentine bodies are often shown plaited together. Most of the stone-tool pieces found are parts of storehouses, which must have been the prestige item for the village.

The Taranaki Tribe of Taranaki

The Taranaki tribe live around the western base of Taranaki mountain. Their carving is a form of the Taranaki style. The head shapes are usually more rounded without the peak on the head. The bodies are tubular but the intermingling of limbs and head is not very common.

The Aotea Tribes of South Taranaki

The Nga Rauru and Ngati Ruanui tribes are the descendants of the Aotea canoe and occupy the South Taranaki coast. The Aotea carving form is an extreme development of the Taranaki style, with very triangular heads and tubular bodies often reduced to a small ridge. Limbs often disappear as patterns. Surface decoration includes the unaunahi (rolling spiral), which could be mistaken for the Hokianga pattern. Most of the items are small (cat. no. 139). The only known larger carvings in this style are in European collections. A related style is that of Whanganui, which, at the other end of its range, mingles with the Waikato style.

Ngai Tahu, Ngati Apa of the Northern South Island

The Ngai Tahu tribe originally migrated from Gisborne ten to twelve generations ago to settle in the South Island, amalgamating with the previous tribes. The art styles of Ngai Tahu and other tribes of the area are closely related to those of the other side of Cook Strait. In the eighteenth century, when Captain Cook made eleven stops at Queen Charlotte Sound over three voyages, he and his men collected many items. The majority of the material in the Cook collections is from the Sound. Some of it had been taken directly across the Strait for trade, but these pieces can be distinguished (Simmons 1981). The eighteenth-century art styles of the area are variations of the Whanganui and South Taranaki styles. Human figures have large smooth heads as in Whanganui work, with the arms and legs being thin. The heads tend to be large in proportion to the body. Many of the other items, such as tiki, also show influences from across Cook Strait, but despite this there is a strong South Island aspect to the culture (cat. no. 160).

Kai Tahu of Te Wai Pounamu (South Island)

The dominant tribe of Te Wai Pounamu (greenstone waters) is Kai Tahu, a local dialect form of Ngai Tahu. The original people of the area, the Kati Mamoe, trace their origin to the Arai Te Uru canoe which spilled its cargo of gourds on the beach at Shag Point. The gourds are still there, turned to stone

as a row of boulders. The Kati Mamoe are culturally the direct descendants of the early settlers. Their art and that of those who absorbed them, the Kai Tahu, retains an Early East Polynesian aspect in the isolation of the South Island. The Kai Tahu were the bearers of the Classic Maori culture of the North Island. This adds an extra dimension and new objects to the cultural repertoire of the area. The carving style, as in the Long Beach prow, combines Classic decoration around the mouth with keeled Polynesian eyes on a prow designed to face down into the water in Otago style (cat. no. 164). The miti clubs of Otago and Canterbury are also very different from the North Island examples (cat. no. 24). This combination of early features of a Polynesian form of bailer decorated with unaunahi of Gisborne type can be seen on the Monck's Cave bailer. Some North Island forms are simply adopted, like the nephrite hei-tiki (cat. no. 165), though in Canterbury the usual form has a very much wider body than head. Classic Maori fishhooks in the area tend to be multibarbed (cat. no. 154).

TE AO RINO Post-European Maori Art

By 1820 European contact with New Zealand was reasonably constant. As early as 1807 some Maori had traveled to England and hundreds had been to Sydney in Australia. This was one aspect; another was the trade that resulted from contact. Even in the eighteenth century, competition for trade caused local wars in Queen Charlotte Sound. Cook remarked on the wars but did not realize that he was the cause. He was more preoccupied with his horror of cannibalism (Beaglehole 1961:293).

One effect of Cook's voyages was the introduction of the white potato, which allowed the agricultural tribes of Canterbury to extend their range into the previously unattractive Otago and Southland area. This expansion was also connected with a desire to control the Otago nephrite trade. Starting in the eighteenth century and continuing into the nineteenth was the European demand for "the grotesque green idols," the hei-tiki (cat no. 165). At Murdering Beach in Otago a village was established where hei-tiki were made (Skinner 1959:223). A Cook Second Voyage medal issued at Queen Charlotte Sound and some European items show the direction of the trade. Hei-tiki were new to Otago, yet twenty-two have been found at Murdering Beach together with an estimated three and one-half hundredweight of nephrite. Murdering Beach is an example of both population movement and the increase in trade brought about by the European presence. In the next few years many tribes moved to more favorable trading areas, often taking them over from weaker tribes. The introduction of iron tools was accompanied by muskets. In 1818 Hongi Hika of Ngapuhi went to England. He returned with 114 stand of muskets, and a new type of slaughter warfare replaced the skirmishes of earlier times. Tribes without muskets were forced to get them. Potatoes, flax, and heads were the trade items demanded: two tons of potatoes, a shipload of flax fiber, or two dried tattooed heads for each musket.

Intertribal musket wars, the arrival of missionaries, the treaty ceding sovereignty, the arrival of European settlers, war against the settlers, withdrawal, and a rapidly declining population were some of the changes affecting Maori life in the nineteenth century. The initial response was quick and vigorous.

At first the art forms flourished as never before, then the effects of the musket wars were felt. The new mission hamlets offered security but demanded adherence to an English cultural norm. The musket raids had stimulated the curio trade at the Bay of Islands, which was soon satisfied by looted goods brought back from the raids. In the process, the Ngapuhi arts were swamped by the imported goods. The far-reaching changes in tribal social life allied with movement and epidemic diseases that reduced the population meant that there were many early tribal art styles that died out in the nineteenth century. Some of them went through brief revivals, but eventually the styles died. The following list gives approximate dates for their demise:

Ngati Hei, about 1820
Whanau-a-Apanui, about 1820
Te Ati Awa, about 1820
Ngapuhi, about 1830
Ngai Tahu, about 1830
Ngati Apa, about 1835
Moriori, about 1835
Ngati Whatua, about 1840
Taranaki, about 1840
Hauraki, about 1850
Aotea, about 1860
Wanganui, about 1860
Waikato, about 1863

These were all eighteenth-century styles of stone-tool carving. Some of the smaller carving styles continued for a number of years with carvers producing tourist items, model canoes, feather boxes, weapons, model carvings, and the like until the late 1860s. Some art styles which were only just beginning developed into new steel-tool schools in association with the new communal art forms. These areas were to some extent isolated, either geographically or politically, from the major areas of change.

The most important art development of this period was largely the work of one man, Raharuhi Rukupo of Rongowhakaata, mentioned earlier. In 1840 he built the first fully carved meeting house, Te Hau-ki-Turanga, which stood at Manutuke near Gisborne. It was opened in 1842. In 1868 it was taken as war compensation by the government and now stands in the National Museum in Wellington (pl. 13). In keeping with the chief's house from which it developed, the building is fairly small, with low walls. The wall slabs are notable for the amount of relief achieved by Rukupo. Rukupo's accomplishment was not just in building meeting houses; he successfully developed a strong steel-tool carving style which is still being used one hundred and forty years later.

In the mid-nineteenth century there were three great schools of carvers: Rongowhakaatua of Gisborne, Ngati Porou of the East Coast, and Arawa of Rotorua. The Rongowhakaata developed from an eighteenth-century style into a steel-tool carving style under Rukupo (fig. 18). The human figures typically have small triangular heads on dumpy, rounded bodies. The Ngati Porou developed from the eighteenth-century forms into the meeting house style of the 1850s with a tremendous efflorescence under such carvers as Tamati Ngakaho,

Hoani Taahu, Te Aotapunui, and Hone Ngatoto. Their human figures have square heads with a knob between the brows. The Arawa developed their carving style used for meeting houses mainly in the nineteenth century. Earlier Arawa carving is on storehouses, canoes, and chiefs' houses. Ngati Pikiao, one of the Arawa tribes, were the recipients of the Gisborne house, which was their model. Another Arawa tribe, Ngati Tarawhai of Lake Okataina, were carvers of war canoes until about 1860 when they changed to meeting houses (pl. 14). There are other Arawa tribal forms but among them the three tribes of Ngati Pikiao, Ngati Tarawhai, and Ngati Whakaue carved most of the Arawa houses known. The characteristic human figure for this area has long slanting brows, a small mouth, a chevron between the brows, and a squarish body.

In the later part of the nineteenth century a number of smaller local styles developed. For example, in the Whanau-a-Apanui area, a meeting house carving style develops which bears no relation to the earlier Te Kaha carvings.

The Mataatua

The most widespread of these local styles is that of Mataatua. In the Whakatane region of the Bay of Plenty the early styles represent a mingling of Arawa, Whanau-a-Apanui, and East Coast styles. About 1860, under the influence of Te Kooti Rikirangi, a religious leader, the carvers developed a new style by taking Arawa head and body shape, combining it with Ngati Porou and Arawa surface decoration, then adding European colors. The Ngati Porou had used red and black colors on carvings; Mataatua carvers added white, then saw the apparent relief this gave to the carving (pl. 15). White was always used but often combined with other colors, so that a house could be painted blue and white, pink and white, or black and white. In the Tuhoe tribe, green, yellow, and white were used. The next development was for some artists to leave out the carving and just use the paint on the boards. A lively folk art in paint is present even in carved houses of Mataatua.

In 1910 the first Maori Art School, Te Aomarama, was established in Rotorua. The tutors were at first from Ngati Tarawhai and the style they taught was that of Rukupo. Later, Ngati Porou carvers carried on the tradition. In more recent times some of the small styles that died out in the early nineteenth century have been revived and have served as the inspiration for houses now in use. In this latter part of the twentieth century Maori art is vigorous and varied and looks set to continue well into the twenty-first.

NGA HUARAHI O TE AO MAORI
Pathways in the Maori World

Anne Salmond

In the tribal landscapes of early historic times, pathways were cut along beaches and ridges, through bush, and beside rivers, passing through the territory of one descent group and into the lands of the next. A traveler in his own countryside could name its features minutely—rocks, caves, beaches, fishing grounds, points, streams, eeling pools, patches of bush, cultivations, swamps, rat runs, trees, ridges, hills, and mountains, even clumps of grass —every smallest feature had its name, which evoked the quality of that unique place and the ancestors who had named it or passed that way. The place names marked the land and domesticated it, fitting it for man's occupation; and the paths gave him direction in his journeys. This was whenua (land), source of life for its people.

The land was known intimately, because people moved often in those days. War parties, groups on seasonal migration, on trading trips, or on the way to some celebration traveled along the paths and waterways, setting up camp and moving through the bush in search of food. And if a group was driven off their land or forced to migrate to a new district, they lamented, singing their grief for the abandoned bones of their forefathers, as in Te Rauparaha's lament for his land:

Nāku ia na koe i waiho i taku whenua iti	I leave you, my beloved land
Te rokohanga te taranga i a tāua	in this unexpected parting
Ka mihi maomao au ki te iwi ra ia,	And greet my ancestors from a distance
Moe noa mai i te moenga roa.	lying on their beds of death.

(Ngata 1959:92; author's translation)

These fighting, singing, talking travelers were nga tangata (people) standing on the earth between underworld (po) and the layered heavens and managing the balance of the universe with their battles and their spells.

Men and land dwelled together in life and death, and their names—of places and men—crossed and crossed again in genealogies and tribal stories. The dead were buried in their settlements, sometimes in the very houses in which they had lived (Taylor 1855:98), and the papa (layers) of the cosmos were echoed in whakapapa (layers of descent lines) which began with Po (nothingness or night) and came down to this world of light, gods, and men:

Ka hua te wānanga	Knowledge became fruitful,
Ka noho i a rikoriko	It dwelt with the feeble glimmering;
Ka puta ki waho ko te pō	And so night was born:
Ko te pō nui, te pō roa	The great night, the long night,
Te pō i tūturi, te pō i pēpeke	The lowest night, the loftiest night,
Te pō uriuri, te pō tangotango	The thick night, to be felt,
Te pō wawā	The night to be touched,
Te pō tē kitea	The night not to be seen,
Te pō i oti atu ki te mate.	The night of death.
Na te kore i ai	From the nothing the begetting,
Te kore te wiwia	From the nothing the increase
Te kore te rawea	From the nothing the abundance,
Ko hotupu	The power of increasing,
Ko hauora	The living breath;
Ka noho i te ātea	It dwelt with the empty space
ka puta ki waho te rangi e tū nei	and the sky above was born
Ko te rangi e teretere ana	The atmosphere which floats
i runga o te whenua	above the earth;
Ka noho te rangi nui e tū nei	The great firmament above us,
Ka noho i a ata tuhi	dwelt with the early dawn,
Ka puta ki waho te marama	And the moon sprung forth;
Te rangi i tū nei, ka noho i a	The sky above us dwelt with the heat,
te werawera	
Ka puta ki waho ko te rā	And the sun was born;
Kokiritia ana ki runga	They were thrown up above,
Hei pūkanohi mo te rangi	As the chief eyes of Heaven:
Ka tau te rangi	Then the Heavens became light,
Te ata tuhi, te ata rapa	The early dawn, the early day,
Te ata ka mahina, ka mahina te	The mid-day, the blaze of the day
ata i hikurangi	from the sky.
Ka noho i Hawaiki	The sky above dwelt with Hawaiki,
	and land was born.
Ka puta ki waho ko Tāporapora,	Taporapora, Tauwarenikau, Kuku-paru,
ko Tauwarenīkau, ko Kūkū-paru,	Wawau-atea, Wiwhi-te-Rangiora.
ko Wawau-atea, ko Wiwhi-te-	
Rangiora.	

(Taylor 1855:98)

The universe that was shaped in this series of cosmological matings, according to the same early source, had

either ten or eleven Heavens; the lowest was separated from the earth, by a solid transparent substance like ice or crystal, and it was along the underside, or that next to the earth, that the sun and moon were supposed to glide. Above this pavement was the grand reservoir of the rain, and beyond that was the abode of the winds.

Each Heaven was distinct, the lowest being the abode of the rain; the next of Spirits; the third of the winds; the fourth of the light, the highest of all, being the most glorious, and therefore the chief habitation of the gods.

(Taylor 1855:17)

The world was not simply a physical structure, though; the sky was Rangi,

the Sky Father, and the earth was Papatuanuku, the Earth Mother, and generations of gods were born from their mating. During the eons that they lay together, the universe was dark and still, and very cold. Rangi clothed his woman with trees and plants to warm her, and as the temperature rose on earth the life of the small creatures began, and Papa gave birth to their sons, the gods. It was a terrible time for the god-children, because there was still no light in the world and they lay imprisoned between their parents

some lying on their sides, some were lying stretched out at full length, some on their backs, some were stooping, some with their heads bent down, some with their legs drawn up, some embracing . . . some with exhausted breath, some crawling, some walking, some feeling about in the dark, some arising, some gazing, some sitting still, and in many other attitudes—they were all within the embrace of Rangi-nui and Papa.

(Smith 1913, 1:118)

Ever since that timeless period of futility and frustration, darkness has had awful connotations for the Maori people:

pirau extinguished (fire, light), decay, death, rotten, pus
mate extinguished (fire, light), decay, sick, unconscious
tinei extinguish (fire), destroy, kill, confused, disordered
ngaro hidden, lost, disappeared, destroyed, distressed, unavenged

It was a younger and active son, Tane the god of forests and men, who finally broke out of this impasse. He said to his brothers, "We must force our parents apart." They argued with him and disputed, but finally they agreed, and Tane used all his strength to put props between Rangi and Papa, and light flooded into the world. This was the first tu tangata, when the ancestor of men stood up and asserted his power to change the universe. The themes of this feat are echoed in the Maori language:

ihi split, divide, separate; fear, dread; power, authority, rank, essential force; a form
 of sacred shrine (tuahu); spell, charm, incantation; dawn, a ray of sun

Like their ancestor Tane, men in the Maori world sought to control the world by exerting their strength in magic and in war:

kaha strength; line on which niu rods are placed for divination; line of an army
hau vitality of man, land; strike, smite; food offered to atua in propitiatory rites

Tane went on to create the first woman, Hine-hau-one, and while his brothers made fish, kumara, fern root, the winds, evil and disease, war and peace, Tane slept with this woman and made her pregnant, and so the generations of man began. In this East Coast tribal cosmological account, as in every other, the universe, land, gods, men, and all living creatures are kinfolk bound in a tangle of shared ancestry, and this binding of man and world was expressed in the term for the people of any locality: tangata whenua (land men).

The principle that ordered the apparent weltering chaos of plants, animals,

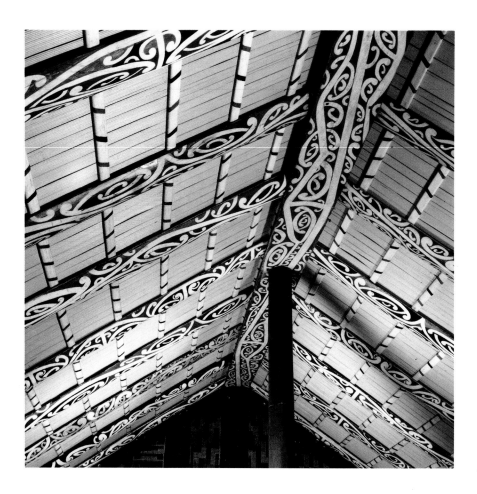

objects, and men in the tribal world was genealogy, described as the twining tendrils of the gourd plant with its stem (tahuhu, also "main line of descent") and branches (kawae, also "subsidiary lines") in one ancient metaphor (Taylor 1855:155) and still thus represented in the curving red, white, and black paintings on the underside of the ridgepole (tahuhu) and rafters (heke, also "descent line") of the modern meeting house (fig. 21).

Genealogy, the preeminent object of Maori scholarship, was an aristocratic reckoning, but this was not a simple aristocracy of birth. Descent lines were claimed according to their vitality and power, and the greater the success of one's ancestors in war, magic, oratory, and feasting, the greater the mana (prestige) that they passed down the descent line to their descendants. This power was like the power that made plants grow and flourish, and I have heard elders speak of one's descent lines as te iho makawerau (iho of a hundred hairs):

iho heart, kernel, pith, essence; that which contains the strength of a thing; the principal person or guest; umbilical cord; lock of hair; upward, in a superior position

This expresses the thought that lines of descent came down to a person like the hundred hairs on his head, bringing him power from his ancestors and effective force in the world. Just like a gourd plant, or a tree, a descent line might flourish and thrive, or if its vital force is attacked in magic or in war, it might fail altogether and die. And like the plant it is rooted in land, as in this characteristic tribal proverb:

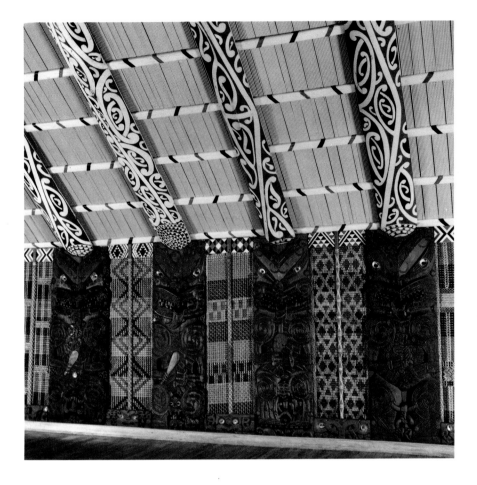

Figure 21. Two interior views of the fully decorated meeting house Mataatua, built by Wepiha Apanui of Ngati Awa in 1874. Left: The ridgepole and its decorations. Right: The side wall with its arrangement of wood carving, tukutuku (latticework) in between, and painted rafters reaching up to the tahuhu (ridgepole). Presented in 1875 to Queen Victoria as a gesture of good will. Otago Museum, Dunedin

Ko Hikurangi te maunga
Ko Waiapu te awa
Ko Porourangi te tangata
Ko Ngati Porou te iwi.

Hikurangi is the mountain
Waiapu is the river
Porourangi is the man
And Ngati Porou the people.

The taonga whakairo (patterned treasures), the works represented in this exhibition, are above all a celebration of this unity of men, ancestor gods, and land. It was precisely because descent lines branched and divided, and new lines took root elsewhere, that Maori social life and the treasures it produced were fundamentally tribal and referred to particular landscapes. Aotearoa (New Zealand) ranges from sub-tropical habitats in the north to chilly fjords in the south, and there was no one way of living that can be described for all of the country. Agnes Sullivan has spoken of regional differences in the archaeological record, and David Simmons has described reflections of these differences in tribal art. I will turn to the early historic accounts to try and bring these differences, and the taonga whakairo of this exhibition, into the context of tribal life.

When Captain James Cook brought his shipload of scientists, artists, and sailors south to New Zealand in 1769, they spent six months circumnavigating the islands and anchoring in various harbors. As they traveled, the observers on board were struck by differences in Maori life in the various communities they visited. At Anaura Bay on the East Coast, for instance, two old chiefs came on board the *Endeavour*, one in a dogskin cloak and the other wearing a cloak ornamented with tufts of red feathers, and they accompanied Cook ashore. About one hundred people were living at Anaura in scattered small clusters of

113

houses among their gardens. Monkhouse, the surgeon on board, wrote that night:

The cultivations were truely astonishing... the ground is completely cleared of all weeds—the mold broke with as much care as that of our best gardens. The Sweet potatoes are set in distinct little molehills which are ranged some in straight lines, in others in quincunx. In one Plott I observed these hillocks, at their base, surrounded with dried grass. The Arum [taro] is planted in little circular concaves, exactly in the manner our Gard'ners plant melons... the Yams are planted in like manner with the sweet potatoes: these Cultivated spots are enclosed with a perfectly close pailing of reeds about twenty inches high.

(Beaglehole 1968:583–584)

Joseph Banks estimated that these gardens ranged from one-to-two to eight-to-ten acres each and totaled about one hundred fifty to two hundred acres in high cultivation. Later that evening Monkhouse wandered up into the hills and visited a family of a man, his wife, two sons, and two female servants living in a single house on its own. The husband showed Monkhouse his paddles and digging tools and some red ocher and brought out of his house a collection of spear tips. The house was low and thatched, with a carved board over the door—the first pare (door lintel) ever to be seen by a European.

Anaura was an agricultural community, with some carved canoes, no great quantity of greenstone goods, and not much carving on the houses. At Tolaga, only ten miles to the south, things were very different. The landscape was attractive; one of the artists on board said of it, "The country about the bay is agreeable beyond description, and with proper cultivation, might be rendered a kind of second Paradise. The hills are covered with beautiful flowering shrubs, intermingled with a great number of tall and stately palms, which fill the air with a most grateful fragrant perfume" (Parkinson 1771:97). There were cultivations there too, but in Tolaga the local preoccupation was carving. On an island in the bay, Banks saw a carved canoe seventy feet long and a house

Figure 22. Above: Pare (lintel), from the house Te Kani-a-Takirau, opened in 1860, carved by Hone Ngatoto. Length 174.4 cm. (68⅝ in.). Auckland Institute and Museum (716). Below: Pare (door lintel). Collected by Gilbert Mair from the Rotorua area. Length 122.5 cm. (48¼ in.). G. Mair Collection, Auckland Institute and Museum (1)

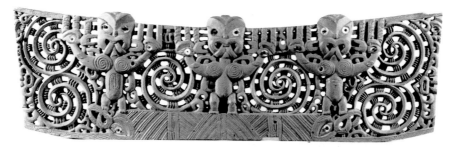

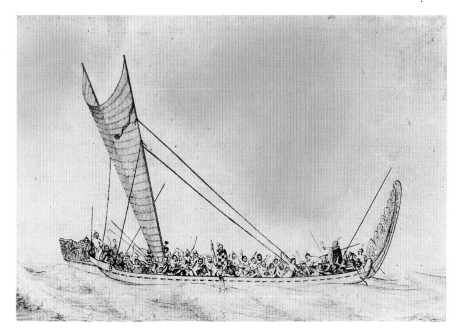

Figure 23. Double canoe at Poverty Bay in 1796 during Captain James Cook's First Voyage. Drawn by Sydney Parkinson, the natural history draughtsman on the Endeavour. Add. Ms. 23920, British Library, London

thirty feet long filled with chips and its side posts elaborately carved. The ship's artist added,

The men [at Tolaga] have a particular taste for carving: their boats, paddles, boards to put on their houses, tops of walking sticks, and even their boats valens, are carved in a variety of flourishes, turnings and windings, that are unbroken; but their favorite figure seems to be a volute, or spiral, which they vary many ways, single, double, and triple, and with as much truth as if done from mathematical draughts: yet the only instruments we have seen are a chizzel, and an axe made from stone.

(Parkinson 1771:98)

Tolaga was a treasure trove of taonga whakairo, and it is no coincidence that this is the place where Te Rawheoro, the school of learning and carving skills spoken of earlier by Sidney Mead and David Simmons, was founded by Hingangaroa.

The settlements on the East Coast were undefended and peaceful, but as the *Endeavour* cruised along into the Bay of Plenty those on board saw the cliffs bristling with huge fortified sites, fleets of canoes drawn up on the beach, and large gardens on shore. This was evidently a densely populated and wealthy area, where warfare was commonplace. The *Endeavour* was chased and overtaken in this area by a carved double sailing canoe, whose crew threw stones and smashed her windows (fig. 23).

Several days later at anchor in Mercury Bay on the Coromandel Peninsula, they could observe at first hand the ravages of war. In Mercury Bay every small rock out at sea had a fortification perched on top, and the local people seemed miserable and impoverished. The canoes that came alongside were simple dugouts, without any decoration, and the people on board were "almost naked and blacker than any we had seen . . . yet these few despicable gentry sang their song of defiance and promisd us as heartily as the most respectable of their countrey men that they would kill us all" (Beaglehole 1962, 1:425). Haka (war dances) were a standard way of greeting strangers and not necessarily

hostile, but the Europeans knew nothing of the proper etiquette and when provoked replied with smallshot or musketballs. There was one good-sized fortification in the Bay which Cook visited and described; it was defended on the land side of its promontory by a double ditch and bank, two palisades and a fighting stage, and inside the ground was laid out in twenty palisaded divisions of one-to-two to twelve-to-fourteen houses each. Dried fish and fern root were piled up inside in heaps, and bundles of darts and heaps of stones were ready on the fighting stage. The local people confided to the Europeans (through the Tahitian interpreter, Tupaea) that they were frequently raided from the north by warriors who captured their wives and children and destroyed all their possessions. Cook summed up the situation in Mercury Bay by saying,

Its inhabitants . . . altho pretty numerous are poor to the highest degree when compair'd to others we have seen; they have no plantations but live wholly on fern roots and fish, their canoes are mean and without ornament, and so are their houses or hutts and in general everything they have about them.

(Beaglehole, 1968:203).

Their taonga had been utterly ransacked.

In the Bay of Islands, several hundred miles to the north, however, there was plenty of visible wealth and this area could well have been the home of the raiders who were making life miserable for the people in Mercury Bay. Certainly Ngapuhi were raiding Thames and much farther south in the very early historic period in their fleets of sailing canoes. As the *Endeavour* ran toward Cape Brett, two large canoes came out to meet her:

The strangers were numerous and appeared rich: their Canoes were well carvd and ornamented and they had with them many weapons of *patoo patoos* [patu] of stone and whale bones which they value much; they had also ribbs of whales [hoeroa] of which we had often seen imitations in wood carved and ornamented with tufts of Dogs hair.

(Beaglehole 1962, 1:438–439)

Clearly, we are back in taonga territory. The chiefs had dogskin cloaks and prolific tattoos, and on shore there were large gardens and fortified towns in every direction. The major local industry appeared to be fishing, and Banks spoke with some awe of nets four to five hundred fathoms (2,400 to 3,000 feet) long, adding that the locals laughed a little at their own net, a common king's seine.

Archaeological work in this area suggests that the main cultivations were some way inland, and the coastal sites were mainly dedicated to collecting sea resources. This area was, like Anaura, able to support a range of cultigens, including a few prized plants of aute (barkcloth). Agnes Sullivan's postulates about settlement patterns would seem to be well supported by the eyewitness accounts of the Bay of Islands. There is also a very curious story collected by Banks just north of the Bay which suggests that two-way voyaging may have persisted well into the settlement period. Tupaea, the Tahitian on board, talked to people who came out to the ship in canoes and asked them

if they knew of any Countries besides this or ever went to any. They said no but that their ancestors had told them to the NW by N or NNW was a large countrey to which some people had saild in a very large canoe, which passage took them up a month: from this expedition a part only returned who told their countreymen that they had seen a countrey where the people eat hogs, for which animal they usd the same name (Booah) [puuaa] as is usd in the Islands. And have you no hoggs among you? said Tupia. —No. —And did your ancestors bring none back with them?—No. —You must be a parcel of Liars then, said he, and your story a great lye for your ancestors would never been such fools as to come back without them

(Beaglehole 1962:446–447)

Unfortunately Tupaea, who was also much given to lecturing the Maori about the evils of cannibalism, was a thoroughgoing Polynesian chauvinist.

The final place visited on this voyage was Queen Charlotte Sound to the south of Cook Strait, where bands of hunters and gatherers retreated to their pa (fortified settlement) on Motuara Island when the *Endeavour* arrived but soon dispersed to open-air camps along the shoreline in groups of fifteen to twenty. These people had no cultivations but lived off fern root and the local supplies of fish, and enthusiastically hunted down their enemies. Cannibalism is mentioned for most other places visited by Cook in 1769–70, but here it was everyday practice. It is difficult to know who was more horrified by the evidence of cannibalistic custom in New Zealand, the Europeans or Tupaea. When they came across some chewed human bones in a provision basket by a shore camp, they asked the local people, "what bones are these? they answered, The bones of a man. . . . Why did not you eat the woman who we saw today in the water?—She was our relation.—Who then is it that you do eat?—Those who are killed in war.—And who was the man whose bones these are?—5 days ago a boat of our enemies came into this bay and of them we killd 7, of whoom the owner of these bones was one" (Beaglehole 1962:455).

Tattoo styles, dialects, clothing, settlement patterns, and the distribution of carving, cultivation, ornamented canoes, greenstone, and other riches varied markedly from district to district in these first fleeting glimpses of classic Maori life. As one contemplates carvings and greenstone ornaments, the great taonga of this exhibition, it is as well to remember also the dugout canoes and rough shelters of more marginal populations living in many parts of New Zealand. It is not only our hearts that might quiver at the sight of spirals and speckled jade; in earlier times, as a war canoe's sternpost swept around the headland and the sun splintered off the edge of a greenstone weapon, then people's hearts quivered in earnest and they ran for their lives to the hills. Wealth, power, and danger came together in Maori life and thought:

kura treasure; red, glowing (the tapu color); a taiaha (weapon) ornamented with red feathers; red ocher; chief, man of prowess; knowledge of karakia (prayers) and mediation with the gods (wānanga); ceremonial restriction, danger

Treasures also implied knowledge and the power to converse effectively with the gods.

Knowledge is the way to a Maori understanding of the taonga in this exhibition,

for each treasure was a fixed point in the tribal network of names, histories, and relationships. They belonged to particular ancestors, were passed down particular descent lines, held their own stories, and were exchanged on certain memorable occasions. Taonga captured history and showed it to the living, and they echoed patterns of the past from first creation to the present. It is not possible to give a single account that will interpret each of these works, because their history belongs to individual groups and each group told its history differently. Wananga (knowledge of mediating with the gods) and matauranga (knowledge of the past, genealogy, chants, and spells) were treasures taken by ancestor gods and passed down the descent lines as part of their sacred power. Descendants claimed the knowledge of their own group and sought to maintain its mana. Listen to the old priest Te Matorohanga, who had taken part in the East Coast school of learning Te Rawheoro, speaking to his pupils in about 1865:

Attention! O Sirs! Listen! There was no universal system of teaching in the Whare Wānanga. Each tribe had its own priests, its own college, and its own methods. From tribe to tribe this was so; the teaching was diverted from the true teaching by the self-conceit of the priests which allowed of departure from their own doctrines to that of other Whare Wānanga [school of learning]. My word to you is: Hold steadfastly to our teaching: leave out of consideration that of other (tribes). Let their descendants adhere to their teaching, and you to ours; so that if you err, it was we (your relatives) who declared it unto you (and you are not responsible); and if you are in the right, it is we who shall leave to you this *taonga*.

(Smith 1913, 1:84–85)

There was no one cosmos in precontact times, then, because variations in the tribal accounts extended right back to the stories of creation; the ecological variations observed by the first explorers were echoed in different ways of explaining the universe. Tribal taonga were located in different conceptual as well as physical landscapes, and the truth of their stories was held to be truth within a particular tribal tradition. What they held in common, though, was their ability to act as a focus for ancestral power and talk.

The famous Taranaki taiaha (long staff) Te Porohanga, for instance, was used by the fighting chief Titokowaru in the 1860s as a medium for Uenuku, his battle god. When Titokowaru was about to go into battle with the British, he gathered his warriors and stood before them with the taiaha balanced horizontally between forefinger and thumb. The spirit of Uenuku entered the taiaha and it would turn and point to those men who should join the war party that day (pl. 16).

Another taonga that is still held by its inheritors is the greenstone tiki Mahutai-te-rangi. When Tahupotiki, the younger brother of Porourangi, founding ancestor of Ngati Porou, was forced to migrate to the South Island, some of his followers discovered a great rock of greenstone hidden in a cave.

They chipped off a piece and showed it to Tahu, and it was lighter in colour than the greenstone in the water. I suppose the sun had been beating down on the river greenstone for years and years and turned it that dark green colour, but the greenstone in the cave was hidden away and it had stayed very pale. They were trying to think of a name for it when somebody spotted some herrings in the river. "Hey! *He inanga*—herrings!

It's pale like those herrings", so they called the greenstone from the cave "inanga." The people decided to make something from that first chip, and because it was for the chief it had to be very fine. "How shall we carve it?" "Oh . . . you design it like a man, he'll be the one to lead us. Give him hands and a face and everything." "Yeah, but don't put his tongue out because we don't want a fighter. If he's going to be our leader we need someone who can talk to us and tell us what to do. Just leave his mouth open as though he's saying 'Go this way . . . no, not that!'" "And don't put a hole through his head, we don't want him dead. Just put the string through his arm and keep his hands up, because if his hands are down that means his work is finished—*ka pu te ruha, ka hao te rangatahi*—the old net is set aside, so you young people go fishing. But this man, no! He's going to live with us forever and be our guide to tell us what to do and what not to do."

So they carved the tiki Mahu-tai-te-rangi with one hand on his hip, and his face looking up at you all the time.

(Stirling 1976:162)

This is Amiria Stirling, the present holder of the tiki, talking about its history. When she was recently interviewed on television about old customs she wore Mahu-tai-te-rangi, and as she spoke the tiki twisted on its cord. Her husband saw this and said to her, "You see? Mahu-tai-te-rangi doesn't agree with what you're saying—he's turning his back!"

Greenstone weapons were also revered and handed down from father to son. A man would risk his life to recapture such a weapon, and might sing in its praise:

I fasten Te Heketua's strap (round my waist)
Indeed, you are not very large
(Still), the skin is clasped as at night by a woman's legs!

(Johansen 1954:102)

A famous mere (hand club) was a great gift, for reasons that are explained in this translation of an early Maori text:

The group of young people got up and put on their girdles, ready to leave, and their hosts gathered for the ritual of farewell. The chief of that fortified village took his greenstone mere and gave it to the young visiting high chief, and he in return presented his greenstone weapon to his host. Those *mere* were *manatunga* (heirlooms), and in the old custom it was proper for such men to exchange such weapons, because they represented the descent lines which held them in keeping. A prized greenstone weapon was kept for a time by the descendants in one line of descent, and then they carried it and presented it to those in another line of descent from the tribal ancestor who first made it. That was the way of exchanging those weapons.

(White 1888,4:125–127; author's translation)

A woman berating the kinfolk of a man who has taken her daughter without consent might say to them, "Come out of your stockade. Why did you rob me of my daughter? What property have I of yours, that you should presume to take my precious greenstone to wear on your breast? Come outside, that we may fight our battle" (White 1888,4:161).

Greenstone heirlooms could be included in genealogies, and all of these manatunga (greenstone treasures, literally, "standing mana") had an extraordinary power of binding, tying the living to the living in alliances, peace, and marriage, and the living to the dead. A peace ratified by greenstone should stand fast, and there was no more bitter treachery than one where a greenstone treasure had already been passed over. A weapon called Te Uira was given by Ngati Maru to Ngapuhi during nineteenth-century warfare, but no sooner was Te Uira received than Ngapuhi attacked, killing many of the local people. About fifty years later a Ngati Maru scribe wrote to the government asking for this treasure to be returned: "If you are the Government, and as Ngapuhi are so loyal to the Government, you might speak to Ngapuhi, and ask them to give the mere Te Uira back to us, the Ngati Maru. We do not ask for the people—they are dead, but Te Uira is still in existence, nor can it decay . . . " (White 1888 4:183).

At marriages, and the funerals of great chiefs, greenstone treasures were passed over to show loyalty and love and were at a later time returned. The pathways of alliance were traveled by women, children (in adoption), and greenstone, and so the tribal groups were bound together.

Carved images also summoned up the ancestor they described. Taylor describes how "the friends of the dead either carved an image, which they frequently clothed with their best garments, or tied some of the clothes of the dead to a neighbouring tree, or to a pole; or else they painted some adjacent rock or stone, with red ochre, to which they gave the name of the dead; and whenever they passed by, addressed it as though their friend were alive and present, using the most endearing expression and casting some fresh garments on the figure, as a token of their love" (Taylor 1855:62).

The heads of dead kin were preserved for this same reason, so that they might be wept over and cherished, and at a funeral in the descent group they were arranged around the head of the body, so that all the dead could be mourned and remembered together. Today, framed photographs are used in just this way. The chief's house of early contact times and the modern meeting house also embody ancestors, quite literally, for the house is named after some great predecessor and is built in his likeness, with the ridgepole (tahuhu, "main line of descent") as his spine, the koruru (carved head at the gable) as his head, the outstretched bargeboards with their end carvings (raparapa) representing his arms with hands spread wide in welcome, and the interior as his belly. When an orator stands to speak on the marae forecourt he addresses the house by name, and when the kin group assemble inside the meeting house at night and lie beneath its carved side posts (poupou) and the photographs on the wall, all of the descent group—living and dead—have come together in the belly of their ancestor (pl. 17).

The alchemy of taonga was to bring about a fusion of men and ancestors and a collapse of distance in space-time. The world was understood as a medium (wa) in which intervals could be marked out (taki) in social space by ritual, in groups by numbers, in physical space by boundaries, and in time by genealogy, but within this medium distance was not immutable. The power of kura (treasures, knowledge, chiefly men) could give men absolute access to their ancestors.

Plate 41. Gable-peak mask from meeting house. Koruru (cat. no. 101)

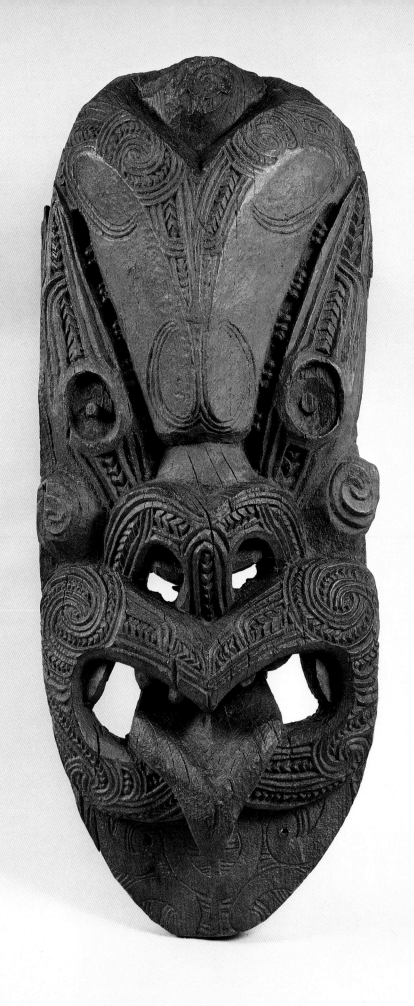

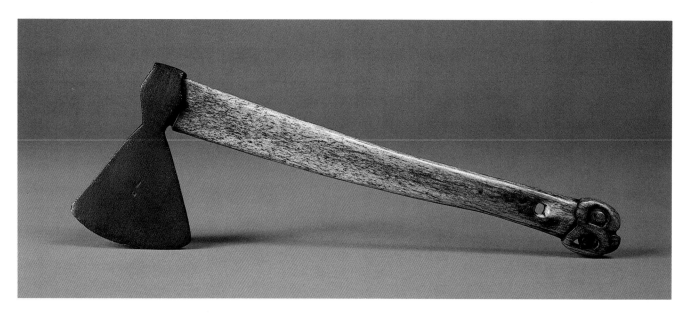

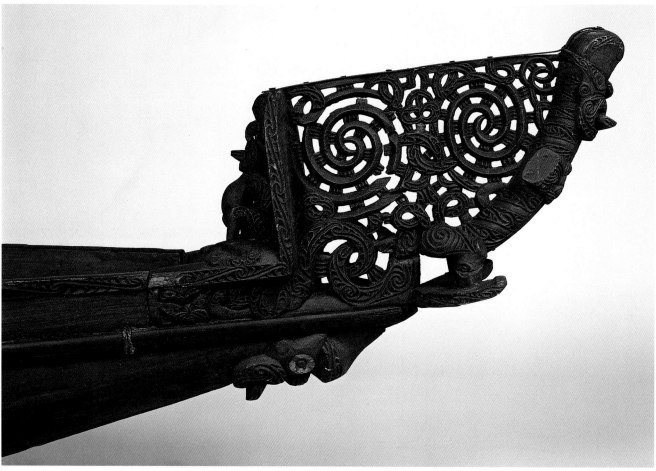

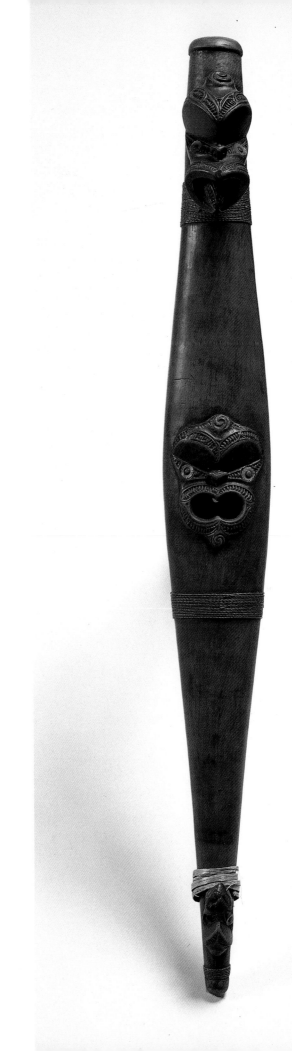

Plate 42. Tomahawk. Patiti
(cat. no. 105)

Plate 43. War canoe model. Wakataua
(cat. no. 113)

Plate 44. Bugle-flute. Putorino
(cat. no. 108)

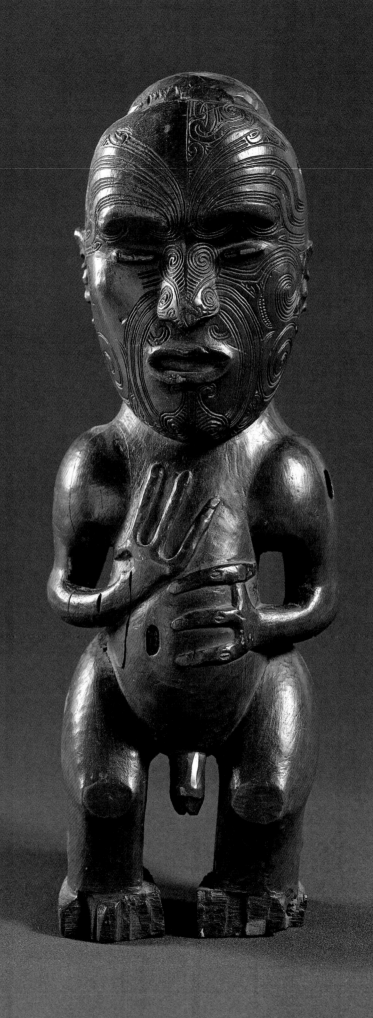

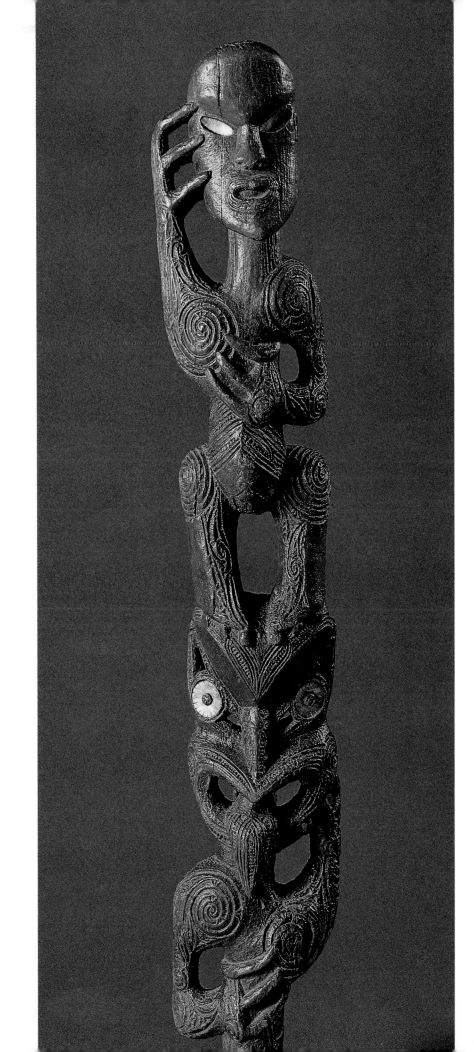

Plate 45. Post figure. Poutokomanawa
(cat. no. 118)

Plate 46. Gable finial. Tekoteko
(cat. no. 119)

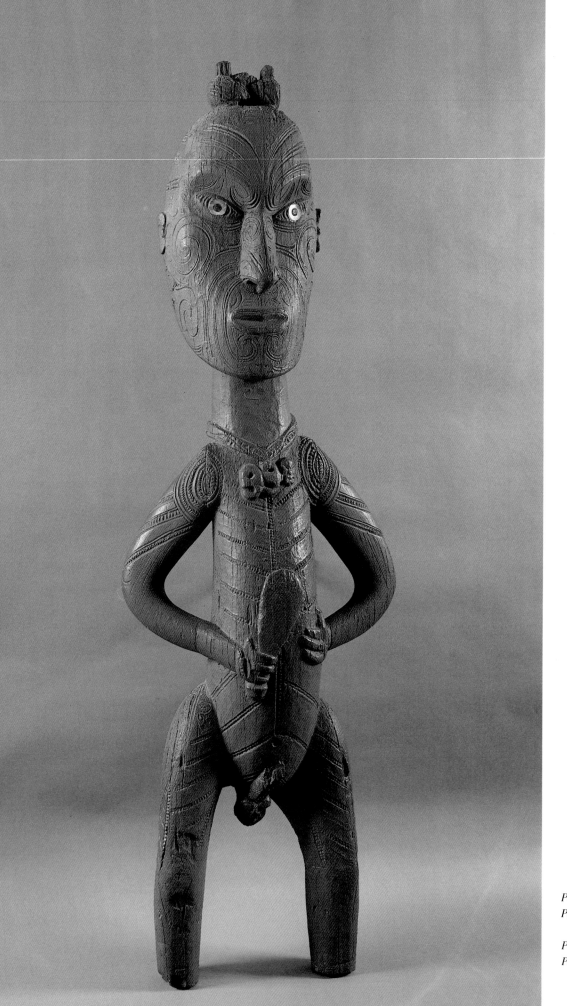

Plate 47. Stockade post figure.
Pou whakairo (cat. no. 130)

Plate 48. Post figure.
Poutokomanawa (cat. no. 127)

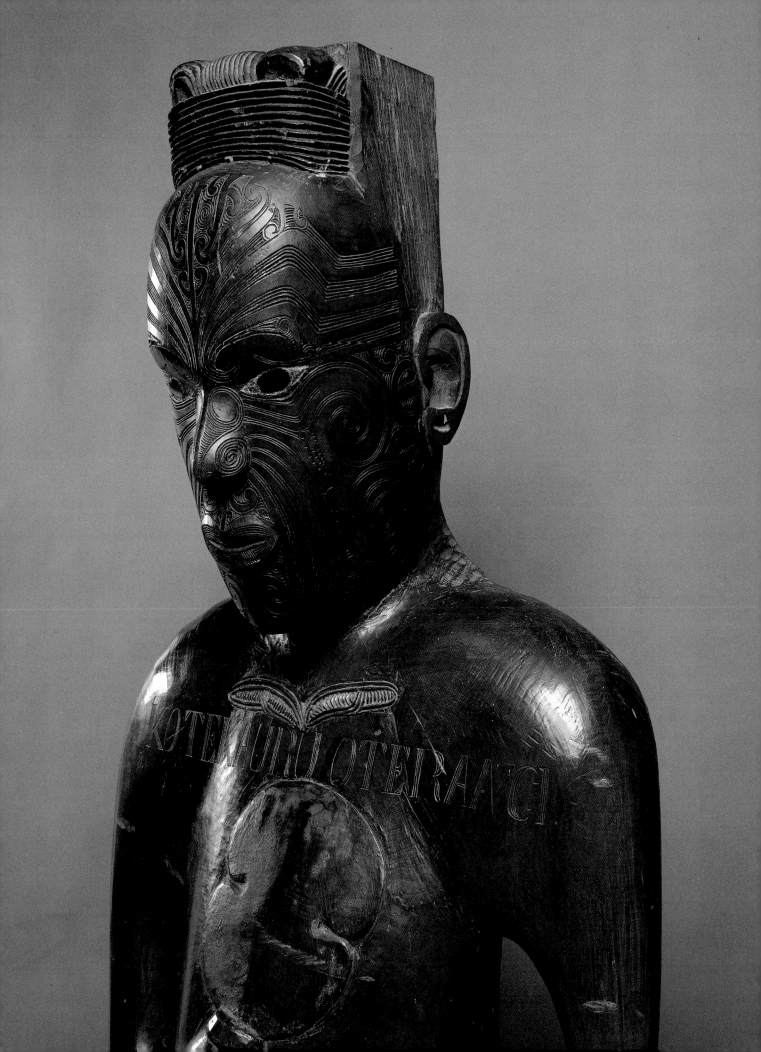

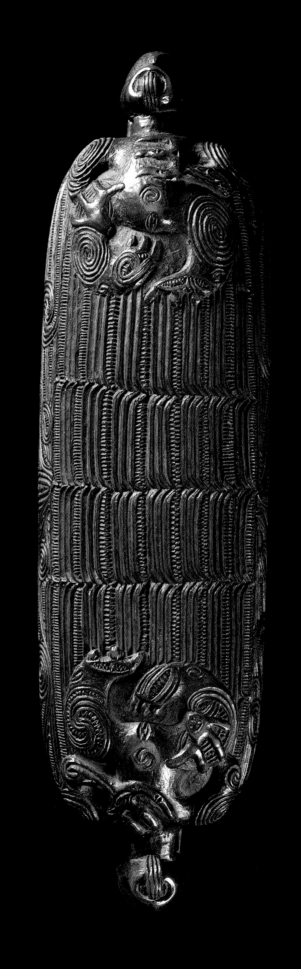

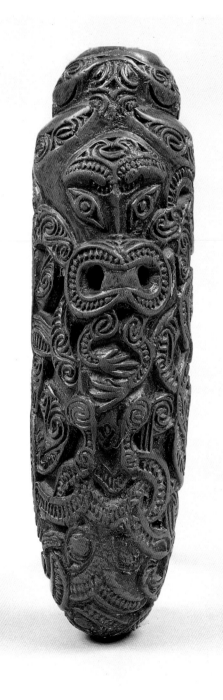

Plate 49. Feather box. Wakahuia
(cat. no. 138)

Plate 50. Flute. Koauau (cat. no. 140)

Plate 51. Club. Patu (cat. no. 149)

129

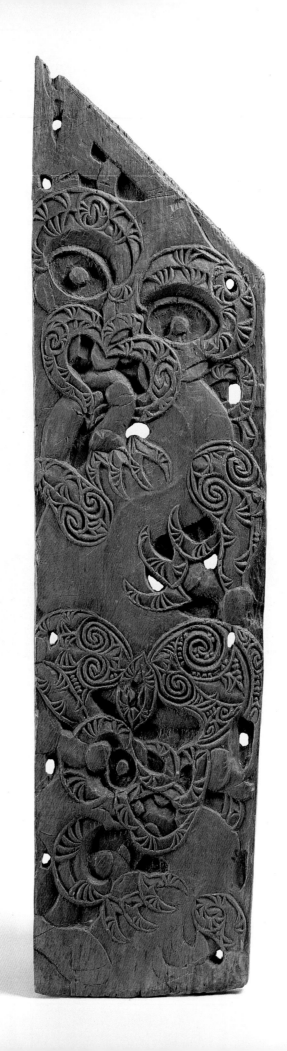

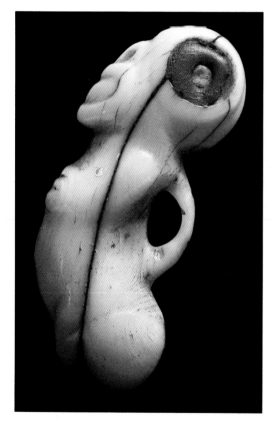

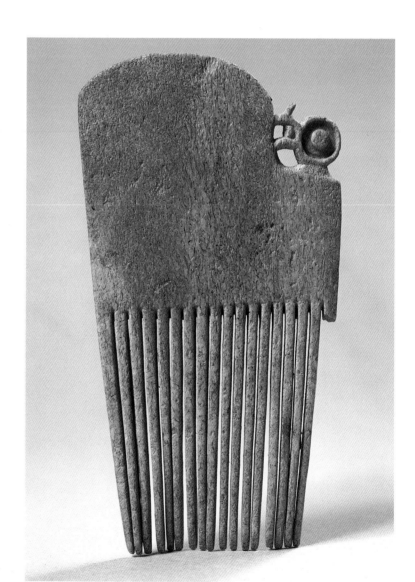

Plate 52. End post. Epa (cat. no. 153)

Plate 53. Pendant. Rei (cat. no. 147)

Plate 54. Pendant. Hei-matau (cat. no. 157)

Plate 55. Comb. Heru (cat. no. 159)

131

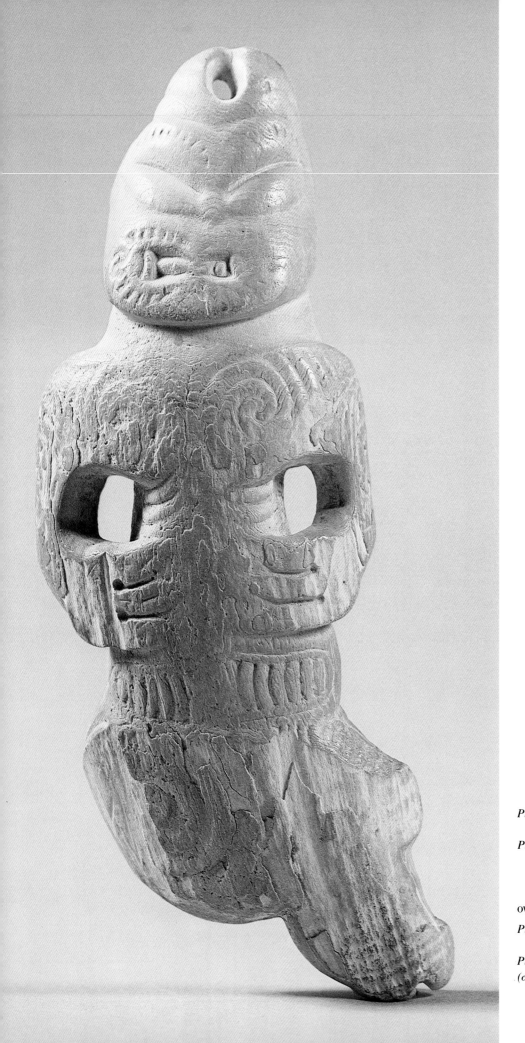

Plate 56. Pendant. Rei niho (cat. no. 160)

Plate 57. Pendant. Rei puta (cat. no. 162)

OVERLEAF:

Plate 58. Pendant. Hei-tiki (cat. no. 165)

Plate 59. Pendant, fishhook. Matau (cat. no. 167)

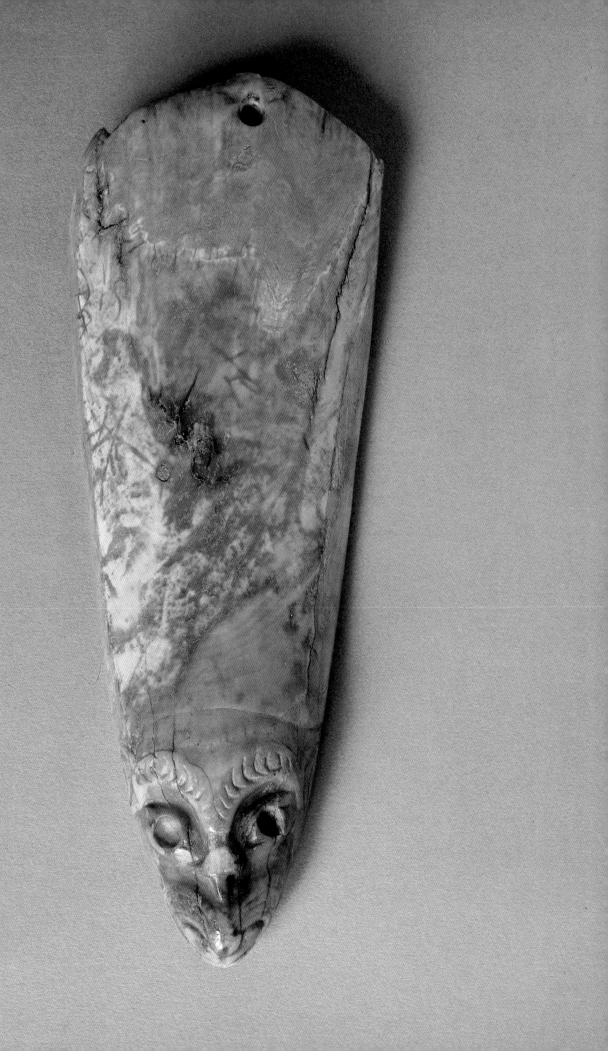

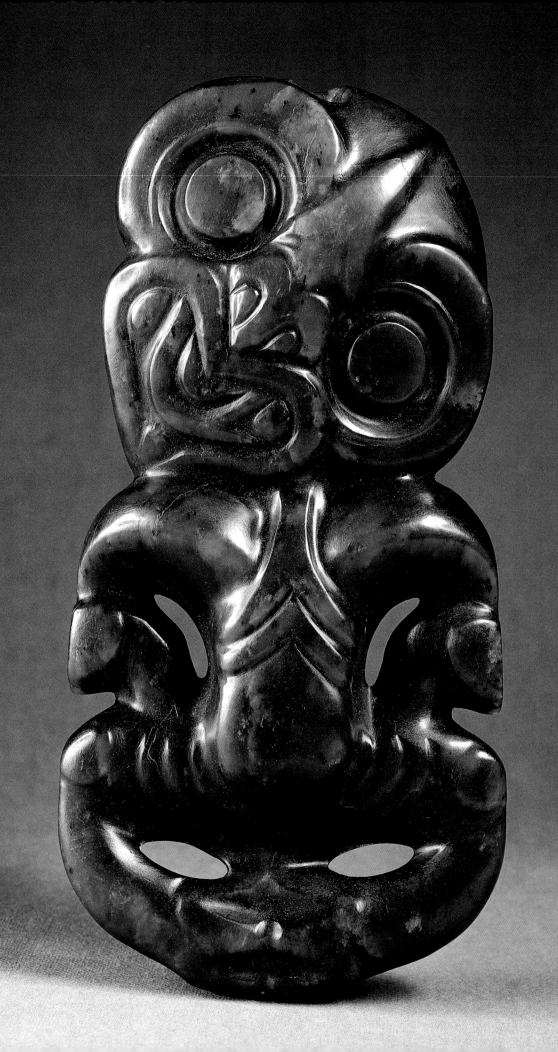

Listen to an old Tauranga chief speaking in a great debate about a century ago, about the canoe origins of the kumara: "As for your canoe Tainui, it was built after my canoe Mahanga-a-tua-mahara came here; what's more I made both these canoes, and I still have the adzes and the priests (their history and names) in my keeping. Of every single canoe that came here to New Zealand, my canoe was the first!" (White 1888, 4:17–18, author's translation.) His knowledge (kura) of the traditions of his tribe and his conviction of their absolute validity transcended perhaps a thousand years of distance and placed him among his ancestor craftsmen as they labored to build their canoe on the beaches of Hawaiki.

Names, knowledge, ancestors, treasures, and land are so closely intertwined in tribal thinking that they should never be separated. An irony of this exhibition is that we know so little of the history of its individual taonga, just because they have left the keeping of their inheritors. The early collectors saw these works as "artificial curiosities," and later as "artifacts" and "primitive art," and they had neither the interest nor in most cases the understanding to note anything more than a physical description of the item, and sometimes a place and date of collection, and an approximate label of use. The "artificial curiosities" were put in storerooms and given to museums, which is indeed the European way of caring for relics of the past. But the distancing and separation from people that this involves could not be more different from the Maori way of caring for manaaki (their treasures). It is only when a work stays with the people, when it is touched, wept and talked over, and takes part in their great gatherings that its history stays alive. It is now impossible to discover the names of most of the taonga in this exhibition—in Maori terms the only really vital piece of information about them—or anything of their history; because either they come from archaeological sites, or elders refused to pass over the stories when the works were first acquired, or their collectors did not think to ask that sort of question, and the works have been held in museums for too long. For all our efforts of interpretation, those of us who write in this catalogue cannot tell the stories that really matter about most of these works. We can only seek to demonstrate that these objects were once—and to Maoris still are —not artifacts, nor primitive art, but things of power.

"Well then, the works themselves stand . . . in collections and exhibitions. But are they here in themselves as the works they themselves are? Works are made available for public and private art appreciation. Official agencies assume the care and maintenance of works. Connoisseurs and critics busy themselves with them. . . . Yet in all this busy activity, do we encounter the work itself?

"However high their quality and power of impression, however good their stage of preservation, however certain their interpretation, placing [works] in a collection has withdrawn them from their own world. . . . The works are no longer the same as they once were. It is they themselves, to be sure, that we encounter there, but they themselves are gone by" (Heidegger 1978:167).

Aue, taku kahurangi e . . . Alas, my precious one . . . !

 (Lament for a lost treasure)

Plate 60. Fishhook ornament. Hei-matau (cat. no. 174)

NGA TOHUNGA WHAKAIRO O MUA
Maori Artists of Time Before

Bernie Kernot

Tohunga whakairo, the master carvers of antiquity, were men of distinction. Their fame and accomplishments were carried down the generations in tribal tradition, in genealogy, and in song. Such men were frequently chiefs of note in other fields too. Some were famed religious experts (tohunga ahurewa), while others were great leaders and fighting chiefs, such as Tuwharetoa, ancestor of the Taupo tribes. Tradition recalls an incident when Tuwharetoa's sons called him to join their taua (war party), but the chief had important work on his hands. He demurred, saying, "Wait until I have finished my new house, Te Korotiwha, the ornaments for which I am now carving" (E. Best 1977:77). Such traditions deserve reexamination in order to reconstruct the biographies of the carvers of old and provide glimpses into their lives.

Turongo was a famous ancestor of the Tainui tribes, the central figure in one of the great romances of those tribes. He was thwarted by his brother Whatihua in his attempt to wed the beautiful Ruaputahanga for whom he had carved a house. Shamed and disappointed, he left his village and the house he had adorned to look elsewhere for a suitable wife. Before leaving, he addressed a lament to the house, which began in the following way:

Hei konā rā, e whare kikino,	Farewell o evil house
Tū mai ai;	Standing there
Hei whakaahua ma te tangata.	As an object for people's gaze.
I te hikitanga o te poupou	When the posts were set up
Ka kopa i tehi tara,	And the sides were closed in
Ka hira kei runga.	You stood imposingly above.
No nōmata mai anō i ako mai	From time immemorial was taught
I te waihanga ko Ruatāhuna	The building knowledge of Ruatahuna.[1]
Ko ta rekoreko, rere mai te pua	Sparkling were you like the wind-blown petals,
Ko te ua-āwha	Then came the storm.
Ko Moananui, ko Moana-tea	Moana-nui and Moana-tea
Ko Manini-kura, ko Manini-aro.	Manini-kura and Manini-aro[2]
Tēnei rā ka tū kei te taku-tai.	Lie scattered on the sea shore.

(Kelly 1949:73–74)

Turongo traveled on to Heretaunga, now Hawke Bay, where his carving and other talents were appreciated by his hosts, who gave him as wife their highborn and lovely Mahinaarangi. From this union is descended the line of the Waikato Kahui ariki (royal family) down to the present incumbent, who is known as Te Mokopuna o te Motu (The Grandchild of the Land).

Tribes of the Hokianga district of North Auckland remember Kohuru Te Whata, an ancestor who lived some twelve generations ago. His story was told by Heremaia Kauere of Ngai Tu and Nga Tene sub-tribes, early this century, when Europeans disturbed a burial cave containing a group of carved bone chests. Of Kohuru he said:

Kohuru was the man that made them [the bone chests]; he was a chief, and was skilled in carving, and an instructor to the tribe. He lived at Otaua, say twenty miles away but used to go all over the place. There are five *tikis* (chests) in the cave. One he made for Kahu Makaka, who had been dead for a long time, to put his bones in. It was the custom to put the body in trees, and then get the bones after. Kohuru died at Waimamaku. He belonged to Ngai Tū and Ngā Tene. The *tiki* was put in a cave called Kohekohe, the cave which the Europeans have now disturbed. Kohuru himself conveyed the bones to the cave in the *tiki*; he took them from a stone close to the cave. He was a priest. I do not know whose bones were in the other *tikis*. They were all taken by Kohuru to the cave.

<div align="right">(Cheeseman 1906:454).</div>

One particular chest was said by Heremaia to have been carved not by Kohuru, but by one of his descendants five generations later.

Tamatakutai was another notable carver who lived at Mahia on the East Coast with his beautiful wife, Rongomaiwahine. Unfortunately for Tamatakutai his reputation as a carver outstripped his reputation as a provider. The wily Kahungunu came to his village and, taken by the beauty of Rongomaiwahine, plotted to take her from Tamatakutai. He showed himself to be such a prodigious provider of food that the women of the village exclaimed, "E, te hunaonga ma tātou. E, tēnei ko tēnei tangata māngere he whakairo anake tāna i mohio ai." (Ah, that's the son-in-law for us. This other lazy fellow knows only his carving.) (Te Whareauahi 1905:68)

Ngata (1958:32) mentions Te Uaterangi, whom he took to be a Hawke Bay ancestor, as carving a house at Taupo. Tradition has it that his art was stolen by an Arawa man called Te Riripo who, however, died by falling from cliffs that now bear his name, Te Pari-O-Riripo. Riripo it seems was not the source of the Arawa carving tradition, which Ngata believed came from the Ngati Awa people of Whakatane as part of a marriage exchange with the Ngati Tarawhai people of Lake Okataina, in the Rotorua district. Ngati Awa themselves have a tradition of three famous carvers, all brothers. They were Ira-peke, Rongo-karae, and Rongomai-noho-rangi. Rongo-karae is better remembered by the Tuhoe people of Ruatoki, but the descendants of Ira-peke in particular were noted for their carving (E. Best 1977:299).

The name that stands out among all the tohunga whakairo of antiquity is that of Hingangaroa, already mentioned by Mead, Simmons, and Salmond as the founder of the celebrated school, Te Rawheoro, at Uawa (Tolaga Bay). Mead

has discussed the mythological sources of carving and their relationship with Hingangaroa and his famous school, and Rangiuia's lament quoted by him refers also to the dissemination of the knowledge of carving in the lines

Ka riro te whakautu, te Ngaio-
 tū-ki-Rarotonga,
Ka riro te manaia, ka riro te
 taowaru.

There was gained in exchange
 the Ngaio-tu-ki-Rarotonga,
There was taken off the manaia
 and the taowaru.

(Ngata 1930:34)

The manaia (fig. 25) and the taowaru, two important carving patterns, were passed on to Tukaki and Iwirakau in exchange for the ancient taonga (heirloom) Ngaio-tu-ki-Rarotonga. The following genealogy traces Hingangaroa's descent from Porourangi, eponymous ancestor of Ngati Porou, and carries it down to some of his descendants through whom the knowledge of carving was passed on.

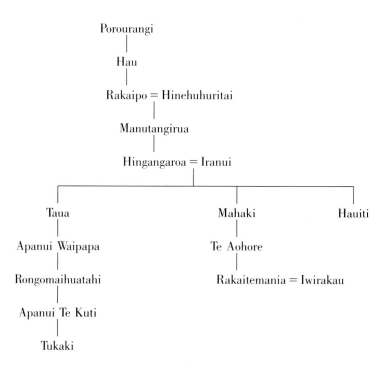

(Ngata 1972: Genealogical Tables 5 and 7; Mead and Phillis 1982:126)

Hingangaroa's school survived through the line of his descendants into historic times. Its last session was held in 1836, when it was presided over by Rangiuia, composer of the lament quoted above. Rangiuia's descent was through Hauiti, eleven generations separating him from Hingangaroa (Ngata 1930:23).

Knowledge of carving spread to Te Whanau-a-Apanui, Ngati Awa, and Te Arawa in the east through Tukaki, a descendant of Taua. Iwirakau, who married Rakaitemania, the great-granddaughter of Hingangaroa, established a school in the Waiapu–Te Araroa area of Ngati Porou, which survived to the death of Hone Ngatoto in 1928 (Ngata 1958, no. 22:37). This school flourished in the nineteenth century under such tohunga whakairo as Tamati Ngakaho, the first to use steel tools; Hone Taahu, the uncle of Ngatoto; and Hone Ngatai and his

Figure 24. Epaepa (end post) featuring an elaborate manaia (profile) form with surface decorations now considered to be typical of the Gisborne region. Carving for the church at Manutuke, Gisborne. c. 1848. Attributed to Raharuhi Rukupo. Photo: M. D. King, Victoria University of Wellington

140

nephew Haare Tokoaka. Ngakaho is best remembered today for his great meeting house named Porourangi (c. 1883), now standing at Waiomatatini. Hone Taahu assisted by his nephew Ngatoto and Wi Tahata carved Hinetapora (c. 1883), still standing near Ruatoria (McEwen 1966:423), while Hoani Ngatai and Haare Tokoaka are credited with carving Tumoanakotore (1872) (Taiapa n.d.:15).

The Te Whanau-a-Apanui school survived into the nineteenth century, becoming extinct about 1820 (see Simmons's discussion). A revival of the art took place later in the century by descendants of the original carvers. According to the late Dr. Wi Repa, nine carvers from Te Kaha "all being able to trace descent from the master carver Tukaki" assisted the Ngati Awa master Wepiha Apanui with his house Mataatua (1872) at Whakatane (Phillipps and Wadmore 1956:33). This house is now in the Otago Museum.

The carvers of old whom we have been discussing were all rangatira, that is, men of rank. Tuwharetoa and Turongo were outstanding chiefs and political leaders as well as accomplished carvers. Hingangaroa, on the other hand, was a priest (tohunga ahurewa) and teacher in the whare wananga (formal schools of learning) as well as a carver, while Kohuru, by Kauere's account, combined all these functions with that of political leadership. Te Uaterangi appears to have been an itinerant tohunga whakairo, an established master accepting commissions from near and far. It is evident in the traditions that carving was considered to be a chiefly occupation and master carvers were drawn from the rangatira families. This view is reinforced by the early ethnographers. For example, Augustus Earle, who greatly admired the arts of carving and tattooing that he saw in the Bay of Islands in 1827, observed how "None but men of rank are allowed to work upon them [canoes] and they labour like slaves" (Earle 1832:110). Robley (1915:29) provides another telling example in the embarrassing incident of a group of chiefs in Auckland having kept the Governor waiting for an appointment because they were so intent on their carving they had not noticed the passing of the time.

Firth (1925:280) claimed that slaves could gain status through skill in wood carving, and there are recorded instances of carvers and tattooers who were slaves. A well-known example is Earle's friend Aranghie [sic], the slave tattooer of the Bay of Islands. Whether "Aranghie" had been enslaved as a tohunga ta moko (tattooing expert), or whether he had achieved such distinction and chiefly patronage as a slave is not clear from Earle's account. It is likely to be the former, as it was not unknown for carvers to be enslaved and forced to carve for their captors (Barstow 1878:74), a point already made by Simmons.

A more direct approach, and one that gives us a better insight into traditional attitudes to carving, comes from several Maori texts in which carving is discussed in relation to chieftainship. Wi Maihi Te Rangikaheke, a leading chief of Ngati Rangiwewehi of the Rotorua district, supplied Grey with manuscript material on traditions and mythology in the 1840s. Much of it was subsequently published by Grey, but the short manuscript entitled "Te Tikanga o Tenei Mea o te Rangatiratanga o te Tangata Maori" (The Customs of Chieftainship among the Maori People) remains unpublished among the Grey papers in the

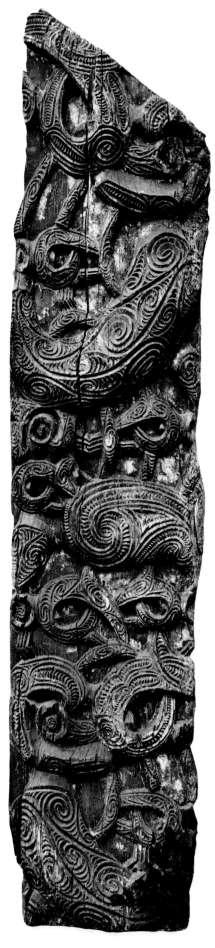

Auckland Public Library (Te Rangikaheke 1849:91–97). The text is a discussion on the attributes of chieftainship, which were thought of as inherited qualities rather than acquired. Commoners could certainly not be expected to share them. "E kore hoki ēnā e poto [sic] ki roto ki te puku tūtūā. Na te moenga rangatira iho ano ēnā mea i taea atu ai." (Such qualities cannot be expected in the belly of the commoner for they are possible only through chiefly marriages.) The attributes identified as being a chiefly endowment include

being knowledgeable in the conduct of discussions on food procurement;
being knowledgeable in building houses and canoes;
possessing warrior qualities;
ability in planting and cultivating;
ability in providing betrothal and wedding feasts.
ability in making guests welcome;
ability in making welcoming speeches.
ability in speaking in the council;
qualities of kindness and generosity.

Food management, oratorical skills, and hospitality appear to be emphasized in this discussion, but high on the list are carving skills, which are included in the general activity of building. The term used, "tango-hanga-whare," implies buildings and canoes as prestigious objects embellished with carving and therefore a sign of prosperity.

In a later discussion on omens, published as appendixes in *Nga Moteatea* (Grey 1853:lxxix ff.), Te Rangikaheke again refers to house- and canoe-making. Evil omens (aitua) are described as evil things and are associated with te po (night, underworld)—"Ko nga mea kikino, nga aitua, no te pō ērā mea kino." Good omens (waimarie) are described as good things and are associated with te ao (daylight, world). Clearly aitua and waimarie include more than the Western ideas of chance and luck. They imply a certain standing with the gods which bears directly on a person's mana. An aitua indicates a loss of favor and a consequent threat to one's mana, while waimarie indicate the gods' favor and an increase in mana. The text tells us it is an aitua to be omitted from the assembling of men for, among other things, house-building and canoe-making. Conversely, nimbleness in house and canoe construction indicates waimarie. The text is not specifically a delineation of chiefly qualities, but indications within it suggest that Te Rangikaheke, himself a man of high rank and accomplishments, had rangatira status in mind in his discussion.

Another source that links carving with chieftainship is the Ngati Awa chief Himiona Tikitu, recorded by Elsdon Best in his notebook as follows:

E waru nga puareare o te manawa. This term is applied to men who are brave, good leaders and counsellors, industrious, clever, hospitable. According to H. Tikitu the eight pū manawa are: He kaha ki te mahi kai. He kaha ki te whakahaere i nga raruraru. He toa. He kaha ki te whakahaere i te riri. He mōhio ki te whakairo. He atawhai tangata. Te hanga whare nunui, pā rānei, waka rānei. He mōhio ki nga rohe whenua. The term applies to inborn cleverness, aptitude, excellence, good qualities, etc., and not to such things as are taught in the whare maire.

(E. Best n.d.:103)

Best later translated and published the eight pu manawa (talents), which are given here in full for comparison with the Te Rangikaheke text:

industry in cultivating or obtaining food;
the power to manage and mediate, to allay troubles;
bravery, courage in war;
generalship, a good leader of men in war;
knowledge of the arts of carving, etc.;
generosity, kindness;
knowledge of house, fort, and canoe building;
knowledge of tribal boundaries.

<div align="right">(E. Best 1901:8)</div>

The close similarity of approved qualities between the two statements extends also to the stress on their innate nature. According to Best (n.d.:103), they are "he mea hanga ki roto ki te kopu o tona whaea" (qualities established in the mother's womb). There is no doubt that these are qualities that belong to chiefly rank, since the comment is made, "E whā anake nga pū manawa o te tūtūā" (Commoners have only four talents), without stating which of the four they share.

These texts suggest not only that carving was considered appropriate for the rangatira, but that they were expected to have some aptitude for it. Commoners, on the other hand, do not seem to have been encouraged in the art. Some chiefs developed their talent and became professional carvers and recognized specialists, but all chiefs appear to have had some competence. Earle's chiefs in the Bay of Islands are one example. In 1814 Hongi Hika, also from the Bay, demonstrated his competence to Marsden when he carved his remarkable "bust" on request while in Paramatta, New South Wales (Missionary Register 1816:524; Binney 1968:48).

We have to agree with Firth (1925:283) who said that little is known of the training and professional preparation of tohunga whakairo. All knowledge had a divine source and was therefore tapu (sacred). Strict ritual conditions attended its transmission, but ritual and technique were part of the stock of knowledge and skills needed for any pursuit. Carving was a particularly tapu activity because it dealt with the ancestors and gods, and tohunga whakairo were highly respected members of the community. The transmission of knowledge generally was highly systematized, according to Best (1923) and others, and it took place either in the formal schools of learning (whare wananga), or on the basis of individual tuition. Either way it involved rituals and karakia (incantations) and was highly formalized. Individual tuition was the transmission of specialized knowledge kept within a descent line. Smith observed that in cases where someone from outside the family or tribe was taught by a tohunga, not all the teacher's knowledge was passed on. "There were certain branches of knowledge and *karakia* that were family and tribal property, and these were not communicated" (Smith 1899:261).

The Hingangaroa tradition clearly associates the carving arts with Te Rawheoro, the whare wananga at Uawa. Best published a Maori text of unidentified source as an appendix to *The Whare Kohanga and Its Lore*. The writer there states that

instruction of boys in the use of weapons and tools begins about the age of seven. Instruction proceeds in stages to the building of all kinds of structures, to the use of adzes in dressing timber, and to the carving and painting of designs. Finally instruction is given in canoe-making. The account is brief and stresses the practical nature of the skills to be taught, but the text makes it clear that the curriculum as given was taught in the whare wananga. "Koia nei nga take ako tamariki a [sic] mua i roto i nga whare wānanga ako i nga mahi pēnei me ēnei i kiia ake nei e au." (These are the matters taught to the children of old in the houses of learning, taught these skills and all those I have spoken of.) (E. Best 1929:62)

In his more extended discussion of the whare wananga in *The Maori School of Learning* (1923), Best does not specifically mention carving, but he stresses the intellectual, oral, and sacred nature of the curriculum taught there. Barrow (1963:6; 1978:13) says that young carvers served a sort of apprenticeship under skilled priest-craftsmen, and Neich (1977:108) also refers to the passing down of carving skills through family lines in the Ngati Tarawhai tradition. What seems most likely is that all rangatira youth were given instruction in carving in the whare wananga, and those intending to become specialists served an apprenticeship under a master carver. Master and pupil were in most cases close relatives. Once the pupil had learned all that the teacher had to impart, including the esoteric meanings, the rituals and the karakia, a final rite was performed by the master to confirm his pupil in his knowledge and status (E. Best 1923:20–24).

As carvers were of chiefly stock so, too, were their patrons. Carved houses, storehouses, and canoes were prestige objects that reflected the mana of the chiefs and, by extension, that of the people. As one proverb has it, *He whare maihi tū ki roto ki te pā tūwatawata, he tohu no te rangatira; he whare maihi tū ki te wā ki te paenga, he kai na te ahi*. (A decorated house that stands within the pa is a sign of a chief; a decorated house that stands outside the pa is food for the fire.) (Turei 1913:63) Two important patrons of the nineteenth century were Te Waata Taranui and his son Te Pokiha of Ngati Pikiao of the Rotorua region. They commissioned canoes, houses, and storehouses from Ngati Pikiao and Ngati Tarawhai carvers, including the great Fox Pataka in the Auckland Museum (Neich 1977:94). As already mentioned by Simmons, Te Rauparaha was another patron of Arawa carvers. On the other hand, chiefs could be the recipients of carved buildings in complicated exchanges sealing political alliances. This occurred in the case of the Nuka Tewhatewha pataka carved by the great Tuwharetoa chief Te Heuheu Tukino IV, otherwise known as Patatai, who presented it to Wi Tako of Wellington as one of the symbolic pillars of the King Movement in the 1850s.

The tohunga whakairo of old tend to be remembered for their achievements and were loved and revered by their descendants even if they failed to engage the interest of the outside world, which found little to identify with in the works of the ancestors. The masters of the nineteenth century, on the other hand, were a different proposition. They lived in the turbulence of a bi-cultural frontier society and in various ways responded to its pressures, challenges, and possibilities. Sometimes they responded politically, like Te Rangihaeata and

Raharuhi Rukupo in the Wellington and Gisborne regions respectively, and came into conflict with settlers and Government, or, like Anaha Te Rahui (fig. 25) in the Rotorua–Bay of Plenty area, they fought for the Government against other tribal forces. Raharuhi adopted Christianity and died a Christian, while Anaha grew up a Christian from an early age. By contrast, Te Rangihaeata rejected the new religion and reaffirmed the old. The non-Maori world could not ignore or remain neutral toward them. They had become identities in the colonial history of New Zealand.

In order to highlight differences of this sort, as well as matters more central to art, I shall now focus attention on the lives of a small number of "traditional" carvers who did most of their work during the first century of Te Huringa—The Turning—period (1800–1899): Te Rangihaeata, associated with the Head of the Fish (Te Upoko o Te Ika; see map 3); the Ngati Tarawhai carvers of the Hot Lakes region around Rotorua; and Raharuhi Rukupo associated with Gisborne.

Te Rangihaeata (c. 1780–1855)

One authority gives Te Rangihaeata's uncertain birthdate as about 1780 at Kawhia on the west coast of the North Island (Carkeek 1966b:45). He died at Otaki and was buried above his village of Poroutawhao in 1855. His life spanned the turmoil and upheaval that marked the transition of New Zealand from te ao tawhito (the ancient world) to te ao hou (the new world) as a British colony and the uprooting of his own Ngati Toa people from their Kawhia homeland and subsequent resettlement in the Cook Strait region under the leadership of his uncle Te Rauparaha.

Described variously by Europeans who knew him as proud, ferocious, volatile, cruel, reckless, merciless, and passionate, he was, nonetheless, a striking figure, tall and powerful, standing over six feet and with a noble bearing. It was said of him, in 1849, that "his air and manner at once betrayed the chief, and would have marked him out among 1,000 people to the eye of the most casual observer" (Lloyd, in Ramsden 1951:150). The Heaphy portrait (fig. 26) pre-

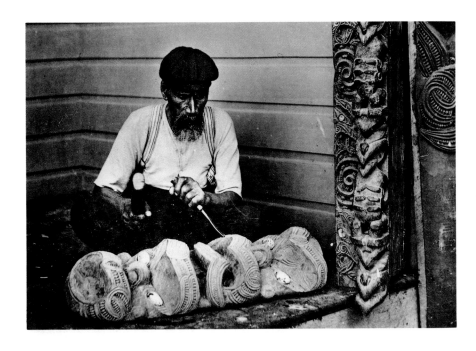

Figure 25. Anaha Te Rahui (1822–1919), one of the great carver-chiefs, working with the steel chisel. Photo: National Museum of New Zealand, Wellington

145

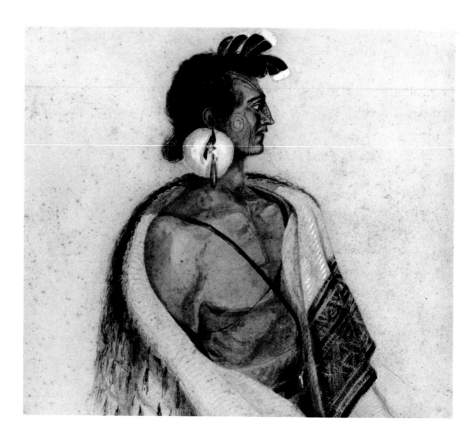

Figure 26. The carver Te Rangihaeata
(c. 1780–1885). Watercolor by Charles
Heaphy, from a sketch dated to 1840.
Alexander Turnbull Library, Wellington

sents him in his prime, a traditional cloak draped over his shoulders, ornaments suspended from his ear, feathers in his hair, and the moko (tattoo) lines on his face emphasizing the fiercely intent gaze.

His whakapapa (genealogy) as traced down from Hoturoa did not put him in the category of rangatira of the highest rank. He was, however, a nephew of Te Rauparaha, one of the greatest of Maori fighting chiefs, and his fortunes were inextricably linked with those of his uncle. The following whakapapa (Burns, 1980:315) gives the relationship:

Te Rauparaha and his sister were related to Ngati Raukawa through their mother Parekohatu. In the course of time he rose from relative obscurity to become a leader recognized by both tribes. His affection for his sister, herself a woman of forceful personality, extended to her children, especially Rangihaeata. The latter was devoted to his uncle, who was for him the very model of warriorhood. In his mature years he became Te Rauparaha's confidante and second-in-command. The relationship of uncle and nephew was crucial to the conquest of the Cook Strait region and, later, in the tragic events that marked the relations between settler and Maori in the infant settlement of Wellington and its environs.

Little is known of his upbringing, though from his accomplishments in later

146

years he seems to have been well schooled in the whare wananga, as befitted his rangatira status. It is said that he was educated in an esoteric school of carvers (Carkeek 1966b:45). However, he also had a reputation as an authority on tribal history and traditions (Burns 1980:154), and his artistic talents extended to the composition of waiata (chanted poetry), an accomplishment in which his sister, Topeora, had also gained recognition. Despite his warrior reputation, by which he is best known today, he appears to have been well educated in the tribal schools and accomplished in many fields of culture.

No authenticated carvings of Te Rangihaeata have survived to the present. Fortunately, the itinerant artist G. F. Angas visited his nearly deserted pa on Mana Island in 1844 and left us the illustration of Te Rangihaeata's famous house Kai Tangata (fig. 27) and the ornate mausoleum for Waitohi who had died a few years earlier. Angas (1846, 1:264) described these two structures as "the most perfect and elaborately ornamented native buildings in this portion of the Straits." Of the house he wrote:

"Kai tangata," or "Eat man" house, is a wooden edifice in the primitive Maori style, of large dimensions, with the door-posts and the boards forming the portico curiously and elaborately carved in grotesque shapes, representing human figures, frequently in the most indecent attitudes: the eyes are inlaid with paua shell, and the tattooing of the face is carefully cut. The tongues of all these figures are monstrously large, and protrude out of the mouth, as a mark of defiance toward their enemies who may approach the house. The whole of the carved work, as well as the wooden parts of the building, are coloured red with *kokowai*, an ochre, found principally on the sides of the volcano of Taranaki. The portico or verandah of Rangihaeata's house is about twelve feet deep, and the ridge-pole and frame-boards of the roof are richly painted in spiral arabesques of black and red; the margin of each spiral being dotted with white spots, which adds richness to the effect. The spaces between the woodwork are filled up with variegated reeds, beautifully arranged with great skill, and fastened together with strips of flax dyed red, and tied crosswise, so as to present the appearance of ornamental basketwork. Above the centre of the gable-roofed portico is fixed a large wooden head, elaborately tattooed, with hair and a beard fastened on, composed of dogs' tails. Within the house is a carved image, of most hideous aspect, that supports the ridge-pole of the

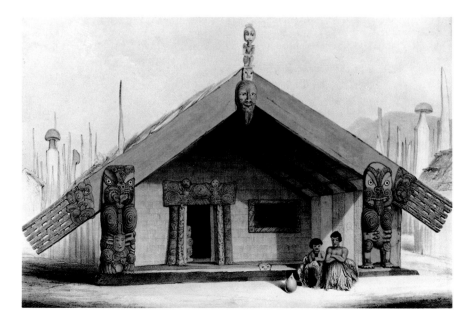

Figure 27. Te Rangihaeata's house, Kai Tangata, begun c. 1830, which stood on Mana Island, Cook Strait. Painting by G. F. Angas, c. 1844. Alexander Turnbull Library, Wellington

roof: this is intended to represent the warlike proprietor, and is said by the natives to be entirely the work of Rangihaeata's own hand.

<div align="right">(Angas 1846, 1: 264–265)</div>

The house was begun about 1830 by Rangihaeata himself (Burns 1980:154) and its proportions and the scale of the carvings indicate steel-tool technology. It is typical of a chief's house built about that period, including the singular feature of his own self-carved effigy. A similar feature is found in Raharuhi Rukupo's house in Poverty Bay which was being carved about the time Angas was visiting Kai Tangata on Mana Island. The mausoleum, which stood nearby, was a painted structure without any carvings.

His house and the mausoleum (which we assume to be his work) establish Rangihaeata as a master in the arts of building and decorating. Surprisingly we have no record of his building canoes, yet he would almost certainly have been trained as a canoe-builder. Ngati Toa had always been a maritime people, both at Kawhia and later in Cook Strait, where canoes had played a vital part in the conquest of the area. As already mentioned, about 1828 Te Rauparaha had commissioned Ngati Tuara and Tuhourangi canoe-builders from Rotorua to help enlarge his fleet, timber for this project coming from Rangihaeata's own forest in the Wairarapa Block near Te Horo (Carkeek 1966a:26), but there is no record of Rangihaeata himself participating in the work.

By the early 1840s both canoe building and house carving appear to have been in decline in the Cook Strait area. Many Maoris were engaged in whaling, and the European whaleboat was replacing the canoe. Political events were moving rapidly and claiming more of the attention of Te Rangihaeata, culminating in the arrest of Te Rauparaha in 1846 and the voluntary exile of his nephew to the swampy seclusion of Poroutawhao until his death in 1855.

Te Rangihaeata exhibited in high degree the chiefly endowments enunciated by Te Rangikaheke and Himiona Tikitu. He was primarily a fighting chief embroiled in the politics of his time, yet he had remarkable intellectual and artistic gifts which had been developed in the tribal schools. Little of his carving work is known to us, though Kai Tangata and his mother's mausoleum would undoubtedly be among his major achievements. He continued to the end of his life as a composer and performer of waiata, many of which are known to the present generation.

Te Amo-a-tai (c. 1800–1880), Wero-Taroi (c. 1810–1880), and Anaha Te Rahui (1822–1919) of the Ngati Tarawhai Carving Tradition[3]

One of the great carving traditions of Te Arawa was that of the Ngati Tarawhai tribe. According to Ngata (1958) the source of this tradition was the school established by Hingangaroa at Uawa which was passed on by the Ngati Awa carvers of Whakatane. By the beginning of the nineteenth century Ngati Tarawhai had a well-established reputation as canoe-builders, but small decorated chiefs' houses and carved pataka (storehouses) were also part of their repertoire. By the mid 1830s these carvers appear to have mastered the new steel-tool technology particularly useful to canoe-builders. However, from about 1868 canoe building ceased and Ngati Tarawhai became embroiled in the Land Wars on

the side of the Government until 1872. In the political and religious ferment that followed the wars, large ornately carved tribal meeting houses (whare whakairo) emerged as the major prestige structures. As Neich says, such buildings served the function of chief's houses, guest houses, and churches.

Missionary influence from 1835 appears to have discouraged the use of carving and carved images in churches. Although churches were built, they do not appear to have been embellished with traditional figures, as had occurred in Poverty Bay. The development of local and indigenous religious movements after the wars, especially the Ringatu Church, had more influence on the development of the whare whakairo.

The carving tradition passed down through family lines, younger carvers serving their apprenticeship under a relative who was already a master carver. As members of ranking rangatira families, many of them also filled other roles, such as political and religious leaders. They would certainly have been educated in Maninihau, the famous whare wananga of Lake Okataina whose presiding tohunga were known well beyond the boundaries of Te Arawa. The major nineteenth-century carvers were descendants of Te Rangitakaroro through one

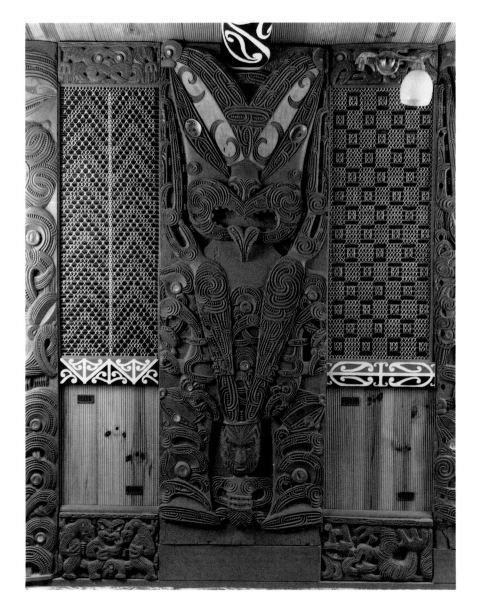

Figure 28. Poupou (side post), from the house Nuku-te-Apiapi, which stood at Whakarewarewa, Rotorua. c. 1871. Attributed to Wero Taroi (c. 1810–1880). Te Awara Trust Board, Rotorua

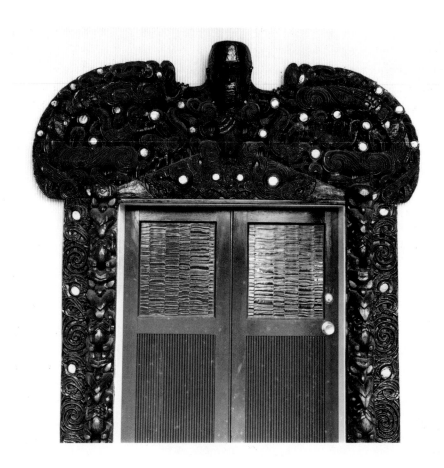

Figure 29. Pare (door lintel), from the house Houmaitawhiti. c. 1860, carved by Wero Taroi. Otaramarae Marae Trustees, Rotorua

or other of his three wives, some six generations back from Te Amo-a-tai.

The series of transitions and transformations in the Ngati Tarawhai tradition during the nineteenth century can be followed through the line of their most important carvers, Te Amo-a-tai, Wero Taroi, and Anaha Te Rahui.

Though he trained as a canoe-builder, probably about 1830 during the transition from stone- to steel-tool technology, Te Amo-a-tai is better known as an innovative house-builder of the postwar period when the large whare whakairo were coming into vogue. Some of his work survives in the meeting houses Uenuku-Mai-Rarotonga (1875), near Lake Rotoiti, and Rangitihi (1871), now in the Auckland Museum, but he is also credited with carving the smaller and earlier chief's house, Te Rangiunuora at Lake Okataina, since lost.

It is not clear who taught Te Amo and his equally famous brother Tara Te Awatapu, but his father's younger brother, Mahikore, had a reputation as a carver and may have been his teacher. What is known for sure is that Te Amo taught Mahikore's son, Wero Taroi, one of the greatest Arawa carvers (fig. 28). As with his cousin-teacher, Wero was trained in canoe building, but his reputation is that of a house-builder, where he stands as one of the greatest formative influences in the whole of Te Arawa. Little is known of Wero himself, but much of his work still survives in extant houses such as Houmaitawhiti of about 1860 (fig. 29) and Uenuku-Mai-Rarotonga, carved in association with Te Amo, or in various museum and private collections. One of his most famous houses is Hinemihi (1880), which sheltered the survivors at Te Wairoa Village on the night of June 9–10, 1886, when Mount Tarawera erupted. It was subsequently sold to Lord Onslow and now stands in Clandon Park, Surrey, England.

Wero had several notable pupils, one of whom was the chief Anaha Te Rahui

(figure 25), whose long carving career brought the Ngati Tarawhai tradition into the twentieth century. Like Wero and Te Amo before him, his carving career began during the canoe-building phase, about 1850, but most of his career was as a house-builder. His father, Te Rahui, a leading chief of Ngati Tarawhai, appears to have been an early convert to Christianity when the Church Missionary Society became established in Rotorua in 1835. Anaha became a Christian at an early age, was educated in the mission schools, and was literate. His older brother, Te Ohu, became a mission teacher, and Anaha assumed the chiefly responsibilities of his father. As Grey's administration was extended to the interior, Anaha was appointed a court assessor at Okataina. Later, when Te Arawa became involved in the Land Wars between 1863 and 1872 on the side of the Government, Anaha led a tribal contingent on several of their campaigns. After the wars his tribal responsibilities left him little time for carving, though he was associated with several notable buildings including Tokopikowhakahau of 1878 (fig. 30) with Wero. In later years Anaha worked on contract for the Government and other European patrons, completing the transformation from tribal to commercial production.

Raharuhi Rukupo (c. 1800–1873)

At a time when carving was in decline in many parts of the country, the Turanga (Poverty Bay) school was at its zenith under the leadership of Raharuhi Rukupo (fig. 33), one of the greatest of all Maori carvers. He was the second son of Pohepohe, sometimes known as Pitau, a chief of the Ngati Kaipoho hapu (subtribe) of the Rongowhakaata tribe of Poverty Bay. His older brother, Tamati Waka Mangere, who succeeded to the chieftainship of his father, was a signatory to the Treaty of Waitangi when it was brought to Poverty Bay, but he died shortly afterward, leaving Rukupo to succeed to the chieftainship. Though primarily of Ngati Kaipoho, he was also closely related to the Ngati Maru hapu, claiming descent through Timata. His genealogy from Kaipoho is

Kaipoho
|
Mokaiohungia
|
Hukaipu
|
Turehe
|
Te Moenga-a-Waitohu
|
Te Puarangi
|
Pohepohe
|
Rukupo

(Appellate Court Minute Book 1976,31:286)

His date of birth is unknown, though at his death in 1873 he was described as an old man, which helps us fix his birth at about 1800 or shortly afterward. He came to maturity in Te Huringa—The Turning—period, which in Poverty Bay

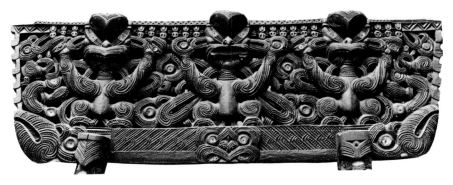

Figure 30. Pare (door lintel), from the house Tokopikowhakahau, carved in 1877 by Anaha Te Rahui (1822–1919) of Ngati Tarawhai. Width 130 cm. (51⅛ in.). National Museum of New Zealand, Wellington (ME.12234). Photo: R. Neich

began with the establishment of shore-based trading in 1831, and lasted up to the collapse of the Hauhau resistance in 1865. During this time metal tools quickly replaced the old stone-tool technology; Christianity was introduced, in 1840, and had early successes in Poverty Bay; and a new farming-trading economy replaced the traditional subsistence cultivation and gathering. Poverty Bay was remote from centers of European settlement so at first there was relatively little pressure from settlers for land; but this was not to last. Events elsewhere in New Zealand during the 1860s, as well as growing local pressure for land for settlement, led to the development of a strong nationalistic sentiment among the Poverty Bay chiefs and culminated, in some of them, including Rukupo, in conversion to Hauhauism in 1865. Later that year the Hauhau resistance collapsed after an unsuccessful confrontation at Waerenga-a-Hika.

It is probable that Rukupo began carving with stone tools, but he quickly mastered the new technology that came with the traders, and all his extant works have been carved with metal tools. Although not mentioned specifically by Bishop Williams as one of the carvers of the celebrated war canoe Te Toki a Tapiri, now in the Auckland Museum, another more recent source does name him. Williams dates the construction of the canoe "between 1840 and 1850,"[4] though Simmons has dated its construction as from about 1836 (in Archey 1977:opp. 136).

The decade of the 1840s was remarkably tranquil in Poverty Bay. Rukupo was an early convert to Christianity, taking the name Lazarus, or Raharuhi. He had also assumed political leadership of Ngati Kaipoho on his brother's death, although there was little to excite political activity. Rukupo attended to his duties, both to the mission where he was a teacher from 1843 (Porter in Williams 1974:268) and to his people, whom he led by example. He had extensive cultivations and later he built a flour mill with Government assistance (Oliver and Thomson 1971:57).

It was during this period that he established his reputation as a carver of renown. In 1842 he began work on the house Te Hau-ki-Turanga (fig. 31), now regarded as his masterpiece, as a memorial to his late brother. He was assisted by a team of eighteen carvers, including his younger brother, Pera Tawhiti (Barrow 1965:7). There is some uncertainty as to the date of completion. The normally accepted date of March 1843 comes from Major R. N. Biggs, Resident Magistrate in Poverty Bay, who supervised the dismantling of the house and wrote a short history of it for the Native Office in August 1868 (Biggs 1868). However, there is good evidence that it was not completed until 1845, and Biggs commented in a covering letter to the Native Under Secretary that

"The time it took in building is a point on which now many of the natives disagree" (Biggs 1868; see also Tareha 1868:445 and Hall n.d.). Whatever the date, the house established Rukupo's reputation far and wide. Years later the important Ngati Kahungunu chief Tareha, who had an interest in the house, said of it, "Such a building as this is only erected by men holding a high position among the tribes, it is a sign of chieftainship, and the proprietor becomes a noted man" (Tareha 1868:445).

In 1848 the Rongowhakaata carvers under Rukupo began work on a new and more ambitious project. Their first church had been destroyed in 1842 and they planned a new one on a scale to equal the great church being built by Ngati Raukawa at Otaki. The carvers were conscious of their reputation and they intended it to display all the glories of the Turanga school. The building was to be 27.45 meters (90 feet) long and 13.72 meters (45 feet) wide, with carved poupou (side posts) 4.57 meters (15 feet) high (Porter in Williams 1974:548). Carvings on such a scale were unheard of. However, the project ran into trouble when the missionary William Williams objected to the patterns being used in the carvings. He considered the full-frontal figures, which were modeled on those in Te Hau-ki-Turanga, as unsuitable for use in

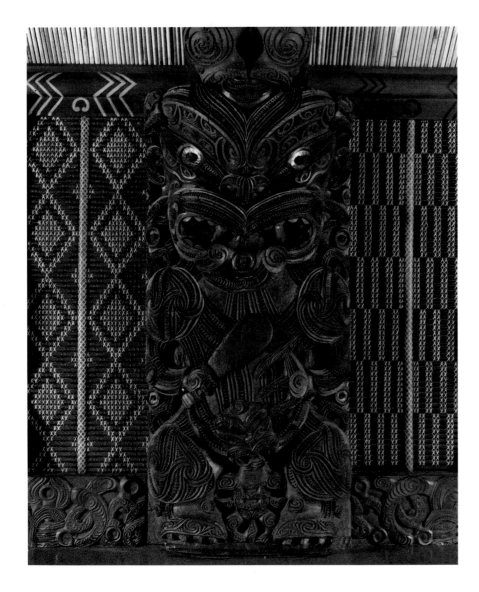

Figure 31. Poupou (side post) of Te Hau-ki-Turanga, 1842–43, carved by Raharuhi Rukupo, of Ngati Kaipoho, Gisborne. Height of figure 140 cm. (55⅛ in.). National Museum of New Zealand, Wellington

Figure 32. Rare photograph of the interior of the church at Manutuke, Gisborne, under construction, 1889. Carved panels attributed to Raharuhi Rukupo. W. F. Crawford Collection, Gisborne Museum and Art Gallery

a church. Eventually new profile (manaia) designs (figure 24) were substituted to Williams's satisfaction, but by then the carvers had lost enthusiasm for the job, which almost came to a standstill (Porter, in Williams, 1974:535, 537). The church was finally completed in 1863. It was later dismantled and the carved timbers were used in another church, at Manutuke (fig. 32), which opened in 1890 and was destroyed by fire in 1910.

The dispute over the church carvings coincided with a growing unease among Poverty Bay chiefs over land dealing by Europeans, and Rukupo was particularly prominent in opposition to these sales. During the 1850s he became more involved in political activities, assuming leadership among the anti-Government faction. The increasing political tempo meant a decrease in his carving output, although he continued to carve throughout the decade, and there is Land Court evidence of his making canoes at Mangatu (Appellate Court Minute Book 1976, 31:298). Fowler (1974:4) says Rukupo continued to carve until his death in 1873.

In his last years Rukupo was overtaken by political events. He flirted with Hauhauism in 1865 and was a sympathizer of the Hauhau rebels in their resistance at Waerenga-a-Hika. However, by 1870 he was one of a group of loyal Maoris who received from the Government a free section in the new town of Gisborne (Hall n.d.:7), and we have it from the Reverend Mohi Turei, who tended him in his last illness, that he died reconciled with the church (Turei 1873:179).

No known portrait or photograph of Rukupo exists. There is not even a description of his appearance. What we do have is his self-carved effigy (fig. 33) set inside his house. Though more naturalistic than the highly stylized poupou figures, it is nevertheless carved according to the conventions of the Turanga school and is not therefore a portrait in the ordinary sense of the term. He holds in his right hand the toki-pou-tangata, symbol of paramount chieftainship, and his hair is arranged in a stylized topknot. The moko on his face is the only evidence we have that he was fully tattooed.

Rukupo was essentially a carver of Te Huringa—The Turning—period. He

was trained according to the conventions of an oral tradition and was steeped in its mythology. When he mastered the new technology he applied it to traditional forms in canoes and houses, and in new architectural structures such as churches, with a freedom and on a scale previously unknown. His carved panels are notable for their complex figure and relief structures and his figures have a remarkably robust vitality in pose and expression (figs. 24, 32, 33). The new literacy introduced in the mission school had a minimal and superficial effect on his work. It can be seen in the engraved names on ancestor figures in Te Hau-ki-Turanga cut in roman script. The Turanga school went into decline after Rukupo, although some notable meeting houses were built and carved, particularly Te Mana o Turanga (1883), which stands on the Whakato marae, Manutuke, a stone's throw from the site where its famous predecessor stood until 1868.

Traditional Maori society respected its carvers, who in turn owed responsibilities to their communities. Carving was a religious activity which related the community to its gods and ancestors and put it in touch with the supernatural sources of power. Carvers had the important function of articulating through their craft the central metaphysical concerns of their society. They were necessary to society, but by virtue of their knowledge and skill they were men who commanded power, and such power could not be entrusted to just anyone. Te Rangikaheke and Tikitu both expressed the view that carving was a responsibility that rightly belonged to the rangatira families, to those of senior descent and therefore close to the gods, as well as the bearers of political power and authority. They represented the traditional establishment which assumed responsibility for all major functions, including the religious and artistic.

Some aptitude for carving was expected of all men of rangatira status, and instruction in the art and in the sacred lore (wananga) associated with it was given in the whare wananga. Professional carvers who were also of rangatira status were usually recruited from within families who were specialists in carving and who jealously guarded their possession of this expertise, presumably for the power and prestige it conferred. In this case young men with necessary aptitude were apprenticed to master carvers, who were also their relatives.

The great schools of carving, such as Te Rawheoro, with their various offshoots, continued down the generations into Te Huringa—The Turning—period. After a brief efflorescence following the introduction of metal tools, most succumbed to the pressures and tensions of the new colonial order, though some survived longer than others. The Iwirakau school of the Waiapu area lasted into the twentieth century, while the Ngati Tarawhai tradition has continued in an unbroken line to the present day.

NOTES
1. Gods who founded the carving schools. See Kelly 1949:74n.
2. The terms Moana-nui, Moana-tea, Manini-kura, and Manini-aro refer to designs used in the interior decoration of houses.
3. Material for this section comes largely from Neich (1977), to whom acknowledgment is due.
4. The Williams account and other sources are recorded in the Auckland Museum Register of Acquisitions.

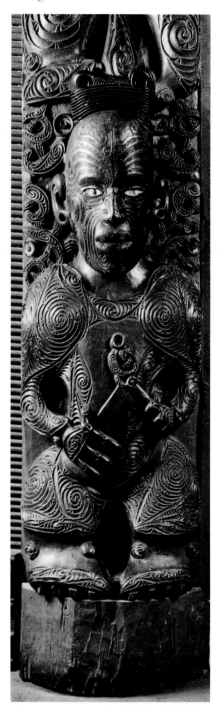

Figure 33. Self-portrait of Raharuhi Rukupo in the house Te Hau-ki-Turunga built in 1842–43 by Ngati Kaipoho in memory of Tamati Waka Mangere, elder brother of Rukupo. Height of figure 127 cm. (50 in.). National Museum of New Zealand, Wellington

155

KA PU TE RUHA, KA HAO TE RANGATAHI
As the Old Net Piles up on Shore, the New Net Goes Fishing

Piri Sciascia

In an address to the INSEA 23d World Congress, W. L. Renwick, Director General of Education in New Zealand, stated: "The years between 1860 and the early 1920s were the blackest period in Maori history. The tribes who had fought the Pakeha in defence of their land were in a state of physical and psychological withdrawal. The Maori generally were regarded as a dying race. Their numbers had declined steadily during the nineteenth century. The view of authoritative Pakehas was that their extinction as a race was inevitable. Happily this dire prediction did not come about" (Renwick 1978). By the late 1940s J. M. McEwen, Secretary of Maori Affairs, was able to comment: "The Maoris are no longer the dying race they were thought to be thirty or forty years ago and it is becoming more and more obvious that they will play a very important part in the future of New Zealand. They are fast recovering the virility and spirit of their forebears and they are discovering, too, that while it is imperative that they should adopt our way of life, there are many things Maori in their inheritance that are well worth preserving or even recovering, things which can be given an important place in a European world" (McEwen 1947).

And so, from the middle of the nineteenth century Maori society began a struggle to survive as a living culture. By the middle of the twentieth century sufficient high ground had been retained upon which the new house could be built. It is worth noting that a Maori perception of the black period referred to above is one that may incorporate the concept of new beginnings, of a time for growth. This is an idea that is well established in Maori philosophy. Out of the darkness—Te Po—there have been many beginnings. In a lullaby by Te Wioterangi of Ngati Kahungunu are the following lines:

Na te Pō tipu tāua	You and I belong to the night of growth
Na te Pō rea tāua	You and I belong to the night of development
Na te Pō tahuri atu	From the night of yielding
Na te Pō tahuri mai. . . .	From the night of possessing. . . .

It is not surprising, therefore, that this time of darkness produced the giants of the modern Maori world, the Maui of this last century, who with new magical jawbones of political authority, religious authority, technology, and native genius fished up new "lands" for their descendants. Who are these giants, these Maui?

In the area of developing Maori philosophy and New Zealand cultural perspectives we would meet Te Whiti o Rongomai, the Taranaki pacifist whose philosophy of "Arohanui ki te tangata" (Good will to all men) provided a model of ideal behavior for many; Te Kooti Rikirangi, founder of the Ringatu faith and instigator of many community development programs; Tawhiao Potatau Te Wherowhero, second Maori king and spiritual leader of the Tainui people and their allies; Sir James Carroll, a person of great importance in the retention of Maori lands and the provision of a place for Maoridom in a European system; Wiremu Tahupotiki Ratana, founder of the Ratana faith and head of the strongest Maori political movement, even to this day; Sir Apirana Ngata, who led a movement of young Maori talent well into the twentieth century; and Frederick Bennett, the first Maori to hold the office of bishop in the Anglican Church in New Zealand.

The visual and performing arts aided and gave expression to the cultural philosophy pursued by such men, incidentally all of whom were great artists themselves—carvers, orators, composers. The visual artists of the period would include Raharuhi Rukupo of the Rongowhakaata tribe, carver of the house Te Hau-ki-Turanga; Wero Taroi, of Ngati Tarawhai, whose carved poupou (side posts) in the house Houmaitawhiti provided an important tauira (example) for other carvers; Eramiha Kapua, instructor at the first Maori Art and Craft School, established in Rotorua by Ngata; and three Ngati Porou carvers, Hone Ngatoto, who assisted in the carving of Hinetapora at Mangahanea, and the brothers Pine and John Taiapa, head carvers at the New Zealand School of Maori Arts and Crafts for many years (pl. 17).

Among the performing artists, including writers and scholars, were Sir Apirana Ngata, whose work *Nga Moteatea* (1961–72) provides the major record of waiata (poetry); Hone Heke, preeminent among the first translators of English songs which became popular among the Maori; Te Puea Herangi, whose influence on song and dance is second only to her contribution to the Waikato people; Paraire Tomoana, a noted composer of Ngati Kahungunu whose work is still widely sung today; Kingi Tahiwi, of Ngati Raukawa, who not only borrowed European popular and classical tunes, but composed his own music in a modern style; Tuini Ngawai, of Te Whanau a Ruataupare, whose compositions are widely known; Te Rangihiroa (Sir Peter Buck), who made a major contribution to the study of Maori culture; Reweti Kohere, a noted essayist and translator of European poetry; and more recently Pei Te Hurinui, who carried on the work begun by Ngata and provided as well his own contribution to Maori literature. These are the national heroes. The revival of Maoridom through the late 1800s and into the twentieth century to around 1950 centers on the mana of these tipuna (ancestors), on their authority, power, and prestige.

Little has been done to educate New Zealanders generally about the contri-

bution of these men and women. Theirs is a major contribution to the survival of Maori culture in a society that has moved from its colonial beginnings to the Pacific nation that New Zealand is today. Much needs to be done. As late as 1978 Renwick stated, in reference to appreciating the place of Maori art symbolism and mythology, "There is important work to be done in art scholarship and art education," and again, "Art historians, art critics, gallery directors and art educators of all kinds have a critically important part to play." We play our part according to our knowledge of what has happened.

There are many views to consider. One Maori viewpoint can be stated thus: The lives of Maori artists, their work, and contribution are an integral part of the life of Maori people and Maori culture. An understanding, therefore, of Maori people and Maori culture as part of the total history of Aotearoa requires an examination of the lives and work of Maori artists. The national figures already mentioned are only a beginning point. There are many other important men and women who made valuable contributions to their people. Every tribe has its own heroes, whose talents were of such a quality that they are remembered today; persons such as Tau Henare, Paraire Paikea Maharaia Winiata, Taiporutu Mitchell, Mihi Kotukutuku, Heni Materoa, Hinekatorangi, Tamahau Mahupuku, Hoeroa Marumaru, Iriaka Ratana, Maui Pomare, Te Heuheu, Tuiti Makitanara, Tirikatene, Karetai, Taiaroa, and many others. If the national heroes are the posts of the renaissance house, then the tribal figures form the matrix of its roof, walls, and floor. Maori communities have always appreciated the need to educate themselves about this history. Each tribe has its own pukenga, its guardians of tribal history, of sub-tribal history, repositories of tribal authority who have provided the necessary education. However, large gaps still remain in the overall educating process, and more problems arise with each new generation.

Urbanization and other forms of demographic displacement have removed many Maori people from their tribal areas, their matauranga Maori, and consequently their heritage. Nearly eighty percent of our people now live in urban areas, and fifty percent of all Maoris are under the age of twenty-five. Two percent of the Maori population are over the age of sixty-five (Ngata 1983). Our marae are largely situated rurally, and our elders are few in number.

Perhaps the greatest threat to the base of Maori culture lies in the demise of the Maori language and Maori oral tradition. This demise has partly removed us from the power of our own language, which generates within our people a view of, and an identity with, that which we call the taha Maori, the Maori side of things. This includes our art heritage. The lack of language obviously creates great difficulties for the younger Maori, but there are problems for the older Maori person as well. He may often be unable to accept the contribution of the younger Maori today because so much of the expression is essentially Pakeha, the language is English. Without the Maori language there can be little meeting within a Maori framework, especially on the marae, or within tribal wananga (schools of learning). One is aware of the older Maori secure in a Maori context and of the younger Maori, English-speaking and ill-at-ease, cut off from the kawai of his tipuna, the descent line of his ancestors. Without

the language, cultural transmission is severely affected. The younger people need the support and authority of their elders, as well as the benefits of their experience. The older generations equally need the loyalty of their own youth.

When the language of communication is mutually intelligible a cultural flow is achieved. However, communication becomes decidedly second best when it relies upon translation from one language to another to effect an ongoing relationship. When there is no translation possible, young and old are separated from one another and the resultant cultural severing has devastating effects. W. Parker, an ahorangi (teacher) of Maori Studies at the Victoria University of Wellington, has correctly pointed out that the push during the early part of this century toward the attainment of the English language was a vital part of the struggle for cultural survival.

It is well to bear in mind that Ngata, Buck, Pomare, Kohere and Wi Repa, and other giants of the Young Maori Party who are widely credited with salvaging the Maori people had all grown up in an era conditioned to accept the notion that the Maoris were doomed to extinction as a result of the clash of cultures. They all saw in the acquisition of English language and English education the most promise for a people's survival and development.

(Parker 1963)

They were right for their time. Today many educators and administrators would advocate rapidly expanding the programs for the teaching of Maori language, particularly so that we do not have to learn Maori as we would a foreign language. Maori language is essential to the continuing growth of Maori culture and, therefore, Maori art. The Maori today has come to look to the education system and beyond it for the necessary provision. The Kohanga Reo movement, which seeks to provide a program of Maori language learning for preschool children, reflects the recognition given to some of the current problems of cultural survival, cultural growth, cultural development. A recent (1982) policy of the Department of Maori Affairs, it has already provided a focus for Maori people to consider the retention of their language. It should provide an avenue for the people at large to participate positively and directly in the revival and maintenance of the language. Sadly, most Pakeha see this as a Maori rather than a New Zealand concern, and the connection of our language to our arts is even less understood. However, A. Highet, Minister for the Arts in New Zealand, noted in his UNESCO address to the World Conference on Cultural Policies that the steps taken through the Kohanga Reo program represented "a uniquely positive approach to the preservation and development of an indigenous language" and that it was a program "of major significance" (Highet 1982).

While we have lost some ground, particularly in the modern or post-1950 period (since the deaths of Ngata and Te Puea), certain Maori values have been retained. Maori art today has mana. It continues to develop and grow in its ability to shape the face of New Zealand society. There are many persons, Maori and non-Maori, with an interest in and a commitment to Maori art—

artists, elders, guardians, educators, and administrators who form committees, councils, trustee boards, etc. Indeed, one of the issues for present administrators is to review the roles of the many agencies who have a responsibility to Maori arts and crafts, including the Maori Purpose Fund Board, the Maori Trustee, the New Zealand Institute of Maori Art and Crafts, the Maori Womens' Welfare League, the New Zealand Maori Council, the New Zealand Polynesian Festival Committee, the Queen Elizabeth II Arts Council, and the Council for Maori and South Pacific Arts.

The general renaissance of Maoritanga today is accompanied by the realization that the language is the key and indeed the catalyst to open the heart and mind of the individual to the past. There is a searching for the stories, for the korero of old. When we lose our elders, our pukenga, we lament their parting, our losing of vital links with the past. This well-known Maori lament captures the sense of loss:

Kimihia, rangahaua! Kei whea koutou	Search for them, seek them! Where are
ka ngaro nei?	you who cannot now be seen?
Tena ka riro ki Paerau,	There, gone to Paerau,
Ki te huinga o te kahurangi	To the gathering place of the loved ones
Ka oti atu koutou e!	From which you will never return!

We seek to know the experiences of our ancestors and try to understand, see, and feel their dreams and creations. Their responses become tauira, an example, a guide, a teacher in our own lives. The tauira are sought not merely for copy purposes, but because they serve to indicate the points of entry into the genealogy of the Maori person and into the continuing flow of our New Zealand experience. The task for the Maori of today, including the artist, is *he rapu i te korero*. We seek the stories, through the appropriate language, in the appropriate manner and time (pl. 18).

As part of our search for the korero of the past we would do well to study the proverbs of our culture. One recent proverb states:

He toi whakairo	Where there is artistic excellence
He mana tangata	There is human dignity

Artistic excellence and creative genius were well recognized and valued among the Maori. Art was, and still is, seen to enhance one's mana. It provides dignity which endures so long as it is a living force which enhances one's ability to influence, to think and to produce, to speak and to do. This dignity, this power, this influence may be described as permanent and untouchable—*he mana toitu*—because of its source. Whatever art is, it cannot be disputed that the artist, in response to what he feels, sees, and believes, creates for others an expression of that which is revealed to him, the knowing that he alone knows, the seeing that he alone sees. This is a relationship which can be described as tapu, meaning that a person in this sacred relationship is open to te reo, the voice, and nga korero, the address of world events upon men. The ability to be open to this exchange, and to respond, marks out the man set apart as artist, leader, tohunga (expert).

160

Other values and lessons of the past are worthy of consideration. Central to the work of the creative artist is a human quality which has been highly valued in Maori society. This value is utu, a term which is generally understood to mean "revenge," but an equally important part of its meaning is "to respond" or "to make response" (Williams 1975). It is a value central to Maori life and a Maori way of living. It is a spiritual course which, when fully valued, leads to an expression of life that is demanding, engaging, open, spontaneous, and above all personal. The themes of modern-day compositions of haka (dance) and waiata (song) illustrate the engagement and openness evident in the work of modern artists. At the 1983 Polynesian Festival some of these compositions dealt with tribal prestige, tribal connections and affiliations, the land (confiscations of the past and the call for redress), the death of loved ones, the place of God and faith in our present-day living, the bishopric of Aotearoa and the spread of the gospel in New Zealand, urbanization and its difficulties, yearning for one's homeland, unemployment, the power of modern technology, space-invader machines, the place of the Kohanga Reo programs of the Department of Maori Affairs, the works of past master composers, etc. These are responses to the realities of life in New Zealand (fig. 34).

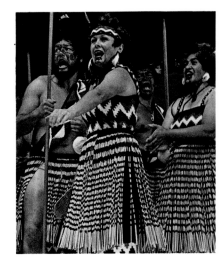

Figure 34. Members of Tamatea Ariki Nui cultural group performing at the 1981 New Zealand Polynesian Festival held in Auckland. Photo: Cliff Whiting

Because Maori art is concerned with mana, the demanding aspects are perhaps more easily understood. On a marae when one group hosts another there is often a friendly rivalry which has host and guest alike reaching more deeply into their reservoirs of song and dance in order to respond appropriately to the delivery of the other side. This may happen on a light note with much laughter and scope for spontaneous performance and composition. At other times, however, when the kaupapa (subject matter) is of a serious nature, one must tread very carefully, choosing one's words with all the skill possible. Mistakes in this kind of meeting can be dangerous. Words may be remembered, slights may assume huge proportions, and the response may be delayed until a later meeting. The ultimate human response possible is the giving of one's life or facing some form of death in the event of there being a need for this level of payment. Artists have been known to die because of the errors they made.

In this day there is a tendency to manage situations more carefully and thus prevent the possibility of people becoming tense and angry. However, mistakes can, and do, occur. To this day most Maori would rather not participate than risk making errors. "Someone may get hurt," goes the reasoning. "Ma wai tena e utu?" (Who will pay [be payment] for that?) Could a creative process be more personal or more demanding?

The expressions of the past remain as the record of the responses of former artists to the world and to life's experiences. As part of our seeking today we would examine this record, the creative expression of yesteryear, feel its permanence, know its meaning, and dream our dreams as a first step toward some continuity. Initially, we must recognize the importance of the appropriate language in order to best appreciate the cultural framework in which we work and live. We must know also the tauira of the past. Our examinations must be thorough and conducted with a sense of mission. Learning in this context is essentially a spiritual exercise. Next we must forge our own experience and understanding. Attempts for such understanding have uncovered processes of

Maori art which are new for some and more familiar for others. In particular, the *communal* approach has been given new life. Many projects have witnessed the sharing of knowledge and expertise of several persons. The supporting communal strength that helps complete an artistic expression helps also to ensure that the expression itself becomes tribal property. That which binds such a community together in projects of this type is a certain spiritual force. For a time several key persons usually become open to this strength and willing to enter into a dialogue with its spirit. The resulting expression is always powerful, as it represents the efforts of combined genius to produce a statement, a korero, of this day.

When such a statement—whether individually or communally processed—reaches a very high level of excellence we are able to say *toi te kupu*, the word lives; it is heard, it is respected, it is felt, it is translated, it is spoken. It is a permanent expression, *he kupu toitu*, unmovable, not able to be disturbed, now present. If the kupu is lost, then it is we who have moved away from it; we who are lost to the sacred relationship. That can happen. But the creation of lasting expression has also happened; expression that, to begin with, was novel and innovative. This kind of creation is possible not only because of the retention of the old ways, but also because of the acceptance and embrace of new ways, new technology.

Today, Maori people aspire to be bicultural. We have felt the demand to value, to maintain, and to live according to our Maori heritage. We share in a Pakeha heritage as well. Many Maori artists have concerns with individual rather than communal artistic expression. Visual artists may choose to work in new mediums, not only in oils, but also in steel, plastic, concrete, new woods (exotic and custom-made), and new fibers (Davis 1976). The response may be an individual one; but where the artist is mature and where the content is seen and felt to be part of the wider concerns of people, then the work and artist gain mana. Performing artists today have concerns far beyond their tipuna of yesteryear. Thus, today we use terms such as choreography, staging, lighting, sound systems, costuming, and rehearsals. New Zealand culture today has for many of its people an increasingly bicultural focus. There is art which has become part of a tribal celebration, a celebration of the descendants of Aotearoa. A true New Zealand identity is slowly emerging and Maori art is central to that identity.

Within New Zealand this influence grows, particularly when people become receiving vessels, open to the korero before them and allowing the spirit to work in them. The production of Maori art assists in binding people to the land. Places have meaning. Order is provided. Stability is given to our Aotearoa existence. When this occurs we can say *toi te whenua*, the land lives through its people, and the people live as part of the land. They are the children of the land who are nourished by it, or rather by her—Papatuanuku, the Earth Mother. This kind of nourishment is known in Maoridom as mauri ora, and one of its sources is in the soil of the land. It is life force, the living essence, a principle of vitality and fruitfulness of all things connecting life to man, his actions, and his relationships. It is toward this end that the Maori artist of today, performing and visual, must be committed.

162

The power of Maori art to embrace even the most conservative of Pakeha institutions is recognizable when considering the church and the development of a Maori expression of the body of Christ. Maoridom and particularly its artists have made a unique contribution to church development. The Ringatu and Ratana churches, the Church of England, the Catholic and Mormon churches have long associations with the performing and visual arts. There is a rich history of religious gatherings and Maori cultural competitions. Each church has its own cultural activities which are distinctive and contributing, e.g., the cultural competitions of the Catholic and Ratana churches, the retention of the more ancient art forms by the Ringatu church, the innovative pageantry of the Mormon church, and the continued cultural concerns of the Anglican church.

Carved meeting houses are used in some tribal areas as churches; in other areas carving and the weaving tradition with its own mythology have entered into the churches of our land. Recently a minister of the Anglican communion, who is also a carver, has helped bring together the church and the meeting house, thus unifying Christian and Maori architecture. The carving in the traditional house represents both ideologies simultaneously. St. Peter, the fisher of men, is also Maui, the fisher of lands. The wharetipuna (ancestral house) has carved "ancestors" among whom are the founding fathers of the church. The church also represents a canoe, the spire serving as taurapa (sternpost). The koruru (gable figure), which is usually an ancestral figure, is replaced by a tauihu (canoe prow) which is adorned with the koru adopted by Air New Zealand on its "canoes." The greater significance is not, however, in the artistic forms and symbols created, which are intentionally open to dual interpretations, but rather that the church now has ministers who have not only ceased voicing disapproval of Maori art, but who are innovative Maori artists themselves (fig. 35).

Such clergy have existed in the performing arts for some time. Many of the tutors and leaders of cultural groups are prominent members of their respective church communities. The national Polynesian Festival is the largest performing arts event in the country, involving hundreds of performers. It has at its head a well-respected composer and tutor of Maori song and dance, who is also an archdeacon of the Anglican Church, as well as the present chairman of the Council for Maori and South Pacific Arts.

Figure 35. St. Michael's Church, a center of the Manawatu–Rangitikei Maori Pastorate, situated at Highbury, Palmerston North

Maori artists continue to occupy places of national importance and to make contributions of national significance. These are people who have mana. Their art has mana. The two elements, creation and human being, go together to complement each other. The human ingredient is a celebrated Maori theme.

Unuhia i te rito o te harakeke	Draw out the shoot of the flax plant!
Kei whea te kōmako, e kō	Where is the bellbird, oh maid?
Whakatairangitia	It flees to no purpose
Rere ki uta, rere ki tai	Far inland and then to the sea
Kī mai ki ahau	Ask me the question:
He aha te mea nui	What is it that is important?
Māku e kī atu	And I shall respond:
He tangata, he tangata, he tangata.	It is humanity, humanity, humanity!

(Poem of Te Aupouri people of North Auckland)

The current exhibition represents a response to the power and influence of Maori art which has been felt beyond the shores of Aotearoa. A sensitive and caring group of people wish to bring their community into contact with Maori art. The exercise is a new one for both parties and questions inevitably arise. Are the Americans willing to receive our taonga in their totality? Are we, as New Zealanders and, in particular, as Maori people, prepared and able to share our taonga in their totality—the physical art form, the associated korero, and, therefore, the resultant dialogue between New Zealander and American? *He aha a tatau korero?* What is it that *we* have to say to one another? These are questions that some of us may well ask. Such concerns are a consequence of a proper understanding of Maori art, of a commitment to Maori art, especially as mana, and as a manifestation of the mauri of our land. We exhibit here the expression of the relationship between artists and the reality that was perceived by them a long time ago. We are challenged to pay attention to the statements they made in their creations. These ancient taonga demand that much respect and regard. Maori people understand this; however, experience has shown that we can at times be sadly lacking as human people in cross-cultural understanding, toleration, and appreciation. We must, therefore, prepare ourselves as partners in sharing the artistic heritage of our ancestors, in putting an old net to sea. We must choose our tides carefully, select our crew judiciously, and be ever mindful of the nature of our treasured net.

Whatever else may develop in such international exercises, we can only be very optimistic about the health and vitality of New Zealand Maori art. We have a wide range of traditional and contemporary art forms, executed in the old ways as well as in what could be called a contemporary way. Innovative Maori art is being produced today that is tribal and that is concerned with korero, with mana, with mauri. At best, Maori art forms combine to support one another and to enhance the statements of each form. Thus, when whakairo (carving) is embraced with whaikorero (oratory), the combination has greater mana, it is a fuller expression of the available mauri.

A recent example of this is offered by the carving *Tumu Korero* (fig. 36), itself a living expression of the Maori art process as expressed in the whakatauki

Figure 36. Carvers of the work Tumu Korero *(the "talking" trunk) at Waahi marae, Huntly, pause for the photographer prior to the opening ceremonies. Photo: Cliff Whiting*

(proverb) *Toi te kupu, toi te mana, toi te whenua.* (When the word is respected, and the authority of the Maori established, the land will survive.) Respect has been given to the tribal ancestors and their korero. This korero is retold by speakers who speak with authority, and as a result, their land lives in them and through them. However, there are some significant features of this expression worthy of note and description. The creation is a novelty. The usual form for the expression of such a body of past and present knowledge is the erection of a new meeting house. This carved tree stump, which in itself develops the idea of whakapapa (genealogy, family tree) as a basis for recording history, is an interesting innovation. The placement of this carving on a marae is also a new thought. There is a move away from the functional use of a house to an abstract and decorative form. A new and powerful statement is made here by young men of a tribal group. They are supported by their elders who give their sanction to the new work. The elders further embrace the carving with the art form in which they as artists have mana. The carving and oratory both contribute, each in a way the other cannot, to a fuller appreciation of the tribal taonga. The novelty, having this kind of inspirational power, quickly becomes a source of pride.

When considering the proverb quoted above, it is essential to note that the korero, the mana, the whenua, are things that are given to the student of Maori art. One cannot decide for oneself that today one will have the korero, tomor-

row the mana, or whatever. Initially *ka whangaia te hinengaro* (one is taught the history), the korero, the tauira of old. If one can accommodate the nurturing process and use the given korero wisely, creatively, and relevantly, then one will grow in mana. When this mana is used to meet the needs of others, as individuals and community, one gains more mana and is put onto one's feet by and for one's people, one's fellow men. Humility and self-knowledge will carry a person to the point where one becomes a puhi, a person set apart, he tangata tapu, a sacred man, with great mana. It is Maori belief that such a person is in close touch with a special part of the Spirit of the land, with its mauri. When this occurs it becomes very evident to those who believe thus, that such has happened, and we say *kei a ia te mauri*, he or she has the mauri. The life force, the mauri ora, is with them. One may lose it—that may be unfortunate —the spiritual world has its own life of which we may or may not be worthy recipients. In both the traditional and the contemporary arts there is much evidence to indicate that the spirit, that is, the spirit in the traditional sense, has visited and resided in the hearts and minds of modern-day Maori artists. Indeed, one may hear a fuller identification with this spirit in the words, *ko ia te mauri*, he or she is the mauri.

The oft-quoted whakatauki states, *Ka pu te ruha, ka hao te rangatahi*—as the old net piles up on shore, the new net goes fishing. The tauira (pattern, or model) of the old provides the basis of formation for the new. The new time dictates changes in both the structure and form of the new net, and also in the choice of fishing ground. By casting it to sea, the old net may tell us even more than we dare hope for. The care taken is reassuring. It is the fishing exercise that now commands our attention, and this must be executed in the same spirit in which the old net was prepared and made.

NOTE

Information for this chapter has been supplied by Te Rehuka Tutaki, Ngati Kahungunu; Tariuha Hiahia, Ngati Takihiku; and Te Karauna Whakamoe, Tuhoe.

MAPS

MAPS
1. *New Zealand*

2. *Distribution of Maori Tribes in the South Island*
Adapted from map courtesy Department of Maori Studies, Victoria University of Wellington

3. *Distribution of Maori Tribes in the North Island*
Adapted from map courtesy Department of Maori Studies, Victoria University of Wellington

4. *Location of Tribal Art Styles in the South Island*
Adapted from map courtesy the Auckland Institute and Museum

5. *Location of Tribal Art Styles in the North Island*
Adapted from map courtesy the Auckland Institute and Museum

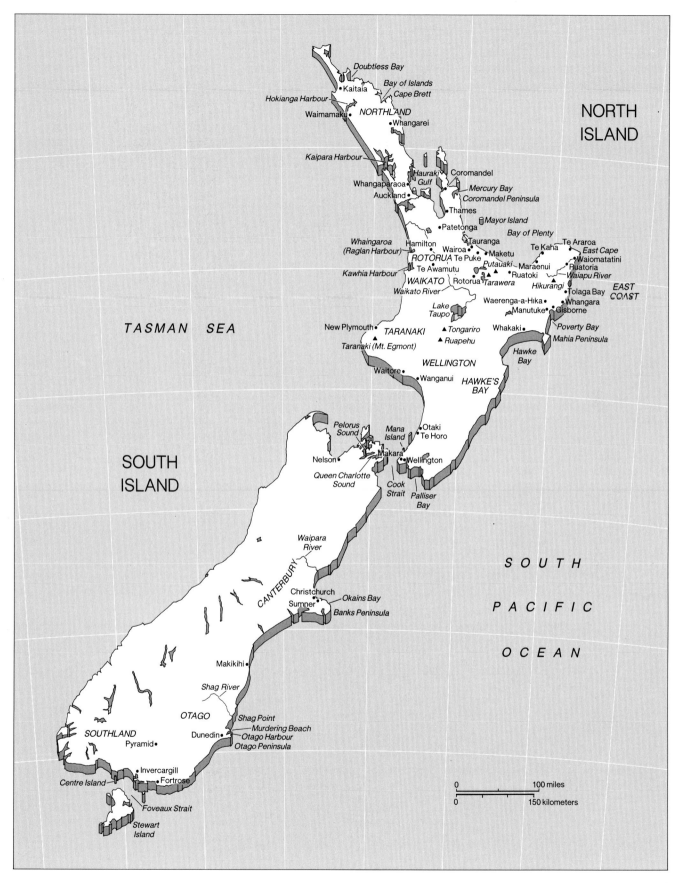

Doubtless Bay

Bay of Islands

Cape Brett

• Kaitaia

Hokianga Harbour

NORTHLAND

Waimamaku •

• Whangarei

Kaipara Harbour

Hauraki Gulf

• Coromandel

Whangaparaoa •

Mercury Bay

• Auckland

Coromandel Peninsula

• Thames

Mayor Island

• Patetonga

Bay of Plenty

Whaingaroa (Raglan Harbour)

Hamilton •

• Wairoa

• Tauranga

Te Kaha

Te Araroa

ROTORUA

Te Puke

• Maketu

East Cape

Putauaki

Waiomatatini

Kawhia Harbour

Te Awamutu •

• Maraenui

Ruatoria

WAIKATO

Rotorua •

Tarawera

• Ruatoki

Waiapu River

Waikato River

Hikurangi

• Tolaga Bay

Waerenga-a-Hika •

Whangara

EAST COAST

Lake Taupo

• Manutuke

• Gisborne

New Plymouth •

TARANAKI

Tongariro

Whakaki

Poverty Bay

Ruapehu

Mahia Peninsula

Taranaki (Mt. Egmont)

WELLINGTON

Hawke Bay

Waitore •

• Wanganui

HAWKE'S BAY

TASMAN SEA

Pelorus Sound

Mana Island

• Otaki

Te Horo

SOUTH ISLAND

Nelson •

Makara •

• Wellington

Queen Charlotte Sound

Cook Strait

Palliser Bay

SOUTH PACIFIC OCEAN

Waipara River

CANTERBURY

Christchurch

Okains Bay

Sumner •

Banks Peninsula

Makikihi •

Shag River

OTAGO

Shag Point

Murdering Beach

SOUTHLAND

Dunedin •

Otago Harbour

Pyramid •

Otago Peninsula

• Invercargill

Centre Island

• Fortrose

Foveaux Strait

Stewart Island

0 100 miles

0 150 kilometers

Map 1

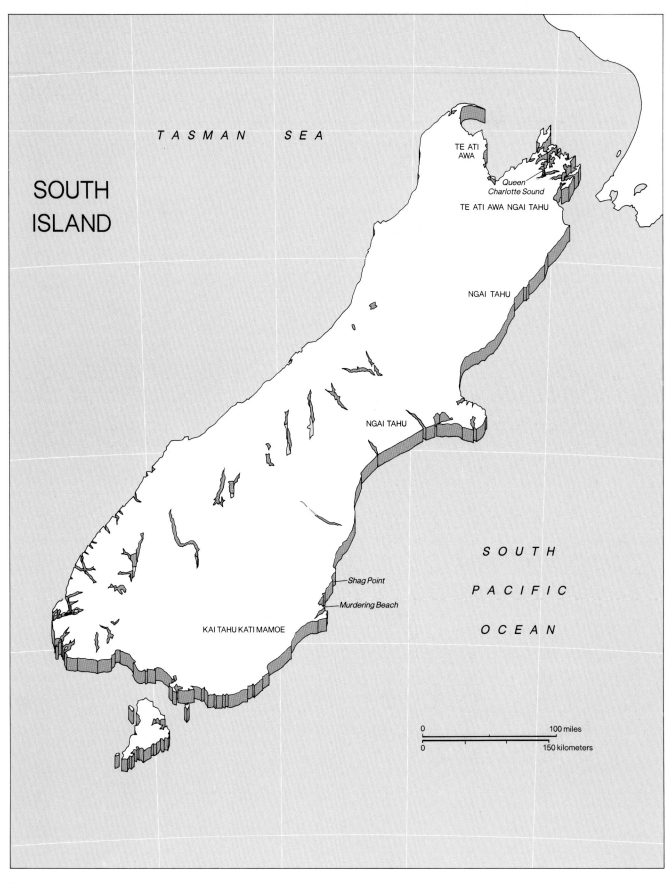

TASMAN SEA

SOUTH
ISLAND

TE ATI
AWA

Queen
Charlotte Sound

TE ATI AWA NGAI TAHU

NGAI TAHU

NGAI TAHU

SOUTH

PACIFIC

OCEAN

Shag Point

Murdering Beach

KAI TAHU KATI MAMOE

0			100 miles
0			150 kilometers

Map 2

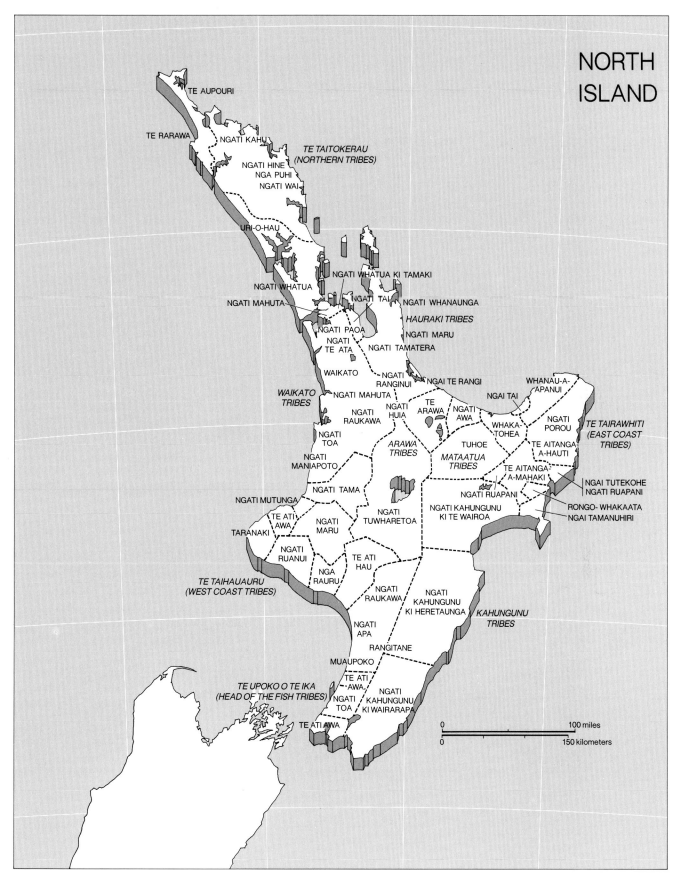

NORTH ISLAND

TE AUPOURI

TE RARAWA

NGATI KAHU

*TE TAITOKERAU
(NORTHERN TRIBES)*

NGATI HINE
NGA PUHI
NGATI WAI

URI-O-HAU

NGATI WHATUA KI TAMAKI

NGATI WHATUA

NGATI MAHUTA

NGATI TAI

NGATI WHANAUNGA

HAURAKI TRIBES

NGATI PAOA

NGATI MARU

NGATI
TE ATA

NGATI TAMATERA

WAIKATO

NGATI
RANGINUI

NGAI TE RANGI

WHANAU-A-
APANUI

*WAIKATO
TRIBES*

NGATI MAHUTA

TE
ARAWA

NGATI
AWA

NGAI TAI

NGATI
RAUKAWA

NGATI
HUIA

WHAKA-
TOHEA

NGATI
POROU

*TE TAIRAWHITI
(EAST COAST
TRIBES)*

NGATI
TOA

*ARAWA
TRIBES*

TUHOE

*MATAATUA
TRIBES*

TE AITANGA-
A-HAUTI

NGATI
MANIAPOTO

TE AITANGA-
A-MAHAKI

NGATI TAMA

NGATI RUAPANI

NGAI TUTEKOHE
NGATI RUAPANI

NGATI MUTUNGA

RONGO- WHAKAATA
NGAI TAMANUHIRI

TE ATI
AWA

NGATI
MARU

NGATI
TUWHARETOA

NGATI KAHUNGUNU
KI TE WAIROA

TARANAKI

NGATI
RUANUI

TE ATI
HAU

*KAHUNGUNU
TRIBES*

NGA
RAURU

NGATI
RAUKAWA

NGATI
KAHUNGUNU
KI HERETAUNGA

*TE TAIHAUAURU
(WEST COAST TRIBES)*

NGATI
APA

RANGITANE

MUAUPOKO

*TE UPOKO O TE IKA
(HEAD OF THE FISH TRIBES)*

TE ATI
AWA

NGATI
TOA

NGATI
KAHUNGUNU
KI WAIRARAPA

TE ATI AWA

0 100 miles

0 150 kilometers

Map 3

171

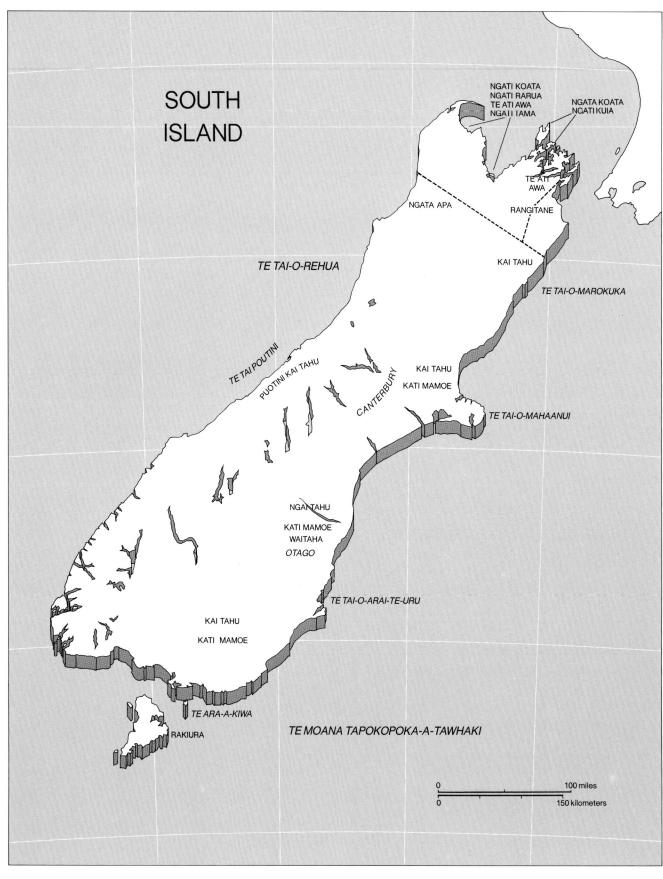

SOUTH
ISLAND

NGATI KOATA
NGATI RARUA
TE ATI AWA
NGATI TAMA

NGATA KOATA
NGATI KUIA

TE ATI
AWA

NGATA APA

RANGITANE

TE TAI-O-REHUA

KAI TAHU

TE TAI-O-MAROKUKA

TE TAI POUTINI

PUOTINI KAI TAHU

KAI TAHU

KATI MAMOE

CANTERBURY

TE TAI-O-MAHAANUI

NGAI TAHU

KATI MAMOE
WAITAHA
OTAGO

TE TAI-O-ARAI-TE-URU

KAI TAHU

KATI MAMOE

TE ARA-A-KIWA

TE MOANA TAPOKOPOKA-A-TAWHAKI

RAKIURA

| 0 | | 100 miles |
| 0 | | 150 kilometers |

Map 4

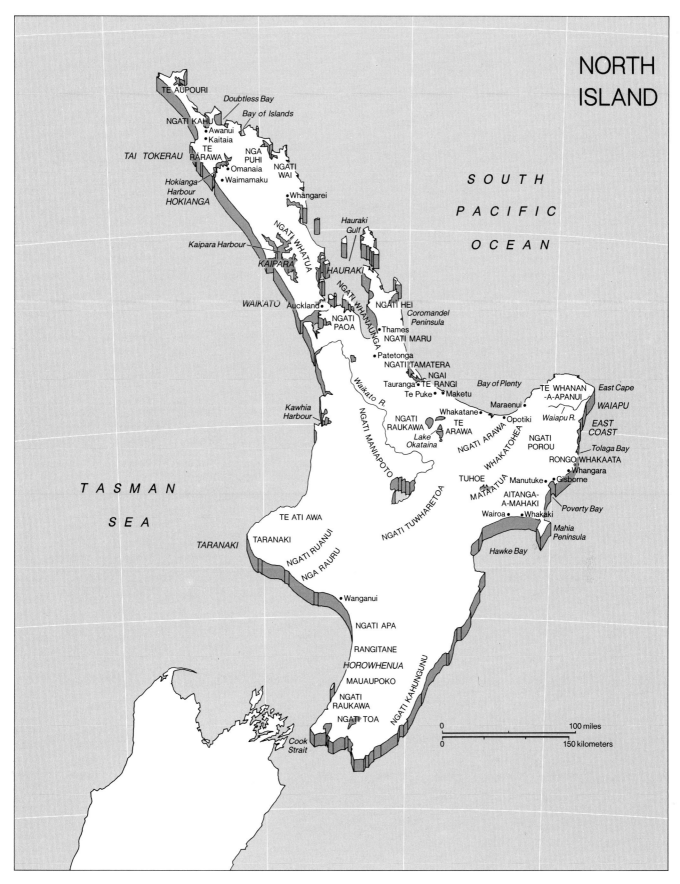

NORTH ISLAND

TE AUPOURI
Doubtless Bay
NGATI KAHU
Bay of Islands
•Awanui
•Kaitaia
TE
TAI TOKERAU RARAWA
NGA
PUHI
NGATI
WAI
•Omanaia
•Waimamaku
Hokianga
Harbour
HOKIANGA
•Whangarei

SOUTH

PACIFIC

OCEAN

Hauraki
Gulf
Kaipara Harbour
NGATI WHATUA
KAIPARA
HAURAKI
WAIKATO •Auckland
NGATI
PAOA
NGATI HEI
Coromandel
Peninsula
NGATI WHANAUNGA
•Thames
NGATI MARU
•Patetonga
NGATI TAMATERA
NGAI
TE RANGI
Tauranga• •Te Puke
•Maketu
Bay of Plenty
Maraenui
TE WHANAN
-A-APANUI
East Cape
WAIAPU
•Whakatane
•Opotiki
Waiapu R.
EAST
COAST
Waikato R.
NGATI
RAUKAWA
TE
ARAWA
Lake
Okataina
NGATI ARAWA
WHAKATOHEA
NGATI
POROU
Tolaga Bay
RONGO WHAKAATA
Kawhia
Harbour
TUHOE
MATAATUA
Manutuke
•Whangara
•Gisborne
NGATI MANIAPOTO
AITANGA-
A-MAHAKI
Poverty Bay
Wairoa •Whakaki
Mahia
Peninsula
NGATI TUWHARETOA
TE ATI AWA
Hawke Bay
TASMAN
SEA
TARANAKI
TARANAKI
NGATI RUANUI
NGA RAURU
•Wanganui
NGATI APA
RANGITANE
HOROWHENUA
MAUAUPOKO
NGATI
RAUKAWA
NGATI TOA
Cook
Strait

0 100 miles
0 150 kilometers

Map 5

CONTRIBUTORS

SIDNEY MOKO MEAD
M.A., University of Auckland;
Ph.D., University of Southern Illinois

Author of books and articles on Maori and Eastern Solomon Island art. Mead convened the first two international conferences on the art of Oceania (one in Ontario, Canada, the other in Wellington); edited *Exploring the Visual Art of Oceania*; co-edited with Bernie Kernot, *Art and Artists of Oceania* (1983); helped found PAN (Pacific Art Newsletter) and PAA (Pacific Arts Association); received the Elsdon Best Memorial Medal in 1983; and is currently Professor of Maori at Victoria University of Wellington. He is a member of the Ngati Awa tribe of the Bay of Plenty and is closely associated with its affairs.

AGNES SULLIVAN
M.A., University of New Zealand

Specialist in prehistory, ethnohistory, and Polynesian technology. Sullivan is Lecturer in Maori Studies at Victoria University of Wellington. Her interests in prehistory focus on early gardening techniques of the Maori people of both New Zealand and the Cook Islands.

DAVID R. SIMMONS
M.A., University of Auckland

Ethnologist, Auckland Institute and Museum. For many years Simmons has been involved in such investigations as history, museum studies, oral history, including the song-poetry of the Maori, technology, and Maori art. He has visited most of the museums overseas that contain Maori objects in their collections. Notable contributions are his book *The Great New Zealand Myth* (1976) and his *Catalogue of Maori Artefacts in the Museums of Canada and the United States of America* published in 1982 as a bulletin by the Auckland Institute and Museum.

ANNE SALMOND
M.A., University of Auckland;
Ph.D., University of Pennsylvania

Senior Lecturer in Social Anthropology at the University of Auckland. Salmond is author of *Hui: A Study of Maori Ceremonial Gatherings* (1975); *Amiria: The Life Story of a Maori Woman* (1976); and *Eruera: The Teachings of a Maori Elder* (1980). She has received the Elsdon Best Memorial Medal and the Wattie Book of the Year Award, first prize and third prize, for her publications. Her interests are in sociolinguistics, ethnobiography, and Maori studies.

BERNIE CLIFTON JOSEPH KERNOT
M.A. (Hons), University of Auckland

Senior Lecturer in Maori Studies at Victoria University of Wellington. Kernot's interests are in Maori art and in race relations. His book *People of the Four Winds* (1972) is a contribution to the study of race relations. Co-editor with Sidney Mead of *Art and Artists of Oceania* (1983) and author of several articles on Maori art, Kernot has a long-standing interest in Maori wood carving and carved meeting houses.

PIRI SCIASCIA
B.A. (Hons), Victoria University of
Wellington; B.Sc., University of Otago

Assistant Director, Queen Elizabeth II Arts Council of New Zealand, with special responsibility for the Maori and South Pacific Arts Council. Executive Officer of the Inter-Departmental Management Committee of the *Te Maori* exhibition. Sciascia is chairman of the Arts and Crafts Board of the Takitimu Runanga Nui of Hawke's Bay-Wairarapa. He has been closely involved with the arts as a scholar, administrator, and as a leader-performer in Maori dancing teams, most recently in Tamatea Ariki Nui Maori Cultural Club. He is a member of Ngati Kahungunu tribe.

TE RARANGI TAONGA
Catalogue

Text by David R. Simmons

Photographs by Athol McCredie

NOTE TO THE CATALOGUE
Catalogue entries are arranged
 in the following order:
Title of object in English and Maori
Material, dimensions in centimeters
 (inches given in parentheses)
Place of origin (where known)
Tribe
Period
Former collections (where known)
Present location
Note

1. Pendant, turtle
Stone, 8 cm. (3¹⁄₈ in.) high
Taranaki, Urenui
Early Maori
Nga Kakano period (900–1200)
Formerly T. Ashwood Collection
Taranaki Museum, New Plymouth (A.71.538)

One hundred years ago Urenui was the birthplace of Sir Peter Buck (also known as Te Rangi Hiroa), a medical doctor, a member of Parliament, and a pioneer anthropologist. He wrote over fifty books on the Maori and Polynesia and later became director of the Bernice Puahi Bishop Musem in Hawaii. His ancestors lived in Urenui from the time this unique stone pendant shaped like a turtle was made, about 800 to 1000 years ago. His people, the Ngati Mutunga hapu (clan) of Te Ati Awa, are still there.

2. Ornament, reel
Stone, 5 cm. (2 in.) long
Taranaki, Opunake
Early Maori
Nga Kakano period (900–1200)
Formerly H. D. Skinner Collection
Taranaki Museum, New Plymouth (A.71.539)

This reel ornament is one of the ancestral forms found in early excavations in East Polynesia. In New Zealand these reels are made from moa bone, whale bone or ivory, and stone. A group of stone units was worn as a necklace with a stone imitation whale tooth in the same way that bone and ivory necklaces were worn. Making the reels in stone appears to have been an aesthetic decision motivated by the beauty of the stone, usually a smooth black or blue-gray serpentine.

3. Club. Patu rakau
Wood, 28 cm. (11 in.) long
Taranaki, Kaupokonui River, Takaora site
Early Maori
Te Tipunga period (1200–1500)
Formerly P. Wakelin Collection
Taranaki Museum, New Plymouth (A.77.203)

This patu rakau (wooden club) comes from the Tokaora site on the Kaupokonui River near Hawera. Other material from this site includes digging implements of late Maori form. This patu seems to be an unfinished early form of the wahaika club (see cat. no. 44).

4. Pendant. Rei niho
Whale tooth, 14.6 cm. (5¾ in.) long
Northland, Whangamumu
Early Tai Tokerau
Te Tipunga period (1200–1500)
Formerly Mrs. Lushington Collection
Auckland Institute and Museum (21859)
See plate 19

At the top of the tooth are two figures back to back with upraised arms. Similar figures are found on Hawaiian wooden ornaments. The chevrons appear to be derived from human legs. The elements of this pendant relate to early island Polynesian forms rather than later Maori. What indications we have for dating suggest that chevron pendants were made about the fourteenth century.

5. Bowl. Kumete
Wood, 96 cm. (37¾ in.) long
Taranaki, Ohura
Early Maori
Te Tipunga period (1200–1500)
Formerly Harper Collection
Auckland Institute and Museum (4470)

The massive simplicity of this food bowl is enhanced by the modest masks on the handles—abstract faces suggested by eyes and an upper lip line. Its form is reminiscent of bowls in Hawaii and the Marquesas.

6. Canoe bow cover. Haumi
Wood, 107 cm. (42¼ in.) long
Northland, Doubtless Bay
Early Maori
Te Tipunga period (1200–1500)
Formerly E. E. Vaile Collection
Auckland Institute and Museum (3078)
See plate 20

The dragon-like figure at the front of this Polynesian-style canoe has some Polynesian features but also foreshadows the manaia (profile/figure) of later Maori carving. A transitional feature are the spikes all over the figure, which can be likened to the knobs on the elaborate Kauri Point comb (cat. no. 78). Some people have seen a resemblance between this prow and those of Viking ships, but this is a chance likeness soon dispelled by closer acquaintance with either form. The prow probably dates from about the fifteenth century.

177

7. Canoe sternpost. Taurapa
Wood, 106.7 cm. (42 in.) long
Northland, Doubtless Bay
Early Maori
Te Tipunga period (1200–1500)
Formerly T. Wallace Collection
Auckland Institute and Museum (35570)

This sternpost was found not far from the Doubtless Bay prow (cat. no. 6) and may be from the same canoe. The small manaia (profile figures) at the base are very similar to the larger head on the prow. At the top is an animal which appears to be a dog with a manaia head. The whole sternpost, and particularly the dog form, is beautifully carved. The skill of a stone-tool worker can be seen in the adzing of the plain surfaces.

8. Bowl. Kumete
Wood, 73.5 cm. (29 in.) long
Hauraki Plains, Mangatarata
Early Maori
Te Tipunga period (1200–1500)
Formerly G. B. Harris Collection
Auckland Institute and Museum (45313)

The shape of this bowl with definite flat rim suggests a Polynesian form. The human head at the front, strongly modeled with high-keeled eyes, is quite unlike later Maori work and equally unlike early Polynesian forms. The use of a simple, strong if realistic, mask places it within the tradition of the Oceanic mask. This would suggest that this bowl is a transitional form by a master sculptor who lived in the fifteenth or early sixteenth century.

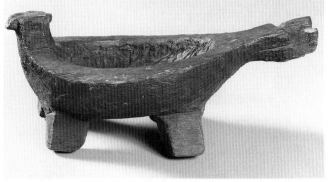

9. Bowl. Kumete
Wood, 50 cm. (19¾ in.) long
Bay of Plenty, Motiti Island
Early Maori
Te Tipunga period (1200–1500)
Formerly H. J. G. Allen Collection
Auckland Institute and Museum (14015)

The overall shape of this unfinished bowl seems to be that of a bird. The four legs, a feature of Polynesian bowls, is rare on New Zealand bowls and not found on later examples at all. The form of the bowl is strong, simple, and clear to behold.

178

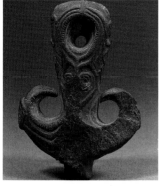

10. Amulet (?)
Stone, 9.3 cm. (3 ⅝ in.) long
Southland
Ngai Tahu (Waitaha)
Te Tipunga period (1200–1500)
Formerly A. Hamilton Collection
National Museum of New Zealand, Wellington (ME.654)

The patterns on this piece are very reminiscent of decoration on artifacts from the Pacific islands. The use of notching as a decorative feature appears early in New Zealand; the concentric circle and spiral forms relate it to other pieces found in the South Island. The function of this artifact is unknown, but its form suggests a neck pendant.

11. Amulet. Reiputa (rendered in stone)
Serpentine, 10.2 cm. (4 in.) long
Pelorous Sound, Laverigne Bay
Early Ngati Kuia
Nga Kakano period (900–1200)
Otago Museum, Dunedin (D35.506)

This amulet from the northern tip of the South Island is a copy in stone of a killer whale (*Orca gladiator*) tooth. This type of tooth may be the origin of the whale tooth imitations in stone. Whales figure prominently in Maori mythology and legends. Throughout the Pacific, whales, dolphins, and porpoises have a special relationship with man and will come when called. In Maori society, wearing a whale ivory or bone ornament or carrying a bone club was, and still is, a mark of a special man. These items are known as iwi ika (fish bones). In early times the real thing or a stone copy seem to have served equally well.

12. Lure hook shank. Pa
Black argillite, 13.1 cm. (5⅛ in.) long
Central Otago, Shag River site, Matakaea
Kai Tahu (Waitaha)
Nga Kakano period (900–1200)
Otago Museum, Dunedin (D27.1054)

The pakohi (black argillite) from which this lure is made was probably obtained from the ancient quarries of the northern end of the South Island. It is a copy in stone of the patuna, or pearl-shell bonito lure, of the tropics. Since the pearl-shell oyster was not found in New Zealand, the early settlers copied the form in stone to make lure hooks for such fish as kahawai and kingfish. The shanks were shaped to give the appearance of small minnow-like fish. Hooks of this type went out of use about the fifteenth century. The Matakaea site, where this hook was found, is dated between the twelfth and fourteenth centuries.

13. Amulet
Serpentine, 7.2 cm. (2¹³⁄₁₆ in.) long
Otago, Waitati
Early Kai Tahu (Waitaha)
Nga Kakano period (900–1200)
Formerly Dr. T. M. Hocken Collection
Otago Museum, Dunedin (D10.279)

The serpentine used for this amulet probably originated in the Nelson area at the extreme north of the South Island. The simple dancing figure is a theme found throughout Polynesia and may be seen, for instance, on the carved drums of the Austral Islands or the Chatham Islands dendroglyphs. The style of this amulet would suggest that it is an early object.

14. Attrition saw
Sandstone, 18.5 cm. (7¼ in.) long
Foveaux Strait, Centre Island
Early Kai Tahu (Waitaha)
Nga Kakano period (900–1200)
Otago Museum, Dunedin (D21.844)

This attrition saw, from the southern tip of the South Island, is the type of saw that was used to cut moa bone. The name "moa" is given to a number of families of large flightless birds now extinct. The largest of these was *Dinornis maximus*, which attained a height of eleven feet, and the smallest was *Anomalopteryx didiformis*, which was about the size of its modern-day relative, the kiwi. The bones of these birds, which became rare after the fourteenth century, were highly prized and used for ornaments and tools. The two faces of the cutter are in the form generally known as the Oceanic mask, which was brought to New Zealand by the earliest settlers but is also a basic feature of the art of Polynesia, Melanesia, Micronesia, and the ancestors of the Polynesians, the Lapita pottery people.

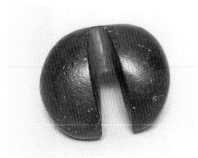

15. Imitation whale tooth necklace. Mau kaki
15 pieces of moa bone, 32 cm. (12⁹/₁₆ in.) overall length
Southland, Fortrose
Early Ngai Tahu (Waitaha)
Nga Kakano period (900–1200)
Southland Museum and Art Gallery, Invercargill (B81.161)

This necklace, in which each unit is a stylized version of a whale tooth, was found in a beach midden with a burial of a young girl which probably dates to the twelfth century. Whale tooth units such as these and reel beads have also been found in excavations in Huahine in the Society Islands where they are dated to about the fourteenth century, while reel beads that have been excavated in the Marquesas date to A.D. 300. Similar pendants in wood, stone, and ivory are found in other parts of Polynesia; a late form, for example, are the lei niho palaoa (hook pendants) of eighteenth- and nineteenth-century Hawaii.

17. Amulet, divided sphere. Rei
Serpentine, 4 cm. (1⁹/₁₆ in.) long
Nelson, Whakapuaka
Early Waitaha (Ngai Tarapounamu)
Nga Kakano period (900–1200)
Formerly T. A. Fuller Collection
Canterbury Museum, Christchurch (E.120.6.1)

This is one of the rare and beautiful types of ornament found only in the early period in New Zealand and, like the chevron pendant, is not found outside New Zealand. It may be related to the double testicle forms of the Austral Islands of the eighteenth century. There is no clear indication of age for the divided spheres but they are found in association with early adz forms. Dr. Roger Duff, late of Canterbury Museum, suggested that they were hybrid forms of the reel ornament associated with Early Maori culture in New Zealand.

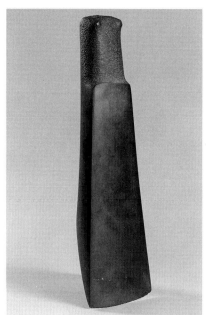

16. Whale tooth pendant. Rei niho
Serpentine, 21.3 cm. (8³/₈ in.) long
Southland, Fortrose
Early Ngai Tahu (Waitaha)
Nga Kakano period (900–1200)
Southland Museum and Art Gallery, Invercargill (B65.63)
See plate 21

The beautiful blue-green serpentine rock from which this pendant is made probably came from the northern tip of the South Island in the Nelson region. This rei niho is an almost perfect and direct copy of a sperm whale tooth and formed the center part of a necklace. Whale teeth were used as pendants in the early period in New Zealand, in the Marquesas, and other Pacific Islands. The suggested dating for this piece would be about the twelfth century.

18. Adz. Toki
Basalt, 43.2 cm. (17 in.) long
South Canterbury, Makikihi
Early Kai Tahu (Waitaha)
Nga Kakano period (900–1200)
Otago Museum, Dunedin (D25.481)
See plate 23

This toki (adz), of Early East Polynesian form with horns, was manufactured about the twelfth century. A small number of adzes as beautifully finished as this one have remained in use as ceremonial adzes used by tohungas (priests) when making the first cut when felling a special tree, in canoe making, and in building a house. All that is known about this particular toki is the place where it was found and that it is a very beautiful example of the adz-maker's art.

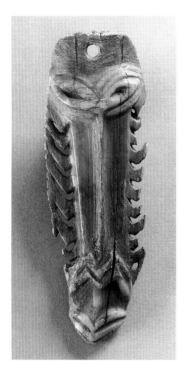

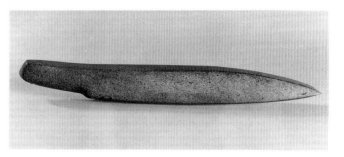

21. Adz. Toki
Metabasalt, 40.3 cm. (15⅞ in.) long
Southland, Tuturau
Kai Tahu (Waitaha)
Te Tipunga period (1200–1500)
Southland Museum and Art Gallery, Invercargill (B.69.147)

This toki (adz) represents a local development of the East Polynesian adz kit brought to New Zealand by the earliest settlers. It has the tang, or grip, of East Polynesian adzes, but its overall proportions are typical of Southland adzes. This adz was made about 1400, when large seagoing canoes were still being constructed for long voyages.

19. Amulet. Rei niho
Whale ivory, 10 cm. (3¹⁵/₁₆ in.) long
Banks Peninsula, Okains Bay
Kai Tahu (Waitaha)
Te Tipunga period (1200–1500)
Canterbury Museum, Christchurch (E.175.39)
See plate 22

This amulet is particularly interesting in that it shows the derivation of the chevron amulet from a human figure. At the top is a pair of eyes, then a very long nose, and at the base the arms and legs of a dancing figure. The arms are elaborated as elbows and hands repeated up the sides of the amulet. This piece is not dated but it could have been made in the thirteenth or fourteenth centuries.

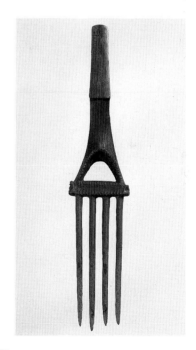

20. Knife. Maripi (Ulu)
Slate (polished stone?), 9.7 cm. (3¹³/₁₆ in.) wide
Otago, Waipahi
Early Kai Tahu (Waitaha)
Nga Kakano period (900–1200)
Otago Museum, Dunedin (D33.23)

"Ulu," the name given to these knives by museums, is Eskimo for the same type of knife. It is the woman's knife of the Eskimo and the stone (and later metal) reaping knife of Asia. In New Zealand it is known only from the South Island, where it may be associated with the working of moa and other skins for clothing. There is evidence that such skins were worn before moa became scarce and forced the development of a type of finger weaving with whitau (flax) fiber.

22. Comb. Heru
Wood, 15.2 cm. (6 in.) long
Christchurch, Sumner, Monck's Cave
Kai Tahu (Waitaha)
Te Tipunga period (1200–1500)
Canterbury Museum, Christchurch (E.72.49)

The simple lines of this comb would suggest that it is artistically intermediate between the Early East Polynesian art and later Maori forms. The small heads at the ends of the crossbar and the notched decoration are archaic time-markers. This comb was probably made about the sixteenth, or possibly seventeenth, century. Because the South Island tends to retain archaic features in its art, the comb could be later than a comparable piece in the North Island.

181

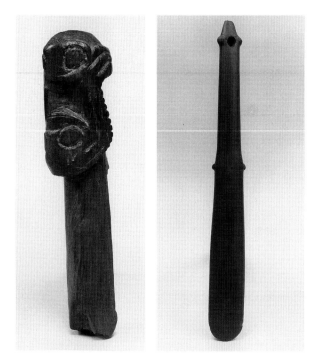

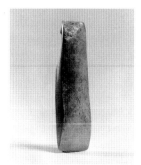

23. Godstick (?) or paddle. Taumata atua or hoe

Wood, 14.5 cm. (5¹¹/₁₆ in.) long
Christchurch, Sumner, Monck's Cave
Kai Tahu (Waitaha)
Te Tipunga period (1200–1500)
Canterbury Museum, Christchurch (E.158.355)

This object is a transitional piece that has resemblances to Tipunga period work, yet it is not Puawaitanga, nor even North Island in form. Interpretation of the piece is difficult because it is a fragment. It might be the handle of a paddle, or it might be a godstick (taumata atua) that was used on important occasions when the gods were called to take up abode in the stick. What is important about the fragment is the evidence it provides of early South Island wood carving.

24. Club. Miti

Basalt, 50.5 cm. (19⅞ in.) long
South Island
Kai Tahu (Waitaha)
Te Tipunga period (1200–1500)
Canterbury Museum, Christchurch (E.100.9D)

This is a two-handed club of the South Island form. Occasional wooden two-handed clubs are known from the North Island. A long basalt club of this form, though, can only be from the South Island. The Puawaitanga period patu onewa club appears to have evolved in the North Island and only reached Otago in the beginning of the nineteenth century.

25. Adz. Toki pounamu

Nephrite, 27.6 cm. (10⅞ in.) long
Otago Harbour, Portobello
Kai Tahu (Waitaha)
Te Tipunga period (1200–1500)
Otago Museum, Dunedin (D49.481)
See plate 24

Horned-front grip adzes of this early shape are found in most of the East Polynesian islands. The type was brought to New Zealand by the early settlers as part of the adz kit. Carefully sawed out of nephrite, this adz (as well as cat. no. 26) probably dates to about the fourteenth century. The color has been changed by fire.

26. Adz. Toki pounamu

Nephrite, 32.8 cm. (12⅞ in.) long
Otago Harbour, Portobello
Kai Tahu (Waitaha)
Te Tipunga period (1200–1500)
Otago Museum, Dunedin (D49.482)
See cat. no. 25

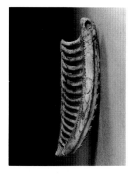

27. Pendant, chevron type. Rei niho

Whale ivory, 16.8 cm. (6⅝ in.) long
Otago Harbour, South Head, Little Papanui
Kai Tahu (Waitaha)
Te Tipunga period (1200–1500)
Otago Museum, Dunedin (D29.1)
See plate 25

It is possible that this chevron pendant was made from a split whale tooth and that it may have been one of a pair worn, suspended, as a breast ornament. Descendant tribes regard the form as symbolizing taniwha or karara, protective beings in the shape of reptilian monsters. This view may, however, owe a debt to scholarly interpretation. Taniwha are a rich surviving element in Maori myth, and the traditions of the area in which this pendant was found feature a number. Some scholars have seen the form as derived from the human figure and as an example of the dancing figure in Polynesian art.

STEPHEN O'REGAN

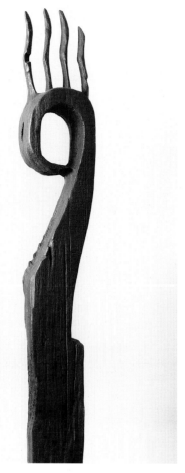

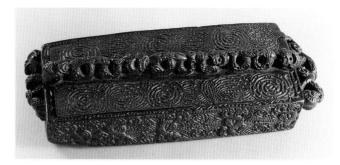

29. Feather box. Wakahuia
Wood, 38.7 cm. (15¼ in.) long
Ngati Kahu tribe
Te Puawaitanga period (1500–1800)
Formerly Crowther-Beynon Collection; Webster Collection
National Museum of New Zealand, Wellington (Web. 864)
See plate 26

A chief's head was especially tapu (sacred), so anything that was worn on his head or neck was also sacred and could harm other people who were not of equivalent rank. Feathers, combs, ear pendants, hei-tiki were therefore placed in a wakahuia which was then hung from the rafters of the chief's house out of reach of children and was not to be touched by anyone except the chief himself. The boxes are carved on the underside, since this is the side usually seen.

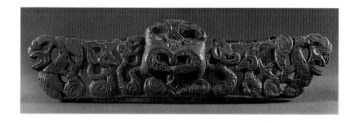

30. Threshold for storehouse. Paepae
Wood, 99 cm. (39 in.) wide
Northland, Doubtless Bay
Ngati Kahu tribe
Te Puawaitanga period (1500–1800)
Formerly Hooper Collection
National Museum of New Zealand, Wellington (ME.13972)
See plate 27

A very fine carving dating from the eighteenth century, this was a prestige piece belonging to an important chief and was probably the threshold for a small storehouse. It is one of the two extant pieces in this carving style. The head has a very similar shape to those of the Ngapuhi from the Bay of Islands, but the flanking manaia (profile figures) are more in the Hokianga tradition. The central figure represents the genealogy of the chief, flanked by spirit beings or manaia representing the supernatural world.

28. War god. Uenukutuwhatu
Wood, 267 cm. (8 ft. 9 in.) high
Found at Lake Ngaroto, 1906
Waikato
Te Tipunga period (1200–1500)
Formerly R. W. Bourne Collection
Te Awamutu Museum (2056)
See plate 2

Uenuku, also known as Uenukutuwhatu, is the tribal and war god of the Waikato tribes. The symbol of Uenukutuwhatu is this large post. When needed, Uenuku was asked to dwell within the post so that the ariki (prominent chief) and priest could talk to him. When the Waikato tribes went to war, Uenuku went with them. He was asked to inhabit a small carving which was then carried by the priest into battle.

This large post was made sometime after the arrival of the Tainui canoe. It has a haunting resemblance to some Hawaiian carving. Traditional information would suggest it was made about 1400, when the art styles of the Maori were still East Polynesian in form.

Uenuku in his more ancient form is a god who appears as a rainbow. In this form he came on the Tainui, the ancestral canoe of the Waikato people. Seven generations later the three sons of Whatihua and Ruaputahanga were named Uenukutuwhatu, Uenuku te rangihoka, and Uenuku whangai—Uenuku who stands as lord, Uenuku the soaring sky, and Uenuku who provides food. Since that time, the rainbow god Uenuku, a descendant of Tumatauenga, god of war, and the deified Uenukutuwhatu, Uenuku the provider, have protected and guarded the property of the Waikato people. Ngati Apakura, the descendants of Whatihua's other wife, Apakura, have always been the custodians of the symbol Uenuku. The present-day ariki of Ngati Apakura and of all Waikato is Queen Te Ata i Rangikaahu.

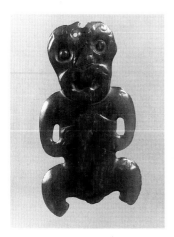
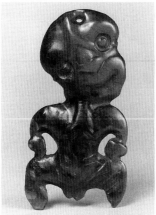
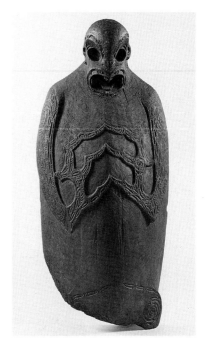

31. Amulet. Hei-tiki

Greenstone, 9 cm. (3½ in.) high
Bay of Islands, Ruapekapeka
Ngapuhi tribe
Te Puawaitanga period (1500–1800)
Otago Museum, Dunedin (D24.1224)
See plate 28

This nephrite hei-tiki not only follows the wood-carving tradition of the Bay of Islands in shape, but it is also decorated on the head, shoulders, and hips with wood-carving patterns. This is the ancestral form of tiki, the open-stance, or upright, tiki which seems to precede the other later forms fitted into a rectangular shape. This tiki is especially well made. It was certainly the treasured heirloom of an important chief worn for many generations.

32. Pendant. Hei-tiki

Nephrite, 12 cm. (4¾ in.) high
Northland
Ngapuhi tribe
Te Puawaitanga period (1500–1800)
Formerly Armitage Collection; Sir J. Gunson Collection
Auckland Institute and Museum (30164.2)
See plate 1

This hei-tiki of upright stance with head slightly on the side and with both hands on the hips is a very old tiki of a form not well known outside Northland and the Ngapuhi tribal area.

33. Burial chest. Waka tupapaku

Wood, 98 cm. (38⅝ in.) high
Northland
Ngapuhi tribe
Te Puawaitanga period (1500–1800)
Formerly Turnbull Collection
National Museum of New Zealand, Wellington (ME.2659)
See plate 31

In the Tai Tokerau region, bodies were exposed after death atamira, or platforms, until the flesh had rotted. The bones were then taken down, cleaned, painted with red ocher, and placed in a waka tupapaku, or secondary burial chest, which was then put into a cave. Waka tupapaku were made only for chiefs or other notable people. The overall design, in which they are made to sit upright in the cave, is intended to frighten intruders away.

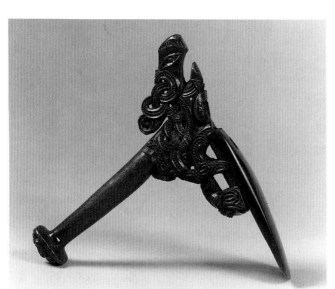

34. Ceremonial adz. Toki poutangata

Wood, nephrite, 26 cm. (10¼ in.) high
Ngapuhi tribe
Te Puawaitanga period (1500–1800)
Formerly W. O. Oldman Collection
Canterbury Museum, Christchurch (E.150.571)
See plate 35

Handles such as this were made for a ceremonial adz and fitted to a tapu adz blade which itself would be a treasured heirloom given a personal name. The rightful holder and direct descendant of the chiefs who had owned it was the ariki, or paramount chief of the tribe. When he took over, a new handle was made and lashed to the sacred blade. Thus a new ariki was visibly proclaimed. During his lifetime it was the insignia of his rank; on his death the handle would be cut off and placed with his body. This handle, carved with figures from mythology, is an ancient one made in the eighteenth century or earlier.

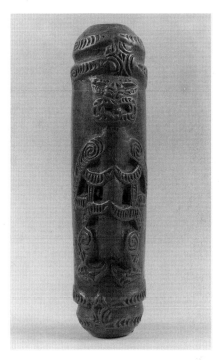

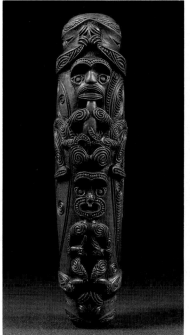

35. Flute. Koauau
Wood, 14.5 cm. (5¾ in.) long
Bay of Islands
Ngapuhi tribe
Te Puawaitanga period (1500–1800)
Formerly W. O. Oldman Collection 34
Auckland Institute and Museum (31515)

This wooden koauau, or flute, decorated with a single figure of stylized form, was obtained by Admiral Lemprière and later owned by W. O. Oldman, who was a well-known collector.

36. Weapon. Tewhatewha
Wood, 116 cm. (45⅝ in.) long
Ngapuhi tribe
Te Puawaitanga period (1500–1800)
Presented by Ngapuhi tribe to Governor Sir George Grey
Auckland Institute and Museum (21105)

This type of two-handed club with expanded end at the blade was used as a signaling device by the commander of an army, the expanded surface making it clearly visible. Often feathers were attached on the lower side of the axlike feature and the feathers could be made to quiver in the wind. The striking part of the club is the straight edge behind the flat surface, the club being swung like a quarterstaff.

37. Flute. Koauau
Wood, 20 cm. (7⅞ in.) long
Bay of Islands
Ngapuhi tribe
Te Huringa 1 period (1800–present)
Formerly W. O. Oldman Collection
National Museum of New Zealand, Wellington (Old. 35)

Three-hole flutes like this early nineteenth-century, open-tube flute were used to play the tunes of the waiata (sung poems). It is said the words could be breathed through the flute, but this was probably just the tune. The carving style suggests this flute came from the southern Bay of Islands. Such flutes are still played.

38. Weapon. Hoeroa
Whale-rib bone, 129 cm. (50¾ in.) long
Northland
Ngapuhi tribe
Te Huringa 1 period (1800–present)
Formerly C. O. Davis Collection
Auckland Institute and Museum (252)

These long and unwieldy clubs appear to have been used mainly as symbolic staffs by the chiefs. They were sometimes carried on land but were more often carried upright in a canoe. Symbolically they are iwi ika, or sea bone, and as such represent the domain of Tangaroa, god of the sea. The name hoeroa could mean a long paddle. Hoeroa are rare and are found mainly in the Northland area.

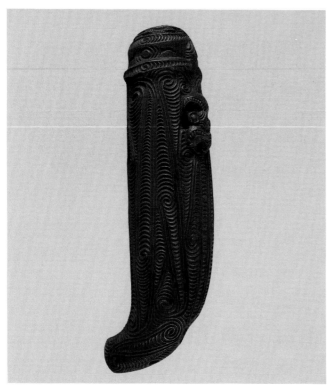

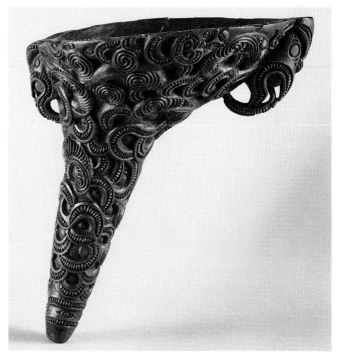

40. Feeding funnel. Korere
Wood, 15 cm. (5⅞ in.) high
Hokianga
Ngapuhi tribe
Te Huringa 1 period (1800–present)
Formerly W. O. Oldman Collection
National Museum of New Zealand, Wellington (Old. 135)

Almost all these funnels, which were used to feed a chief when his face was being tattooed, come from the Northland area. A chief's head was very tapu. Cooked food has the property of removing or diminishing tapu. If any food touched the lips when they were still raw from tattooing, it would remove the tapu from the work and cause it to fail. At the same time, during the tattoo process the tattooer would not have been able to touch food with his hands, which were also tapu from the spilled blood. He would be fed pieces of food on sticks. This funnel has the head shapes of Hokianga combined with the surface decoration of the Bay of Islands.

39. Flute. Nguru
Wood, 19 cm. (7½ in.) long
Hokianga
Ngapuhi tribe
Te Huringa 1 period (1800–present)
Formerly J. Edge-Partington Collection; Dr. T. W. Leys Collection
Auckland Institute and Museum (16390)
See plate 36

This nguru, or flute, carved with iron tools in the early nineteenth century, is decorated with unaunahi, or rolling spirals, in the Hokianga style. Nguru were called nose flutes, since some scholars thought they were played from the curved end. The blowing end is, in fact, the large end. The shape of the flute would appear to derive from the form of a gourd top from which these flutes were originally made. They are also made in stone. The musical range is a major third.

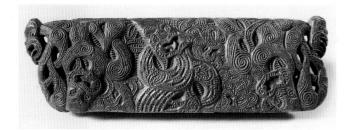

41. Feather box. Papahou
Wood, 54 cm. (21¼ in.) long
Hokianga
Ngapuhi tribe
Te Huringa 1 period (1800–present)
Formerly W. O. Oldman Collection
National Museum of New Zealand, Wellington (Old. 331)

This papahou, or rectangular feather box, made in the early nineteenth century, is decorated with unaunahi (rolling spirals) on the lid. The base is decorated with three figures carved in the serpentine style of Hokianga or the western area of Northland. This box was probably made by a Te Roroa carver. Te Roroa is a border tribe of mixed Ngati Whatua and Ngapuhi descent. One of the signs of accomplishment for the son of a chief was to carve a feather box to contain his own personal possessions; the other signs were the ability to compose waiata (sung poetry) and to lead his people in a tribal enterprise. As is usual on such feather boxes, the base is ornately carved because the box was designed to hang in the rafters of the house and thus was seen from the underside.

186

42. Lintel. Pare

Wood, 58.5 cm. (23 in.) wide
Bay of Islands
Ngapuhi tribe
Te Huringa 1 period (1800–present)
Formerly K.A. Webster Collection
Otago Museum, Dunedin (D63.783)

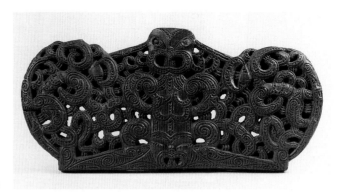

This is a lintel from a chief's house which stood in the Bay of Islands about 1820. The Ngapuhi of the Bay of Islands had their own carving style until about 1830, when it was abandoned in favor of items picked up on musket raids farther south. The lintel has a human figure in the center representing the ancestry of gods and man, with a manaia (profile figure) on either side which represents the spirit world. This lintel is carved in kauri (*Agathis australis*), a tree that grows only in the northern half of the North Island. About 1840 this lintel was taken to England from whence it was purchased.

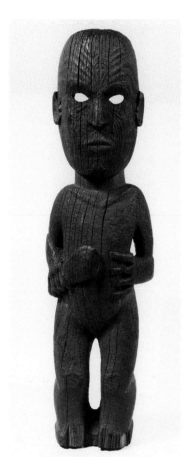

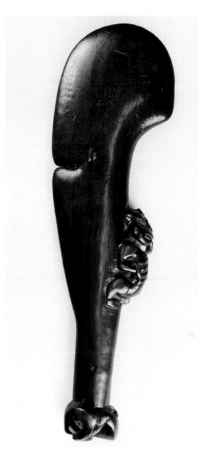

43. Gable figure. Tekoteko

Wood, 99 cm. (39 in.) high
Northland
Ngapuhi tribe
Te Huringa 1 period (1800–present)
Formerly F. O. Peat Collection
Auckland Institute and Museum (22737)

Although this tekoteko, or house gable figure, is from Northland, it is carved in the style of the Tuhoe of the Urewera. This figure belongs to a house carved with steel tools about 1850. The realistic face mask with eyeholes is a feature of the carving style of the Ngati Manawa sub-tribe. The house to which this tekoteko belonged was either a gift from the Bay of Plenty or was carried by an artist from the Tuhoe area.

44. Club. Wahaika

Wood, 37 cm. (14½ in.) long
Ngapuhi tribe
Te Huringa 1 period (1800–present)
Formerly Russell Collection
National Museum of New Zealand, Wellington (ME. 12750)

This wooden club is said to have belonged to Hongi Hika, a chief of the Ngapuhi tribe. In 1814 Hongi went with European missionaries to Sydney and to Europe. At Oxford University he assisted Professor Lee and the missionary Thomas Kendall to devise a written alphabet and write a grammar for the Maori language. On his return from Europe in 1818, Hongi embarked on a series of swift raids with muskets, some of which he had purchased while overseas by selling off some of the presents given to him by the crowned heads of Europe. His raids were undertaken by fast-moving, tightly organized groups who ignored most of the courtesy usually associated with wars among the Maori people. Fear of the Ngapuhi raiders spread over the whole of the North Island and completely altered the tribal pattern of life.

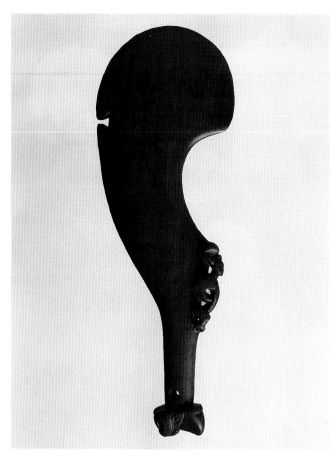

45. Club. Wahaika

Wood, 46 cm. (18⅛ in.) long
Ngapuhi tribe
Te Huringa 1 period (1800–present)
Formerly W. O. Oldman Collection 66
Canterbury Museum, Christchurch (E.150.579)
See plate 29

This type of curved wooden hand club was used for close infighting.
The weapon is handled rather like a short sword and is used for
thrusting, with the blow being made by the end not the sides. The
figures on the side and butt are mythological. It should be noted that the
shape of a wahaika (literally, fish mouth) is quite distinctive and differs
from all other short hand clubs of the patu category.

46. Doorjamb. Whakawae

Wood, 245 cm. (96½ in.) high
Otakanini
Ngati Whatua tribe
Te Puawaitanga period (1500–1800)
Formerly A. S. Bankart Collection
Auckland Institute and Museum (6206)

This whakawae, or doorjamb, comes from a house named Tutangimamae,
which stood at Manakapua in the central Kaipara. It was carved about
1650 for the chief Rangitaumarewa who fell in love with Te Hana, a
beauty from across the harbor, and who enticed her to elope. Her
people took revenge by killing Rangitaumarewa's tribe. Te Hana stood
over the door of the house and any who passed inside were saved even
though they lost their mana (power) by passing between her legs. The
carvings were taken from Manakapua and later re-erected for a house at
Otakanini in the south Kaipara. This carving is one of the great pieces
of Maori art.

188

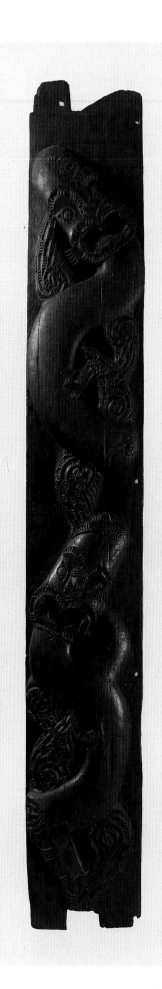

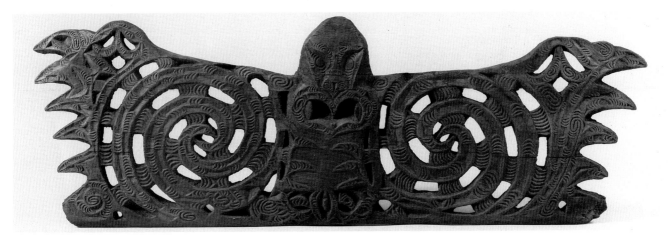

47. Lintel. Pare
Wood, 81.5 cm. (32⅛ in.) wide
Kaitaia
Ngati Whatua tribe
Te Puawaitanga period (1500–1800)
Formerly D. J. Quigley Collection
Auckland Institute and Museum (45058)

This pare, or lintel, for a chief's house is carved in the style of the Ngati Whatua tribe of Kaipara. It was found hidden carefully in a swamp, in a prepared bed of rushes that had been made to enclose the lintel before it was placed in the peat. It was probably hidden during the Ngapuhi musket raids on the area about 1825. The carving was done with stone tools. It is the only early lintel so far known in this style. A feature that links it with earlier carving is the serrated sides which echo the decoration of Kaitaia carving. The spirals seem at first glance to be symmetrical but are in fact quite different. This apparent symmetry is a feature of Maori art.

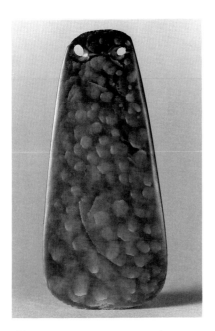

48. Pendant. Hei-pounamu
Nephrite, 12 cm. (4¾ in.) long
Kaipara
Ngati Whatua tribe
Te Puawaitanga period (1500–1800)
Formerly Rintoul Collection
Auckland Institute and Museum (6425)
See plate 30

This nephrite pendant is made of pipiwharauroa greenstone. The stone is speckled like the breast of a shining cuckoo (pipiwharauroa), the harbinger of spring. The pendant is in the shape of a thin adz, but this stone has been chosen for its beauty, not its utility. Pipiwharauroa greenstone is rare and highly prized even today.

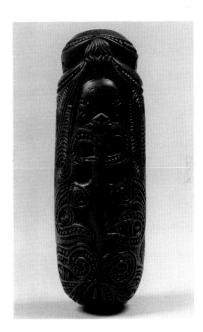

49. Flute. Koauau
Wood, 13 cm. (5⅛ in.) long
Waimamaku Valley
Te Roroa (Ngati Whatua)
Te Huringa 1 period (1800–present)
Formerly W. O. Oldman Collection 1025
Otago Museum, Dunedin (050.014)

This koauau, or wooden flute, is decorated in the style of Te Roroa, the Ngati Whatua–Ngapuhi tribe of the Waimamaku valley. The shape of the figure with domed head is typical of the western tradition of carving. The unaunahi, or rolling spiral decoration, is characteristic of Hokianga. The arms and legs have almost become patterns and are only marked out by the use of square block pakati. The flute has two finger holes, with a third under the curved tip.

189

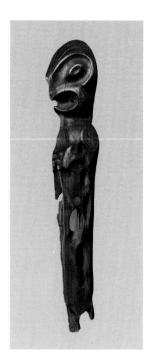

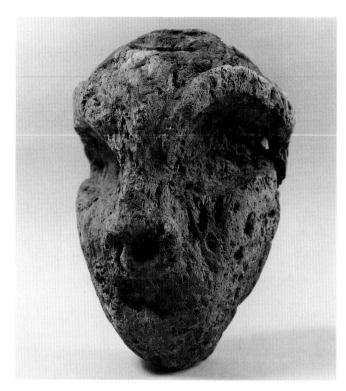

50. Godstick. Taumata atua

Wood, 44 cm. (17¼ in.) high
Auckland City, Ngataringa Bay
Kawerau tribe
Te Puawaitanga period (1500–1800)
Formerly E. E. Vaile Collection
Auckland Institute and Museum (49009)
See plate 33

This taumata atua, or godstick, a resting place for a god, is one of the
few relics from the Ngataringa Bay area which have survived. It is quite
remarkable not only for its form and size, but also because it is the only
such figure found in the northern area. Other godsticks are known from
the Whanganui area. This one is in the form identified with the god
Hukerenui, the guardian of the bones of the dead.

51. Head. Whakapakoko

Pumice, 18.7 cm. (7⅜ in.) high
Coromandel, Whakahau, South Bay pa
Ngati Hei tribe
Te Puawaitanga period (1500–1800)
Waikato Art Museum, Hamilton (1975/65/1)

This pumice head from the South Bay pa (village) on Whakahau Island
off the coast of the Coromandel Peninsula is one of the rare works of
Ngati Hei, a tribe that was decimated by musket raids in the early
nineteenth century. This head and one or two other small pieces are all
that is known of the art styles of the area.

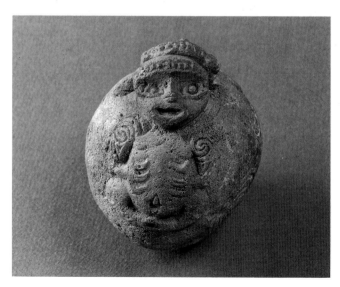

52. Sinker. Mahe

Stone, 8 cm. (3⅛ in.) high
Hauraki Gulf, Kaiaua
Ngati Paoa tribe
Te Puawaitanga period (1500–1800)
Formerly T. Te Ahipo Collection
Auckland Institute and Museum (26452)
See plate 34

The carving on this ceremonial fishing sinker is very similar to that of
another ceremonial sinker from the Auckland area, also in the Auckland
Museum. Ceremonial sinkers could be mauri (life force bearers) in their
own right; this is true of the mauri Marutuahu, the fertility symbol for all
the Ngati Maru tribes, which include Ngati Paoa. Otherwise such
sinkers were used in the ceremonies at the altar before fishing started;
they were then hung in the bow of the fishing canoe to remind the god
that his help had been invoked.

53. Bowl. Kumete

Wood, 125 cm. (49¼ in.) long
Clevedon
Ngati Paoa tribe
Te Puawaitanga period (1500–1800)
Formerly D. E. Ryburn Collection
Auckland Institute and Museum (44626)

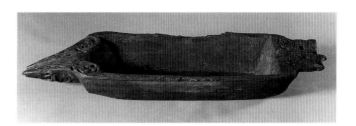

The general style of this bowl with a spout from Kawakawa Bay would
tie it in with the Ngati Tamatera rather than Ngati Paoa. In the
mid-nineteenth century Taraia, chief of Ngati Tamatera, had a village at
Taupo on the foreshore at Kawakawa Bay. This bowl is made with stone
tools and could predate Taraia's village. Spouted bowls were used in the
process of preserving flesh in which the flesh was roasted, the fat
collected and poured over the meat, usually pigeons, placed in a gourd.
These were prestige foods that were usually served to visiting chiefs.

54. Window sill. Matapihi

Wood, 89 cm. (35 in.) high
Patetonga
Ngati Tamatera tribe
Te Huringa 1 period (1800–present)
Formerly L. Carter Collection
Auckland Institute and Museum (6306)

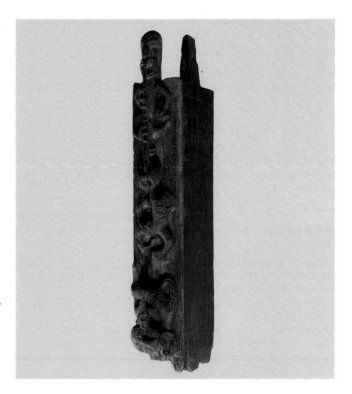

The Patetonga house probably had a sliding door and window and no
other aperture. This piece from the window would suggest that there
were other carved sections of the same house which have not survived or
have not yet been found.

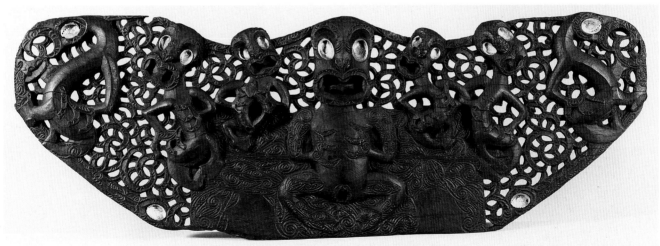

55. Lintel. Pare

Wood, shell, 235 cm. (7 ft. 8 in.) wide
Patetonga
Ngati Tamatera tribe
Te Huringa 1 period (1800–present)
Formerly L. Carter Collection
Auckland Institute and Museum (6189)

This very large pare was made with stone tools. According to tradition,
this is part of a house that was built about 1850 on an island pa (village)
in the Hauraki swamps. The carver or carvers were trained in the use of
stone tools and do not seem to have wished to change to metal tools.
Thus this piece represents a contradiction—a stone-tool lintel made for
a later type of meeting house structure. The Ngati Tamatera style relates
to the western Tai Tokerau and Taranaki. The background decoration is
a loose spiral form. Lintels such as this represent the separation of the
primal parents, Rangi the Sky Father and Papa the Earth Mother, but
also remind us, with the female figure, of Maui's failure to defeat death
by reversing the process of birth. This pare is one of the great treasures
of Maori art; it has no peer.

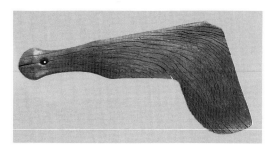

56. Club. Patu
Wood, 31 cm. (12¼ in.) long
Lake Mangakaware
Waikato tribe
Te Tipunga period (1200–1500)
Waikato Art Museum, Hamilton (1972/103/35)

This wooden patu comes from a prehistoric site at Lake Mangakaware near Te Awamutu in the Waikato. This type of patu is known in a stone example from the Waikato and in another from the Kaipara to the north. It is not a type known in the eighteenth century. Parallels are the wooden tewhatewha, a club shaped like a battle-ax (cat. no. 36), and the wahaika, short wooden clubs (cat. nos. 44, 45).

57. Canoe sternpost. Taurapa
Wood, 99.8 cm. (38 in.) high
Possibly Lake Waikato/Waiuku
Waikato
Te Puawaitanga period (1500–1800)
Waikato Art Museum, Hamilton (1977/60/7)

This piece of an early canoe decorated with a series of transverse pecked lines could be a companion piece to the Waitore bow cover (cat. no. 136) which is decorated with the same row of pecked lines in rows and spirals. These two pieces would seem to represent the beginning of Maori art.

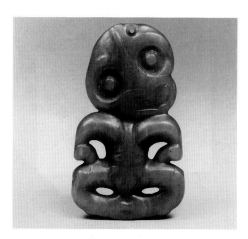

58. Double-sided pendant. Hei-tiki
Nephrite (inanga), 8 cm. (3⅛ in.) high
Hamilton, Opoia pa
Waikato tribe
Te Puawaitanga period (1500–1800)
Waikato Art Museum, Hamilton (1964/56/1)

Traditionally such double-sided tiki of squat shape are rare, as they were the mark of very special distinction and had personal names since they carried the mana of those who had owned them. When they were brought on to a marae they were often greeted as people, as though the ancestors they represented were physically present.

192

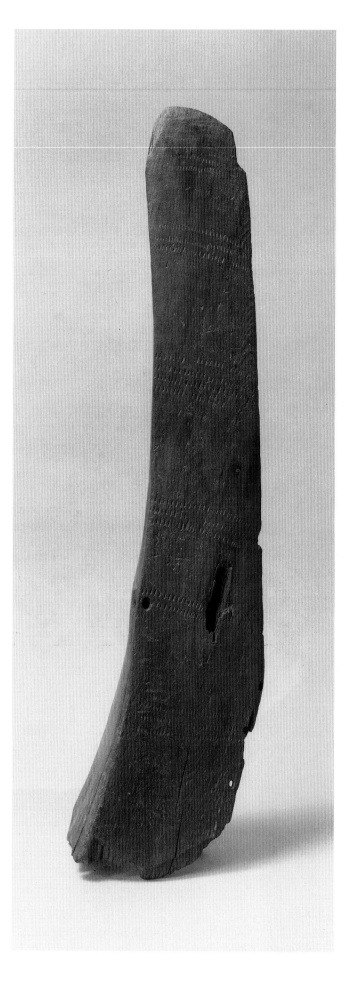

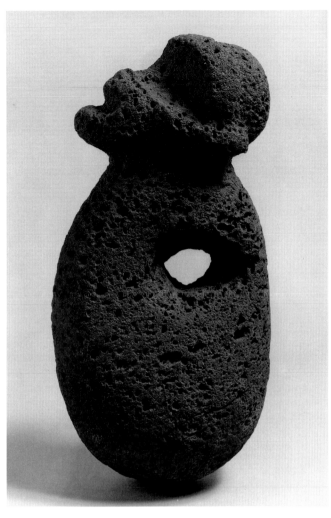

59. Figure. Taumata atua
Vesicular basalt, 48.5 cm. (19⅛ in.) high
Kawhia Harbour, Tiritiriomatangi
Waikato tribe
Te Puawaitanga period (1500–1800)
Waikato Art Museum, Hamilton (1982/113/1)
Held in trust for the Arikinui Dame Te Atairangikaahu
and her people

This stone figure was found protruding from the eroding edge of a tihi, the summit of a pre-European pa (village), where it had been placed in a pit prepared for its burial. The stone is broken, suggesting some form of ritual breakage. This figure is a mauri, talisman or life force container, which can also be a taumata atua, resting place of the god.

60. Memorial post. Pouwhakamaharatanga
Wood, 232 cm. (7 ft. 11¼ in.) high
Waikato tribe
Te Huringa 1 period (1800–present)
Formerly E. E. Vaile Collection
Auckland Institute and Museum (25053)

This memorial post was made from a canoe that belonged to the chief being commemorated. George French Angas painted many such posts standing in the Waikato in 1844. The form of this Waikato post—a smooth realistic face with a spike on top—is also found in other Waikato carvings. The base figure of a war canoe sternpost, for instance, is often a three-dimensional version.

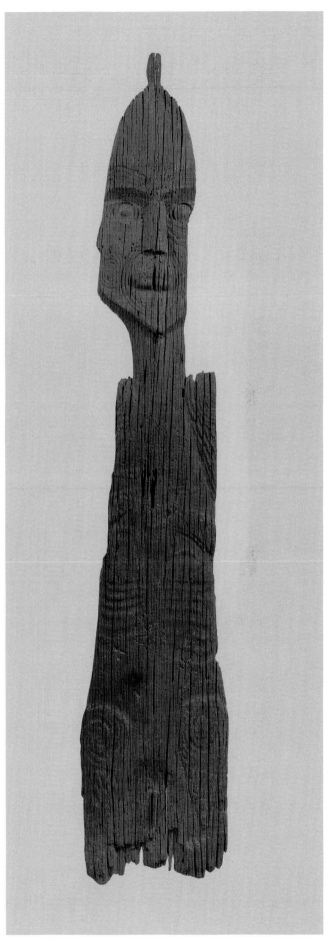

193

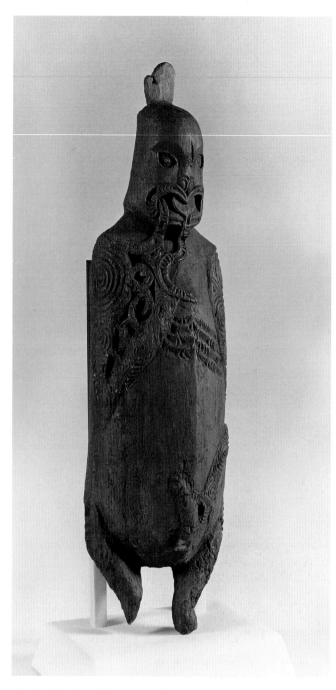

61. Burial chest. Waka tupapaku
Wood, 123.4 cm. (48½ in.) high
Waikato area, Raglan
Ngati Tahinga tribe
Te Huringa 1 period (1800–present)
Formerly Turnbull Collection
National Museum of New Zealand, Wellington (ME.2660)
See plate 32

This waka tupapaku (burial chest) was made to contain the scraped and painted bones of a person of chiefly rank. At death the body was put in a primary burial area, probably in the sandhills, and then, at a later date, exhumed and prepared for secondary burial in a cave. This chest is one of three that were found in the same area. It is one of only five such burial chests that have come from areas outside Northland. It was carved by Waikato carvers who elaborated the spike normally found on the heads of their figures into a comb.

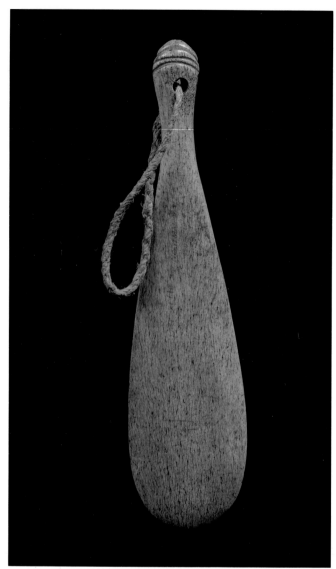

62. Club. Patu paraoa
Whalebone, 45.4 cm. (17⅛ in.) long
Te Kuiti
Ngati Maniopoto tribe
Te Huringa 1 period (1800–present)
Formerly Mrs. J. M. Bullock Collection
Auckland Institute and Museum (31653)

This whalebone club was made from bone that had been cut out of the jaw of a sperm whale with a sandstone saw. Grooves are cut from the front, then the back is sawed away to take out the slab. This is then made into a club shape by chipping and sawing with stone tools. Each individual club was weighed and balanced to suit the hand and preference of the person for whom it was being made. Such a club would have been used over many generations and passed down as an heirloom through the tribe. This particular patu has a deep patina which has come with age.

194

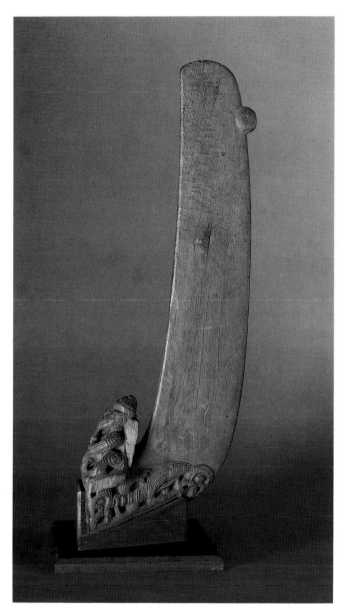

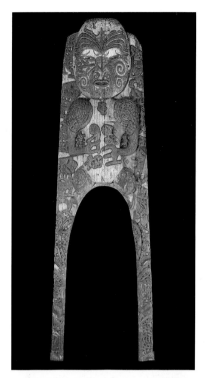

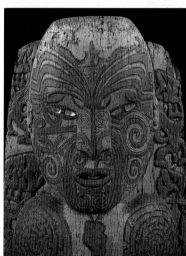

63. Sternpost. Taurapa
Wood, 63.5 cm. (25 in.) high
Lake Rotoiti, Okere
Arawa tribe
Te Puawaitanga period (1500–1800)
Formerly Blair Collection
National Museum of New Zealand, Wellington (ME.1829)

This particular taurapa (sternpost) of a fishing canoe is an abstract
version of the Maori war canoe sternpost but without the sacred
connotations that were attached to a war canoe. However, it still
incorporates the same elements of a figure at the base, a manaia (profile
figure), and a figure beneath this, and, near the top of the sternpost, a
circular knob on the back edge which represents the manaia figure
found on war canoe sternposts. This little sternpost was made with stone
tools in the eighteenth century and is the work of an Arawa artist of
the period. It was probably made originally in the coastal area of
the Bay of Plenty and only later reached the inland area. Very similar
sternposts are known from Whakatane, Maketu, and Coromandel. In
some books they are depicted as a standard fitting for fishing canoes for
all tribes in New Zealand, but they would appear to be largely
confined to the Bay of Plenty.

64. Gateway of Pukeroa pa. Waharoa
Wood, paint, 350 cm. (16 ft. 5½ in.) high
Rotorua
Arawa tribe (Ngati Whakaue)
Te Huringa 1 period (1800–present)
Formerly New Zealand Government
Auckland Institute and Museum (160)
See plate 3

This waharoa is the gateway of Pukeroa pa, a palisaded village, which
until 1845 was still standing on the foreshore of Lake Rotorua. The site
is today occupied by the Rotorua Hospital. Pukeroa was one of the main
villages of the Ngati Whakaue tribe, part of the confederation descended
from the Arawa canoe people. In this male figure the artist has used an
Arawa realistic tattooed face mask and placed appropriate symbols on
the body. The face of the figure was originally painted white with black
tattoo, and this original finish has been restored for the exhibition.
Except for the shoulders and arms, the body was also white; all else
was red.

195

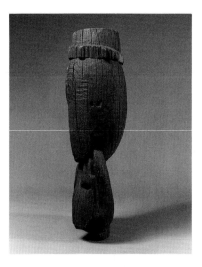

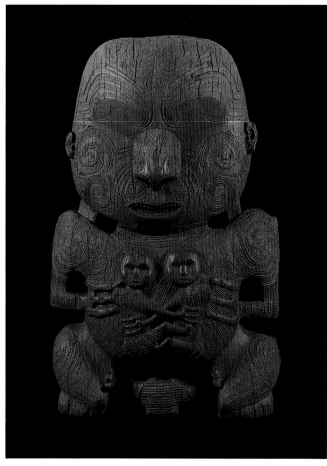

65. Top of palisade post. Pou

Wood, 85 cm. (33½ in.) high
Rotorua
Arawa tribe
Te Huringa 1 period (1800–present)
Auckland Institute and Museum (5483)

This represents a figure with an ovoid head topped by a hat and one hand going to the chin area. It is essentially seen as an abstract design, although the front of the post was originally decorated with a very simplified tattooed face. It is probably one of the palisade posts of the pa for which cat. no. 64 was the gateway. It was carved with metal tools in the early nineteenth century.

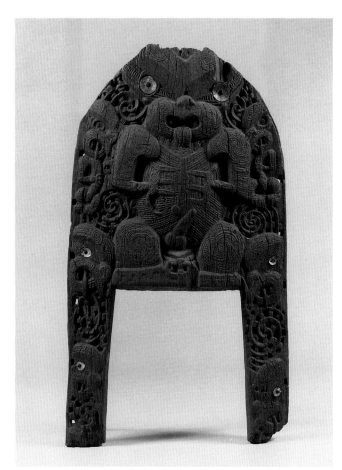

66. Gateway figure

Wood, 196 cm. (6 ft. 5⅛ in.) high
Lake Rotorua, Te Ngae
Arawa tribe (Ngati Whakaue)
Te Huringa 1 period (1800–present)
Auckland Institute and Museum, Gift of Justice Gillies (161)
See plate 4

This figure comes from the gateway of a pa (village) that stood at Te Ngae on Lake Rotorua in the early nineteenth century. The figure originally topped a gateway that was about fifteen feet high, but the lower part has been broken off and lost. It represents a chief of the Ngati Whakaue tribe named Pukaki with his wife and two children. The hapu of the tribe is still known by his name, "descendants of Pukaki." The figure has the realistic tattooed face mask of the Arawa people with the arms and legs of the main figure decorated with typical Arawa spirals.

67. Doorway for a storehouse. Kuwaha pataka

Wood, paint, 90.5 cm. (35⅞ in.) high
Gisborne, gift to the people of Rotorua
Arawa tribe
Te Huringa 1 period (1800–present)
Auckland Institute and Museum, Gift of Judge F. D. Fenton (156)
See plate 37

The carving style of this kuwaha pataka (storehouse doorway) is similar to that of Rongowhakaata. It was carved in the Gisborne area, possibly with stone tools, as a gift for the people of Rotorua. The head is triangular and the body very squat.

196

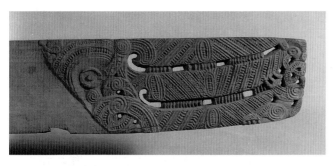

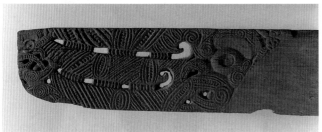

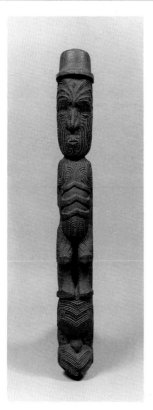

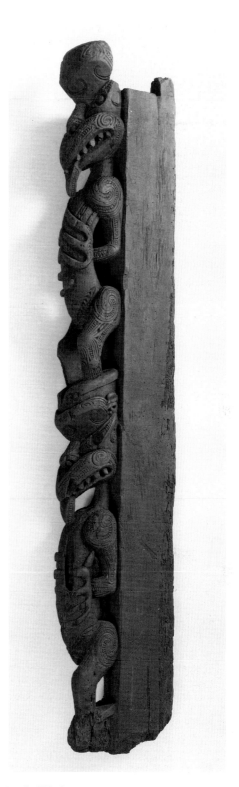

68, 69, 70. Bargeboards and gable-peak figure. Maihi raparapa and tekoteko

Wood, each bargeboard 433 cm. (13 ft. 8½ in.) long,
figure 135 cm. (53⅛ in.) high
Lake Rotoiti, Okere
Arawa tribe
Te Huringa 1 period (1800–present)
Formerly Mrs. Peeti Collection
Auckland Institute and Museum (22046.1, 22046.2, 22047)

Maihi (bargeboards) and tekoteko (gable apex figure) from a house that
stood at Okere near the outlet of Lake Rotoiti. The maihi came from a
smaller house that stood near the house Rangitihi carved about 1860 for
Te Waata Taranui, ariki (paramount chief) of all the Arawa tribes. This
smaller house was a gift from the ariki of the Ngati Porou tribe of the
East Coast to Te Waata Taranui, about 1850.

71. Doorjamb. Whakawae

Wood, 97 cm. (38¼ in.) high
Rotorua
Arawa tribe (Tuhourangi)
Te Huringa 1 period (1800–present)
Rotorua Museum (M2–8A)

This whakawae (doorjamb) comes from a house constructed about
1830 with iron tools for a chieftainess of the Tuhourangi tribe of Arawa.
The guardian figures on the jamb represent her main lines of descent,
in this case from the Arawa and Tuwharetoa tribes. These figures are
the protectors of the people within the house.

197

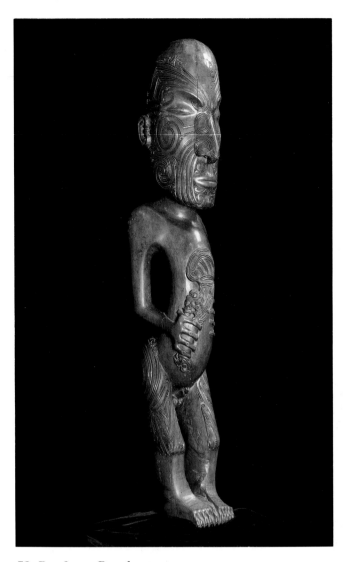

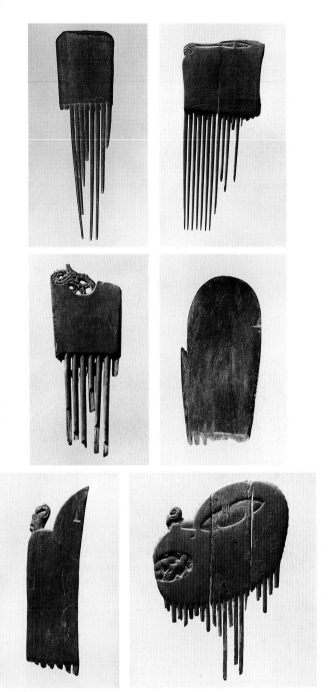

72. Post figure. Poutokomanawa

Wood, 97 cm. (38⅛ in.) high
Bay of Plenty
Arawa tribe (Ngati Pikiao)
Te Huringa 1 period (1800–present)
National Museum of New Zealand, Wellington (ME.5250)

A poutokomanawa is an interior figure that rests by the post that holds up the ridgepole of a house. The ridgepole is symbolically the backbone of the ancestor whose body is the house. Post figures usually represent fairly recent ancestors. This one was carved about 1860 for a meeting house which probably stood in the Whakatane area of the Bay of Plenty. Its carver was most likely of Ngati Pikiao of Rotoiti, although it is possible that he trained in a school linked to Ngati Tarawhai of Rotorua, who also had historical links with Ngati Awa. The figure is beautifully carved.

73–78. Six combs

Wood, no. 73: 14.6 cm. (5¾ in.); no. 74: 14 cm. (5½ in.);
no. 75: 7.6 cm. (3 in.); no. 76: 7.6 cm. (3 in.);
no. 77: 7.6 cm. (3 in.); no. 78: 10.5 cm. (4⅛ in.) high
Tauranga, Kauri Point
Ngaiterangi tribe
Te Puawaitanga period (1500–1800)
Waikato Art Museum, Hamilton (1973/50/324, 1973/50/309/383,
1973/50/370, 1973/50/260, 1973/50/449, 1973/50/405)
For cat. no. 78, see plate 38

The deposits in which this group of combs was found date between the sixteenth and eighteenth centuries. The combs were part of a tapu (sacred) haircutting place. The heads of ariki (high chiefs) and chiefs were very tapu and any objects that had touched the head were carefully disposed of. Over three hundred combs or pieces of combs were put in the Kauri Point swamp. They show the development from the geometric type of design brought from Polynesia to the curvilinear forms of eighteenth-century Maori art. The early combs in the Kauri Point deposit are flat topped with fairly stylized geometric design (cat. nos. 73, 74); this undergoes a development to a complete head with large eye, knob nose, and mouth (cat. no. 78). Late forms of combs, like those collected by Captain Cook, utilize a stylized form of this head so that (similar to cat. no. 159) the comb has a curved top with knob at the side. These combs illustrate the development of Maori art from a style based on geometric forms through a curvilinear development and back to an abstract form.

79. Feeding funnel. Korere

Wood, 30.5 cm. (12 in.) long
Tauranga, Kauri Point
Ngaiterangi tribe
Te Puawaitanga period (1500–1800)
Waikato Art Museum, Hamilton (1973/50/190)

This korere (feeding funnel) was found in the same Kauri Point deposit as the combs (cat. nos. 73–78). Such funnels are used in conditions of extreme tapu (sacredness), when blood has been shed either by a tohunga (expert) or by the person being tattooed. Food cannot be touched by a person under tapu; neither can a person with a bleeding face eat food. Both are fed by a korere such as this.

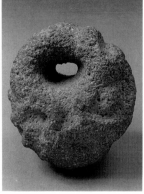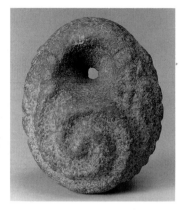

81. Sinker. Mahe

Stone, 15 cm. (5⅞ in.) high
Tauranga
Ngaiterangi tribe
Te Huringa 1 period (1800–present)
Formerly Mrs. Stafford Collection
Auckland Institute and Museum (22371)

This elaborately carved mahe is a sinker for a fishing line. It features two heads upside down and back-to-back in relation to the handle, which is a projection of the two tongues. It is likely that, while entirely functional, this sinker also had a ceremonial role to play in fishing. Decorated sinkers were blessed at the tribal shrine when the help of the gods was desired. They were then taken in the canoe and perhaps used. The gods were thus reminded that their help had been invoked.

82. Sinker. Mahe

Stone, 20 cm. (7⅞ in.) high
Ngaiterangi tribe
Te Huringa 1 period (1800–present)
Formerly A. Merrilees Collection
Auckland Institute and Museum (3106.5)

This mahe, a stone sinker, is decorated with a tribal sign, a double spiral, and knobs. These identify the tribe to whose net or line the sinker was attached. Any person who interfered with the net or line risked the anger of the chief and tribe.

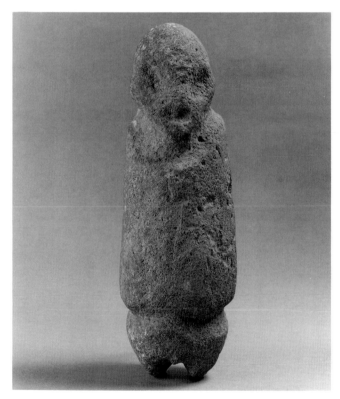

80. Figure. Mauri

Stone, 31 cm. (12⅛ in.) high
Tauranga, Motuhoa Island
Ngaiterangi tribe
Te Puawaitanga period (1500–1800)
Formerly F. C. Mappin Collection
Auckland Institute and Museum (22200)

The mauri, or resting place of the life principle, may also be called a fertility symbol. Although shaped like a penis, it actually represents a human figure. All objects in the world have mauri; living things could not exist without mauri. The mauri of growing kumara (sweet potatoes) or the trees in a forest area are thought of as residing in such a stone.

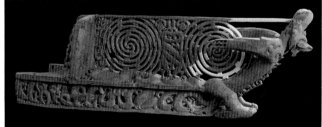

83. Canoe prow. Tauihu

Wood, 135 cm. (53⅛ in.) long
Whakatane, Thornton Beach
Ngati Awa tribe
Te Puawaitanga period (1500–1800)
Whakatane and District Museum (MP644)

This tauihu (prow) of a small war canoe was found at Thornton Beach. It was being made with stone tools, and the carver had put the piece back into the swamp before completing the surface carving. It appears that this was one of the techniques used to provide a surface that could be worked more easily. The carving is East Coast in style and dates to the eighteenth century.

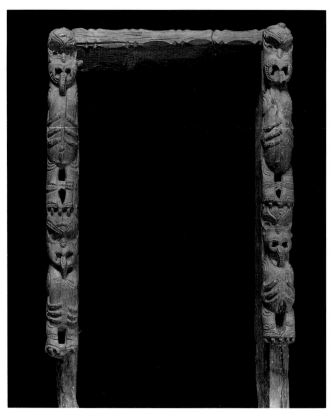

84. Doorway. Kuwaha
Wood, 60 cm. (23⅜ in.) high
Ngati Awa tribe
Te Puawaitanga period (1500–1800)
Whakatane and District Museum, on loan from Mr. Moore
(MP696, 697, 698)

This kuwaha is a small doorway made for the dwelling house of an eighteenth-century ariki (paramount chief). The four figures on the doorjambs appear to be carved in Arawa style with stone tools; but this style could well have been an essential part of Ngati Awa carving as well. The figures are the protectors of the house. They represent ancestors from the tribes from whom the chief takes his origin and serve as ancestral guardians who keep the family from harm. This doorway belonged to a house which was about twelve feet long by eight feet wide with walls about thirty inches high. The walls and roof were probably made from thick raupo rush thatch about two feet thick. In some winter houses the walls were made of a double row of tree fern trunks with insulating material packed between.

85. Canoe sternpost. Taurapa
Wood, 190 cm. (6 ft. 2¾ in.) high
Gisborne, Manutuke
Rongowhakaata tribe
Te Huringa 1 period (1800–present)
Gisborne Museum and Art Gallery (54.285)

This taurapa (sternpost) for an unfinished small war canoe shows the basic form of what has come to be expected as the shape of a decorated canoe sternpost.

86. Ridgepole of a chief's house. Tahuhu
Wood, 239 cm. (7 ft. 10 in.) high
Bay of Plenty
Ngati Awa tribe
Te Huringa 1 period (1800–present)
Auckland Institute and Museum (50434)

This tahuhu, the porch portion of the ridgepole of a chief's small house, stood in the Ngati Awa tribal area of the Bay of Plenty and belonged to the Warahoe hapu. It represents the beginning of the main line of descent from which the chief took his mana (power) and position within the tribe. A ridgepole symbolically is the backbone of the ancestor who is represented by the house. In many houses the figures shown on the outside ridgepole were the primal parents. In this house the chief wished to emphasize his local descent and connection with other powerful tribes. The more stylized figure represented his descent from Kahungunu, ancestor of Ngati Kahungunu of Hawke Bay. At some stage in its history this carving was defaced and most of the Kahungunu identification removed. It is possible that the connection between the chief whose house this was and Hawke Bay was no longer recognized, and because of this the house was allowed to fall into decay and the carvings to pass into the hands of collectors. The carvings were restored to their original finish in readiness for this exhibition.

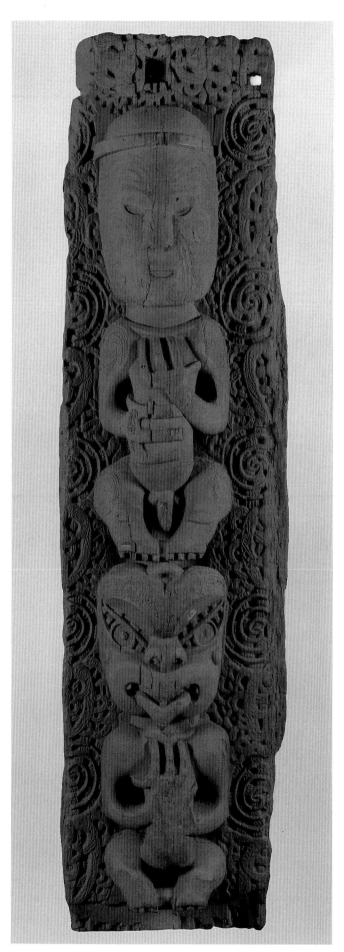

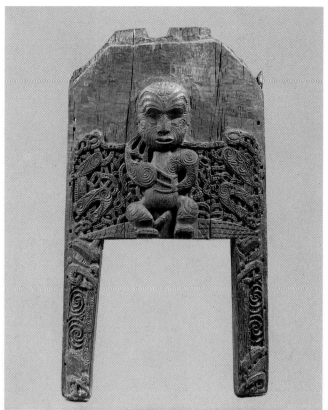

87. Doorway for a storehouse. Kuwaha pataka
Wood, paint, 115 cm. (45¼ in.) high
Whakatane
Ngati Awa tribe
Te Huringa 1 period (1800–present)
Formerly Buller Collection
Auckland Institute and Museum (185)
See plate 5

This kuwaha pataka (storehouse doorway) was made in the early
nineteenth century and is a prime piece of Ngati Awa art. The central
figure appears to be similar to Arawa's naturalistic face mask, but the
surface decoration is in East Coast style. Similarly, the two "legs" on
either side of the door are carved in both styles. This combination is
quite typical of the early-nineteenth-century carving from the Ngati
Awa. At a later period the carving amalgamates into the Mataatua style.

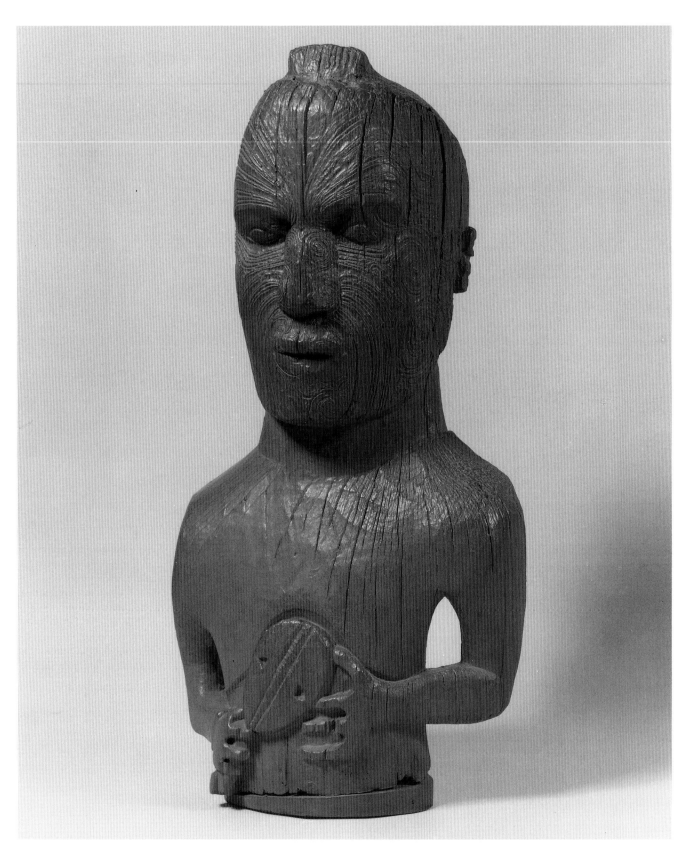

88. Figure from a palisade. Pou
Wood, 177 cm. (69⅛ in.) high
Opotiki
Whakatohea tribe
Te Huringa 1 period (1800–present)
Formerly Sanderson-Black Collection
Auckland Institute and Museum (5167)

The pou (palisade post) of which this figure is a fragment comes from a pa at Opotiki which was made in the early nineteenth century. It is carved in the Arawa manner with a fairly realistic figure. The ancestor depicted is a very strong man and must have been a noted leader in war and peace. The artist has captured his human qualities in wood so that the figure has a feeling of dignity, calm, and mana (power).

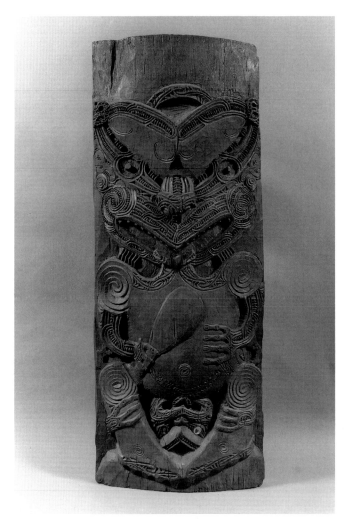

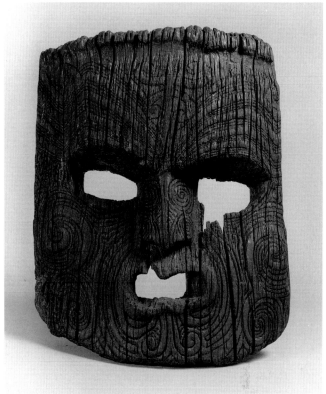

90. Mask from gateway of a pa
Wood, 64 cm. (25¼ in.) high
Whirinaki River, Okarea
Ngati Manawa tribe
Te Huringa 1 period (1800–present)
Otago Museum, Dunedin (D34.455)
See plate 6

89. Side post. Poupou
Wood, 126 cm. (49⅝ in.) high
Opotiki
Whakatohea tribe
Te Huringa 1 period (1800–present)
National Museum of New Zealand, Wellington (ME.1414)
See plate 40

This carving depicts Rongowhatiata, an early-nineteenth-century ancestor of Whakatohea, the tribe that live at Opotiki in the Bay of Plenty. An important line of descent on the female side is that of Kahungunu through his daughter Tauheikuri. This line is symbolized by the greenstone mere (club), held in the right hand. This descent line connects Whakatohea with the surrounding tribes of Te Whanau-a-Apanui, Aitanga-a-Mahaki, and Rongowhakaata. The other side of the descent line connects Whakatohea with Ngati Awa and Tuhoe, thus completing the network of relationships with neighboring tribes.

The carving is in the Mataatua style which combines elements from the East Coast and Bay of Plenty areas and dates to the period 1850–60, when the various design elements had not yet coalesced into the later Mataatua style in which the carving was decorated with polychrome painting.

Ngati Manawa have strong connections with Arawa, and this may be seen in their art. In this gateway mask they have combined the tattooed face mask of Arawa style with their own innovation, pierced eyeholes, to produce a very strong carving. Traditions of the area would suggest that this gateway belonged to the pa (fortified settlement) taken about 1829 by Ngati Awa, but it seems that it belongs to a later period, when Ngati Manawa were living under the protection of the Tuhoe people. The missionary William Colenso described gate masks on Ngati Manawa pa on the Whirinaki River in 1842. This mask probably belongs to that period.

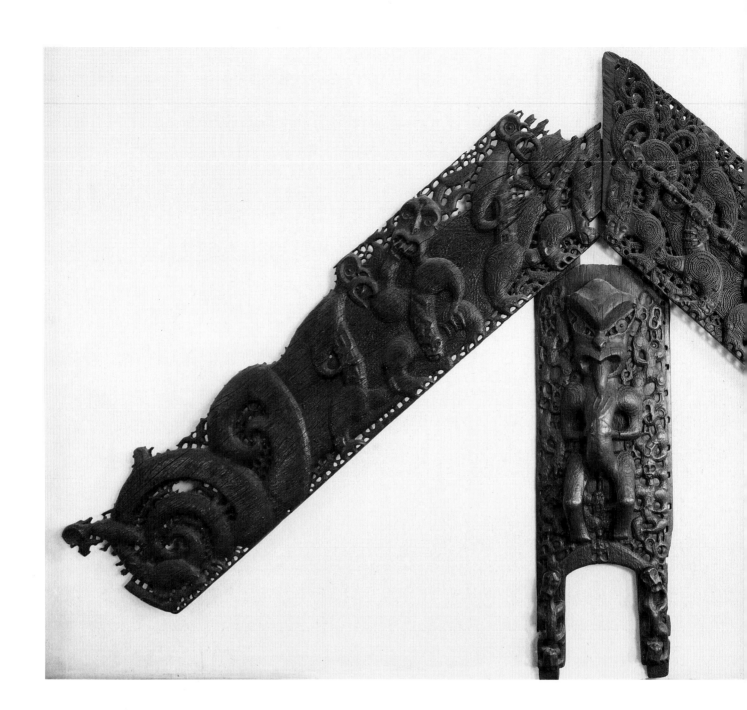

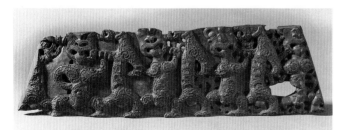

92. Sideboard from a storehouse. Rauawa pataka
Wood, 131 cm. (51½ in.) long
Maraenui (?)
Te Whanau-a-Apanui tribe
Te Puawaitanga period (1500–1800)
Formerly W. O. Oldman Collection
National Museum of New Zealand, Wellington (Old. 174c)

This rauawa, or sideboard, from a pataka (storehouse) is in the Whanau-a-Apanui style, though the surface decoration on the heads would suggest that the pataka may have stood in the Ngati Porou area of the East Coast. The figures are alternate manaia and human. The manaia have one leg forward and one leg back. This is said to represent time, both future and past, with the human being in the present. The manaia themselves represent the spiritual forces of the world, life and death, against which man struggles. This is shown by the manaia grasping the jaw. This carving is part of a pataka taken to England before 1850 by Admiral Michael Seymour of Cardlington.

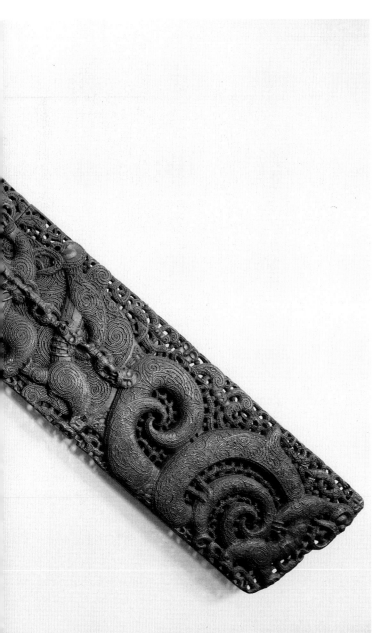

91. Doorway and bargeboards. Kuwaha and maihi

Wood, kuwaha 246 cm. (8 ft. 1 in.) high; left maihi 315 cm.
(10 ft. 4 in.) long; right maihi 360 cm. (11 ft. 9¾ in.) long
Te Kaha
Te Whanau-a-Apanui tribe
Te Puawaitanga period (1500–1800)
Formerly Spencer Collection
Auckland Institute and Museum (22063)

These maihi (bargeboards) and doorway (kuwaha) are from a pataka (storehouse) named Te Potaka, which was one of three standing at Maraenui in 1780. It was later moved to Raukokore where it was being renovated in 1818. When word of the Ngapuhi musket raids reached the district a few years later, the carvings were hidden in a sea cave at Te Kaha. They were recovered from there in 1912 and placed in the Auckland museum. The more damaged maihi and the doorway were carved about 1780 with stone tools. The less damaged maihi was probably just completed when the carvings were hidden. The two sides also show the difference between the original carver, a sculptor interested in shape and form, and the second carver, a skilled craftsman essentially copying what had been done before, albeit with a few extra touches. These carved boards are among the most highly valued pieces of the Maori and represent some of the most beautiful and elegant carvings ever done.

93. Fishhook. Matau

Wood, bone, fiber, 6.8 cm. (2⅝ in.) long
East Cape area
Te Whanau-a-Apanui tribe
Te Huringa 1 period (1800–present)
Formerly G. Mair Collection
Auckland Institute and Museum (67)

The Whanau-a-Apanui tribe of the East Cape area had a distinctive pre-European style of carving. Here it is applied to a very simple utilitarian bait hook. It has a wooden shank made by training a branch on a tree, to which is attached a bone point. The snooding knob has been decorated, indicating that this is a hook that was to be used by a tohunga (man of rank) of the early nineteenth century.

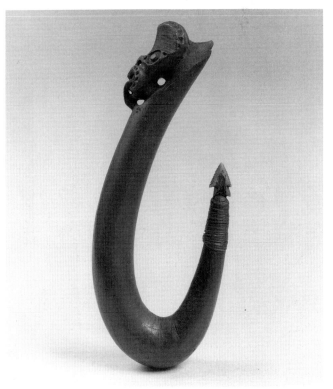

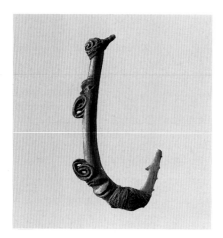

94. Albatross hook. Matau

Wood, bone, flax, 10 cm. (3¹⁵/₁₆ in.) long
Te Kaha (?)
Te Whanau-a-Apanui tribe
Te Huringa 1 period (1800–present)
Gisborne Museum and Art Gallery (72.77.24)

Most fishhooks used by the Maori have incurved points with only occasional jabbing hooks. There are a series of hooks from East Cape collected in the nineteenth century which are described as hooks for catching albatross. They are all jabbing hooks. In the nineteenth and early twentieth centuries the Whanau-a-Apanui were noted shore-based whalers. Albatross could have been commoner in the area at that time than before or since. The heads and carving style on this hook would suggest an early date, as the form is that of the Te Kaha carvings; however, the quality of the flax cord would suggest a later date. Such hooks were collected in 1863. The earlier Te Kaha carving style may have survived until then.

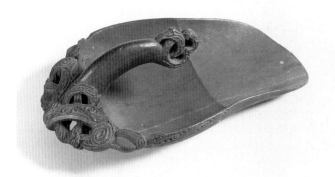

95. Bailer. Tiheru

Wood, 46 cm. (18⅛ in.) long
Te Whanau-a-Apanui tribe
Te Huringa 1 period (1800–present)
National Museum of New Zealand, Wellington (ME.590)

This tiheru, a war canoe bailer, was made in the mid-nineteenth century when the earlier Te Kaha style of carving had been replaced by the East Coast style of Ngati Porou. In the earlier period, elements of the distinctive Whanau-a-Apanui carving extended as far south as Gisborne. Some of the paddles collected by Captain Cook on the Second Voyage in Queen Charlotte Sound at the northern edge of the South Island were carved in this style. Later the Te Kaha carving was replaced with a form originating in Gisborne. This bailer is carved in that style.

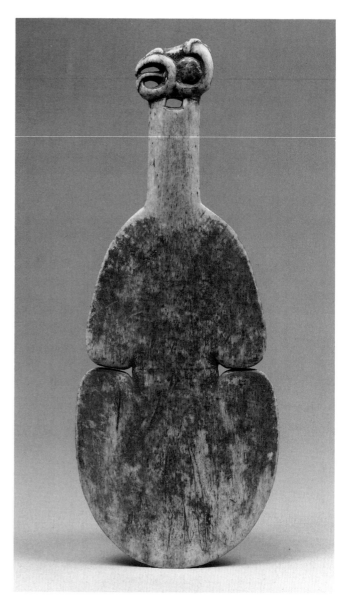

96. Club. Kotiate paraoa

Whalebone, 35 cm. (13¾ in.) long
Te Kaha (?)
Te Whanau-a-Apanui tribe
Te Huringa 1 period (1800–present)
Formerly C.O. Davis Collection
Auckland Institute and Museum (335)
See plate 7

Kotiate literally means "cut liver" and describes the shape of this club. All Maori short clubs are used as thrusting weapons in close infighting. After a blow to the temple the notches at the side were used, which, by a twist, lifted off the top of the skull. A chief carrying such a weapon would often challenge the opposing chief to single combat. The first to get in three blows won the duel and often the war. This kotiate was made about 1830.

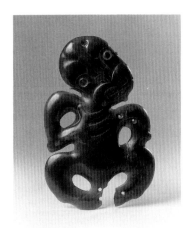

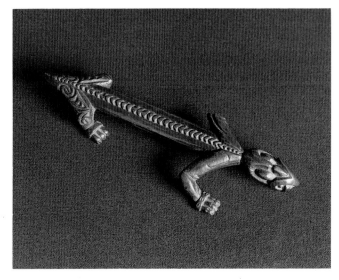

97. Pendant. Hei-tiki Rutataewhenga
Greenstone, 12 cm. (4¾ in.) high
Tuparoa
Ngati Porou tribe
Te Tipunga period (1200–1500)
Formerly Waipare Collection
Hawke's Bay Art Gallery and Museum, Napier (38/390)
See plate 39

This pendant is a named ancestral tiki, Rutateawhenga, which is the heirloom and mana (prestige) of the Ngati Hine sub-tribe of Ngati Porou. Ngati Hine are the descendants of Hinemate, a paramount chieftainess who lived about ten generations ago. The tiki has a traditional history which suggests that it might have been made at least ten and probably twenty generations before the time of Hinemate.

98. Lizard. Moko
Wood, 19.7 cm. (7¾ in.) long
Ngati Porou tribe
Te Puawaitanga period (1500–1800)
Formerly W. O. Oldman Collection; Webster Collection
National Museum of New Zealand, Wellington (Web. 662)

This lizard is a fragment of a larger carving. A lizard is a sign of life and death, therefore of mana and tapu. Such a sign sets an object apart. In this instance it is the sign that the objects protected by this lizard are the property of a woman of high rank, probably Hinematioro of Te Aitanga a Hauiti at Tolaga Bay.

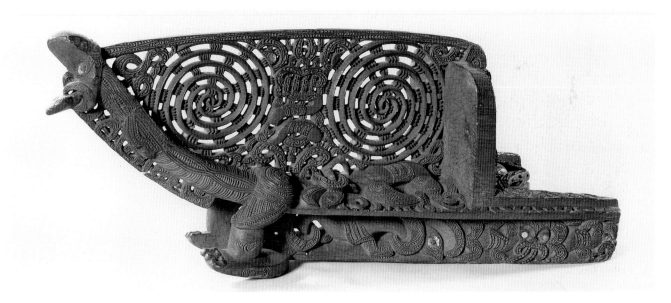

99. Canoe prow. Tauihu
Wood, 115 cm. (45¼ in.) long
Tolaga Bay, Pourewa Island
Ngati Porou tribe
Te Puawaitanga period (1500–1800)
Formerly Enys Collection; K. A. Webster Collection
National Museum of New Zealand, Wellington (Web. 1202)

This tauihu (prow of a war canoe) belonged to Hinematioro, mother of Te Kani a Takirau, a paramount chieftainess of the Ngati Porou tribe. The canoe was kept on Pourewa Island in Tolaga Bay. The carving of the prow includes surface decoration features which show Hinematioro's relationship to other tribes in New Zealand. Hinematioro was of such high birth that she was treated in all respects as a man for ceremonial occasions.

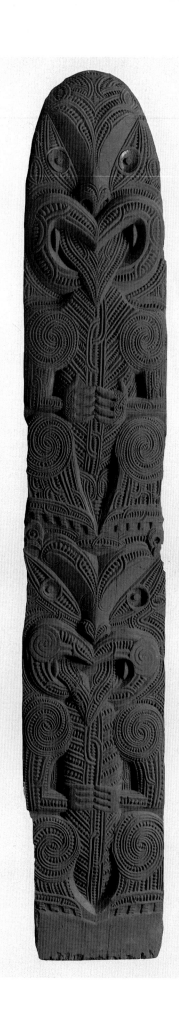

100. Ridgepole. Tahuhu
Wood, 390 cm. (12 ft. 9½ in.) long
Tolaga Bay
Ngati Porou tribe
Te Huringa 1 period (1800–present)
Formerly Buller Collection
Auckland Institute and Museum (717)

This tahuhu (ridgepole) of the house Te Kani a Takirau was carved by
Hone Ngatoto at Tolaga Bay and erected in the 1860s. When it was
opened a haka (dance) was composed and performed for the occasion.
This haka, *Uia mai koia*, is still the favorite haka of the Ngati Porou
people and is performed with great verve and vigor. The beginning of the
haka is:

Uia mai koia,	Let it be asked
Whakahuatea ake,	Let it be said
Ko wai te whare nei?	Who is this house?
Ko Te Kani!	It is Te Kani!
Ko wai te tekoteko	Who is the gable figure?
kei runga?	
Ko Paikea, ko Paikea.	It is Paikea, it is Paikea.

Te Kani a Takirau was the ariki (paramount chief) of the area who died
in 1853. Paikea was the ancestor of the East Coast tribes. Te Kani was
his direct descendant.

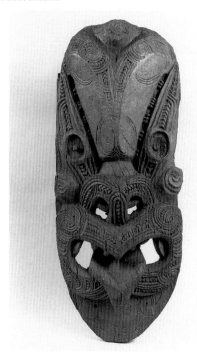

101. Gable-peak mask from meeting house. Koruru
Wood, 90 cm. (35 ¾ in.) high
Tokomaru Bay
Ngati Porou tribe
Te Huringa 1 period (1800–present)
Canterbury Museum, Christchurch (E.108.29.1)
See plate 41

This koruru (gable-peak mask) of the house Hau Te Ananui o Tangaroa
was carved at Tokomaru Bay for Henare Potae, chief of Te Whanau-a-
Ruataupare. The carvers were Hoani Taahu and Tamati Ngakoho. Due to
local wars in 1868 the house was never erected. It was taken to
Canterbury Museum where the carvers came to finish it in 1876. The
name Hau Te Ananui o Tangaroa means "life from the cave of Tangaroa"
and refers to the local myth that the origin of carving was from the
depths of the sea.

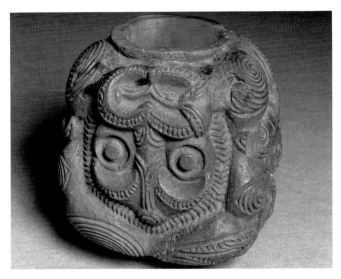

102. Pigment pot
Wood, 6.4 cm. (2½ in.) high
East Coast
Ngati Porou tribe
Te Huringa 1 period (1800–present)
Formerly Webster Collection
National Museum of New Zealand, Wellington (Web. 1761)

This pigment pot for holding tattooing pigment was a very special pot made to hold the black soot mixed with fat which was inserted in the groove made by the first tattoo process. Maori moko (tattoo) was a carving technique that involved cutting a groove in the skin before using a toothed chisel to insert the pigment. It was a very tapu (sacred) operation. There are many tales of chiefs' sons asking their fathers to allow them to be tattooed with their pigment. Anything that touched the head was tapu, so using the father's pigment would convey the mana or tapu of the father to the son. Sometimes junior wives schemed to advance their sons above their elder brothers by this means. The human figure on this pot emphasizes its tapu nature.

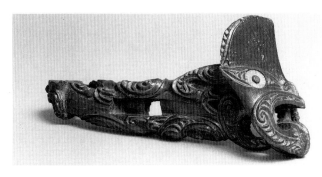

103. Carved bar. Paepae
Wood, 23 cm. (9 in.) long
East Coast
Ngati Porou tribe
Te Huringa 1 period (1800–present)
Formerly W. O. Oldman Collection 1040
Canterbury Museum, Christchurch (150.557)

This paepae, a carved bar, was probably for the end of a latrine seat. The seat was a flat board on which the person squatted. In certain rites, biting the end of the latrine seat was the final act for removal of tapu. This paepae was carved in the early nineteenth century.

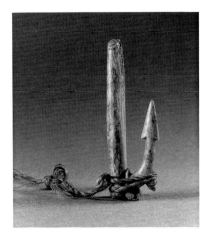

104. Minnow lure fishhook. Pa
Wood, bone, fiber, 8 cm. (3⅛ in.) long
Tokomaru Bay (?)
Ngati Porou tribe
Te Huringa 1 period (1800–present)
Gisborne Museum and Art Gallery (68.40)

This minnow lure fishhook is a late lure hook, probably made in the early nineteenth century but following a form that harks back to the bonito lure of Polynesia. It is recorded that until 1843 the people of Tokomaru Bay were digging up sub-fossil moa bone to make minnow lures. This hook is probably a version of the same thing, although the bridle to the front of the shank has slipped off. Like a bonito lure, the point is attached by a bridle to the main line which is in turn lashed to the minnow shank. The point on this hook is somewhat too elaborate for use and the hook may have been used for ceremonial purposes.

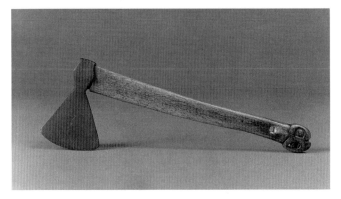

105. Tomahawk. Patiti
Whalebone, iron blade, 37.9 cm. (14⅞ in.) long
East Coast
Ngati Porou tribe
Te Huringa 1 period (1800–present)
Formerly E. E. Vaile Collection
Auckland Institute and Museum (30869)
See plate 42

The iron blade of this patiti (short-handled tomahawk) was originally traded from a British naval vessel in the early nineteenth century and the whalebone handle was made to fit it. Like the Indians of North America, Maori warriors became very skilled in using such a short tomahawk for close infighting. These were never used for throwing. In the wars against Europeans the usual weapons for a Maori warrior were a musket, club, and tomahawk. Tomahawks, because they had been used in war, could not be used for utilitarian purposes.

209

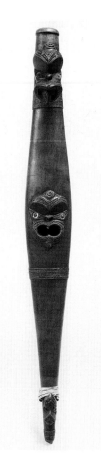

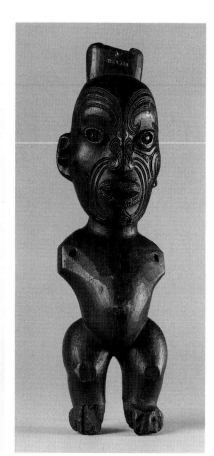

106. Carver's mallet. Patu whakairo

Whalebone, 28.5 cm. (11¼ in.) long
Ngati Porou tribe
Te Huringa 1 period (1800–present)
Formerly Hill Collection
National Museum of New Zealand, Wellington (ME. 270)

This whalebone mallet was used by East Coast carvers in the nineteenth century. It is the type of mallet used by the meeting house carvers when they were using metal chisels. It is actually too hard to use such a mallet with stone chisels. Whalebone mallets are not uncommon in the nineteenth century when the activity of European whalers left a lot of unwanted whalebone, which the Maori used to make artifacts.

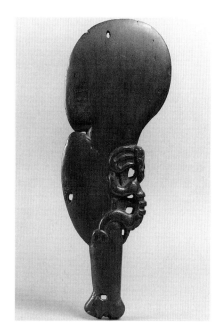

107. Club. Wahaika

Wood, 37.5 cm. (14¾ in.) long
Gisborne
Rongowhakaata tribe
Te Puawaitanga period (1500–1800)
Collected by Captain James Cook 1767–70,
presented to Thomas Skottowe
Auckland Institute and Museum, Gift of Beverly Sanders (33640)

This wooden club was obtained by Captain James Cook on his First Voyage, 1767–70, which he presented to his patron, Thomas Skottowe, on his return to England. The figure on the side represents the spirits, as this weapon is essentially intended for taking life. It is a thrusting weapon used like a short sword.

108. Bugle-flute. Putorino

Wood, 50 cm. (19⅝ in.) long
Gisborne
Rongowhakaata tribe
Te Puawaitanga period (1500–1800)
Formerly W. O. Oldman Collection 25
Otago Museum, Dunedin (050.004)
See plate 44

This instrument has only two notes when played either as a flute or a bugle. Traditional information would suggest that these were used more for signaling when a chief was returning to a village than for making music.

109. Jumping jack. Karetao

Wood, 38 cm. (15 in.) high
Gisborne
Rongowhakaata tribe
Te Puawaitanga period (1500–1800)
Otago Museum, Dunedin (D24.329)

These small puppets (karetao) have movable arms which were manipulated by a string which enabled them to perform the appropriate actions as accompaniment to a song. The figure is an ancestor with a topknot to which was attached a wig of human hair. The eyes would have shone with paua (abalone) shell inserts. The large head, dumpy body, and powerful legs combined with a very strong face make this figure very striking.

210

110. Canoe bailer. Tiheru
Wood, 45.7 cm. (18 in.) long
Gisborne
Rongowhakaata tribe
Te Puawaitanga period (1500–1800)
Canterbury Museum, Christchurch (E. 84.10)

This tiheru, or war canoe bailer, is one of a pair that is a treasured heirloom of the Rongowhakaata people. The bailers are named Porourangi after an ancestor of the East Coast tribes. It is said that originally the art of carving was taken from the wharewananga (house of learning) at Tolaga Bay. The two chiefs who learned the art were Tukaki of Te Whanau-a-Apanui and Iwirakau of Ngati Porou. The bailers are carved in the styles of Tukaki and Iwirakau, and this particular one is carved in Te Whanau-a-Apanui style of Tukaki.

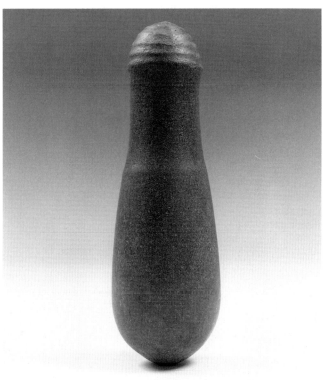

111. Pounder. Patu muka
Graywacke, 24.7 cm. (9¾ in.) long
Gisborne, Mamouhai
Rongowhakaata tribe
Te Puawaitanga period (1500–1800)
Gisborne Museum and Art Gallery (62.2143.2)

This patu muka is a stone pounder for softening the flax fiber used in the finger twining of cloaks. The leaves of the flax *(Phormium tenax)* were scraped, the fiber was stripped away and washed and bleached in the sun. It was then rolled into hanks which were beaten on a flat stone with a patu muka such as this. The preparation of fine flax cloaks was women's work. No loom was used, the weft being completed by finger twining.

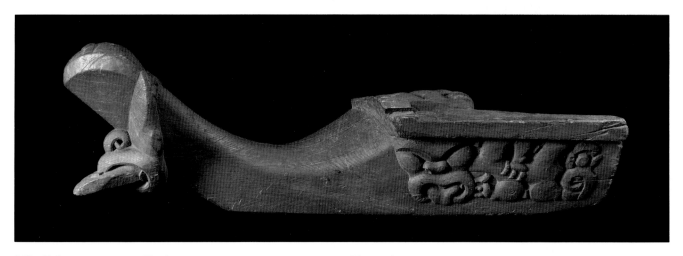

112. Fishing canoe prow. Tauihu
Wood, 110 cm. (43 ¼ in.) long
Gisborne
Rongowhakaata tribe
Te Huringa 1 period (1800–present)
Gisborne Museum and Art Gallery (76.62)

This tauihu, prow of a fishing canoe, was carved by Rakaruhi Rukupo with metal tools about 1840. The prow lacks the splashboard and was not given surface decoration. The Rukupo style is quite distinctive if deceptively simple. Rukupo was one of the great artists of his time.

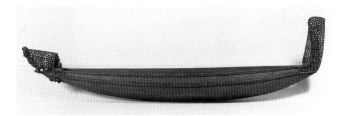

113. War canoe model. Wakataua
Wood, 245 cm. (8 ft. ½ in.) long
Gisborne, Manutuke
Rongowhakaata tribe
Te Huringa 1 period (1800–present)
Auckland Institute and Museum (44117)
See plate 43

This wakataua (war canoe) was carved in the mid-nineteenth century and has been attributed to Rakaruhi Rukupo. The prow and stern have been very finely done and it is a faithful replica of a full-sized war canoe, except that the hull of the canoe is too large to accord with the true proportions of a canoe that would have been quite slender for its length. For instance, the full-sized war canoe Te Toki a Tapiri in the Auckland museum has a length of ninety-two feet and a maximum hull width of six feet. Canoes like Te Toki carried eighty paddlers, at least two bailers, and half a dozen chiefs and priests. The canoes could be paddled or sailed with a triangular matting sail used either in the spritsail position or on an angle, as a lateen sail.

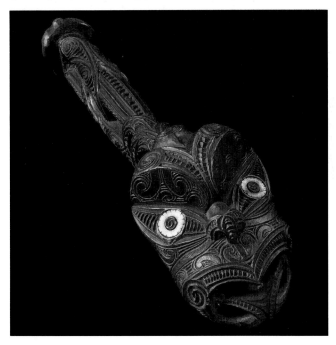

114. Latrine bar end. Paepae
Wood, 24 cm. (9½ in.) long
Gisborne
Rongowhakaata tribe
Te Huringa 1 period (1800–present)
Formerly W. O. Oldman Collection
National Museum of New Zealand, Wellington (Old. 170)

This latrine bar end, probably carved by Rukupo of Rongowhakaata, was taken to England by an early missionary in 1830. Rakaruhi Rukupo became the great innovator of the meeting house, a ceremonial house which is so much a feature of modern Maori villages. Many carvers even today are inspired by him.

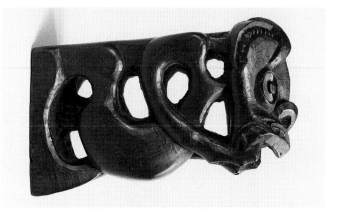

115. Footrest for digging stick. Teka
Wood, 15 cm. (5⅞ in.) long
Gisborne
Rongowhakaata tribe
Te Huringa 1 period (1800–present)
Formerly George Graham Collection
Auckland Institute and Museum (5425)

This teka, a footrest for a digging stick, was probably a ceremonial item used by the tohunga (priest) when starting the cultivation and calling on the gods for their goodwill. The figure is very simply made, with hands in the mouth indicating fruitfulness. Surface decoration has been kept to a minimum, leaving the main forms uncluttered. It was made in the eighteenth century with stone tools.

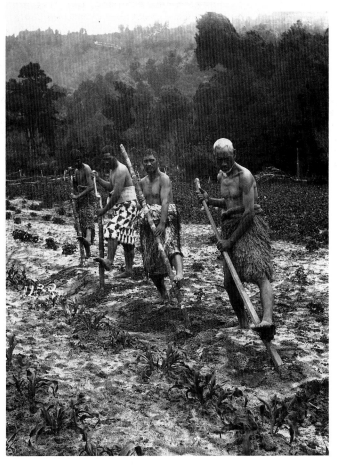

FIELD PHOTO
Men preparing ground for planting, using digging sticks

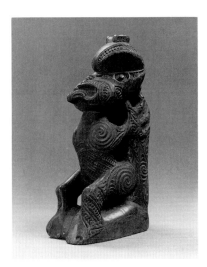

116. Footrest for digging stick. Teka

Wood, 21 cm. (8¼ in.) long
Gisborne
Rongowhakaata tribe
Te Huringa 1 period (1800–present)
Formerly E. B. and J. N. Williams Collection
Gisborne Museum and Art Gallery (72.77.27)

This footrest was carved by Rukupo of Rongowhakaata about 1840. The carving on the step, which identifies the tribe of the owner, represents an important ancestor of the tribe who assists the gardener in his work. The more elaborately carved digging sticks were used by the tohungas (priests) when turning the first piece of ground and planting a special plot while invoking the aid of the gods, Rongo, the god of agriculture, and Pani, the goddess who brought the kumara (sweet potato) to this world.

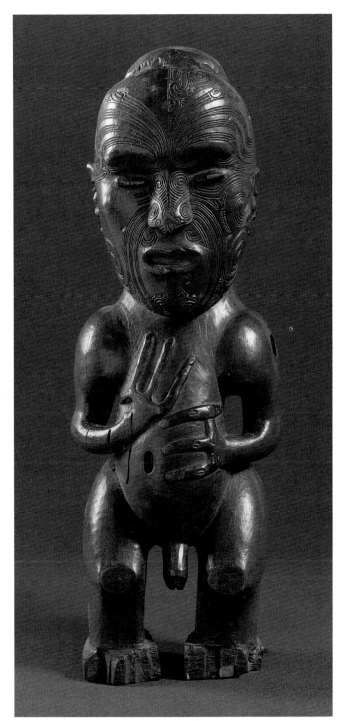

118. Post figure. Poutokomanawa

Wood, 46 cm. (18⅛ in.) high
Gisborne
Rongowhakaata tribe
Te Huringa 1 period (1800–present)
Formerly W. O. Oldman Collection
National Museum of New Zealand, Wellington (Old. 148)
See plate 45

This poutokomanawa (center post figure) from a chief's house depicts a recently dead ancestor whose tattoo was not complete at the time of death. The proportions of the figure are typical of the Rongowhakaata style of carving. The eyes are slitted and filled with red sealing wax. The head was originally provided with a wig of human hair which would have hung down to the shoulders. It was carved about 1840.

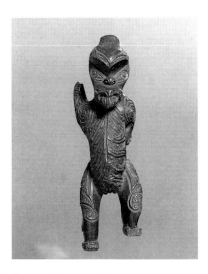

117. Female figure. Whakapakoko

Wood, 15 cm. (5⅞ in.) high
Gisborne
Rongowhakaata tribe
Te Huringa 1 period (1800–present)
Formerly W. O. Oldman Collection
National Museum of New Zealand, Wellington (Old. 168)

This small figure of a female carved in the round possibly served as a handle for a staff, though the surface shows little sign of wear. The carving is the work of a master craftsman.

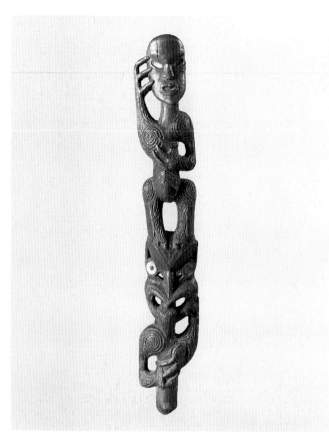

119. Gable finial. Tekoteko
Wood, 85.1 cm. (33½ in.) high
Poverty Bay
Aitanga a Mahaki tribe
Te Puawaitanga period (1500–1800)
Formerly Captain J. Wilson Collection; W. O. Oldman Collection
National Museum of New Zealand, Wellington (Old. 150)
See plate 46

This tekoteko (gable figure) of a chief's house was taken to England by
Captain James Wilson of the missionary sailing ship *Duff* in 1796–98.
The figures portrayed are Tauhei, daughter of Kahungunu, with her son
Mahaki beneath her. The tribal name Aitanga a Mahaki means the
progeny of Mahaki. Wilson did not call at New Zealand in 1796 but did
stop at Sydney in Australia, where this and other pieces were obtained.

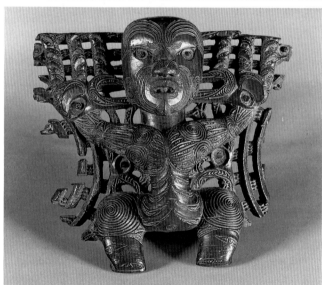

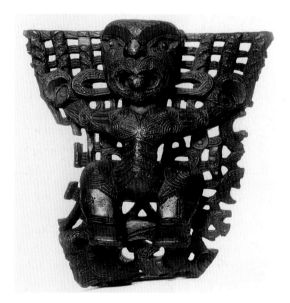

120. Fragment of a lintel. Pare
Wood, 37 cm. (14½ in.) high
Poverty Bay
Aitanga a Mahaki
Te Puawaitanga period (1500–1800)
Formerly W. O. Oldman Collection
National Museum of New Zealand, Wellington (Old. 44)

This fragment of a pare is the center figure of a three-figure lintel from a
chief's house which stood in the Aitanga a Mahaki territory near
Gisborne in the late eighteenth century. Another fragment of the same
lintel is in the University Museum at Philadelphia (see cat. no. 121).
Examples of Aitanga a Mahaki carving are extremely rare. In the
mid-nineteenth century the Rongowhakaata style became dominant in
the whole of the Gisborne area.

121. Fragment of a lintel. Pare
Wood, 42 cm. (16½ in.) high
Poverty Bay
Aitanga a Mahaki
Te Puawaitanga period (1500–1800)
Formerly W. O. Oldman Collection
The University Museum of Pennsylvania, Philadelphia (P3222)
See cat. no. 120

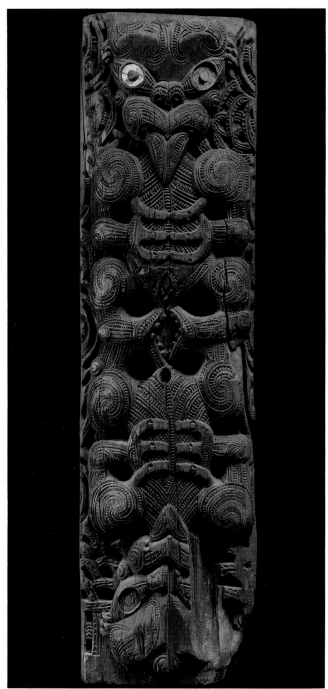

122. Adz. Toki

Stone, 25 cm. (9⅞ in.) long
Napier, Pakowhai
Ngati Kahungunu tribe
Te Puawaitanga period (1500–1800)
Formerly Black Collection
Hawke's Bay Art Gallery and Museum, Napier (37/713)

This stone adz of high rectangular section and decorated poll is typical of the Hawke Bay area.

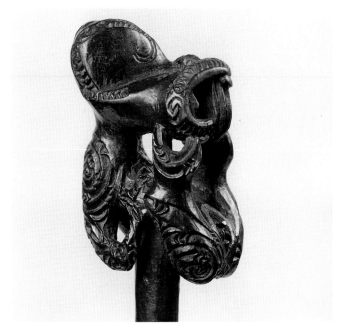

123. Sling. Kotaha

Wood, 97 cm. (38⅛ in.) long
Wairoa
Ngati Kahungunu tribe
Te Puawaitanga period (1500–1800)
Formerly Webster Collection
National Museum of New Zealand, Wellington (Web. 559)

This type of kotaha was used to sling small spears or darts by a cord wrapped around the shaft. The dart was stuck in the ground, the cord was wrapped around the shaft, and the kotaha was used to lengthen the arm and whip the dart. This staff, like others of its kind, was also a staff used by the commander of an attack. Signals were made by slinging darts in the direction of the advance.

124. Ridgepole of a storehouse. Tahuhu

Wood, shell, 109 cm. (42⅞ in.) high
Ngati Kahungunu tribe
Te Puawaitanga period (1500–1800)
Gisborne Museum and Art Gallery (63.2265)

This tahuhu, ridgepole of a small pataka, was carved with stone tools. The two figures depicted are male and female and represent Rangi, the Sky Father, and Papa, the Earth Mother, from whose union came the gods, who in turn made man. The style of carving is the northern form of Kahungunu carving, which has a close relationship with the contiguous Rongowhakaata tribal area. The pataka to which this ridgepole belonged would have been the personal storehouse of an important chief.

215

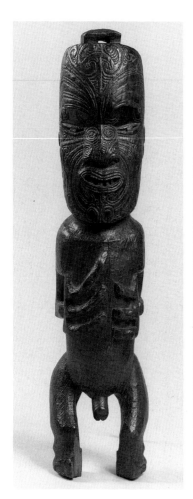
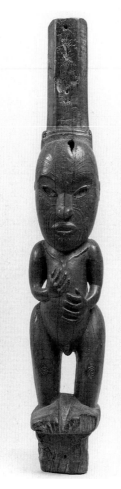
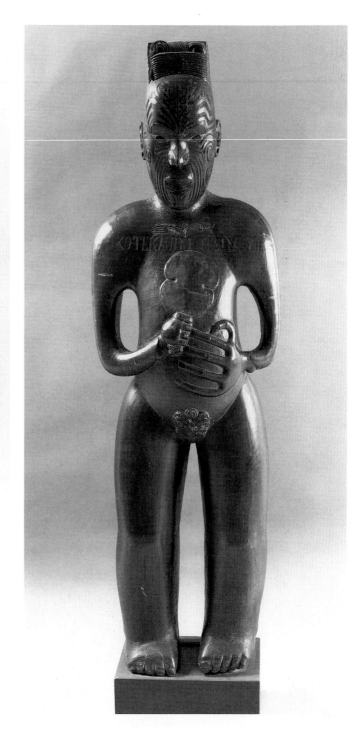

125. Post figure. Poutokomanawa
Wood, 51 cm. (19⅞ in.) high
Whakaki
Ngati Kahungunu tribe
Te Puawaitanga period (1500–1800)
Formerly W. O. Oldman Collection 147
Otago Museum, Dunedin (050.028)

This poutokomanawa figure from an eighteenth-century chief's house originally had a human hair wig attached to the lug at the top. This figure, like the figure in cat. no. 118, has slitted eyes. It portrays a recent ancestor of the Nga Herehere hapu of Ngati Kahungunu, probably Te Awaroa. The carving was obtained by Captain James Wilson of the missionary ship *Duff* in 1796–98.

126. Post figure. Poutokomanawa
Wood, 93 cm. (36⅝ in.) high
Wairoa
Ngati Kahungunu tribe
Te Huringa 1 period (1800–present)
Formerly Brook-Taylor Collection
Hawke's Bay Art Gallery and Museum, Napier (A.1)

This small figure, the central figure of a chief's house or small meeting house, is part of the post that held up the ridgepole, or backbone, of the house. The person depicted is an important ancestor of the chief in whose house it stood. The house was probably built in the early years of the nineteenth century. The style of this figure is close to the Rongowhakaata and Aitanga a Mahaki carving style, though the figure as part of the post is more often found in the Ngati Porou area. It is likely the carver was from Rongowhakaata.

127. Post figure. Poutokomanawa
Wood, 144 cm. (56⅞ in.) high
Napier, Pakowhai
Ngati Kahungunu tribe
Te Huringa 1 period (1800–present)
Hawke's Bay Art Gallery and Museum, Napier (37/748)
See plate 48

The base of an interior support post carved to represent a named ancestor, this poutokomanawa belonged to a house that stood in the vicinity of Pakowhai near Napier. The name of the ancestor is carved across the chest thus: Ko Te Kauru o-te-rangi (This is the Head of the Sky). At one time this and other poutokomanawa carvings were kept in the Heretaunga house at Taradale. This is one of a group of such carvings that has survived into the present time.

128. Doorway of storehouse. Kuwaha pataka

Wood, 92 cm. (36¼ in.) high
Heretaunga
Ngati Kahungunu tribe
Te Huringa 1 period (1800–present)
Formerly W. O. Oldman Collection
National Museum of New Zealand, Wellington (Old. 489)
See plate 8

This kuwaha pataka (doorway of a storehouse) has been cut at the base and the top. The figure was male and in this case probably represents Kahungunu, ancestor of the tribe, who was famous for his sexual equipment. The topmost finger of the left hand would have touched the tip of the penis. The identification of such a figure is secondary to its mythological significance within the framework of a storehouse. This pataka doorway was carved in the late eighteenth or early nineteenth century.

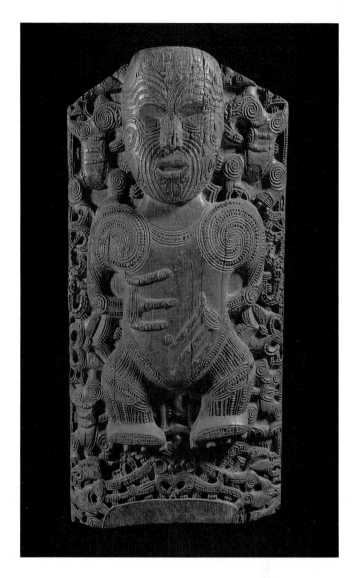

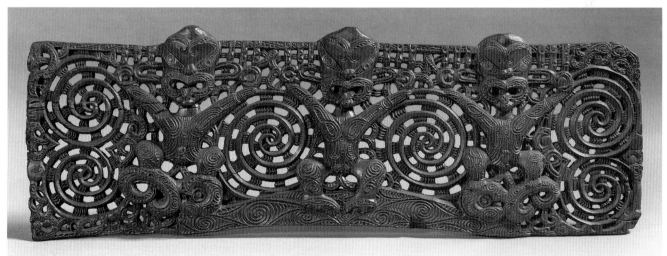

129. Lintel of a meeting house. Pare or korupe

Wood, 109 cm. (42⅞ in.) wide
Heretaunga
Ngati Kahungunu tribe
Te Huringa 1 period (1800–present)
Formerly W. O. Oldman Collection
National Museum of New Zealand, Wellington (Old. 579)

This korupe or pare is the lintel of a meeting house that was built with metal tools about 1860. It was carved in the Wairoa area. The three figures on the lintel represent the separation of Rangi and Papa by their children. Papa, the Earth Mother, is indicated by the base with a manaia at each end on which the children stand. Their fingers are pushing up the roof of the house, which is Rangi, the Sky Father. The spirals between the figures are the light that came into the world.

217

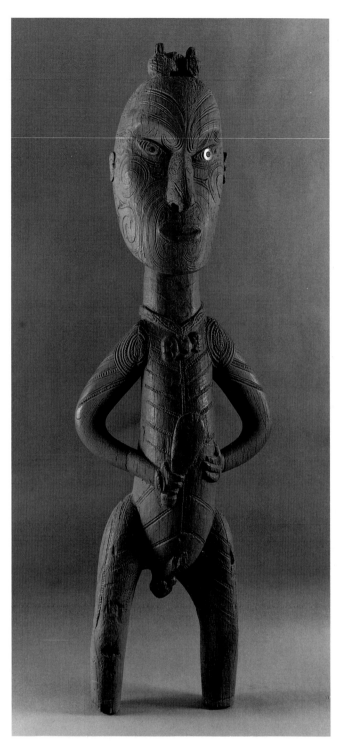

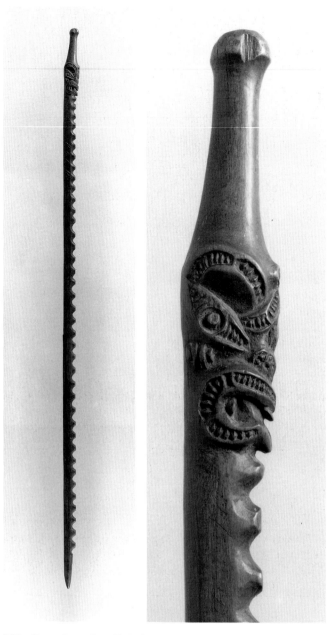

130. Stockade post figure. Pou whakairo
Wood, 175 cm. (68⅞ in.) high
Ahuriri
Ngati Kahungunu tribe
Te Huringa 1 period (1800–present)
Hawke's Bay Art Gallery and Museum, Napier (R72/16)
See plate 47

This pou whakairo, carved top of a palisade post, depicts a famous ancestor holding his patu (club) and wearing an ancestral tiki. He is shown in a guard position. This ancestor was one of the protectors of the village. The carved representation indicates that he was present spiritually to help his descendants. The style is partly determined by the position on top of a high post but more by the local Kuhungunu form of carving.

131. Genealogical staff. Rakau whakapapa
Wood, 114.8 cm. (45¼ in.) long
Heretaunga
Ngati Kahungunu tribe
Te Huringa 1 period (1800–present)
Formerly Athenaeum Collection
Hawke's Bay Art Gallery and Museum, Napier (A.11)

This staff is associated with Te Hapuku, ariki (paramount chief) of the Ngati Kahungunu of Heretaunga. His genealogical position is important to a chief in Maori society. A paramount chief is one who can trace his descent from his ancestors and, before them, the gods. He thus has the right to call on the gods and the ancestors for any tribal enterprise. The descent line preferably goes down from the eldest male in each family but may equally well descend through the female line, so that Te Hapuku, for instance, counted among his important ancestors Rongomaiwahine, a legendary ancestress of unparalleled status. When recounting his genealogy, a chief would use a staff such as this as a memory aid. Even if he did not recite his genealogy, the fact that he had such a staff could often still the doubts of those who would question his authority.

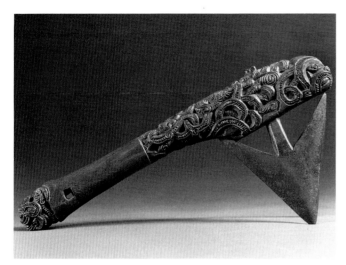

132. Club
Wood, iron harpoon head, 36 cm. (14⅛ in.) long
Otaki
Ngati Raukawa tribe
Te Huringa 1 period (1800–present)
Formerly W. O. Oldman Collection
National Museum of New Zealand, Wellington (Old. 1037)

An iron harpoon head is mounted on a handle for use as a club. The harpoon head is an early type, which would date the club to sometime before 1835. The handle was carved as a gift from Ngapuhi to Ngati Toa–Ngati Raukawa. It was probably one of the gifts made by Ngapuhi of the Bay of Islands when they invited Te Rauparaha of Ngati Toa to join them in raiding Wellington. The style of carving of the handle end is Ngapuhi, while the main carving is in the Ngati Raukawa style with some slight differences. Ngati Toa had had few contacts with Europeans: an iron club was a remarkable if not particularly useful gift.

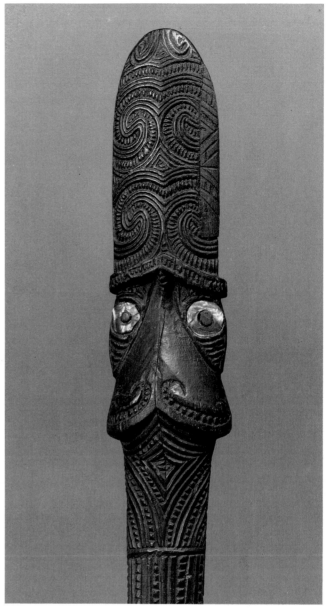

133. Staff. Taiaha
Wood, shell, 159 cm. (62⅝ in.) long
Porirua
Ngati Toa tribe
Te Huringa 1 period (1800–present)
Formerly E. E. Vaile Collection
Auckland Institute and Museum (23696)

This taiaha (chief's staff) belonged to Te Rauparaha, a great leader and fighting chief of the early nineteenth century. The taiaha is a two-handed club or quarterstaff, which was an important weapon and also a chief's staff of office. Te Rauparaha led his tribe, the Ngati Toa, from their ancestral lands at Kawhia on the west coast of the North Island to Wellington on Cook Strait. From there he carried this taiaha and the war to the South Island, attacking Banks Peninsula and many strongholds of the Ngai Tahu tribe. His stronghold was on Kapiti Island, off the west coast of Wellington. He was an influential figure during the European settlement of the area. For one hundred and fifty years his reputation suffered because of his skirmishes against Europeans who sought to steal his land, but today even the descendants of those same Europeans see him as the great leader that he was. The carving on the blade of the taiaha was added by his descendant at a later date.

219

134, 135. Stockade post top. Pou

Wood, 118 cm. (46½ in.), 65 cm. (25¾ in.) high
Dannevirke, Oringi
Rangitane tribe
Te Huringa 1 period (1800–present)
Hawke's Bay Art Gallery and Museum, Napier (R72/31, R72/32)

These are tops of the tall palisade posts that form the fence around a pa (fortified village). These particular ones, from a pa at Oringi, were the main posts, with the area in between filled with shorter, pointed stakes. Posts with mushroom tops would appear to be a nineteenth-century development. They were relatively common from 1800 to 1850, after which the need to live in fortified villages became unnecessary.

136. Canoe bow cover. Haumi

Wood, 100 cm. (39⅜ in.) long
Waitore site, near Patea, Taranaki
Early Taranaki
Te Puawaitanga period (1500–1800)
Formerly in the Patea Museum
Taranaki Museum, New Plymouth (A.82.500)

The deposit in which this bow cover from a Polynesian-style canoe was found has been dated by radiocarbon to the sixteenth century. A haumi (bow cover) is the forerunner of the later tauihu (bow piece). Other pieces of canoe found in the deposit suggest that the canoe might have been made in pieces rather than as a dugout. The simple lines of this haumi are evident in the horn decoration, enhanced by the row of notching in the style of an earlier period. Decoration has been applied by indenting with the edge of a small adz. The spiral and line forms represent the two successive lines of development in Maori art: the early Polynesian form of geometric shapes and the later Maori curvilinear art. On this truly transitional piece, both lines coincide.

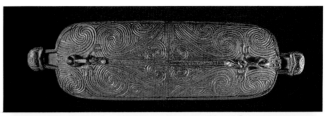

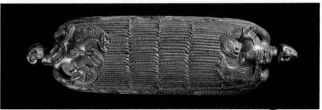

138. Feather box. Wakahuia
Wood, 47 cm. (18½ in.) long
South Taranaki
Ngati Ruanui tribe
Te Huringa 1 period (1800–present)
Formerly Purvis Russell Collection
National Museum of New Zealand, Wellington (ME.3815)
See plate 49

A wakahuia (feather box) was made to hold ornaments that had been worn on the head of a chief and were thus tapu. The box was hung in the rafters of the house, out of the way so that people in the house were not endangered. This box was carved in the period around 1840 when the Gisborne style of carving was beginning to replace the local forms. The end figures are Gisborne, but the decoration is of South Taranaki type.

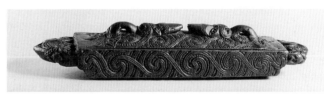

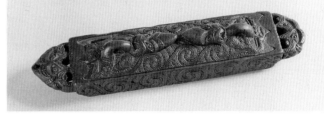

139. Feather box. Papahou
Wood, 43 cm. (16⅞ in.) long
South Taranaki
Ngati Ruanui tribe
Te Huringa 1 period (1800–present)
Formerly W. O. Oldman Collection
National Museum of New Zealand, Wellington (Old.484)

This papahou (flat feather box) was carved with stone tools using the Nga Rauru style, which is basically a Taranaki form but with features from Wanganui. The surface decoration of continuous rolling spirals with separate diamond notches is fairly typical of Ngati Ruanui and Nga Rauru work. The pointed-head figures on the lid are a variation of Taranaki work, while the handles at the ends relate to Wanganui or even Waikato shapes.

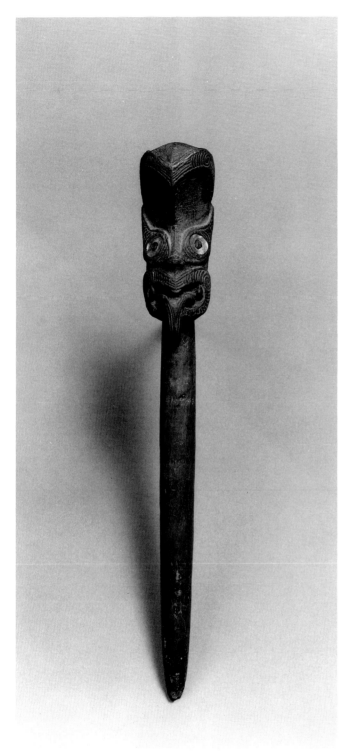

137. Godstick. Whakapakoko atua
Wood, shell, 45.5 cm. (17¾ in.) high
South Taranaki
Ngati Ruanui tribe
Te Puawaitanga period (1500–1800)
Formerly E. B. Williams Collection
Auckland Institute and Museum (Z1894.3)

A whakapakoko atua (godstick) is also known as a taumata atua, a resting place of the god. Sticks like this were places to which the god was asked to come so that the priest could talk to him. The carving of the head combined with decorative lashing identifies the stick as the resting place of a particular god.

221

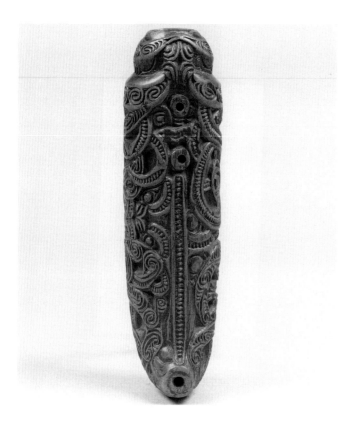

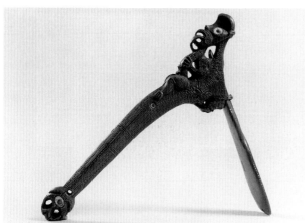

141. Adz. Toki poutangata

Wood, greenstone, paua shell, 44 cm. (17¹/₄ in.) long
Ngati Maru tribe
Te Puawaitanga period (1500–1800)
Otago Museum, Dunedin (D51.509)

This toki poutangata, a chief's ceremonial adz, is a gripped nephrite adz of very great age hafted onto a more recent but also ancient handle. The nephrite blade is an heirloom and an object of mana (prestige). It is a mauri (life force) of the tribe which has been passed down over many generations. The ariki (paramount chief of the tribe) was holder of the adz. When a holder died, the handle was taken off and buried with him. Sometimes the whole adz was buried, the blade being later recovered. When a new paramount chief was proclaimed, another handle was made and the blade was ceremoniously lashed on. Thus a new ariki was seen to be installed. The nephrite blade is attached to the present handle, which was made for it but would be better suited to a much earlier type. The handle was made with stone tools in the eighteenth century. This toki was formerly in Salisbury Museum, England, where it was acquired during the first half of the nineteenth century.

140. Flute. Koauau

Wood, 16 cm. (6¹/₄ in.) long
South Taranaki
Ngati Ruanui tribe
Te Huringa 1 period (1800–present)
Formerly W. O. Oldman Collection
Canterbury Museum, Christchurch (E.150.555)
See plate 50

These instruments, which have a range of a major third, are played from the large end. The note is produced by blowing at an angle across the top. The surface features on this koauau illustrate the admixture of the rolling spirals with long notches. Rolling spirals are found in South Taranaki and Wanganui, the long notches in Taranaki. The pattern on this instrument has almost reached abstract status, with the original human figures only just discernible.

142. Resting place of a god. Taumata atua

Stone, 53 cm. (20⁷/₈ in.) high
Taranaki, Puketapu
Te Ati Awa (Ngati Puketapu)
Te Puawaitanga period (1500–1800)
Formerly A. Hoby Collection
Taranaki Museum, New Plymouth (A78.141)

This taumata atua, a talisman for the kumara (sweet potato) crops, represents Rongomatana as god of agriculture. Rongomatana incorporates the attributes of two gods: Tane, god of the forests, and Rongo, god of cultivated plants. Such a taumata would be placed in a special garden, the first one made, which was tapu (sacred) and set aside for the god. The taumata not only reminds the god to look after the crop, but is also a way of ensuring that only the best kumara planted in this garden would be used for seed the next year. When the crop was lifted, some of the seed kumara was placed in a special storepit to provide seed for the next year; the rest was placed in a special oven and cooked for the god. A portion of the cooked kumara was taken to the tribal tuahu (sacred place) and put before the god; some was eaten by the tohunga (priest) during the presentation to the god, but any left over was buried.

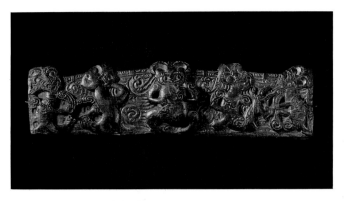

143. Threshold for a storehouse. Paepae
Wood, 77.3 cm. (30 ⅜ in.) wide
Taranaki tribe
Te Puawaitanga period (1500–1800)
Formerly Enys Collection; K. A. Webster Collection
National Museum of New Zealand, Wellington (Web. 1204)

This paepae (threshold for a storehouse) has a central frontal figure with
arms linked with profile figures on either side. The figures are carved
in the Taranaki tribal style but were probably carved by Te Ati Awa as a
gift to Taranaki.

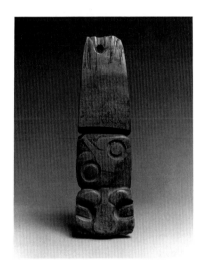

144. Adz-pendant. Toki poutangata
Greenstone, 23.6 cm. (9 ⁵⁄₁₆ in.) high
New Plymouth, Puketapu
Te Ati Awa (Ngati Puketapu)
Te Huringa 1 period (1800–present)
Formerly A. Hoby Collection
Taranaki Museum, New Plymouth (A.77.282)

This is a greenstone adz that has been converted into a tiki. The original
adz was probably a toki poutangata, or sacred adz, a symbol of
chieftainship. Such an adz could be placed in the care of somebody for
safekeeping but could not be given away; to do so would be to give away
the chieftainship of the tribe. However, one way of honoring an
important relationship could be to share the mana by placing part of the
greenstone in the care of another, but in a different form, for instance, a
tiki.

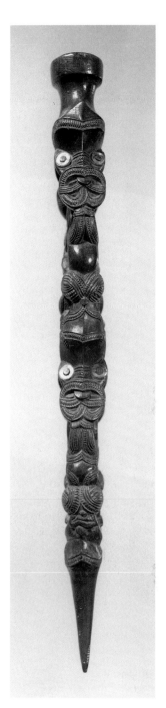

145. Weaving peg. Turuturu whatu
Wood, shell, 49.2 cm. (19 in.) long
Taranaki
Taranaki tribe
Te Huringa 1 period (1800–present)
Formerly Tau Fletcher Collection
National Museum of New Zealand, Wellington (ME.13842)

Maori twining or weaving was done on two pegs placed in the ground,
one plain and the other a more elaborately decorated peg for the
right-hand side. The topmost weft thread was strung between these and
the warp threads hung down. The material was then woven using four
threads in a twining technique. The decorated peg was dedicated to the
goddess who was the patroness of weaving. Weaving was originally a
skill learned from the patupaiarehe, the "other world people." Taranaki
was famous throughout New Zealand as the home of beautiful cloaks,
which were eagerly sought by other tribes.

223

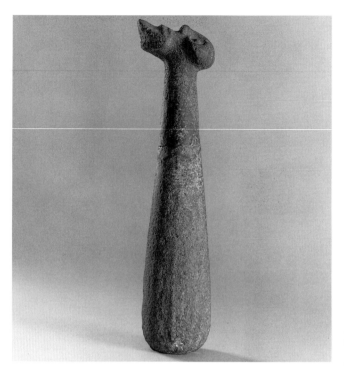

146. Flax beater. Patu muka
Andesite, 40.9 cm. (16⅛ in.) long
Mangarakau
Te Ati Awa tribe
Te Puawaitanga period (1500–1800)
Formerly W. Devenish Collection
Taranaki Museum, New Plymouth (A.46.577)

The patu muka (flax beater) was used for softening flax fiber. The Ngati Rahiri hapu of the New Plymouth area were especially skilled in working the andesite from Taranaki mountain (Mount Egmont). Andesite is a fairly difficult material to handle because the surface is always very uneven. The stone-carving artists frequently turned this factor to their advantage, as in this piece.

147. Pendant. Rei
Ivory, 4.5 cm. (1¾ in.) long
Te Ati Awa tribe
Te Puawaitanga period (1500–1800)
Formerly A. Bayly Collection
Taranaki Museum, New Plymouth (A.76.743)
See plate 53

This is a small ivory pendant of unique type. The figure has been carved in masterly style from a whale tooth. The head is well shaped, but the arms and legs are only suggested with an absolute economy of modeling.

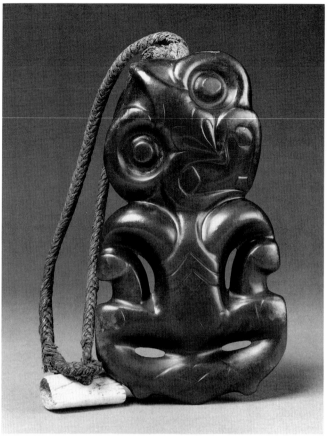

148. Pendant. Hei-tiki
Nephrite, cord, bird bone, 15.5 cm. (6⅛ in.) high
Te Ati Awa tribe
Te Puawaitanga period (1500–1800)
Formerly Mrs. Palmer Collection
Auckland Institute and Museum (5587)

In most tribes the god who formed man was Tiki. Among the East Coast tribes this task is given to Tane, who nevertheless uses his tiki or penis. This nephrite tiki was collected in 1795 by Matthew Flinders, the cartographer who mapped much of the coast of Australia. The tiki forms follow the wood-carving patterns. This one has the typical peak of Taranaki mountain between the brows. It is a very large tiki and would normally be regarded as being slightly later in time. The cord is original, but the bird bone toggle has been added. The eyes were originally provided with paua shell inserts.

224

149. Club. Patu

Nephrite, 39.8 cm. (15⅝ in.) long
Te Ati Awa tribe
Te Puawaitanga period (1500–1800)
Formerly J. Houston Collection
Taranaki Museum, New Plymouth (A.77.258)
See plate 51

This old patu, a nephrite club, the weapon of a chief, has seen many
generations of use. As a weapon it was used like a short sword with the
main attacking stroke being a thrust with the tip after a series of parries
and counterparries. The warrior code of chiefs often involved challenges
to single combat, the issue being decided by the first three blows struck
by one side or the other. A patu was often a treasured heirloom passed
down from father to son and given a personal name. A nephrite one was,
and still is, a symbol of chieftainship.

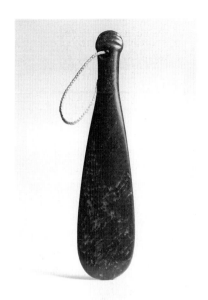

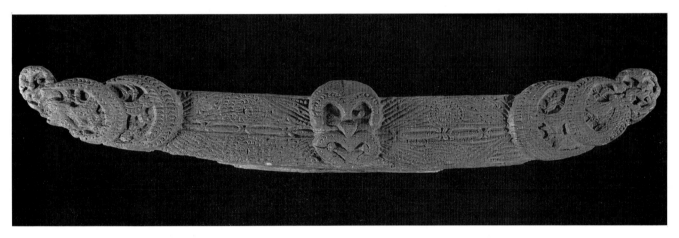

150. Lintel. Korupe

Wood, 123.6 cm. (48⅝ in.) wide
North Taranaki
Te Ati Awa tribe
Te Puawaitanga period (1500–1800)
National Museum of New Zealand, Wellington (ME.5249)

This korupe (lintel for a house) was probably for the house of the chief.
It features a round-browed head in the center with smaller triangular
heads at the ends. This lintel is also a good example of subtle
asymmetry in design. Storehouse carvings are much more common
than house carvings in Taranaki.

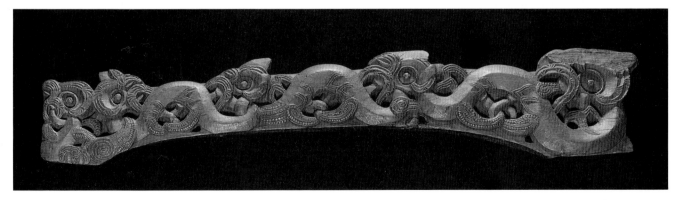

151. Threshold for a storehouse. Paepae

Wood, 150 cm. (59 in.) wide
North Taranaki, Waitara
Te Ati Awa tribe
Te Puawaitanga period (1500–1800)
National Museum of New Zealand, Wellington (ME.4657)

This paepae (threshold) is from a pataka (storehouse) in Manukorihi,
Waitara. The figures are five manaia (profile figures) probably representing
the five hapu (clans) of the Te Ati Awa. The arrangement of the manaia
illustrates an important principle of Maori art, that of apparent symmetry.
At first glance the paepae appears to be symmetrically arranged with
equal masses at either end, but this is an optical illusion. The overall
effect keeps the eye moving.

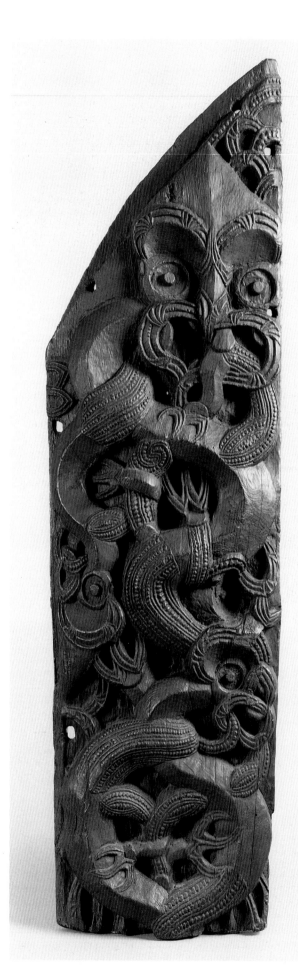

152. End post from storehouse. Epa

Wood, 117 cm. (46 in.) high
North Taranaki, Waitara
Te Ati Awa tribe
Te Puawaitanga period (1500–1800)
Formerly W. Crowe Collection
Taranaki Museum, New Plymouth (A.77.331)

This epa (end post) from a storehouse probably comes from the same
storehouse mentioned in cat. no. 151. The heavily modeled figures
with tubular serpentine bodies are completely intertwined. In Te Ati Awa
art forms, heads are not regarded as solid but can be penetrated
from behind by arms which come out of mouth or eyes. The bodies,
arms, and legs can twist together to form patterns or knots.

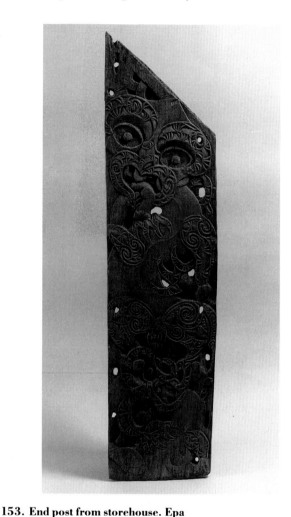

153. End post from storehouse. Epa

Wood, 100 cm. (39⅜ in.) high
North Taranaki, Waitara
Te Ati Awa tribe
Te Puawaitanga period (1500–1800)
Formerly P. Cole Collection
Taranaki Museum, New Plymouth (A.77.332)
See plate 52

This epa, also from a Waitara storehouse, is carved in very low relief by
a carver quite different from those who carved the other pieces just
discussed (cat. nos. 151, 152). Yet the same principles apply, the figures
being regarded as two-dimensional but operating in three-dimensional
space. This can be seen by the hand going behind the jawbone and
emerging out of the mouth. Lower down, a leg comes out of the eye
socket of a manaia (profile figure).

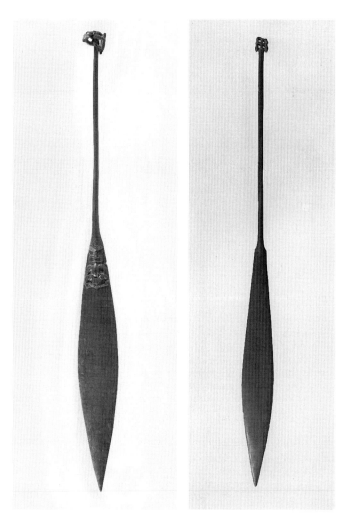

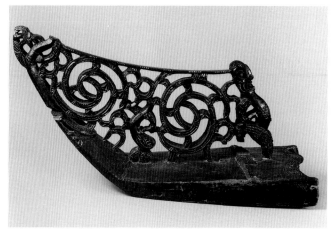

156. Canoe prow. Tauihu
Wood, 91 cm. (35¾ in.) long
North Taranaki, Waitara
Te Ati Awa tribe
Te Huringa 1 period (1800–present)
Formerly Manukorihi Marae Collection
Taranaki Museum, New Plymouth (A.78.127)

The style of this canoe prow, hidden near Manukorihi pa at Waitara, is not as abstract as earlier prows from this and other regions. The rear and front figures are more definite than would be expected, and the elements connecting the arms of the spirals look slightly different from other examples. These "problems" would disappear if the prow were a gift carved by another tribe who used the style of the recipients. I am told that this was the case; the prow was a gift from the Tuwharetoa people of Taupo to Te Ati Awa in the early years of the nineteenth century.

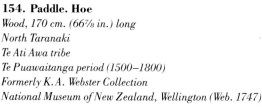

154. Paddle. Hoe
Wood, 170 cm. (66⅞ in.) long
North Taranaki
Te Ati Awa tribe
Te Puawaitanga period (1500–1800)
Formerly K. A. Webster Collection
National Museum of New Zealand, Wellington (Web. 1747)

This paddle, made for an important war canoe, has a protective ancestor figure carved on the loom of the blade and a gymnast figure carefully carved on the butt. The Taranaki gymnast figures seem to originate not as one but as two figures in a copulating position. As the design develops the main figure loses its lower limbs, while the secondary figure retains only the lower limbs, which are in a reversed position in relationship to the main figure. Variations of this two-becoming-one theme can be seen commonly on paddles but are also present on other items such as tekoteko (gable figures).

155. Paddle. Hoe
Wood, 188 cm. (6 ft. 2 in.) long
North Taranaki
Te Ati Awa tribe
Te Huringa 1 period (1800–present)
Formerly Mrs. Mantell Collection
Auckland Institute and Museum (1406)

This hoe (paddle) for a war canoe with gymnast figure on the handle is carved in the Te Ati Awa style. Maori paddles were flat and slender, unlike the broad dished paddles of Polynesia.

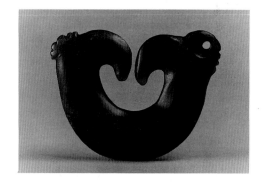

157. Pendant. Hei-matau
Nephrite, 6 cm. (2⅜ in.) wide
Te Ati Awa tribe
Te Huringa 1 period (1800–present)
Formerly Mrs. Walsh Collection
Auckland Institute and Museum (19256)
See plate 54

It is said that experts in fishing wore such fishhook pendants. This may be, but the symbolic meaning of hei-matau is a reminder of the fishhook of Maui with which he fished up his fish Te Ika a Maui, the North Island of New Zealand. The island is shaped like a ray, with head to the south, tail to the north. Hei-matau were an especial mark of knowledge and the most powerful prayers are the incantations of Maui used by paramount chiefs and priests who would be entitled to wear the hei-matau.

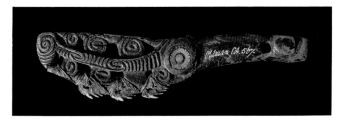

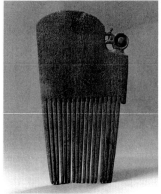 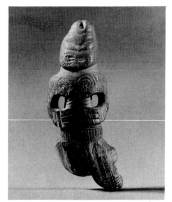

158. Knife. Maripi

Wood, shark tooth, shell, 13.8 cm. (5⅜ in.) long
Queen Charlotte Sound
Ngati Kuia (Ngati Apa)
Te Puawaitanga period (1500–1800)
Formerly W. O. Oldman Collection
National Museum of New Zealand, Wellington (Old. 567)

This maripi (shark tooth knife) is carved in the style of the Cook Strait area. This style owes much to that of the Wanganui and South Taranaki region. The two tribes to whom it is tentatively ascribed were seventeenth- and eighteenth-century occupants of the Cook Strait region but had their origins in the North Island. The traditional history of Queen Charlotte Sound features a rich succession of tribal association which makes ascription difficult. The present ascription is based on the tribal association with the period. Maripi such as this were used in the ritual cutting up of human flesh, an act surrounded by the restrictions of tapu. The detailed decoration is associated with this function.

STEPHEN O'REGAN

159. Comb. Heru

Whalebone, 13 cm. (5⅛ in.) high
Queen Charlotte Sound
Ngai Tahu (Ngati Mamoe)
Te Puawaitanga period (1500–1800)
Formerly Knapp Collection
Nelson Provincial Museum (K.34.72)
See plate 55

This heru (bone comb) is very like those collected by Captain Cook on his three voyages to Queen Charlotte Sound. Men wore their hair in tikitiki (topknots) tied into a bun; wood or bone combs and feathers were thrust into the topknot. Fine combs, a varying number of feathers, and facial tattoo ranked the status of the individual chiefs.

160. Pendant. Rei niho

Whale ivory, 11.7 cm. (4⅝ in.) long
Golden Bay
Ngati Apa (Ngati Tumatakokiri)
Te Puawaitanga period (1500–1800)
Nelson Provincial Museum (E.3.66)
See plate 56

The style of carving is Taranaki in origin, but in a form and style also practiced in the South Island. The pendant comes from the area in the northwestern corner of the South Island in which the two old tribes mentioned above once lived. Although they have now disappeared from the region, most of the old sites and artifacts recovered there are associated with them.

STEPHEN O'REGAN

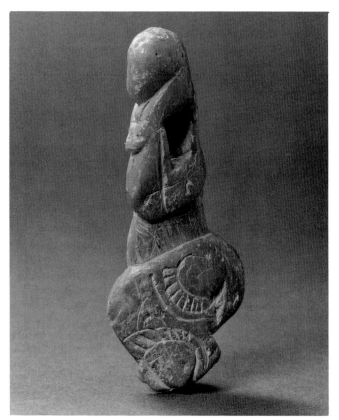

161. Figure. Whakapokoko

Stone, 8 cm. (3⅛ in.) high
D'Urville Island, Patuki
Ngati Kuia (Ngati Apa)
Te Puawaitanga period (1500–1800)
Nelson Provincial Museum (E.20.68)

Small stone figures of serpentine, soapstone, talc sandstone are a feature of the northern area of the South Island. Dr. H.D. Skinner of Otago Museum has called them "gymnast figures." The artists appear to have found a freedom in making these small three-dimensional figures that was not available to them in other figures.

162. Pendant. Rei puta
Whale tooth, 21.8 cm. (8⅜ in.) long
Otago, mouth of Clutha River
Kai Tahu (Waitaha)
Te Puawaitanga period (1500–1800)
Otago Museum, Dunedin (L.72.2)
See plate 57

This neck ornament, a whale tooth pendant, is made from a sperm whale tooth that has been split. Rei puta were commonly worn in the eighteenth century but became fairly uncommon after that time. North Island rei puta usually have only a pair of eyes and perhaps a line for the nose. A full face mask is used only in the Kai Tahu area of the South Island.

163. Canoe sternpost. Taurapa
Wood, 74 cm. (29 ⅛ in.) high
Banks Peninsula, Okains Bay
Kai Tahu (Kati Mamoe)
Te Puawaitanga period (1500–1800)
Canterbury Museum, Christchurch (E.140.180)

This taurapa (canoe sternpost) is of early Maori form. It has two linked spirals at the top with holes back and front for the attachment of feather streamers. This sternpost would appear to date to the beginning of the Puawaitanga period in this area, when the simplicity of the early forms was still a strong force even though the impetus toward curvilinear forms had already produced the spiral form. This sternpost could be dated to the late sixteenth or early seventeenth century.

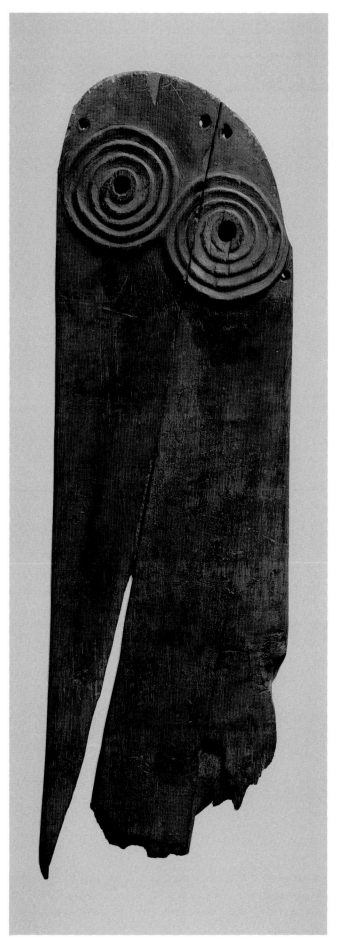

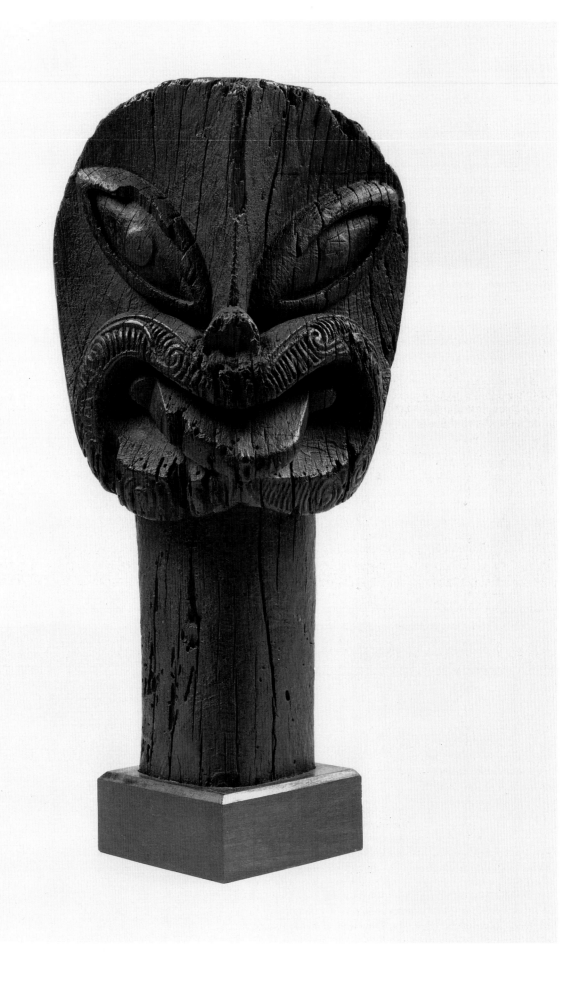

230

164. Canoe figurehead. Tauihu

Wood, 54 cm. (21¼ in.) high
Otago Harbour, Long Beach
Kai Tahu (Kati Mamoe)
Te Puawaitanga period (1500–1800)
Otago Museum, Dunedin (L71.68)

This tauihu (figurehead for a canoe) is from Wharauwerawera (Long Beach) on the north head of Otago Harbour. Although the form is early, with keeled Polynesian-style eyes, it has later Maori surface decoration. This blend of cultural phases may reflect the experience of the Kati Mamoe tribe to whom it is ascribed. They were an ancient North Island tribe pushed southward by the expansion of later groups with whom they had extensive contact and intermarriage. This tauihu is thought to date from the seventeenth or eighteenth century. Kati Mamoe were pressured out of the Cook Strait area in the mid-seventeenth century.

STEPHEN O'REGAN

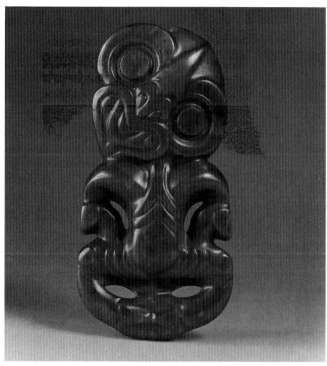

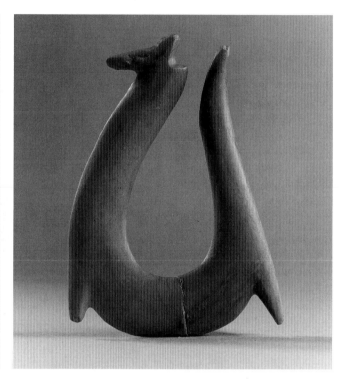

165. Pendant. Hei-tiki

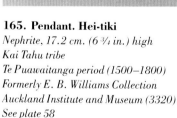

Nephrite, 17.2 cm. (6 ¾ in.) high
Kai Tahu tribe
Te Puawaitanga period (1500–1800)
Formerly E. B. Williams Collection
Auckland Institute and Museum (3320)
See plate 58

This large nephrite hei-tiki was collected by a lieutenant on the *Endeavour*. The ship was probably not Captain Cook's *Endeavour* but the sealer of Captain Bampton which foundered in Dusky Sound at the extreme southwest of the South Island in 1795. The style of the tiki and its size would be appropriate to a very late eighteenth-century or even early nineteenth-century date of manufacture in the South Island and reflects the Kai Tahu dominance of the Poutini nephrite resource on the western side of the South Island in that period. The struggle for dominance of pounamu (nephrite) is a central feature of South Island Maori history.

166. Pendant, fishhook. Hei-matau

Nephrite, 7.5 cm. (2¹⁵/₁₆ in.) high
North Otago, mouth of Pleasant River
Kai Tahu tribe
Te Puawaitanga period (1500–1800)
Otago Museum, Dunedin (D65.846)

The fishhook form has here been reinterpreted slightly to serve as an ornament form. The corner barbs are not functional. Barbed hooks of this general shape are a late introduction into the area when the Kai Tahu moved down from Canterbury.

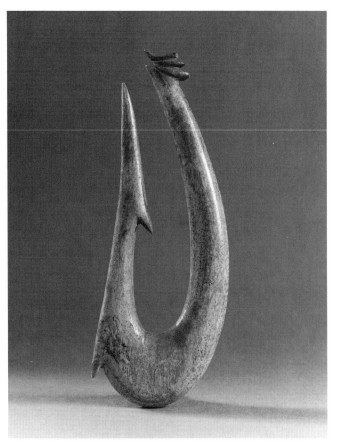

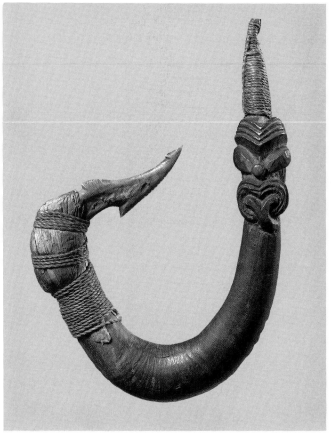

167. Pendant, fishhook. Matau
Whalebone, 16 cm. (6¼ in.) high
Otago Heads, Papanui Inlet
Kai Tahu (Kati Mamoe)
Te Puawaitanga period (1500–1800)
Otago Museum, Dunedin (D27.257)
See plate 59

This late matau (fishhook) of whalebone is one of a pair found with a burial. The hook is large and, for its size, somewhat delicate. While it has the form of a late eighteenth-century hook, it is doubtful that it served a utilitarian function. It is much more likely to have been a ceremonial hook worn as an amulet.

168. Fishhook. Matau
Wood, bone, flax fiber, 11.4 cm. (4⅜ in.) high
Otago
Kai Tahu tribe
Te Huringa 1 period (1800–present)
Formerly W. O. Oldman Collection
National Museum of New Zealand, Wellington (Old. 105)

This matau is a barbed composite hook of late Kai Tahu form. The carving and multibarb point date this hook to about 1820–30. The shank has been made by training a branch into shape. The point is made from albatross bone and has been wrapped with rush leaves. The lashings are of flax *(phormium tenax)* fiber. This is a functional hook that has been put together beautifully.

169. Housefront figure. Amo
Wood, 134 cm. (52¾ in.) high
Kai Tahu tribe
Te Huringa 1 period (1800–present)
Otago Museum, Dunedin (D60.30)

This amo (housefront board) is of unusual form. Carvings from the South Island are rare in any form, most, according to tribal tradition, having been destroyed during the musket warfare of the early nineteenth century. Surviving house carvings are restricted to one or two enigmatic pieces. This figure is very well carved, the pierced head with no lower jaw contrasting with the strong simplicity of the body. This carving was in the possession of a family at Maheno in north Otago and some doubts have been expressed as to its origin. Knowledgeable Maori elders who have seen a photograph unhesitatingly assign it to the Kai Tahu tribe.

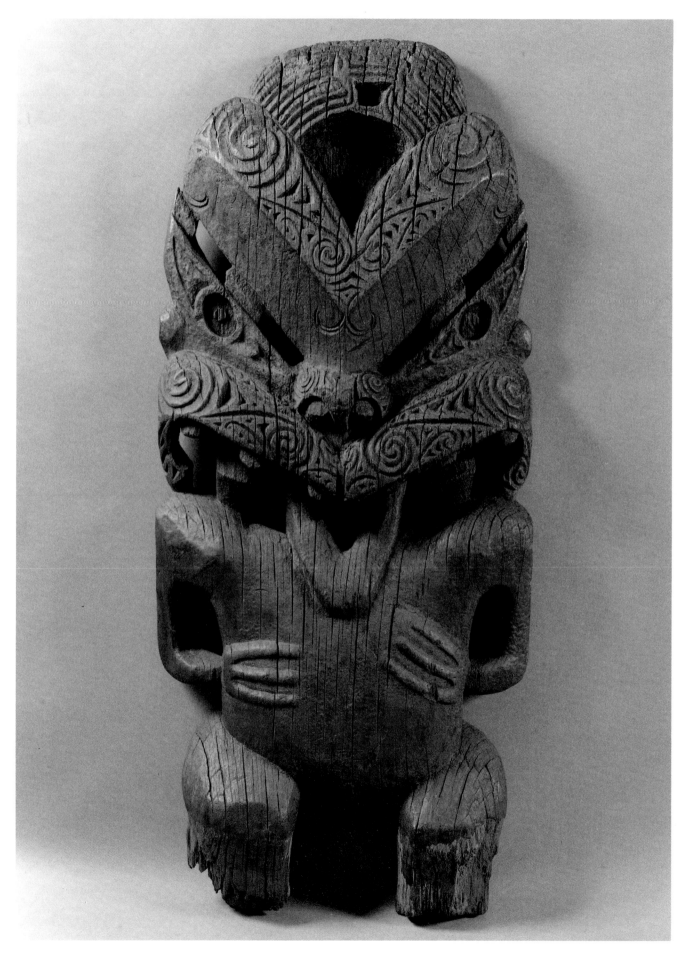

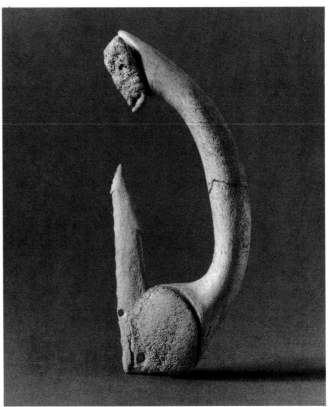

170. Adz. Toki
Metabasalt, 35.3 cm. (13⅞ in.) long
Southland, Pahai region
Kai Tahu (Kati Mamoe)
Te Puawaitanga period (1500–1800)
Southland Museum and Art Gallery, Invercargill (B.81.2)

This toki (adz) of basalt with marked chin bevel and bevel on lower part of the grip is a very distinctive style of adz manufactured in the Pahia region of Murihiku (Southland). It would date to about 1500 or 1600 and is a later version of the more Polynesian-style adz. It is possible that these outstanding Kati Mamoe adzes were still being made at the beginning of the eighteenth century or even later, when they were replaced by the adz imported by the Ngai Tahu tribe, who became dominant in the southern South Island in the mid-eighteenth century.

171. Hook. Matau
Bone, 15.5 cm. (6⅛ in.) high
Southland, mouth of Tokanui River
Kai Tahu (Kati Mamoe)
Te Puawaitanga period (1500–1800)
Southland Museum and Art Gallery, Invercargill (B.64.153)

The multi-barb and serrated point and the head of this composite bone fishhook suggest that the hook was made in the late eighteenth century. The shank is probably the flipper bone of a seal, while the point is made from whalebone. Very few composite bone hooks have survived. In the late period (eighteenth to nineteenth centuries) bone points were normally lashed on to wooden shanks. One-piece hooks are rare.

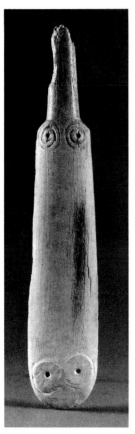
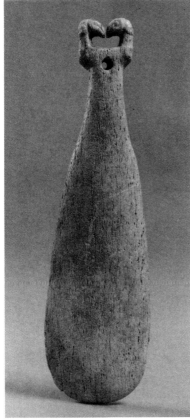

172. Club. Patu paraoa

Whalebone, 43.7 cm. (17½ in.) long
Lake Manapouri
Kai Tahu (Kati Mamoe)
Te Puawaitanga period (1500–1800)
Southland Museum and Art Gallery, Invercargill (B.81.159)

This patu paraoa is a bone version of the long stone miti clubs (cat. no. 24). It is decorated with a pair of spirals at the beginning of the blade and another, unfinished pair at the tip of the blade. The style of the decoration is similar to that found on a canoe sternpost from the Banks Peninsula (cat. no. 163) and to similar pairs of spirals found on some versions of the chevron amulet. This would suggest that the club could belong to the sixteenth century.

173. Club. Patu paraoa

Whalebone, 36.9 cm. (14½ in.) long
Southland
Kai Tahu (Waitaha)
Te Puawaitanga period (1500–1800)
Southland Museum and Art Gallery, Invercargill (Z.1207)

North Island forms of whalebone club did not reach the South Island, where a simpler and much earlier form was still in use in the eighteenth century. The butt handle of this patu is of a very rare form, only one other like it being known. The two manaia (profile figures) represent a motif which features very strongly an early South Island Maori design.

174. Fishhook ornament. Hei-matau

Nephrite, 13 cm. (5¼ in.) high
Kai Tahu tribe
Te Puawaitanga period (1500–1800)
Canterbury Museum, Christchurch (E.138.325)
See plate 60

This hei-matau is a nephrite fishhook ornament generally worn only by learned men. It represents the fishhook with which Maui fished up the North Island of New Zealand. His fishhook, made from his grandmother's jawbone, was baited with blood from his own nose. It plunged into the depths and caught in the gable of the house of Tangaroa, the god of the sea. According to the South Island people, their island (Te Waipounamu) was the "canoe" from which the North Island was fished up. Thus, for the tribes of that area hei-matau have heightened significance, particularly those made from their treasured pounamu (nephrite).

GLOSSARY

The translations given here have been taken from Herbert William Williams, *A Dictionary of the Maori Language*, 7th ed., rev. and enl. (Wellington: Government Printer, 1971).

aha *pron.* what, why, for what purpose
ahi-kā-roa *n.* literally, long-burning fire, title to land by long occupation
ahorangi *n.* term for teacher and scholar of high standing
āhua *n.* form, appearance
ahurewa *n.* sacred place for performing rituals
ai *v.t.* begat, procreated
aitua *n.* tragedy, misfortune, bad luck, death
ako *v.t.* to learn, teach, advise, instruct
amo *n.* upright carved posts on either side of a house entrance
ana *particle*, postponed
ao *n.* daytime, world, cloud, dawn
ao rino *n.* world of steel or iron
Aotearoa *n.* place name, indigenous term for New Zealand; literally, Long White Cloud
arā *adv.* namely, in other words
ariā *n.* likeness, resemblance, notion, idea, feeling
Arohanui ki te tangata good will to humankind; literally, big love to man
aruhe *n.* fern *(Pteridium aquilinum* or *esculentum)* which provided an edible rhizome
ata *n.* early morning
atamira *n.* stage, platform on which a corpse is placed
ātea *adj.* clear, free from obstruction
atu *loc. particle*, direction away from speaker
atua *n.* gods
aturere *n.* a fish, sea fish (not identified) highly prized for eating
aua *pron., pl.* those mentioned before
aute *n.* paper mulberry tree *(Broussonetia papyrifera)*
awa *n.* stream, river

e *v. particle*
ēnā *pron., def., pl.*, those near person addressed
epa, epaepa *n.* internal posts at front and back ends of a house; in contrast to poupou (side posts), q.v.

haehae *n.* a carved pattern, of side-by-side V-shaped grooves
haka *n.* dance, usually applied to male posture dancing
hanga *v.t.* to make, build, fashion
hao *v.t.* to catch in a net
hapa *n.* error, crooked
hapū *n.* literally, pregnant; a social division below the level of tribe (iwi), hence sub-tribe
hara *n.* a ritual transgression regarded as a sin
harakeke *n.* flax *(Phormium tenax)*

hau *n.* vitality of man
hau-kāinga *n.* home village, home
Haumia-tiketike *personal name* God of Fern Root
hauora *n.* health, vigor; *adj.* healthy, well, fresh, lively
Hawaiki *place name* mythical homeland of the Maori people
he *art., indef., sing.* a; *pl.* some
hei *prep.* for, to, as
hei-tiki *n.* pendant worn at the neck
hei-matau *n.* a neck ornament in the form of a fishhook
hei-pounamu *n.* a neck pendant of jade
heru *n.* comb
hika *n.* a term of address to people of both sexes; girl, daughter
hiki-tanga *n.* the lifting
hikurangi *n.* probably a place name but not translated as such by Taylor (1855: ch. 5)
Hinemihi name of an Arawa house now in England (1880)
hinengaro *n.* mind; but traditional meanings refer to spleen, as seat of thoughts and emotions
Hinetāpora *n.* name of a carved meeting house in East Coast region (1883)
hira *adj.* important, of consequence
hiri *adj.* requiring exertion, laborious, eagerly desired
hoe *n.* paddle
hoeroa *n.* a weapon, usually made of bone, curved, not pointed, and shaped like a long paddle
hongi *n.* ceremonial greeting which involves touching of noses
hora *v.t.* to spread out, display
hotupu *v.* to grow, increase; *n.* growth
hou *adj.* new
Houmaitawhiti name of a carved house in Arawa region (c. 1860)
hua *n.* fruit, product, progeny
hue *n.* calabash, gourd *(Lagenaria vulgaris)*
hui *n.* meeting of people, coming together to talk
huia *n.* rare bird *(Heteralocha acutirostris)*, feathers of the huia
huinga *n.* the gathering
hunga *n.* company of persons, people
hunga ngaro *n., pl.* departed ones
huri-nga *n.* turning; Te Huringa (The Turning), a historical period (1800 to present)

i *v. particle*, forms indefinite past tenses
ia *pron., 3d pers. sing.* he, she, him, her
ihi *n.* power (as in an artistic statement); *adj.* has

force, authority, and dread, usually linked with wehi and wana, q.v.
iho *n.* kernel, pith, heart; *loc. particle*, implies direction from superior to inferior, or from above to below
ihu *n.* nose, prow
ika *n.* fish
inanga *n.* whitebait, adult of minnow *(Galaxis attenuatus)*, and fry of smelt *(Retropinna retropinna)*
ira atua *n.* life principle (ira) of gods (atua)
ira tangata *n.* life principle (ira) of humans (tangata)
iti *adj.* small
iwi *n.* literally, bone; a social unit—knit together by bonds of kinship and locality—above level of hapu, tribe

ka *v. particle*, denoting beginning of a new action, condition or state of things new to the speaker
kaha *adj.* strong
kahawai *n.* a sea fish *(Arripis trutta)* good for eating; still caught and eaten today
kāhui *n.* group of
kāhui ariki *n.* group of people who are descended from the first Maori king, Potatau Te Wherowhero
kahurangi *n.* prized, precious, honorable, distinguished
kāinga *n.* home
Kai Tangata Te Rangihaeata's house (c. 1830)
kākano *n.* seed, stock, descent; Ngā Kākano (The Seeds), a historical period (900–1200)
kakī *n.* neck
kanohi *n.* face
kanohi ora *n. pl.* living faces
karakia *n.* incantation; modern meaning of prayers
karanga *n.* calling; ceremonial calling performed by women usually to welcome visitors onto a marae but not confined to that
karanga *v.t.* to call, call out, shout
kārara *n.*, South Island variant of ngārara (reptile), q.v.
karetao *n.* jumping jack, a toy carved in human form with arms moved by pulling a string
kātahi *adv.* then; *conj.* now, for the first time, only just
Kāti *n.* South Island variant of Ngāti, q.v.
kaua *adv.* not
kaupapa *n.* matter under discussion, platform, layer
kauri *n.* forest tree *(Agathis australis)* suitable for woodcarving, highly prized; now difficult to obtain

kāwae, kāwai *n.* lineage, pedigree, branch

kē *adj.* separate, apart from

kei *prep.* at, on, in

kete *n.* basket made of flax

ki *loc. particle* to, toward, into

kī *v.t.* to say, tell, mention, call

kia *adv. conj.*, introduces a proposition

kimi-hia *v.t.* to seek, look for

kino, kikino *adj.* evil, bad, ugly

kite-a *v.t.* to see, perceive, find, discover

kiwi *n.* well-known flightless bird often used as a metaphor for New Zealanders. The feathers of this bird are highly prized in cloaks.

ko *particle, spec.*, to indicate the subject about which something is about to be said

kōauau *n.* a musical instrument, usually straight, tubular in shape, with three holes, played with nose or mouth

koe *pron., 2d pers. sing.* you

koha *n.* gift, present to give to hosts

Kōhanga Reo *n.* language nest. A new language teaching program introduced by Department of Maori Affairs to teach pre-school children from infancy to speak Maori

kōkiri *n.* fish, leatherjacket *(Cantherines convexirostris)*

kōkiri-tia *v.t.* to thrust

kōkō *n.* bird; same as tūī, q.v.

kōkōwai *n.* red ocher

kōmako *n.* bellbird, same as korimako, q.v.

konā *loc.*, that place near person spoken to

kopa *n.* floor space inside house to left as one enters

kōpū *n.* womb; *cap.* the planet Venus

kore *n.* nothingness, lack of anything

korere *n.* funnel

kōrero *v.* to tell, say, speak, talk; *n.* conversation; here given a special meaning: story or iconography

korimako *n.* bird, the bellbird *(Anthornis melanura)*

koroua *n.* elderly male

kōrupe *n.* another name for a door lintel, same as pare

koruru *n.* a carved figure placed on the gable of a house

kotaha *n.* a sling for throwing stones

kotiate paraoa *n.* a flat weapon with a lobed blade made of whalebone

koutou *pron., 2d pers. pl.* you (three persons or more)

kōwhaiwhai *n.* painted patterns traditionally on house rafters and canoe hulls

kuia *n.* elderly woman

kūmara *n.* sweet potato

kumete *n.* wooden bowl or trough very common in traditional times but not used now

kupu *n.* word, message, saying, talk; here given a special meaning: iconography, ideology, philosophy

kura *n.* treasure, red, glowing

kuwaha *n.* doorway

mahau *n.* porch of a house

māhē *n.* sinker for a fishing line

mahina *n.* combined with ata (ata mahina) means early morning

mai *loc. particle*, direction toward the speaker

maihi *n.* bargeboards, facing boards on the gable of a house

makawērau *n.* literally, a hundred (strands of) hair

māku *pron., 1st pers. sing.* my, mine

mamao, maomao *adj.* distant, far away

mana *n.* psychic force, authority, control, prestige, power, influence; same as wana, q.v.

manaaki *v.t.* to show respect or kindness to, look after, care for

manaia *n.* an art form in which the face and sometimes the body is shown in profile

manatūnga *n.* keepsake, heirloom, valued treasure; literally, mana, standing up

mānu *v.t.* to float, be launched

Manuruhi *personal name* meaning Exhausted Bird, main victim of anger of Tangaroa, q.v.

maomao *n.* an edible sea fish *(Diretmus argenteus)*

Māori *n.* name for indigenous people of New Zealand

Māoritanga *n.* concept of Maori identity and aspirations, often used to mean Maori culture

marae *n.* enclosed space in front of a meeting house, the courtyard

marakihau *n.* a motif in wood carving, said to represent a fabulous sea monster resembling a mermaid

marama *n.* moon

māripi *n.* cutting instrument, knife

mata *n.* edge, point, headland

Mātaatua *name* of a carved house from Whakatane, Bay of Plenty (1874) now in Otago Museum, Dunedin

matamoe *n.* eel caught in fresh water *(Anguilla australis)*

matapihi *n.* window

matau *n.* fishhook

mātauranga *n.* knowledge, education, philosophy

mātauranga Māori *n.* Maori education, knowledge

mate *n.* death; *adj.* dead

mātua *n., pl.* parents

mātou *pron., 1st pers. pl.* we, us (excluding person spoken to)

mau *n.* pendant

Māui *personal name* culture hero well known in Polynesia. In New Zealand he fished up the North Island, tamed the sun, obtained fire, and ultimately died in his final task, which was to conquer death.

mau kakī *n.* pendant (mau) to wear around the neck (kakī)

maunga *n.* mountain

mauri ora *n.* life principle, source of life, of vitality

me *prep.* with

mea *n.* thing

mere, meremere *n.* hand-held weapon of symmetrical shape

mihi *v.t.* to greet

miti *n.* club, weapon made of stone

mo *prep.* for the benefit of, for the use of

moa *n.* flightless bird now extinct; several species, best known is *Dinornis gigantea*

moana *n.* ocean, sea

moe *v.t.* to sleep, lie at rest

moenga *n.* bed

moho *n.* bird *(Notornis hochstetteri)*

moki *n.* fish, good for eating *(Latridopsis ciliaris)*

moko *n.* tattoo patterns, tattoo as an art form; general word for lizards

mokopuna *n.* grandchild

motu *n.* island

mua *n.* the front, forepart; former time, the past

muri *loc.* behind

na *particle*, used after words or clauses to indicate position near person addressed

nāku *pron., 1st pers. sing.* belonging to me, mine, by me

namata *n.* ancient or olden times

nei *loc. particle*, indicating proximity to speaker

nga *def. art., plur.* the

Nga Moteatea the body of traditional songs

ngārara *n.* reptile, monster; literally, the (nga) ribs (rara)

ngaro *adj.* hidden, out of sight, disappeared, missing, lost, absent

Ngati *n.* tribal prefix, usually followed by name of founding ancestor; the progeny or people of

nguru *n.* musical instrument curved in shape and narrow at blowing end, played with nose or mouth

noa *adj.* free from tapu (taboo) or restriction, of no moment, ordinary

noho *v.t.* to dwell, stay, remain

nui *adj.* big, large

o *prep.* of, belonging to

ora *adj.* alive, well, in health

oti *part.* with atu means gone for good, finished

pā *n.* fishhook made of paua (Haliotis shell)

pā *n.* fortified and stockaded village often on a hilltop; now used to mean the village where the carved meeting house stands

paepae *n.* beam or bar across the front of a carved house or storehouse at floor or ground level

Paerau *n.* mythical place where the spirits gather

paiaka *n.* root (of a tree)

pākati *n.* a carved pattern of notches which are usually ordered by V-shaped grooves

Pākehā *n.* common term for non-Maori and typically referring to persons of European, American, or British origin

pakitara *n.* wall

pakohe, pakohi *n.* a dark-gray close-ground stone, black argillite

papa *n.* anything broad, flat, and hard, layer, earth floor, site of a house

papahou *n.* a carved box or chest for holding huia feathers; term applied to flat chests, while wakahuia is used for more rounded and oval ones

Papatuanuku *personal name* Earth Mother

pare *n.* door lintel, same as kōrupe

pari-nga *n.* flowing over of the tide, full tide

pātaka *n.* storehouse raised upon posts

pātiki *n.* flatfish much sought after for eating, flounder, several species, e.g., *Rhombosolea plebia*

pātītī *n.* tomahawk blade often hafted into a whalebone or wood handle which can be short or long, hatchet

patu *n.* a one-hand weapon of symmetrical shape used to hit or strike

patu muka *n.* a beater, for beating and softening the fibers of flax

patupaiarehe *n.* fairy people, sprite

patu parāoa *n.* a hand club made of whalebone

patu whakairo *n.* a mallet used in carving

pāua *n.* univalve mollusk, e.g., abalone *Haliotis australis*, but several species

pēpeke *v.i.* to draw up the legs as one is sitting down so as to stay in a crouching position

pīpīwharauroa *n.* bird, shining cuckoo *(Chalcites lucidus)*; also a variety of greenstone

pirau *n.* decay, death; *adj.* rotten

piupiu *n.* traditional garment worn around waist; now used during ceremonial occasions or for dancing performances

pō *n.* night

poto *adj.* short

pou *n.* general term for post

pounamu *n.* jade or greenstone

poupou *n.* side post inside a house, usually flat so as to present a surface for carving; in contrast to epa or epaepa, q.v.

poutokomanawa *n.* the center post which holds up the ridgepole of a large house

pouwhakamaharatanga *n.* memorial post

pū, pū te ruha *v.i.* to lie in a heap

pua *n.* flower, seed

puhi *n.* a woman set apart, a virgin, a betrothed woman, usually of high status

pūkana *v.i.* to distort the face as in dance, stare wildly

pūkanohi *n.* eye

pukatea *n.* forest tree suitable for wood carving (*Laurelia novaezealandiae*)

pukenga *n.* pool of tribal heritage, knowledge and people to teach it

puku *n.* stomach

pūmanawa *n.* natural talents, intuitive cleverness

puta *v.t.* associated with to appear, to come into sight, as in the phrase puta ki waho, to be born

pūtōrino *n.* a kind of flute, longer than a kōauau (q.v.), one large hole near the center, narrow at the ends

rā *n.* sun; *loc. particle* there, yonder

rākau *n.* wood, timber, tree

rākau whakapapa *n.* shaped and notched piece of wood used as an aid to reciting genealogy

rangahau-a *v.t.* to seek, look for; an old form used mainly in chants

rāngai *n.* herd, flock, shoal, company

rangatahi *n.* fishing net in good condition; modern word for youth

rangatira *n.* chief

rangi *n.* sky, heaven, abode of supernatural beings

Ranginui *personal name* Sky Father, the ultimate father of the Maori people

Rangitihi *n.* name of a carved house in Arawa district (1871)

rapa *adj.* spread out, extended, wide, flat; *n.* sternpost of a canoe

raparapa *n.* lower carved end of facing board on front of a superior house

rapu-a *v.t.* to seek, look for, ascertain

rārangi *n.* line, row, rank

raro *loc.* below, lower part, bottom

rātou *pron., 3d pers. plur.* three or more persons, they, them

rauawa pātaka *n.* sideboard (rauawa), often decorated, of a storehouse (pātaka)

rawa *adv.* intensive, quite, very, very much

rawea *v.t.* to clasp lightly; *adj.* abundant

rea *v.i.* to spring up, grow, multiply

Rehua *personal name* grandchild of Tangaroa (q.v.), some of whose children fled to the land and others to the water

rei *n.* tusk, large tooth, ivory, anything made of ivory

rei puta *n.* ornament made of a whale tooth

rekoreko *adj.* dazzling

reo *n.* language

rere *v.t.* to travel, sail, flow, fly

rikoriko *n.* twilight, dusk, feeble glimmering

rino *n.* modern word for iron

riri *v.i.* to be angry, quarrel, fight; *n.* strife

riro *v.i.* to be gone, depart

rito *n.* center shoot or heart of a plant

roa *adj.* long

roi *n.* grated pulped food, often fern root or sweet potato

roko-hanga *v.t.* to come upon, be overtaken, be found

Rongomātāne *personal name* God of the Sweet Potato

rua *n.* underground pit for storing food

rua-tāhuhu *n.* a roofed subterranean pit for storing sweet potato

Ruatepukenga *personal name* son of Manuruhi (q.v.), and cause of his father offending Tangaroa (q.v.)

Ruatepūpuke *personal name* the ancestor who obtained the art of wood carving from the sea god Tangaroa

ruha *adj.* ragged, worn out, as of a net

runga *loc.* the top, upper part

Rūtatae-whenga *personal name* a tiki from Tuparoa, East Coast

taea *v.i.* to be accomplished, be effected

taha Maori *n.* literally, the Maori side (of culture) in the culture contact of New Zealand

tāhuhu *n.* ridgepole of a house

tahuri *v.i.* to turn oneself, turn over

tai *n.* the sea or water, as opposed to land

taiaha *n.* weapon, long staff made of wood with a tongue at the lower end

taka *v.t.* to go, pass around

takataka *v.t.* to make ready

take *n.* cause, reason, root, stump, origin, beginning

takoto *v.i.* to lie down

taku *pron., poss., 1st pers. sing.* my

takutai *n.* seacoast

tā moko *v.t.* to tattoo (tā) with tattoo patterns (moko)

tāmure *n.* good eating fish, reddish in color, e.g., snapper (*Pagrosomus auratus*)

Tāne *personal name* God of Forests and Trees

Tangaroa *personal name* God of the Sea

tangata *n.* human being, man

tangata whenua *n.* people of the land, the hosts as opposed to visitors

tangi *n.* mourning and funeral ceremony

tango *v.t.* to take possession of, acquire, remove, take away

tangohanga *n.* acquisition of wealth

tangohanga-whare *n.* acquisition of wealth for household

tangotango *adj.* intensely dark

taniwha *n.* monster

tāonga *n.* anything highly prized, property

tāonga tuku iho prized possessions, e.g., heirlooms, handed down to present generation

tāonga whakairo *n.* carved object, art object

taowaru *n.* a carving pattern claimed by some to refer to the Te Kaha type of surface decoration and by others to a central raised spearlike feature found in some carvings, and especially in Te Kaha

tapotu *v.i.* to be brought down to the water ready for launching

tapu *adj.* under religious restriction, ceremonial restriction

tara *n.* abbreviation for pakitara, q.v.

tārai-a *v.t.* to dress, shape, fashion, especially as applied to working wood

taranga *n.* separation

taratara-a-kae *n.* a carving pattern associated with storehouses, sometimes called the great pattern

tārekoreko *adj.* dimly seen, out of sight

taro *n.* a plant (*Colocasia antiquorum*) cultivated for food

tau *v.i.* to float, come to anchor, settle down; *adj.* becoming, befit

tāua *pron., 1st pers. dual.* you and I, you and me

tauihu *n.* carved prow of a canoe

tauira *n.* teacher, skilled person, pupil

taumaha *adj.* heavy

taumata atua *n.* resting place for gods

taurapa *n.* carved sternpost of a canoe

Tawhirimatea *personal name* God of the Wind

tē *adv.* negative, not

te *def. art. sing.* the

te ao hou *n.* the new world

te ao tawhito *n.* the old world, as opposed to the new

Te Aomārama first Māori art school at Rotorua, established in 1910; name means world of light

Te Hau-ki-Tūranga name of the oldest carved house in New Zealand, from Gisborne region (1842–43)

Te Ika a Māui Fish of Maui, i.e., the North Island of New Zealand

teka *n.* dart thrown for amusement; footrest attached to a digging stick

Te Kani-a-Takirau name of a carved house opened in 1860 at Tolaga Bay, East Coast (no longer extant)

Te Kore *n.* place in mythology, characterized by nothingness out of which the primal parents emerged

tekoteko *n.* technically, the carved figure on the gable of a house or the figurehead of a canoe; commonly taken to mean a carved figure

Te Mana o Turanga name of a carved house in Gisborne region (1883)

tēnei *def. pron.* this (near speaker)

Te Rangiunuora name of a carved house at Rotoiti

teretere *v.i.* to swim about floating, spread out

Te Toki a Tapiri a famous war canoe, now in the Auckland Museum

Te Waipounamu the South Island of New Zealand

tewhatewha *n.* weapon, made of wood or bone, shaped something like an ax, with short rounded blade at one end, pointed handle at the other

tī *n.* ti palm (Cordyline), commonly called the cabbage tree, several species, e.g., *Cordyline australis, Cordyline banksii*

tieke *n.* bird, the saddleback (*Philesturnus carunculatus*)

tiheru *n.* bailer, vessel to bail with

tiki *n.* neck ornament usually made of greenstone (but other materials also employed)

timunga *n.* timu-nga, ebbing of the tide

tinei *v.t.* to extinguish, quench, put out

tipuna, tupuna *n.* ancestor, grandparent

tipu-nga *n.* growth, the growing; Te Tipunga, a historical period (1200–1500)

tītī *n.* muttonbird highly desired as food, several species, e.g., *Puttinus ariseus*

tohunga *n.* skilled person, priest, wizard

toi *n.* art, knowledge, origin, source of mankind, aboriginal, native

tōia *v.t.* to drag, haul

toi te kupu the language survives

toki *n.* adz

toki pounamu *n.* adz made of jade or greenstone

toki pou tangata *n.* adz to dispatch men or to stand men up, a ceremonial adz

Tokopiko-whakahau name of a carved house of Arawa style (1878)

tomo *v.i.* to pass in or out or under, usually means to enter

tomotomo *v.i.* to pass frequently (under the prow of the canoe)

tōna *pron., poss.* his, hers, its

tōtara *n.* timber highly favored for wood carving, a large forest tree (*Podocarpus totara*)

tū *v.i.* to stand, be erect

tūāhu *n.* sacred place where certain rites were performed

tuhi *v.t.* to redden, cause to glow

tūī *n.* bird, also called kōkō (*Prosthemadera novaeseelandiae*), commonly the parson bird

tuku iho *adj.* handed down, used with tāonga (q.v.) to mean heirloom

tukutuku *n.* latticework with decorative features expressed in stitches, usually placed between carved posts

Tūmātauenga *personal name* God of Men, and hence of War

Tūmoanakōtore name of a carved house from East Coast region (1872)

tūpāpaku *n.* corpse

tūpato *adj.* cautious

tupu, tipu *v.t.* to grow

turaki *v.t.* to subdue, make calm

turuturu whatu *n.* weaving peg

tū tangata *n.* concept of standing up like a man, hence, self-help

tūtūā *n.* slave

tūturi *v.i.* to draw up the knees

ua-āwha *n.* very heavy rain

Uenuku-mai-Rarotonga name of a carved house in Arawa region (1875)

Uenuku-tūwhatu *personal name* war god, name given to a highly stylized piece of carving from Waikato region

unaunahi *n.* a carving pattern associated with fish scales, often a complex of rolling and connected spirals

unu-hia *v.t.* to pull off

ūpokororo *n.* freshwater fish *(Prototroctes oxyrhynchus)*

uri *n.* descendant

uriuri *adj.* dark, deep in color

uta *n.* the land, as opposed to the sea or water

uta-ina *v.t.* to put persons or things on or aboard a canoe, load or man a canoe

utu *n.* return for anything, ransom, reward, price, reply

wā *n.* linked with kāinga (q.v.) to mean the homeland or home village

wahaika *n.* a hand weapon asymmetrical in shape and made of wood or bone

waharoa *n.* entrance to a fortified village, often an elaborately carved feature

wāhi *n.* location, place

wāhi ngaro *n.* the lost portion (of the heritage)

waho *loc.* outside

wai *n.* water

waiata *v.t.* to sing; *n.* song

waiho *v.i.* to remain, let be, leave alone

waimarie *adj.* lucky, quiet

wairua *n.* spirit of an individual or of a group, an indistinct and shadowy image, style, flair, elan

waka *n.* canoe, any long narrow receptacle or trough

wakahuia *n.* carved box, literally, a container for prized huia feathers; see papahou

wā kāinga *n.* home village, home

waka-taua *n.* war canoe

wana *n.* same as mana (q.v.), authority

wānanga *n.* knowledge; meeting to discuss transmission of traditional knowledge; house of learning

wawā *v.i.* to separate, scatter

wehi *n.* awe, fear

werawera *n.* warmth, sweat, heat

whaea *n.* mother, auntie

whaihanga *v.t.* to make, build, construct; *n.* architecture

whaikōrero *n.* oration, speech

whaitere *n.* stingray *(Dasyatis brevicaudatus)*

whaititiri *n.* thunder

whakaahua *n.* picture to look at

whakahuatia *v.t.* to pronounce, recite, call out the name

whakairo *v.t.* to ornament with a pattern, used of carving, tattooing, painting, weaving; more generally applied today to wood carving

whakapakoko *n.* carved image, dry, mummy

whakapapa *n.* genealogy

whakatairangi-tia *v.t.* to move about in an aimless manner

whakataukī *n.* proverb

whakautu *v.t.* to reply

whakawae *n.* the side carvings surrounding a door of a meeting house

whānau *n.* family, extended family unit at the level of sub-sub-tribe; literally, to be born

whāngaia *v.t.* to feed, nourish, bring up

whare *n.* house

whare kōhanga *n.* house for mother and baby after birth

whare maire *n.* house set apart for instruction in sacred lore

whare-nui *n.* large house, usually the main carved house

whare tipuna *n.* house of ancestors

whare whakairo *n.* carved house

whatukura *n.* prized stone

wheketoro *n.* octopus or squid

whenua *n.* land, country, ground; also placenta or afterbirth

whiti *v.i.* to cross over, reach the opposite side

wiwi-a meaning not clear; translation suggests increase. Williams indicates it might mean to be scattered or distributed, that is, of no purpose.

BIBLIOGRAPHY

ANGAS, GEORGE FRENCH
1850 *Savage Life and Scenes in Australia and New Zealand.* 2d ed.
 2 vols. London: Smith, Elder.

APPELLATE COURT MINUTE BOOK
1976 Gisborne, Maori Land Court. Appellate Court Minute Book,
 vol. 31, p. 286. Tairawhiti Register, vol. 1. Case of Raharuhi
 Rukupo (deceased).

ARCHEY, GILBERT
1977 *Whaowhia: Maori Art and Its Artists.* Auckland: Collins.

ARNHEIM, RUDOLF
1961 Expressionism. In *Aesthetics Today,* edited by Morris H.
 Philipson, pp. 188–207. Cleveland: World Publishing Co.,
 Meridian Books.

BARROW, T.
1963 *The Life and Work of the Maori Carver.* Secondary School
 Bulletin, School Publications Branch. Wellington: Department
 of Education.
1965 *A Guide to the Maori Meeting House "Te Hau-ki-Turanga."*
 Wellington: Dominion Museum.
1969 *Maori Wood Sculpture of New Zealand.* Wellington: Reed.
1972 *Art and Life in Polynesia.* Wellington: Reed.
1978 *Maori Art of New Zealand.* Wellington: Reed; Paris: UNESCO
 Press.

BARSTOW, R. C.
1878 The Maori Canoe. *Transactions and Proceedings of the New
 Zealand Institute* 11:71–76.

BEAGLEHOLE, JOHN C., ed.
1961 *The Journals of Captain James Cook on His Voyages of Discov-
 ery.* Vol. 2, *The Voyage of the "Resolution" and "Adventure"
 1772–1775.* Cambridge: Hakluyt Society.
1962 *The "Endeavour" Journal of Joseph Banks, 1768–1771.* 2 vols.
 Sydney: Angus and Robertson.
1968 *The Journals of Captain James Cook: Addenda and Corrigenda
 to Volume 1, The Voyage of the "Endeavour," 1768–1771.*
 Cambridge: University Press.

BELL, E.
1791–1794 Journal of a Voyage in HMS Chatham to the Pacific Ocean,
 1791– 1794. 2 vols. Manuscript. Alexander Turnbull Library,
 Wellington.

BELLWOOD, PETER
1978a *Archaeological Research at Lake Mangakawere, Waikato,
 1968–1970.* Otago University Studies in Prehistoric Anthro-
 pology, vol. 12; New Zealand Archaeological Association Mono-
 graph no. 9. Dunedin: University of Otago Department of
 Anthropology.
1978b *Archaeological Research in the Cook Islands.* Pacific Anthropo-
 logical Records, no. 27. Honolulu: Bishop Museum.
1978c *Man's Conquest of the Pacific: The Prehistory of Southeast Asia
 and Oceania.* Auckland: Collins.

BEST, ELSDON
n.d. Maori Notebook 7. Ms. Papers. Alexander Turnbull Library,
 Wellington.
1898 Omens and Superstitious Beliefs of the Maori. *Journal of the
 Polynesian Society* 7:119–136, 233–243.
1901 The Spiritual Concepts of the Maori, part 2. *Journal of the
 Polynesian Society* 10:1–20
1923 *The Maori School of Learning: Its Objects, Methods, and Cere-
 monial.* Dominion Museum Monograph, no. 6. Wellington:
 Dominion Museum.
1929 *The Whare Kohanga (the "Nest House") and Its Lore.* Domin-
 ion Museum Bulletin, no. 13. Wellington: Dominion Museum.
1941 *The Maori.* 2 vols. Memoirs of the Polynesian Society, vol. 5.
 Wellington: Polynesian Society.
1977 *Tuhoe. Children of the Mist.* 1925. Reprint. Memoirs of the
 Polynesian Society, vol. 6. Wellington: Polynesian Society.

BEST, SIMON
1977 The Maori Adze: An Explanation for Change. *Journal of the
 Polynesian Society* 86:307–337.

BIGGS, R. N.
1868 Manuscript papers. National Museum of New Zealand,
 Wellington.

BINNEY, JUDITH M. C.
1968 *The Legacy of Guilt: A Life of Thomas Kendall.* Auckland:
 Oxford University Press.

BURNS, PATRICIA
1980 *Te Rauparaha: A New Perspective.* Wellington: Reed.

CARKEEK, WAKAHUIA
1966a *The Kapiti Coast: Maori History and Place Names.* Wellington:
 Reed.
1966b Te Rangihaeata. In *An Encyclopedia of New Zealand,* edited
 by A. H. McLintock, vol. 3, pp. 44–45. Wellington: Govern-
 ment Printer.

CASSELS, RICHARD
1979 Early Prehistoric Wooden Artefacts from the Waitore Site
 (N136/16), near Patea, Taranaki. *New Zealand Journal of Ar-
 chaeology* 1:85–108.

CHARLOT, JOHN
1977 The Application of Form and Redaction Criticism to Hawaiian
 Literature. *Journal of the Polynesian Society* 86:479–501.

CHEESEMAN, T. F.
1906 Notes on Certain Maori Carved Burial-Chests in the Auckland
 Museum. *Transactions and Proceedings of the New Zealand
 Institute* 33 (n.s. 22):451–456.

DAVIDSON, JANET M.
1975 The Excavation of Skipper's Ridge (N40/7), Opito, Coromandel
 Peninsula, in 1959 and 1960. *Records of the Auckland Insti-
 tute and Museum* 12:1–42.

1979 Samoa and Tonga. In *Prehistory of Polynesia*, edited by J. D. Jennings, pp. 82–109. Cambridge: Harvard University Press.

DAVIS, F.
1976 Maori Art and Artists. *Education Magazine* (Wellington) nos. 1–10 (1976).

DODD, EDWARD HOWARD
1967 *Polynesian Art*. Vol. 1, *The Ring of Fire*. New York: Dodd, Mead.

DUFF, ROGER S.
1956; 1977 *The Moa-Hunter Period of Maori Culture*. 2d ed. Canterbury Museum Bulletin, no. 1. Wellington: Government Printer; 3d ed. Wellington: Government Printer.

DYEN, I.
1981 The Subgrouping of Polynesian Languages. In *Studies in Pacific Languages and Cultures in Honour of Bruce Biggs*, edited by J. Hollyman and A. Pawley, pp. 83–100. Auckland: Linguistic Society of New Zealand.

EARLE, AUGUSTUS
1832 *A Narrative of Nine Months Residence in New Zealand in 1827....* London: Longman, Rees, Orme Brown, Green and Longman.

EMORY, KENNETH P., and SINOTO, YOSIHIKO H.
1964 Eastern Polynesian Burials at Maupiti. *Journal of the Polynesian Society* 73:143–160.

FAGG, WILLIAM BULLER
1973 In Search of Meaning in African Art. In *Primitive Art and Society*, edited by J. A. W. Forge, pp. 151–163. London: Oxford University Press.

FINNEY, BEN RUDOLPH
1979 Voyaging. In *Prehistory of Polynesia*, edited by J. D. Jennings, pp. 322–351. Cambridge: Harvard University Press.

FIRTH, RAYMOND W.
1925 The Maori Carver. *Journal of the Polynesian Society* 34: 277–291.

FORGE, J. ANTHONY W.
1979 The Problem of Meaning in Art. In *Exploring the Visual Art of Oceania*, edited by S. M. Mead, pp. 278–286. Honolulu: University Press of Hawaii.

FORSTER, JOHANN REINHOLD
1778 *Observations Made During a Voyage Round the World....* London: G. Robinson.

FOWLER, PERCY LEO
1974 *Te Mana o Turanga*. Auckland: New Zealand Historic Places Trust.

FRASER, DOUGLAS
1962 *Primitive Art*. Garden City, N.Y.: Doubleday.

GOLSON, JACK
1959 Culture Change in Prehistoric New Zealand. In *Anthropology in the South Seas: Essays Presented to H. D. Skinner*, edited by J. D. Freeman and W. R. Geddes, pp. 29–74. New Plymouth, N.Z.: Avery.

GREEN, ROGER C.
1963 *A Review of the Prehistoric Sequence in the Auckland Province*. New Zealand Archaeological Association Monograph no. 2. Auckland: University of Auckland Bindery.
1965 Linguistic Subgrouping within Polynesia: The Implications for Prehistoric Settlement. *Journal of the Polynesian Society* 75: 6–38.
1967 Sources of New Zealand's East Polynesian Culture: The Evidence of a Pearl Shell Lure Shank. *Archaeology and Physical Anthropology in Oceania* 2:81–90.
1977 Adaptation and Change in Maori Culture. In *Biogeography and Ecology in New Zealand*, edited by G. Kuschel. The Hague: Junk, 1975. Reprint. Albany: Stockton House.
1979 Lapita. In *Prehistory of Polynesia*, edited by J. D. Jennings, pp. 27–60. Cambridge: Harvard University Press.
1981 Location of the Polynesian Homeland: A Continuing Problem. In *Studies in Pacific Languages and Cultures in Honour of Bruce Biggs*, edited by J. Hollyman and A. Pawley, pp. 138–158. Auckland: Linguistic Society of New Zealand.

GREY, SIR GEORGE
n.d. New Zealand Maori Ms. Auckland Public Library.
1853 *Ko Nga Moteatea, me nga hairara o nga Maori*. Wellington: R. Stokes.
1953 *Nga Mahi a Nga Tupana*. 3d ed. 1928. Reprint. Maori Texts of the Maori Purposes Fund Board Research, vol. 1. Wellington: L. T. Watkins.

GROUBE, M. L.
1967 A Note on the Hei-Tiki. *Journal of the Polynesian Society* 76:453–457.
1970 The Origin and Development of Earthwork Fortifications in the Pacific. In *Studies in Oceanic Culture History*, edited by R. C. Green and M. Kelly, vol. 1, pp. 133–164. Pacific Anthropological Records, no. 11. Honolulu: Bishop Museum.

GUDGEON, THOMAS WAYTH
1885 *The History and Doings of the Maoris: From the Year 1820 to the Signing of the Treaty of Waitangi in 1840*. Auckland: H. Brett.

HALL, ROBERT
n.d. Te Hau ki Turanga. Unpublished typescript. National Museum of New Zealand, Wellington.

HAMEL, G.
1978 Radiocarbon Dates from the Moa-Hunter Site of Papatowai, Otago, New Zealand. *New Zealand Archaeological Association Newsletter* 21:53–54.

HAMILTON, AUGUSTUS
1896–1900 *The Art Workmanship of the Maori Race in New Zealand*. Dunedin: Fergusson and Mitchell.

HARLOW, R.
1979 Regional Variation in Maori. *New Zealand Journal of Archaeology* 1:123–138.

HARRIS, MARVIN
1968 *The Rise of Anthropological Theory: A History of Theories of Culture*. New York: Crowell.

HEIDEGGER, MARTIN
1978 *Basic Writings from "Being and Time" (1927) to "The Task of Thinking" (1964)*, edited by D. F. Krell. London: Routledge and Kegan Paul.

HIGHET, A.
1982 *World Conference on Cultural Policies (Address to UNESCO)*. Wellington: Department of Internal Affairs.

HOLLYMAN, J., and PAWLEY, A., eds.
1981 *Studies in Pacific Languages and Cultures in Honour of Bruce Biggs*. Auckland: Linguistic Society of New Zealand.

HOUGHTON, PHILIP
1980 *The First New Zealanders*. Auckland: Hodder and Stoughton.

IRWIN, G. J.
1980 The Prehistory of Oceania: Colonisation and Cultural Change. In *Cambridge Encyclopedia of Archaeology*, edited by A. Sherrat, pp. 324–332. New York: Cambridge University Press and Crown.

JACKSON, TED; McCASKILL, DON; and HALL, BUD L., eds.
1982 *Learning for Self-Determination: Community-Based Options for Native Training and Research*. Special issue. *Canadian Journal of Native Studies* 2, no. 1.

JENNINGS, J. D., ed.
1979 *Prehistory of Polynesia*. Cambridge: Harvard University Press.

JOHANSEN, J. PRYTZ
1954 *The Maori and His Religion in Its Non-ritualistic Aspects*. Copenhagen: Ejnar Munksgaard.

KELLY, LESLIE G.
1949 *Tainui: The Story of Hoturoa and His Descendants*. Polynesian Society Memoir, no. 25. Wellington: Polynesian Society.

KRUGER, TAMATI
1980 The Qualities of Ihi, Wehi and Wana. In *Customary Concepts of the Maori*, edited by S. M. Mead and J. Fleras, pp. 138–145. Wellington: Victoria University, Department of Maori Studies.

KUBLER, GEORGE
1962 The Shape of Time: Remarks on the History of Things. New Haven: Yale University Press.

LAWLOR, IAN
1979 Stylistic Affinities of the Waitore Site (N136/16), Assemblage. New Zealand Journal of Archaeology 1:109–114.

LEACH, B. F., and LEACH, H. M.
1979 Prehistoric Communities in Eastern Palliser Bay. In Prehistoric Man in Palliser Bay, edited by B. F. Leach and H. M. Leach, pp. 251–272. Bulletin of the National Museum of New Zealand (Wellington), no. 21.

LEAHY, ANNE
1974 Excavations at Hot Water Beach (N44/69), Coromandel Peninsula. Records of the Auckland Institute and Museum 11:23–76.

LEVISON, M.; WARD, R. GERARD; and WEBB, JOHN W.
1972 The Settlement of Polynesia: A Report on a Computer Simulation. Archaeology and Physical Anthropology in Oceania 7:234–245.

McEWEN, J. M.
1947 The Development of Maori Culture since the Advent of the Pakeha. Journal of the Polynesian Society, 56:173–187.
1966 Maori Art. In An Encyclopedia of New Zealand, edited by A. H. McLintock, vol. 2, pp. 408–429. Wellington: Government Printer.

MAQUET, J. J. P.
1971 Introduction to Aesthetic Anthropology. Reading, Mass.: Addison-Wesley.

MEAD, S. M.
1975 The Origins of Maori Art: Polynesian or Chinese? Oceania 45:173–211.

MEAD, S. M., and PHILLIS, ONEHOU ELIZA
1982 Te One Matua: The Abundant Earth. Te Teko: Ngati Pahipoto and Te Komiti Maori o Kokohinau.

MISSIONARY REGISTER
1816 Missionary Register. London.

MOKOMOKO, MEREANA, and MAIR, GILBERT
1897 The Building of Hotunui, Whare Whakairo, W. H. Taipari's Carved House at Thames, 1878. Transactions and Proceedings of the New Zealand Institute 30 (n.s. 13):41–44.

MOORE, P. R.
1975 Preliminary Investigations of the Tahanga Basalt, Coromandel Peninsula. New Zealand Archaeological Association Newsletter 18:32–36.
1976 The Tahanga Basalt: An Important Resource in North Island Prehistory. Records of the Auckland Institute and Museum 13:77–93.

MOORE, P. R., and McFAGDEN, B. G.
1978 Excavation of a Shell Midden at Turakirae Head, near Wellington, and a Date for the Haowhenua Earthquake of Maori Tradition. Journal of the Polynesian Society 87:253–255.

NAHE, HOANI
1860 He Korero mo te haerenga mai o nga tupuna. Manuscript. Auckland Institute and Museum.

NEICH, R.
1977 Historical Change in Rotorua Ngati Tarawhai Wood-carving Art. Master's thesis, Victoria University of Wellington.

NGATA, APIRANA TURUPA
1930 He Tangi na Rangiuia mo Tana Tamaiti, mo Tuterangiwhaitiri. Te Wananga 2, no. 1:21–35.
1958 The Origin of Maori Carving. Te Ao Hou/The New World 6, no. 22:30–37; 6, no. 23:30–34.
1972 Raura-Nui-a-Toi Lectures and Ngati Kahungunu Origins. Wellington: Victoria University of Wellington, Anthropology Department.

NGATA, APIRANA TURUPA, and JONES, PEI TE HURINUI
1959–1970 Nga Moteatea (The Songs). Polynesian Society Maori Texts, vols. 1–3. Wellington: Polynesian Society.

NGATA, P.
1983 Report to Gerentology Delegation to Australia and New Zealand. Paper read February 22, 1983, at Waiwhetu Marae, Wellington.

OLIVER, WILLIAM HOSKING, and THOMSON, JANE M.
1971 Challenge and Response: A Study of the Development of the Gisborne East Coast Region. Gisborne: East Coast Development Research Association.

PANOFSKY, ERWIN
1955 Meaning in the Visual Arts. Garden City, N.Y.: Doubleday, Anchor Books.

PARKER, W.
1978 The Substance that Remains. In Thirteen Facets: Essays to Celebrate the Silver Jubilee of Queen Elizabeth the Second, edited by I. M. Wards, pp. 167–198. Wellington: Government Printer.

PARKINSON, SYDNEY
1771 A Journal of a Voyage Round the World. London: T. Becket and P. A. de Hondt.

PAWLEY, ANDREW
1966 Polynesian Languages: A Sub-Grouping Based on Shared Innovations in Morphology. Journal of the Polynesian Society 75:39–64.
1971 Austronesian Languages. Working Papers, no. 14. University of Auckland Department of Anthropology.

PHILLIPS, WILLIAM JOHN
1955 Carved Maori Houses of Western and Northern Areas. Dominion Museum Monograph, no. 9. Wellington: Government Printer.

PHILLIPS, WILLIAM JOHN, and WADMORE, J. C.
1956 The Great Carved House Mataatua of Whakatane. Wellington: Polynesian Society.

PIDDINGTON, RALPH L.
1956 A Note on the Validity and Significance of Polynesian Traditions. Journal of the Polynesian Society 65:200–203.

PIETRUSEWSKY, MICHAEL
1970 An Osteological View of Indigenous Populations in Oceania. In Studies in Oceanic Culture History, edited by R. C. Green and M. Kelly, vol. 1, pp. 1–12. Pacific Anthropological Records, no. 11. Honolulu: Bishop Museum.

PRICKETT, N. J.
1979 Prehistoric Occupation in the Moikau Valley, Palliser Bay. In Prehistoric Man in Palliser Bay, edited by B. F. Leach and H. M. Leach, pp. 29–47. Bulletin of the National Museum of New Zealand (Wellington), no. 21.

RAMSDEN, GEORGE E. O.
1951 Rangiatea. The Story of the Otaki Church, Its First Pastor and Its People.... Wellington: Reed.

RENWICK, WILLIAM L.
1978 Arts in Cultural Diversity (Address to INSEA 23d World Congress). Sydney: Holt, Rinehart and Winston.

ROBLEY, HORATIO GORDON
1915 Pounamu: Notes on New Zealand Greenstone. London: T. J. S. Guildford.

SALMOND, ANNE
1978 "Te Ao Tawhito": A Semantic Approach to the Traditional Maori Cosmos. Journal of the Polynesian Society 87:5–28.

SHARP, ANDREW
1957 Ancient Voyagers in the Pacific. Harmondsworth: Penguin.
1964 Ancient Voyagers in Polynesia. Berkeley: University of California Press.

SHAWCROSS, F. WILFRED
1964 An Archaeological Assemblage of Maori Combs. Journal of the Polynesian Society 73:382–398.
1976 Kauri Point Swamp: The Ethnographic Interpretation of a Prehistoric Site. In Problems in Economic and Social Archaeology, edited by G. de G. Sieveking, I. H. Longworth, and K. E. Wilson, pp. 277–305. London: Duckworth.

SIMMONS, D. R.
1976 The Great New Zealand Myth: A Study of the Discovery and Origin Traditions of the Maori. Wellington: Reed.

1981 Stability and Change in the Material Culture of Queen Charlotte Sound in the Eighteenth Century. *Records of the Auckland Institute and Museum* 18:1–61.

1982 *Catalogue of Maori Artefacts in the Museums of Canada and the United States of America.* Auckland Institute and Museum Bulletin, no. 12.

SINOTO, YOSIHIKO H.

1979a Excavations on Huahine, French Polynesia. *Pacific Studies* 3:1–40.

1979b The Marquesas. In *Prehistory of Polynesia*, edited by J. D. Jennings, pp. 110–134. Cambridge: Harvard University Press.

SKINNER, H. D.

1959 Murdering Beach: Collecting and Excavating, The First Phase, 1850–1950. *Journal of the Polynesian Society* 68:219–238.

1974 *Comparatively Speaking: Studies in Pacific Material Culture 1921–1972.* Dunedin: University of Otago Press.

SMITH, HOWARD L.

1976 A Principal Component Analysis of Samoan Ceramics. In *Excavations on Upolu, Western Samoa*, edited by J. D. Jennings et al., pp. 83–95. Pacific Anthropological Records, no. 25. Honolulu: Bishop Museum.

SMITH, S. PERCY

1899 The Tohunga-Maori: A Sketch. *Transactions and Proceedings of the New Zealand Institute* 32 (n.s. 15):253–270.

1913–1915 *The Lore of the Whare-Wananga, or, Teachings of the Maori College on Religion, Cosmogeny, and History.* Polynesian Society Memoirs, vols. 3–4. New Plymouth, N.Z.: Avery.

1921 *Hawaiki: The Original Home of the Maori, With a Sketch of Polynesian History.* 4th ed. Auckland: Whitcombe and Tombs.

SORENSON, MAURICE P. K.

1979 *Maori Origins and Migrations: The Genesis of Some Pakeha Myths and Legends.* Auckland: Auckland University Press; Wellington: Oxford University Press.

STACK, JAMES W.

1875 An Account of the Maori House Attached to the Christchurch Museum. *Transactions and Proceedings of the New Zealand Institute* 8:172–176.

STIRLING, AMIRIA MANUTAHI, and SALMOND, ANNE

1976 *Amiria: The Life Story of a Maori Woman.* Wellington: Reed.

SUTTON, DOUGLAS G.

1980 A Culture History of the Chatham Islands. *Journal of the Polynesian Society* 89:67–93.

TAIAPA, PINE

n.d. *Tuwhakairiora* (Souvenir booklet). Gisborne.

TAMAKI, KARENA

n.d. Pikirangi. In *Maori Settlement of the Waikato District*, edited by J. B. W. Robertson, p. 15. Te Awamutu Historical Society Bulletin, no. 2 (1965).

TAONUI, APERAHAMA

1849 He Pukapuka Whakapapa mo nga Tupuna Maori. Ms. 120. Auckland Institute and Museum.

TAREHA

1868 [Description of the Maori House at the Colonial Museum.] *Transactions and Proceedings of the New Zealand Institute* 1:445–446.

TAYLOR, RICHARD

1855 *Te Ika a Maui, or, New Zealand and Its Inhabitants.* . . . London: Wertheim and Macintosh.

TE AOTERANGI, WIRIHANA

n.d. No Hawaiki tenei waka. Manuscript. Auckland Institute and Museum.

TE RANGIKAHEKE

1849 Te Tikanga Tenei Mea o te Rangatiratanga o te Tangata Maori. Grey New Zealand Maori Ms. 85. Auckland Public Library.

TE UREMUTU, ERUERA

n.d. He Wakapapa Tupana. Manuscript. Alexander Turnbull Library, Wellington.

TE WHAREAUAHI, PANGO

1905 Te Hekenga o Kahu-hunu. *Journal of the Polynesian Society* 14:67–80.

TROTTER, MICHAEL M., and McCULLOCH, BEVERLEY

1981 *Prehistoric Rock Art of New Zealand.* Rev. ed. New Zealand Archaeological Association Monograph, no. 12. Auckland: Longman Paul.

TUREI, MOHI

1873 Death of Raharuhi Rukupo. *Te Waka Maori o Niu Tirani* 9, no. 19 (December 10, 1873):179–180.

1913 Taharakau. *Journal of the Polynesian Society* 22:62–63.

UMLAUFF, J. F. G.

1902 *Whare Whakairo Huiteananui: Maori Raths- und Versammlungshaus.* Catalogue no. 130. Hamburg: Museum Umlauff.

WHITE, JOHN

1887–1890 *The Ancient History of the Maori: His Mythology and Traditions.* 6 vols. Wellington: Government Printer.

WILLIAMS, HERBERT WILLIAM

1971 *A Dictionary of the Maori Language.* 7th ed. Rev. and enl. Wellington: Government Printer.

WILLIAMS, WILLIAM

1974 *The Turanga Journals, 1840–1850: Letters and Journals of William and Jane Williams, Missionaries to Poverty Bay*, edited by F. Porter. Wellington: Price Milburn.

YEN, D. E.

1974 *The Sweet Potato and Oceania: An Essay in Ethnobotany.* Bishop Museum Bulletin (Honolulu), no. 236.

THE AMERICAN FEDERATION OF ARTS